THE
LOUVRE

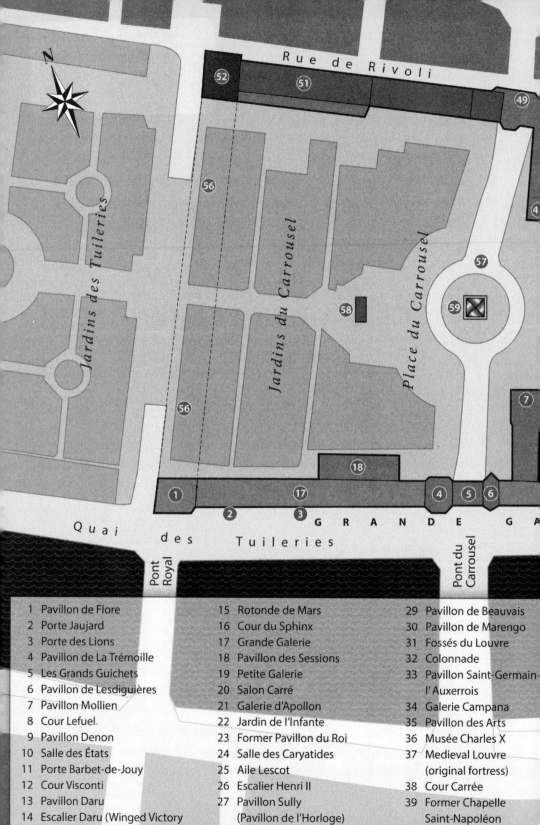

Rue de Rivoli

㊾ ㊶ ㊿ ㊾

Jardins des Tuileries

Jardins du Carrousel

Place du Carrousel

㊺ ㊼ ㊾ ㊿

①

② ③ G R A N D E G A

Quai des Tuileries

Pont Royal

Pont du Carrousel

1 Pavillon de Flore
2 Porte Jaujard
3 Porte des Lions
4 Pavillon de La Trémoille
5 Les Grands Guichets
6 Pavillon de Lesdiguières
7 Pavillon Mollien
8 Cour Lefuel
9 Pavillon Denon
10 Salle des États
11 Porte Barbet-de-Jouy
12 Cour Visconti
13 Pavillon Daru
14 Escalier Daru (Winged Victory of Samothrace)

15 Rotonde de Mars
16 Cour du Sphinx
17 Grande Galerie
18 Pavillon des Sessions
19 Petite Galerie
20 Salon Carré
21 Galerie d'Apollon
22 Jardin de l'Infante
23 Former Pavillon du Roi
24 Salle des Caryatides
25 Aile Lescot
26 Escalier Henri II
27 Pavillon Sully
(Pavillon de l'Horloge)
28 Aile Lemercier

29 Pavillon de Beauvais
30 Pavillon de Marengo
31 Fossés du Louvre
32 Colonnade
33 Pavillon Saint-Germain-
l'Auxerrois
34 Galerie Campana
35 Pavillon des Arts
36 Musée Charles X
37 Medieval Louvre
(original fortress)
38 Cour Carrée
39 Former Chapelle
Saint-Napoléon
40 Pavillon Colbert

Praise for *The Louvre*

"James Gardner makes the walls talk. He traces the many metamorphoses of the Louvre, revealing how from its humble origins as a fortress it has come to occupy the heart of Paris and the center of French—and indeed world—culture. His remarkable achievement is to show us how the building is every bit as spectacular and as fascinating as the treasures it holds."
—Ross King, bestselling author of
Brunelleschi's Dome and *The Bookseller of Florence*

"With its fast-moving and rich narrative, this truly excellent book needed to be written: the fascinating and turbulent story of the Louvre as a royal palace has been largely eclipsed by its much shorter and more famous life as a museum. Here both parts of its long history have been splendidly recounted."
—Philippe de Montebello, Director
Emeritus, The Metropolitan Museum of Art

"[An] extensive exploration of the Parisian cultural institution."
—*Smithsonian Magazine*

"Chronicles the Parisian icon's 800-year evolution from workaday fortress to beloved art institution." —*New York Post*

"Engrossing . . . In elegant prose, Gardner describes how over the next 200 years [after 1793] the Louvre endured constant evolution and construction as its reputation as a leading repository for art treasures grew and it became the world's most famous museum. Fast-paced and evocative, this is a must for Francophones as well as art and architecture lovers."
—*Publishers Weekly* (starred review)

"Magisterial . . . The whole book is enlivened by his stories of the people involved, and by the lyricism with which he describes certain rooms . . . The book does what all good books of this kind should do: it makes me want to go back to the Louvre and see some of the things he writes about and that I never noticed before." —*Midwest Book Review*

"The evolution of the Louvre reflects the political, intellectual, and aesthetic history of France . . . The author offers a vivid chronicle of strife, wars, rivalries, and aspirations culminating in the present grand architectural complex . . . A richly detailed journey through a palimpsest of the past." —*Kirkus Reviews*

"Comprehensive . . . Recommended for readers interested in the history of France, the history of architecture, and museology."
 —*Library Journal*

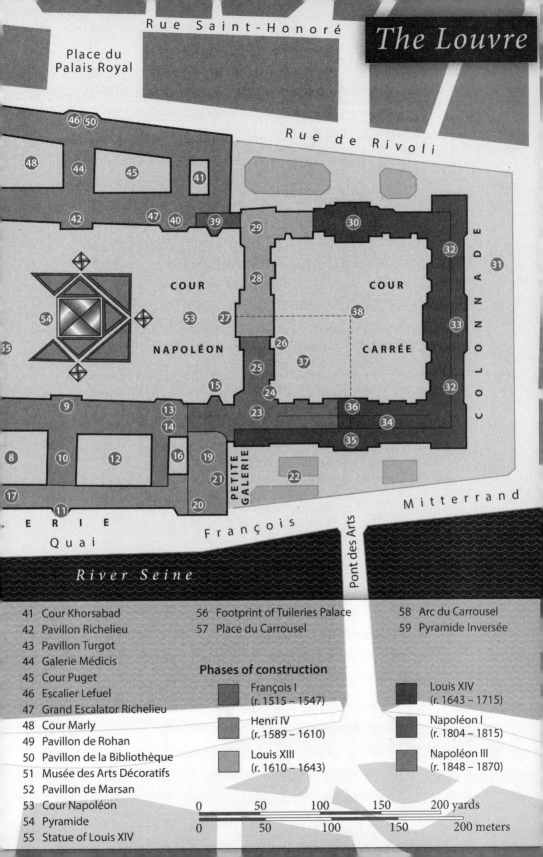

The Louvre

Rue Saint-Honoré

Place du Palais Royal

Rue de Rivoli

COLONNADE

COUR NAPOLÉON

COUR CARRÉE

PETITE GALERIE

Mitterrand

Pont des Arts

E R I E

Quai

François

River Seine

41 Cour Khorsabad
42 Pavillon Richelieu
43 Pavillon Turgot
44 Galerie Médicis
45 Cour Puget
46 Escalier Lefuel
47 Grand Escalator Richelieu
48 Cour Marly
49 Pavillon de Rohan
50 Pavillon de la Bibliothèque
51 Musée des Arts Décoratifs
52 Pavillon de Marsan
53 Cour Napoléon
54 Pyramide
55 Statue of Louis XIV
56 Footprint of Tuileries Palace
57 Place du Carrousel
58 Arc du Carrousel
59 Pyramide Inversée

Phases of construction

François I
(r. 1515 – 1547)

Henri IV
(r. 1589 – 1610)

Louis XIII
(r. 1610 – 1643)

Louis XIV
(r. 1643 – 1715)

Napoléon I
(r. 1804 – 1815)

Napoléon III
(r. 1848 – 1870)

0 50 100 150 200 yards

0 50 100 150 200 meters

Also by James Gardner

Buenos Aires: The Biography of a City

Published simultaneously in Canada
Printed in Canada

First Grove Atlantic hardcover edition: May 2020
First Grove Atlantic paperback edition: April 2022

Library of Congress Cataloging-in-Publication data is available for this title.

ISBN 978-0-8021-4878-0
eISBN 978-0-8021-4879-7

Grove Press
an imprint of Grove Atlantic
154 West 14th Street
New York, NY 10011
Distributed by Publishers Group West
groveatlantic.com

22 23 24 25 10 9 8 7 6 5 4 3 2 1

THE
LOUVRE

The Many Lives of the World's Most Famous Museum

JAMES GARDNER

Grove Press
New York

This book is dedicated to the memory of my mother,

Natalie Jaglom Gardner
29 September 1924–22 February 2019

CONTENTS

Preface xi

Introduction xv

1 The Origins of the Louvre 1

2 The Louvre in the Renaissance 29

3 The Louvre of the Early Bourbons 67

4 The Louvre and the Sun King 103

5 The Louvre Abandoned 141

6 The Louvre and Napoleon 173

7 The Louvre under the Restoration 215

8 The Nouveau Louvre of Napoleon III 237

9 The Louvre in Modern Times 289

10 The Creation of the Contemporary Louvre 333

Epilogue 355
Glossary 361
Notes 363
Bibliography 371
Image credits 376
Index 377

PREFACE

In telling the story of the Louvre, I have proceeded simultaneously along three fronts, the architectural, the institutional and the historical. That is to say that the present book describes the evolution of the building known as the Louvre from its earliest foundations as a medieval fortress to the completion of I. M. Pei's glass pyramid eight centuries later. But the book also considers the institutional genesis of the great museum that has now inhabited that structure for over two hundred years, animating it as a soul animates a body. Finally, and no less essentially, the book explores the crucial role that the Louvre has played in the history of France and its ruling dynasties, from the time of the Third Crusade, through the Revolution, to the Second World War and beyond.

Although this tale is well worth telling, it is also one of nearly incalculable complexity. Architectural history is to art history as three-dimensional chess is to the standard version of the game. In general, a painting or sculpture is created by one artist in a fairly abbreviated span of time and it remains in that final condition, shielded from the elements, for as long as its material foundations hold up. But a building, especially a great building, is often a labor of centuries, engaging the talents of generations of architects and codifying in stone the often discordant whims of several great dynastic families. It is subject to constant attack from the elements, and not infrequently from the fusillades of invading armies and the vicissitudes of siege warfare.

Perhaps no single structure on the planet exhibits this complex and protracted genesis as well as the Louvre, which, for more than eight hundred years, has been in a process of becoming. What we see

today—not counting what has been destroyed beyond recall—is the result of some twenty discrete building campaigns over five hundred years, and indeed, the building's history goes back three and a half centuries before the construction of the earliest structures that are now visible above ground.

But traditionally architects and their patrons seek to belie such troubled gestation and to persuade visitors that they stand before a serenely unified project born of a single building campaign. And that is how most visitors see the Louvre, and how, for a long time, I too saw this incomparable palace. I was aware that there were stylistic disparities among its parts and that it had emerged over a period of centuries. But one day, as I was entering the grounds of the Louvre for perhaps the hundredth time, it suddenly came home to me that I knew almost nothing of the story behind what I was seeing. As I began to look into the matter, my initial curiosity grew upon itself, resulting in the book that you now hold in your hands.

In several respects this book is antithetical to the one I wrote immediately before it, a history of the city of Buenos Aires. That book engaged a massive subject—an entire city—that had been relatively little studied and, to the extent to which it had been studied at all, in a rather unsystematic, even shoddy way. By contrast, the focus of the present book is a single object—although, admittedly, one of the largest on earth—every square inch of which has been scrutinized by the most eminent and exacting art and architectural historians, not only in France, but throughout the world. My skills and training being those of a cultural critic rather than a researcher in recondite fields, I freely admit that I have left archival inquiries to the many scholars who are far more practiced and proficient in such pursuits. I am also delighted to acknowledge my debt to the three-volume *Histoire du Louvre*, edited by Geneviève Bresc-Bautier and Guillaume Fonkenell, which appeared at precisely the moment when I began writing my book. Engaging the talents of nearly a

hundred scholars and extending to nearly two million words, that book is a summa of archival research—intended mainly for scholars in the field—into every imaginable aspect of the history of the Louvre as a building and an institution.

In the interests of housekeeping, the reader will allow me to make several somewhat disconnected points. The first is that, for the sake of consistency, I have numbered the floors in the Louvre, and elsewhere, after the European fashion, rather than the American: the lowest externally visible part of a building is its ground floor, followed by the first floor (which in the United States is called the second floor). The Louvre thus has three levels (not counting several levels below grade): the ground floor, the first floor and the second floor.

Next, it should be stated that the entire western side of the Louvre—as it opens outward to the Champs-Élysées and the Arc de Triomphe—was once occupied by a great palace, *Les Tuileries*, that was integral, and physically connected, to that architectural complex that we call the Louvre. This palace burned to the ground under the Communards in 1871. Of necessity, I refer to it frequently in the course of the present narrative, but far less for its own sake than for its influence on the evolution of the Louvre as we know it today.

A book of this sort necessarily mentions a great number of paintings, sculptures and architectural elements, more than could be conveniently included among the illustrations. But if this book has a generous complement of images, it has been written in the full awareness of the new realities of the internet: an illustration of every work of art mentioned in the book can be found with relative ease online, and in a higher, crisper resolution than any printed book could achieve. The reader is therefore encourged to seek these images at that bountiful source.

In writing this book, I have more people to thank than could be reasonably named in the present context, and so I will be brief.

My gratitude goes first to my editors at Grove Atlantic, Joan Bingham and George Gibson, for their unfailing patience, sensitivity and enthusiasm for this project. Also at Grove Atlantic, I must thank their editorial assistant Emily Burns, the managing editor Julia Berner-Tobin, the copyeditor Jill Twist, the proofreader Alicia Burns, the art director Gretchen Mergenthaler, who designed the book's splendid cover, and my publicist John Mark Boling. My thanks as well to my gifted agent, William Clark, a committed Francophile who brought me to the attention of Grove Atlantic. I would also like to thank the staffs of the Frick Art Reference Library and especially of the Watson Library at the Metropolitan Museum: it is a great but rarely appreciated testament to the cultural standing of New York City that two of the finest art history libraries in the world should stand within ten blocks of one another along Fifth Avenue. I must also express my gratitude to Colin Bailey, director of the Morgan Library and an expert in French art, for so generously agreeing to review this manuscript, as well as to Iris Moon, assistant curator of European Sculpture and Decorative Arts at the Metropolitan Museum of Art, who kindly reviewed the chapter on Napoleon Bonaparte. It hardly needs to be stated that any remaining errors are entirely my own. My thanks as well to my niece Nadya Gardner, who took the photo of me that accompanies this book. Finally, I must thank the staff of the Hotel Brighton, my home in Paris, for taking such good care of me while I was researching this book. There could be no greater inspiration than to look out the window of my room and, from across the Jardin des Tuileries, to see the Louvre, on a fine morning in early spring, spreading out before me *dans sa gloire*.

INTRODUCTION

Before the Louvre was a museum, it was a palace, and before that a fortress, and before that a plot of earth, much like any other. In French there is a term for such a place, *un lieu-dit*, for which no real equivalent exists in English. This term refers to an area that is familiar to the inhabitants of a region and that may have a name, but, whether populated sparsely or not at all, it has no official, legal recognition. Through what would become the three main open spaces of the modern Louvre—the Cour Carrée, the Cour Napoléon and place du Carrousel—human beings passed and repassed for thousands of years before the ancestors of the Celts and Romans ever began their migration from the Eurasian Steppe westward to the territory of modern France.

We know this because, simultaneously with the vast construction at the Louvre in the 1980s, resulting in the museum we know today, extensive archaeological work was carried out in those three main open spaces. The site of the Cour Napoléon yielded up pottery dating back more than seven thousand years, while the skeletal remains of a man who died over four thousand years ago were unearthed near the Arc du Carrousel and what is now the underground bus depot of the Louvre. Toward the end of the Gallo-Roman period, in the first centuries of the common era, two farms, one in the Cour Napoléon, the other at the site of the place du Carrousel, raised cattle and pigs, and abounded in plum, pear and apple trees, as well as vineyards.

At some point, long before King Philippe Auguste of France decided, in 1191, to build a fortress on this spot of land, the entire area acquired a mysterious name, *le Louvre*, which has defied all

efforts to decipher it. What we do know is that Philippe did not name his fortress *le Louvre* or anything else, since it was really nothing more than a piece of military infrastructure designed to shelter a garrison. Standing outside of Paris at the time of its construction, it merely came to be known by the name that, for centuries, human beings had called the land where it stood: *le Louvre*.

I emphasize the "placeness" of the Louvre in part because everything about it today seems designed to reject and cover up its infinitely humble, elemental origins. Certainly since the time of Louis XIV in the late seventeenth century, if not before, the Louvre has contrived, both in its general design and in its specific details, to appear almost superhuman. Nearly half a mile long from end to end, it is one of the largest man-made structures on the planet, so large that no human eye can take in its entirety from any angle on the ground. But it defies our common humanity in other ways as well. Although much of the structure that the visitor sees today is from the seventeenth century, most of it was either built, rebuilt, or reclad in the nineteenth century: in this sense, the Louvre is a nineteenth-century project, even if its formal components owe a great deal to the architectural aesthetics of two centuries before. At its completion in 1857, the Louvre was the defining architectonic triumph of Napoleon III, if not the material embodiment of the entire Second Empire. Everything about French culture at that time had such superhuman longings. These aspirations are expressed both in the peerless symmetries of the Cour Napoléon and in the extravagant neobaroque language in which the entire complex was reconceived under Napoleon III. There is a hardness, a massiveness to the Louvre, with its burnished railings and marble floors and gilded capitals, that seems to repudiate human frailty. It is the virtuosic expression of something that reaches deep into French culture since the time of the Sun King: a tyrannous, all-conquering discipline, expressed in the faultless couplets of Racine and Boileau and the ballet *en pointe*

of Jean-Georges Noverre, in the culinary precision of Carême and Escoffier, and in the obsessive grammatical precision of Mallarmé and Marcel Proust. Perhaps more than any other building ever made, the Louvre stands as an implicit reproach, a programmatic rejection of the art and architecture that the West favors today, with its asymmetries, its puerile rebellions, its clamorous proclamation of its own insufficiency. It is as though, in the pavilions and colonnades of the Louvre, civilization itself stood in pitched battle not only with human nature in all its weakness, but also with mother Earth, with all those clumps of grass and viscous clay that once occupied this parcel of land and that continue to lie beneath it, waiting for the moment when, at some point in remote posterity, they will regain their former empire.

The place that is the Louvre occupies a position of radical centrality, or so it would have us believe. If Paris is figuratively the center of the world—as it certainly seemed to be in the nineteenth century—the Louvre is the center of Paris. This is literally true. The circumference of the city—represented by the highway known as le Périphérique—spins around the Louvre like a pinwheel at a radius of about three miles in every direction. But here again, the origins of the Louvre belie this assertion of centrality. Today there is as much Paris to the west of the Louvre as to the east. But when the original fortress was built around 1200, it was a military outpost just west of the newly built walls of the city. This is to say that, by strategy and design, the Louvre was *eccentric* to Paris, which lay entirely to the east. And the Louvre would preserve that status until a new wall, built around 1370, finally assimilated it into the city. But even then, the Louvre stood at the western edge of the capital and would remain there for the next five hundred years.

Most of the great events that influenced the histories of England and the United States did not occur in London and New York, respectively, but on some field of battle in open country. And yet,

there is probably no city in the world in which history—the history not just of France but of Europe and beyond—played out more consistently than Paris. By the same token, there is no part of Paris denser in historical consequence than the Louvre. This heritage will surprise many visitors to the museum, who may not even realize that it ever served any other function than that of a repository of great art. In fact, although the Louvre has existed for more than eight hundred years, it has been a museum for only a little over two hundred of those years.

This fact is not to deny, of course, the importance of the Louvre in the history of art. The museum's role in creating the grand narrative of art history should be fairly obvious: the Louvre was the first and is almost certainly the greatest encyclopedic museum in the world, bringing together the art of almost every age and almost every region. What is less widely known, however, is that the Louvre, in addition to being a veritable nursery of architectural innovation, was more directly responsible for the actual production of Western painting and sculpture than any other institution yet conceived. Not only did Nicolas Poussin show up every day to paint the ceiling of la Grande Galerie (although he didn't get far before he abandoned a task he clearly saw as a distasteful burden): for more than a hundred years after Louis XIV abandoned Paris for Versailles in 1682, the Louvre was repurposed as an academy where the greatest artists of France were given studios, free of charge, in which to create whatever they wished. Here the charm of local specificity asserts itself. We can point to the very spot in the northern wing of the Cour Carrée where Jean-Honoré Fragonard painted so many of the world's most endearing paintings. On the first floor of the southern wing, Chardin and Boucher were hard at work in what are now the Egyptian Galleries. The concept of the Salon (the Salons of 1759 and 1761, for example), which lives on today in the Whitney Biennial and the Biennale di Venezia, was born in and named for the Salon Carré, a

few steps to the right of the *Winged Victory of Samothrace*, where the works of Giotto and Duccio now appear.

But it is one of the paradoxes of the Louvre that, although it is among the most frequented places in the world, it is also one of the least understood. Such confusion is hardly surprising, since there is probably no one structure—or more accurately, no complex of structures—in architectural history whose gestation was as protracted or convoluted. What we see today is the result of no fewer than twenty distinct building campaigns that drew on the very diverse and unequal talents of scores of architects over eight centuries. And yet, because there is no glaring disparity among the many parts of this complex, it rarely presents itself as a question to the common visitor. Most tourists enter the Louvre through the *Pyramide*, never realizing that everything they see dates to the 1850s or soon after. In a strictly historical sense, then, they are hardly seeing the Louvre at all, at least not what a Parisian of 1600 or 1800 would have understood by the term.

In fact, what they are seeing can be divided conceptually into four main parts. The Palace of the Louvre, properly understood, consisted of the four wings that now make up the Cour Carrée, occupying the eastern extremity of the Louvre complex. For most of its history, when people spoke of the Louvre, they meant this square structure, and only this. But if you turn west, with the *Pyramide* and the Cour Carrée at your back, you will see the Arc de Triomphe several miles in the distance, at the top of the Champs-Élysées. You should not be seeing the Arc de Triomphe in the distance, however, and this brings us to the second component of the Louvre: the reason you can see the arch at all is that the Tuileries Palace, which was begun in 1564 and should be blocking your view, was burnt to the ground by revolutionaries during the Paris Commune of 1871. But although the Tuileries Palace no longer exists, almost every part of the Louvre that you see today was created in response to it. For

example, to the south lies the third component of the Louvre, a stunningly long and narrow building, half a kilometer in length and known as the Grande Galerie. For most visitors to Paris, even for most Parisians, *this* is the Louvre, because it contains those paintings by Leonardo da Vinci and other Italian masters that they have come to see. And yet, this gallery was created as little more than a covered passageway leading between the Louvre Palace and the Tuileries Palace, which thereafter became part of the Louvre complex. As for everything else you see, the entire northern half of the Louvre (except for one section built around 1805) did not exist before the 1850s. Instead, this entire area was filled for centuries with churches, a hospital and many houses great and small, some of them little better than huts.

In chronicling the dynastic and urbanistic forces that influenced each stage of the Louvre's evolution, as well as the myriad events that took place within the walls of the fortress, then the palace, and later the museum, I will argue that the Louvre is as great a work of art as anything it contains. It would be fairly easy to argue that the façades of the Aile Lescot and the Colonnade all the way at the eastern end of the Louvre should be so considered. But I foresee some resistance when the discussion turns to the Escalier Daru or to the design of the interior of the Grande Galerie. In making this argument, I offer up a totalizing view of the Louvre complex, every part of which is something one should know about. Every element of it that crosses one's line of vision potentially deserves attention, not least the murals of Romanelli and Le Brun that adorn the ceilings of the museum, but that tend to be overlooked because they do not sit politely in a frame.

Comprising nearly four hundred thousand objects from fifty centuries and two hundred generations of human culture, the Louvre is almost certainly the greatest collection of human artifice ever assembled in one place. And yet those objects are not simply there.

Vast, overarching historical and cultural forces brought each of those objects into the galleries of the museum. The Louvre is, among other things, a vast, indiscriminate cocktail of princely collections purchased or purloined over the course of centuries. Not all of it is good, which is of some interest in itself, shedding light as it does on the ever shifting and infinitely unstable progress of taste. More importantly, every work of art that it contains has its story. The *Mona Lisa* is there because François I bought it from Leonardo da Vinci shortly before the painter died. As regards Raphael's great *Saint Michael Routing the Demon,* Pope Leo X gave it to François I in hopes that he would return the favor by invading the Ottoman Empire. And Veronese's *Wedding Feast at Cana,* one of the largest works ever painted on canvas, occupies a wall of the Salle des États because Napoleon Bonaparte stole it from the Venetians and never gave it back. These and four hundred thousand other stories like them all come together to form the Musée du Louvre, the latest chapter, and surely not the last, in the evolution of that little corner of the earth that rests upon the right bank of the Seine.

- 1 -

THE ORIGINS OF
THE LOUVRE

Most visitors to the Louvre come to see the Italian paintings and especially the *Mona Lisa*. This part of the museum, the Aile Denon, is flooded with light that pours in from the ceiling and the windows that look out onto the Seine. Even the gilded frames seem to give off light. To reach it one must ascend, climbing the grand Escalier Daru and turning right at the *Winged Victory of Samothrace*, before emerging into the brilliance of the Salon Carré.

But there is another part of the Louvre, rather less frequented, that seems to belong to a different world. Although it does indeed receive its share of visitors, it is unlikely to be the reason for which they have come to the museum. To reach it, one descends into the earth, into something like twilight or even night, to find the remains of the original Louvre: the fortress that Philippe Auguste built at the end of the twelfth century and the palace into which it evolved under Charles V, late in the fourteenth century.

For fully two hundred years after the last visible traces of the medieval Louvre were razed to the ground in 1660, these subterranean realms were completely forgotten. Not until 1866 did the archaeologist Adolphe Berty, on a hunch, begin to excavate the site. He discovered the intact remnants of the *soubassement*, the twenty-one-foot-high foundation of what had once been the eastern and northern walls of the palace, hidden beneath the modern Cour Carrée. But these stunning discoveries would soon be forgotten by all

but a few scholars, not to be seen again for another century. Only when the great work began on the Grand Louvre, that pharaonic labor initiated by President François Mitterrand in the mid-1980s, was a systematic excavation finally undertaken, not only of the original palace, but also of the Cour Napoléon, where I. M. Pei's *Pyramide* now sits, and—several hundred meters to the west—the area surrounding the Arc du Carrousel.

The circumstances under which the Louvre came into being, as well as the reasons for its construction in the first place, are intimately involved with the form and nature of Paris itself at the end of the twelfth century. Consider the magnificent opening of Victor Hugo's 1831 novel *Notre-Dame de Paris* (better known in English as *The Hunchback of Notre Dame*): "Today it is three hundred and forty-eight years, six months and nineteen days since the Parisians awoke to the clamor of all the bells resounding mightily in the three-fold enclosure of the Town (la Cité), the University and the City."

There is nothing arbitrary in that wording. "The Town, the University and the City" succinctly sum up the tripartite division of Paris from medieval times down to the French Revolution (Hugo was writing about the 1480s). The town occupied the Île de la Cité, the largest island in the Seine and the natural bridging point between its right and left banks. This island had been the center of government and religion as far back as the Roman Empire, when, seven hundred feet west of today's Notre-Dame, a palace was built that would serve for a thousand years as the official residence of the kings of France. Immediately to the south, on the left bank, rose the university, established in the year 1200 through the consolidation of several preexistent monastic schools. And finally there was *la ville*, the city. Not accidentally, Hugo mentions this part last. It had neither the royal and ecclesiastical glamour of the Île de la Cité nor the prestige of the schools and monasteries of the Left Bank. And yet, by the time the Louvre, in its earliest form, was completed

around 1200, *la ville* accounted for most of Paris. This was its center of population and seat of commerce, the home of a restless and enterprising bourgeoisie. For centuries to come, the growth of Paris would occur here, while the Left Bank largely stagnated. And the immoderate growth of this part of Paris forced the king, Philippe II, to build the fortress of the Louvre.

Known to history as Philippe Auguste, he was one of the ablest and most powerful monarchs of the Capetian dynasty that ruled France from 987 to 1328. But when he ascended the throne at fifteen, in 1180, few kingdoms were in as weak or perilous a state. The realm he inherited was almost entirely blocked from the Atlantic by the Angevin kings of England, Henry II, Richard the Lionheart and John Lackland, who controlled the western third of modern France from Normandy down to the Pyrenees. To make matters worse, a wedge of English-controlled land jutted eastward along the Massif Central, cleaving his kingdom in two. Meanwhile, the eastern third was in the hands of the Duke of Burgundy, hardly a trusted ally. All told, the territory that Philippe ruled at the outset of his reign constituted barely a third of modern France, and even this was chipped away at many points by ecclesiastical lands ultimately subject to the pope in Rome. By the end of his forty-three-year reign, however, he had wrested most of Western France from the English, and greatly increased the crown lands, the territory that belonged to him outright, the source of his power and wealth.

Throughout his reign, Philippe was constantly on the move. In addition to embarking on the Third Crusade to the Holy Land and vanquishing the English at the Battle of Bouvines in 1214, he centralized the administration of his kingdom and crushed the Albigensian heretics in Provence. And yet, some of his greatest contributions were made in Paris itself. At this time the capital was undergoing an energetic urban development that, relative to its earlier condition, could be compared to its expansion under Henri

IV in the seventeenth century or under Napoleon III in the nine-teenth. Although it is common to treat the capital, and even the French monarchy itself, as weak and marginal at this time, no city of the second rank could have built one of the largest and greatest cathedrals in Christendom, Notre-Dame de Paris. Louis VII had begun construction in the 1160s and Philippe Auguste, his son, substantially completed the work by 1200. At this time as well, the convent schools on the Left Bank were consolidated into what would become one of the finest universities of Europe, the Sor-bonne. Meanwhile there could be no greater testament to the vigor of the Right Bank than the new commercial area of les Halles, which Louis VI created in 1137 and Philippe Auguste greatly expanded early in his reign. At the same time, he enlarged the nearby cem-etery known as the Cimetière des Innocents, thus creating one of the largest open spaces in a city that had very few of them. And for the first time, he paved over some of the city's principal streets. As cause and consequence of these actions, in the year 1200 the city's population surpassed one hundred thousand for the first time since the fall of the Roman Empire.

It was precisely this frantic pace of development that moved Philippe to construct a great wall, or *enceinte*, more than three miles in circumference, around his capital. And the Louvre itself was nothing more or less than a consequence of the wall. This struc-ture was to be but a small part of a vast system of fortifications that would comprise twenty castles throughout France. Because an English onslaught was most likely to come from the northwest, Philippe began to fortify the Right Bank, the northern half of the city, in 1190, just before he embarked on the Third Crusade. This part of the wall was completed in 1202. The less urgent fortifica-tion of the Left Bank began in 1192, shortly after Philippe's return, and was built by 1215. In one of the ironies of history, however, Philippe Auguste's massive system of fortifications ultimately proved

unnecessary, since he conquered and annexed Normandy in 1204, effectively ending the English threat.

Formed of mortar and rubble and faced with blocks of dressed limestone, the wall of Philippe Auguste was ten feet wide and twenty-five feet high. It was punctuated, at intervals of two hundred feet, by seventy-seven towers, while four massive towers, each more than eighty feet tall, guarded the points where the ramparts met the Seine. Although a few remnants of the wall are still visible on the rue Clovis and rue des Jardins Saint-Paul, as well as in some of the basements, back alleys and parking lots of the Left Bank, it has otherwise left little trace beyond what we can infer from certain lingering street patterns.

As impressive as these defensive walls surely were, one great tactical problem went unaddressed: the English could simply float down the Seine, slip through the iron chains suspended across the river from the Tour du Coin to the Tour de Nesle—the two large defensive towers to the west—and stand a good chance of entering the city unobserved. And so Philippe Auguste decided, soon after he returned from the Holy Land in 1191, to protect this weak flank with a fortification that initially stood, not in Paris itself, but on a plot of land just beyond the western border of the walls that now defined the capital. For centuries, the people of Paris had been in the habit of referring to this area as *le Louvre*. And so, by the early thirteenth century, shortly after its construction, the fortress was already being called *le manoir du louvre près Paris*, roughly translated as "the castle in the area known as 'the Louvre' next to Paris."[1]

Perhaps the most intractable mystery of the Louvre has to do with the origin and meaning of its name. Over the centuries many hypotheses have been proposed, and all of them appear to be wrong. Of the two most prevalent explanations, one was put forward by the seventeenth-century French antiquary Henri Sauval, who claimed to have found an ancient Anglo-Saxon glossary—which no one since

has ever seen—that contained the word *loevar*, which apparently meant "castle" in the Saxon language. (It is also worth noting that many of Sauval's contemporaries firmly believed that the Louvre was not five hundred years old at the time of his writing, but well over a thousand and that it had been built by the Merovingian king Chilperic, who died in 584.) A more popular but even less plausible derivation is based on the similarity between the words *louvre* and *louve*, the latter word being French for she-wolf. According to this theory, the land now occupied by the Louvre was once infested by wolves or, alternatively, was used to train dogs to hunt them down.

What is important, and often overlooked, is that the Louvre was never formally designated as such, but gradually assumed the name of a preexisting feature of the right bank of the Seine as it flowed through medieval Paris. Thanks, however, to the inexhaustible industry of the first archaeologist of the Louvre, Adolphe Berty, whose six-volume *Topographie historique du vieux Paris* (1866) is a monument of nineteenth-century science, it is certain that the area was designated *Luver* in 1098, nearly a century before the Louvre itself existed, and that as early as the ninth century, the name *Latavero* was applied to this part of the French capital. With his punctilious reverence for the truth, however, Berty claimed to have no idea what the word meant, although he suspected that it was of Celtic origin. In any case, he recognized that the form *Latavero* precluded any connection to *louve* or to its Latin cognate *lupa*.[2] As for the castle itself, it appears to have been known initially as the *tour neuve*, or in the Latin of Guillaume le Breton, *turris nova extra muros* (the new tower beyond the walls).[3]

This area of Paris, directly to the west of the wall of Philippe Auguste, lay near what in ancient days had been the main road through the right bank of the Seine: it lives on today as the rue Saint-Honoré and the rue du Faubourg Saint-Honoré. Although traces of farming, burial and the occasional hut came to light

through excavations carried out during the creation of the Grand Louvre in the 1980s, the area largely remained in its natural state until Philippe Auguste came to power.

Before his accession, nothing of note had ever happened in this part of Paris, with one crucial exception. Between 885 and 887, the Normans, a Viking clan, descended from Scandinavia into the Île-de-France region and laid siege to the area of today's First Arrondissement, west of le Grand Châtelet. Included therein was the Church of Saint-Germain l'Auxerrois, directly across from today's Colonnade du Louvre, the museum's easternmost extension. These nomadic invaders, however, had no interest in conquering the city: they wanted only to extort tribute from the Carolingian emperor Charles the Fat. This he was happy enough to give them, before sending them on their way to plunder the neighboring region of Burgundy. Once the invaders had left, the Parisians responded by erecting their first new city walls since antiquity, extending roughly one kilometer along the Right Bank from the Church of Saint-Gervais in the Marais to Saint-Germain l'Auxerrois. The western limit of the wall, like that of Philippe Auguste's wall three centuries later, lay just east of the modern Louvre.

Philippe was well aware that, by the last quarter of the twelfth century, a change had come over Paris. After nearly a thousand years of torpor or decline, the city had begun to expand to the north and to the east, but also, in a very limited degree, to the west. When Thomas à Becket, the archbishop of Canterbury, was murdered in his cathedral in 1170, a wave of revulsion and sorrow reached many parts of Europe, including Paris. Perhaps only a few months later, but decades before the fortress of the Louvre had even been conceived, a church was dedicated to him just beyond where the fortress would rise thirty years later, on the land where I. M. Pei's *Pyramide* stands today. In 1191, a decade before the Louvre was completed, perhaps before its cornerstone was even laid, a document referred

to this church as the *hospital pauperum clericorum de Lupara*, the shelter of the poor clerics of the Louvre.[4] It was more commonly called Saint-Thomas du Louvre, and it remained standing into the 1750s. That church appears to be the first substantial structure ever built on the land now occupied by the Louvre Museum.

* * *

Philippe Auguste, who ruled France from 1180 until his death in 1223, was more renowned as a warrior king than as a patron of the arts. Although he chartered the University of Paris, established churches and granted land to monasteries, it is difficult to find, amid his full and tumultuous life, any avid pursuit of culture as such, any aliveness to the life of the mind, any alertness to the refinement of a building or the charm of a painted manuscript.

Not surprisingly, then, his Louvre was no thing of beauty and was never intended to be. Standing just beyond the western limit of Philippe's new walls, ninety miles from the English Channel and thirty-five from lands occupied by the bellicose king of England, its simple, uninflected square-massing was not really meant to be seen at all, except by the marauding English troops, whom it was intended to cow into retreat. Other than the soaring donjon—its central tower—that rivaled the belfries of Notre-Dame, the bulk of the fortress was largely invisible from inside the capital, especially from the right bank, where the many intervening structures would have made it difficult to see. The castles and fortifications of France are among the finest works of medieval architecture: one thinks of the hard splendor of the walls of Carcassonne or the combined solidity and grace of Pierrefonds in Picardy. But the Louvre of Philippe Auguste knew nothing of such presence or grace. No contemporary image of it survives, and what we know of it is only what can be

inferred from the archaeological remains of its successor, the palace of Charles V, completed two centuries later. From this evidence it appears to be the progenitor of all those drab barracks, blockhouses and flak towers of a later and far less chivalrous age.

Its four massive walls, rising forty feet, were entirely bereft of ornament. To the north and east were curtain-walls, purely defensive structures that extended—like curtains—between the towers. To the west and south, the *corps-de-logis*—the living quarters as opposed to the fortifications—provided shelter for a small garrison of several dozen men and their commanding officers, but the accommodations could hardly have been pleasant: beyond the narrow slits in the walls, few windows admitted light into this sullen fortification. Of its two entrances, one faced south, toward the Seine, while the other faced east, toward the city. Visitors entered each through a gate flanked by two cylindrical towers. With a tower at each corner and at the midpoint of the southern and western walls, the fortress had ten in all, crowned with a *toit en poivrière*, a pepperpot dome, that shielded the sentries from the elements and from incoming fire. The waters of the Seine flowed through a moat that surrounded the fortress on all sides except to the east, and untilled fields extended just beyond the northern and western walls.

The most distinguishing feature of the fortress, perhaps its only one, was the keep, or donjon, la Grosse Tour, whose cylindrical mass rose nearly one hundred feet and could be seen, for centuries to come, from almost any point in Paris. It occupied the center of the fortress and was separated from the rest of the interior by the deep, waterless moat that encircled it. The Grosse Tour served as a prison for high-value captives. In 1216, only a few years after its completion, it received its first important prisoner, Ferrand, Count of Flanders, an ally of the English who was taken prisoner at the Battle of Bouvines. In what appears to be the earliest mention of the Louvre that we have, this event is described in Guillaume Le

Breton's *Philippide*, a poem in Latin hexameters devoted to the reign of Philippe Auguste and completed before 1225. In its second book, the author vividly describes Ferrand's arrest:

> *At Ferrandus, equis evectus forte duobus . . .*
> *Civibus offertur Luparae claudendus in arce*
> *Cujus in adventu clerus populusque tropheum*
> *Cantibus hymnisonis regi solemne canebant.*

> *But Ferrand, led on perchance by two horses, was delivered*
> *to the citizens [of Paris] to be imprisoned in the fortress of the*
> *Louvre. At his coming, the clergy and the people solemnly*
> *sang hymns to the king in celebration of his triumph].*[5]

The drab utilitarianism of the fortress of Philippe Auguste stands in stark contrast to the Louvre that we know today, where ornament often seems to take on a life of its own. But even though the differences are obvious, even though not a stone of the original structure survives above ground, still the ghost of the medieval building can be summoned from the Corinthian pillars, the oculi and the sculpted swags of the modern Cour Carrée, which rise over the site of the original fortress. For the scale of the Louvre, so arbitrarily determined eight centuries ago, remains embedded in much that we see today. Each side of the original building was 236 feet across, dimensions that survived its transformation into a medieval palace and then into a Renaissance palace. And even when Louis XIII decided to enlarge the structure to its present dimensions around 1640, his architect Jacques Lemercier simply recreated the original building a little to the north, linking the two identical structures by means of the Pavillon de l'Horloge that we see today. The influence of the fortress extends nearly half a mile to the westernmost parts of the Louvre, whose height and width are largely determined by the

fortress of Philippe Auguste. The fortress was exactly one-quarter the size of the modern Cour Carrée, fitting into the southwest quadrant in such a way that its northeast corner rose over the spot now occupied by the central fountain.

If this aesthetic assessment seems unduly harsh, let it be said that what little survives of the original structure, especially the twenty-foot-tall *soubassement*, or base, in the Aile Sully, has been well made. Its dressed stone is more finely cut and finished, perhaps, than was necessary for a fortification that few Parisians would ever see, especially since much of what survives lay submerged beneath the waters of the Seine. One historian has stated that "the Louvre, together with [Philippe Auguste's] other constructions, fully merits inclusion in the pantheon of French castle architecture."[6] Philippe's Louvre also influenced subsequent castles: Seringes-et-Nesles and Dourdan, with their corner and median turrets set into a square enclosure, follow the model of the Louvre in their rejection of the generally irregular footprint of most earlier castles. Even on the outskirts of Paris itself, this influence persisted one and a half centuries later in the Château de Vincennes, not to mention the legendary Bastille itself.

Presumably for reasons of defense, the Louvre fortress did not border the Seine, but was recessed nearly three hundred feet to the north. For centuries to come this decision would bedevil the monarchs and masons of France. As we will see in later chapters, the creation of a second palace, the Tuileries, half a kilometer to the west, and the ambition to join these palaces by means of the Grande Galerie—which now houses the Louvre's collection of Italian paintings—resulted in all kinds of odd asymmetries. A solution, and a fine one, was found only in the 1850s, with the completion of the Nouveau Louvre under Napoleon III. Still, that original decision to recess the fortress from the Seine is the reason why, to this day, the Cour Carrée does not feel organically connected to the

rest of the Louvre, and it is also why, in moving from one building to the other, the uninitiated visitor is apt to feel that he is passing through a labyrinth.

* * *

In the century and a half between the completion of Philippe Auguste's fortress and Charles V's decision to transform it into a royal palace, the Louvre was visited only rarely by the nomadic kings of France, and it sustained few modifications. Other than incarcerating prisoners of rank and holding jousting tournaments, it served little function, since the Anglo-Norman threat had receded and the threat of the Plantagenets had not yet emerged. One section of the fortress was placed at the disposal of the royal treasury, and another part was allocated to the manufacture of cross-bows.

But the French monarchy gradually came to see the advantages to being closer to the *ville* of Paris, the Right Bank, that center of its enterprising bourgeoisie. As the royal bureaucracy became ever larger at the Palais de la Cité, the Louvre began to seem like a quieter, more convenient alternative to the bustle of officialdom on the Île de la Cité. Philippe Auguste's grandson, Louis IX, better known as Saint Louis, ordered the construction of a chapel in the southwest corner of the fortress, at the southern end of what is now the Salle des Caryatides. Underneath that chapel was a crypt whose remains were discovered in the 1880s and are now part of the medieval excavations in the Aile Sully.

In short order the fortress engendered a small town—later known as the Quartier du Louvre—where before there had been little or nothing. As this area evolved, it did not become a typically medieval tangle of streets, such as one still finds elsewhere in Paris in the Marais or the Quartier Latin, but a fairly orderly

development. Its two main avenues, stretching north to south from the rue Saint-Honoré to the Seine, were the rue Saint-Thomas and the rue Froidmanteau, the latter possibly older than the fortress itself. The rue Saint-Thomas extended roughly from the Pavillon Denon to the Pavillon Richelieu, the rue Froidmanteau to its east, from the Pavillon Daru to the Pavillon Colbert. As a direct consequence of the fortress's construction, five other streets came into being: the rue Beauvais, which ran parallel to its northern edge, and the rue Jean Saint-Denis, rue du Chantre, rue du Champ-Fleury and rue du Coq, all extending northward from the rue Beauvais. Little trace of these streets remains today. The easternmost, the rue du Coq, was widened, and, now reborn as the rue de Marengo, leads up to the Pavillon Marengo, which stands at the center of the Cour Carrée's northern façade. By the time Philippe Auguste died in 1223, Adolphe Berty writes, "he was able, from the height of the towers of his Louvre, to contemplate at the foot of the castle an entire new *quartier* whose buildings . . . were sufficiently numerous to reveal no trace of the tilled earth that was there before."[7]

Some idea of the emerging bustle of this new district will be found in Christine de Pizan's description, less than two centuries later under Charles VI, of "the multitude of people and diverse nationalities, princes and others, who arrive from all over chiefly because [the Louvre] is the main seat of the noble court."[8] Most of the resulting building stock was fairly humble, unlike the proud aristocratic dwellings that arose there at the end of the next century. As for the expansive area west of the rue Saint-Thomas, all the way to the modern place de la Concorde, it largely remained arable land, although tile factories—required, as a potential fire hazard, to lie at some distance from the wooden houses that predominated in medieval Paris—began to appear there under Louis IX.

The biggest single structure on the grounds of the modern Louvre, other than the palace itself, was the Hôpital des Quinze-Vingts

(the Hospital of the Three Hundred) founded by Saint Louis around 1260 and so named because it had a capacity of three hundred beds for patients who were blind and poor. Situated west of the rue Saint-Thomas du Louvre it stretched from the rue Saint-Honoré south to what is now the Pavillon de Turgot, built by Napoleon III in the 1850s. It comprised a church and chapel as well as a small cemetery. As such it was one of three burial grounds in what is now the Cour Napoléon, together with those of the Churches of Saint-Nicolas and Saint-Thomas. Among those buried—several centuries later—in the last of these churches was Pierre Bréant, "barber to the great man and powerful prince the Duc of Bretagne," as well as Robert Rouseau, "priest, native of the islands of the Philippines and, during his lifetime, a canon of this church." Perhaps the most important tomb belonged to Mellin de Saint-Gelais, an important figure in the history of French poetry, who may well have introduced the sonnet into France.[9]

* * *

We know little if anything about the appearance of Philippe Auguste: he hardly emerges from the shadows of the Middles Ages, and his main chronicler, Guillaume Le Breton, comes closer to hagiography than to history. But as regards the appearance of Charles V and his wife, Jeanne de Bourbon, we are singularly well informed: a life-sized statue of each ruler—made during their reign—now stands beside the Cour Marly, in the Richelieu Wing of the Louvre. Especially the king, with his flabby cheeks and weak chin, bulbous nose and oddly parted hair, seems true to life, looking weary and older than his years. Since he was only forty-two when he died in 1380, the statue could not have been made long before his death. Together, the paired images represent an important example of the late Gothic naturalism that

prefigures the advances of Jan Van Eyck and the other Flemish masters fifty years later. These crowned figures, which retain traces of their original polychrome, are thought to have stood high up on the eastern façade of the Louvre palace, the part that faced the city of Paris and would be instantly seen by all who entered. There the pair remained for nearly three centuries until, in 1660, Louis XIV ordered the destruction of the last visible remnants of the medieval Louvre.

Charles V, who ruled from 1364 to 1380, had the demeanor of a scholar, but the circumstances of the realm that he inherited, especially early on, forced upon him the role of a man of action. He was the son and successor of Jean II of France, who ruled from 1350 to 1364 and sired four of the greatest artistic patrons of the later Middle Ages: in addition to Charles, these were Louis I of Anjou, Jean,

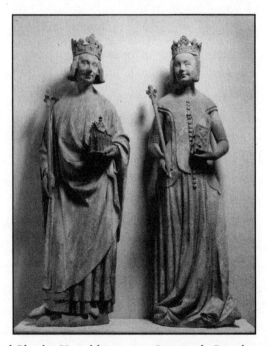

Statues of Charles V and his queen, Jeanne de Bourbon, c. 1380, that adorned the eastern entrance to the original Louvre, which he converted from a fortress into a palace. Now in the Aile Richelieu.

Duc de Berry and Philippe II of Burgundy. Not the least of Jean II's distinctions is a portrait of him, now in the Louvre, that was painted at the outset of his reign in 1350. Depicting him in profile, with a mane of red hair and a scruffy beard against a golden background, this panel has the distinction of being, for all we can determine, the first painted portrait of an individual human being to survive since the end of antiquity. It is not, of course, the direct progenitor of the *Mona Lisa* and of portraits painted by Raphael and Rembrandt, but it is the earliest example we have of a genre that would prove supremely important for the future of Western art.

But Jean was destined to come to a bad end. He was defeated by Edward of Woodstock, the Black Prince of England, at the Battle of Poitiers in 1355, one of the most important early battles in the Hundred Years War. While Jean was imprisoned in the Tower of London, his eldest son, Charles, then seventeen years old, served as regent in his absence. History affords few more inspiring examples of chivalrous conduct than Jean's after he gained his freedom by paying a steep ransom and—as was customary at the time—offering one of his sons, Louis of Anjou, as hostage: when Louis escaped, Jean was so troubled by what he saw as a dishonorable act that he returned, voluntarily and for the remainder of his life, to imprisonment in England (admittedly in the Savoy Palace), where he died in 1364. Thereupon Charles became king outright.

The Parisians had always been and would always be restive subjects of the crown. Even before Charles became king he found himself in the midst of a civil war that pitted the monarchy against Étienne Marcel (the provost of merchants and, in effect, the mayor of Paris), who sought to curb royal power and even, some said, to seize the crown itself. Only with Marcel's assassination in 1358— soon after he burst into Charles's council chamber in the Palais de la Cité and killed two of his advisors—did something like peace return, thanks in large part to Charles's issuing a general amnesty

that conciliated the nobles and the Parisian bourgeoisie. By the end of his reign, with Normandy and Brittany having been recaptured from the English some years before, Charles left the kingdom far stronger than when he had received it.

Despite the tumult of his early years, however, he seems to have preferred the *vita contemplativa* to the *vita activa*. In her *Livre des fais et bonnes meurs du sage roy Charles V* of 1404 (Book of the Deeds and Good Character of the Wise King Charles V), Christine de Pizan calls him "a true philosopher and lover of wisdom." Surnamed *le Sage*, the Wise, he was renowned among his contemporaries for his manifold intellectual attainments. At his death, more than nine hundred volumes were inventoried in his library at the Louvre, a staggering number for that age. An additional three hundred were dispersed among his palaces in or near Paris. As one of his services of enlightenment, he lent books to scholars and to men of wealth who wished to commission a copy. His library, which included devotional works as well as volumes of political theory, history, astronomy and fiction, occupied three levels of the Tour de la Fauconnerie (the Falconry Tower), which he had built in the northwest corner of the Louvre when he turned the fortress into a palace. The most precious manuscripts were kept on the ground floor, while lighter fare, such as *The Travels of Sir John Mandeville* and Jean de Meun's *Roman de la rose* (The Romance of the Rose), occupied the intermediary level. The highest level was reserved for learned and devotional works, in both French and Latin: among these were Guillaume Peyraut's *Livre du gouvernement des rois et des princes* (Book of the Government of Kings and Princes), John of Salisbury's *Policraticus* and Aristotle's *Economics*, *Politics* and *Nicomachean Ethics*.[10]

Although these precious volumes were mostly dispersed after his death, a number of them found their way early on into the Bibliothèque nationale. Indeed, they may fairly be seen as the

foundational tomes of the national library of France. In 1986, after preliminary excavations had been carried out for the Grand Louvre of François Mitterrand, one of the stones from the tower of Charles's library came to light. In an extraordinary act of symbolism, it was taken across the Seine to the Left Bank, where it now forms the cornerstone of the new national library, the Bibliothèque nationale de France.

As much as Charles cherished the life of the mind, he shared with many potentates a love of great building projects, among these the Château de Vincennes at the eastern limit of modern Paris and the now vanished Hôtel Saint-Pol in the Marais. Writing of his love of architecture, Christine de Pizan described him as a "wise artist who showed himself to be a true architect, and confident deviser and prudent arranger . . . when he laid the beautiful foundations [of his buildings]."[11] The largest of his undertakings was the construction of a new wall around the northern half of Paris, to encompass all those areas that had emerged since the completion of Philippe Auguste's wall nearly two centuries before. This fortification, far more sophisticated in conception and construction than its predecessor, encircled only the right bank. And it too would have an incalculable effect on the fortunes of the Louvre.

If the earlier wall was three miles in total on both sides of the Seine, this new one, although confined to the Right Bank alone, had a longer circuit, embracing most of today's First, Second, Third and Fourth Arrondissements. As such it extended roughly half a kilometer further to the east and to the west and one kilometer further to the north. In terms of urban development, the Left Bank would lag behind the Right for several centuries to come.

This wall of Charles V had been initiated, in fact, by Étienne Marcel in 1356, but was completed only in 1383, three years after Charles died, in the reign of his son Charles VI. Unlike the earlier wall, which rose directly out of the ground, Charles's wall emerged

from a broad and continuous earthwork whose sequence of crests and valleys, 280 feet wide, held the English at a sufficient distance that their arms could have no effect on the capital. Much later, these ramparts would come to be known as *boulvars* (cognate with the English word bulwark), from which is derived the modern English word *boulevard*. What connects these two seemingly disparate concepts is the fact that Paris's *grands boulevards*—which technically refer only to the boulevards of the First through the Fourth Arrondissements—are the remains of Charles V's fortifications. His bulwarks—together with those that were added to them by Louis XIII—were dismantled, flattened and filled in by Louis XIV starting around 1670, to be replaced by the sort of broad, landscaped avenues to which we now refer, wherever we find them in the world, as boulevards.

Interrupting the fourteenth-century bulwarks were grandiose gates through which pedestrians and riders passed into and out of the capital, among these the Porte Saint-Martin, the Porte Saint-Denis and an entirely new fortification all the way at the eastern end of the wall, known as *la Bastille*: this term referred to a specific kind of fortified gateway. Initially the Bastille, as conceived by Étienne Marcel in the 1350s, had been little more than the entrance to Paris through the rue Saint-Antoine, whose eastern extremity was flanked by two imposing towers. A decade later, however, Charles V found it to be inadequate in its initial form, and so he transformed it into a castle, whose regular and rectangular footprint was defended by eight towers, one at each corner, together with two additional towers in the middle of the eastern and western exposures. Its overall conception, in fact, was modeled on the Louvre's—as was Charles V's Château de Vincennes two miles further east—and it is surely not an accident that it came into being at precisely the moment when the Louvre itself, freed from any military function, was beginning its metamorphosis into a palace.

At the opposite, western limit of Paris, the new wall shifted sharply from the rue Saint-Honoré toward the Seine, slicing through what are now the Pavillon de Rohan and les Grands Guichets (two nineteenth-century entrances to the Louvre), before reaching the river in the form of a new tower, la Tour de Bois. A few feet from the Pavillon de Rohan, beside the Porte Saint-Honoré, Joan of Arc was wounded in 1429 by a cross-bow as she led an assault against the English occupiers of Paris who had briefly taken up residence in the Louvre. One of the great revelations of the work on the Grand Louvre in the 1980s was the discovery of a part of this fortification, a fifth of a mile in length, that had previously been known through old engravings (and some superficial archaeological soundings in the 1860s). The two sides of the fortification, its scarp and counterscarp, can be seen today at the western entrance to the Carrousel du Louvre,

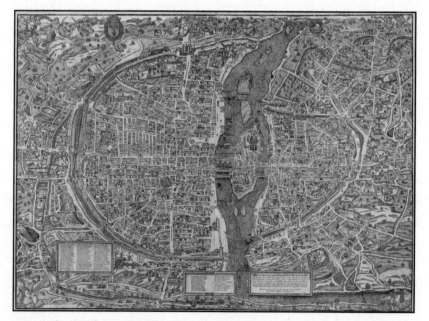

Map of Paris from 1553 by Olivier Truschet and Germain Hoyau. The dominant oval shape represents the walls of Charles V that surround the city, with the Louvre near the base of the oval, beside the Seine.

a vast subterranean shopping area at the museum's western limit. What we now encounter differs slightly, however, from what one would have seen in the days of Charles V, due to repairs carried out in 1512 by Louis XII, when the wall was fortified with dressed stone.

With the completion of the wall, the Louvre now stood for the first time squarely within the city of Paris. What had been a sort of frontier fortress now ceased to have any defensive function at all. At the same time, however, it had certain advantages over Charles V's other palaces in and around Paris. The Hôtel Saint-Pol and the Château de Vincennes were too far removed from the center of the city, while the Palais de la Cité, the traditional home of the monarch when visiting Paris, had only recently been the scene of mob violence that Charles had witnessed with his own eyes. The events of that day surely weighed on his decision both to reside in a fortified structure like the Louvre and to transform it into a palace worthy of a king.

* * *

According to Christine de Pizan, Charles V rebuilt the Louvre *de neuf*, from scratch. Surely this is an exaggeration, but there can be no question that he completely altered the spirit, and largely altered the form, of the fortress of Philippe Auguste. As with so many of the labors of the Louvre, work proceeded slowly: Charles's alterations would consume ten of the sixteen years of his reign. To oversee the work he chose Raymond du Temple, one of the few architects of the Middle Ages whom we can name and to whom we can attribute a legible aesthetic profile. Like Jacques Lemercier under Louis XIII and Percier and Fontaine under Napoleon I, he created many buildings for a monarch who had full confidence in his talents. Although almost no trace remains of his Hôtel Saint-Pol in the Marais, one of the largest urban interventions in fourteenth-century Paris, the

Château de Vincennes survives splendidly intact, its chapel rivaling the better-known Sainte-Chapelle, which inspired it. In addition to overseeing the reconstruction of the Cathedral of Notre-Dame, Raymond du Temple was probably responsible for an early version of the Petit Pont, the bridge that connected the cathedral with the Left Bank, and for the Bastille itself.

Even though nothing survives of Charles's Louvre beyond the foundation of its eastern and northern wings, we have a very good idea of how it looked, thanks to three painted depictions: the *Retable du Parlement de Paris* and the *Pietà of Saint-Germain-des-Prés,* both in the Louvre, and the page representing the month of October in *Les très riches heures de Jean, duc du Berry* (the Book of Hours), painted by the Limbourg brothers before 1416, and one of the masterpieces of late-medieval art. There is a fairyland quality to this lustrous depiction of the Louvre, seen from across the Seine, roughly where the Tour de Nesle once stood. Despite the painting's somewhat willful proportions, the evidence it provides is corroborated by the remains that came to light in the 1980s and that can now be visited in the Aile Sully.

Preserving the footprint and the general dimensions of the old fortress, Charles's most substantive act was to build up the northern and eastern sides of the square-shaped enclosure. What had been mere curtain-walls now acquired a living area, of similar size to what Philippe Auguste had attached to the southern and western sides of the fortress. Thus the Grosse Tour, or donjon, that had originally stood at the center of the interior courtyard now found itself closer to the expanded northern wing, where Charles had his public and private apartments. To allow access befitting a king, either Raymond du Temple or his assistant Drouet de Dammartin designed a prodigious spiral stairway that was famous in its day. Known as la Grande Vis—the Big Screw, or the Big Spiral—this stunning piece of engineering, decked out in all the filigreed elegance of the later

Gothic style, stood between the Grosse Tour and the new northern wing. This was one of the first of those grand stairways that would figure so prominently in the stately homes and palaces of France, down to the end of the nineteenth century. Nearby stood the Petite Vis, a smaller stairway by which the king and queen alone were able to reach their private apartments. Some remains are visible in the excavations of the Aile Sully.

To admit light and air into the palace, the architect breached the thick walls with windows that would hardly have been acceptable in a fortress. Lancet, cross and dormer windows suddenly pierced the ramparts and turrets alike. Even the donjon now had windows. In addition to sculptures of the king and queen, decorative string coursings enlivened the upper levels of the walls. With its chimneys and pepperpot domes covered in bluish gray slate and fleur-de-lis weather vanes gleaming in the sun, the palace came to dominate the skyline of the Right Bank. In his eagerness to transform the

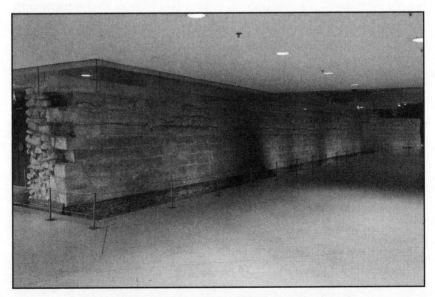

*Part of the remains of the wall of Charles V in the
Carrousel du Louvre, a shopping center.*

Louvre into a palace, Charles had stone brought down the Seine from Vitry, as well as from the local Parisian quarries of Bicêtre, Gentilly and Vaugirard. Such was his hunger for fine stone that, in creating la Grande Vis, he did not scruple to acquire tombstones from the Cimetière des Innocents, the cemetery beside les Halles.

An important element of the Louvre's transition from a fortress to a palace was the sumptuous gardens planted along its northern and western flanks, stretching beyond the walls to the former rue Froidmanteau in the west and in the north to the rue Beauvais, now part of the rue de Rivoli. The northern garden contained five pavilions, four round and one square, with hedges, arbors and a wicker trellis covered in vines. As was usual with medieval gardens, it was divided up into square segments arrayed with a variety of flowers and plants chosen for their colors and scents, among them rose and strawberry bushes. Beyond the western garden, but still within the grounds of the palace, a court was built for the fashionable game of *jeu de paume*, a prototype of tennis. There was also a menagerie that included falcons, hawks and a cage of nightingales. A few of the Louvre's smaller gardens to the south, along the Seine, were transformed under Charles's successor, Charles VI, into a *basse-cour* where farm animals and plants were raised and then brought to the kitchens of the Louvre.

Henri Sauval, the seventeenth-century historian of Paris, has left a fairly extensive description of the gardens of the Louvre, which still existed when he was a young man and which occupied the northwest quadrant of what became the Cour Carrée. These gardens were surrounded from one end to the other by trellises, rosebushes and hedges. Chard, lettuce and purslane were grown for consumption in the palace. In addition to having a menagerie, l'Hostel des Lions, the garden's four corners were enhanced with a pavilion of either round or square footprint that offered seating to guests.[12] It is a curious coincidence that, six centuries later and in the same location, the two

landscaped areas on either side of the Pavillon de Marengo would once again be used to grow leeks amid the rationing of the Second World War.

Soon a fruitful coexistence emerged between the Louvre palace, where Charles lived when he was in Paris, and the Palais de la Cité, the seat of his administration. While this latter structure housed the king's ever expanding bureaucracy, the Louvre increasingly became the ceremonial center of Paris. Here, in 1368, Charles received with full honors the Duke of Clarence, second son of Edward III of England. And it was here, eleven years later, that he chose to receive the Holy Roman emperor, Charles IV. On this occasion, as on others, the king seemed to take considerable satisfaction in his new palace. According to Christine de Pizan, he showed off to the emperor "the beautiful walls and masonry that he had ordered to be built at the Louvre."[13] Indeed, Pizan spoke of Charles's *belle manière de vivre*, his "beautiful way of living."[14]

Because so many people, including nobles, commoners and strangers wanted to see the king with their own eyes, the Louvre became a very crowded place. According to Pizan, there was hardly space to turn around. Naturally, all these crowds created logistical and sanitary issues. Just as the day and night chambers of the king and queen had their *aisances*, or lavatories, some now had to be provided for the public, a provision that continues to challenge the administration of the museum more than six centuries later. The accommodations of around 1400, however, apparently proved difficult to access, since it was deemed necessary to prohibit members of the public from urinating in the halls and gardens of the palace.[15]

As soon as Charles chose the Louvre as his principle dwelling in Paris, two changes occurred in this part of the city. First, prostitutes, drawn to centers of power and wealth, installed themselves in the rue Champfleury, near the museum's Porte Marengo in the Cour Carrée.[16] At the same time, the French aristocracy, including

the bishops, began to build stately homes in direct vicinity to this new center of royal power. Two of the largest of these dwellings stood immediately to the east of the Louvre, just beyond Philippe Auguste's wall, bordering the now vanished rue d'Autriche. Known by their later names, these were the Hôtel du Petit-Bourbon, built around 1390 (in the reign of the king's son and successor, Charles VI), and the Hôtel d'Alençon, which stood on land that had been variously occupied since the middle of the previous century. Each of these structures was almost as large as the fourteenth-century Louvre, and together they occupied the entire eastern half of the modern Cour Carrée. In subsequent centuries both would play an important role in the history and cultural life of France. The splendor of the Hôtel du Petit-Bourbon especially reflected the extravagance of the reign of Charles VI, an extravagance that extended to the aristocracy as well. Its Grande Salle was famous three centuries later. Sauval, who would have seen it shortly before its destruction in 1660, could claim that "without fear of contradiction, it is the broadest, highest and longest [chamber] in the entire kingdom."[17] Seized by François I in 1527, le Petit-Bourbon functioned as an extension of the Louvre, and it remained a prominent feature of the Parisian cityscape until Louis XIV razed it to build his great Colonnade, the easternmost point of what is now the modern museum.

* * *

After the early death of Charles V in 1380, the fortunes of the Louvre itself fell into steep decline. The Hundred Years War, which pitted the French crown against England, Burgundy and sundry domestic enemies, was entering its deadliest phase. Few cities would be more directly or adversely affected than Paris. Although armed insurgents, known as the Maillotins, or Hammer-Wielders, were unsuccessful in

their quest to tear down the Louvre under Charles VI in 1383, the amount of damage they caused was considerable. Even as Charles VI received the emperor of Byzantium at the Louvre in 1400, the physical condition of the palace was beginning to deteriorate, together with the mental condition of the king: during his recurring bouts of insanity, he forgot he was king, forgot his own name, could not recognize his wife or children, and believed he was Saint George of Cappadocia. The physical decay of the Louvre accelerated between 1431 and 1439, when Paris itself suffered the indignity of an English occupation, during which the ten-year-old Henry VI of England was crowned in Notre-Dame and lived for a time in the Louvre. Another century would pass before a very different French king, François I, took up residence in the palace and began to transform it beyond recognition into something like what we see today.

- 2 -

THE LOUVRE IN
THE RENAISSANCE

Few monarchs appeal as forcefully to the modern imagination as François I, who ruled the French nation from 1515 to 1547. Emerging from that general fog of anonymity that seems to hedge his predecessors, he rises up before us fully formed, a creature of flesh and blood. He is perhaps the first French king whom we feel we know in an almost personal way. Painters took to him as well: Ingres, in 1818, depicted a famous and probably apocryphal scene of François holding the dying Leonardo da Vinci in his arms, and soon after, in one of his most charming works, the English Romantic artist Richard Parkes Bonington portrayed the king in the company of his plump mistress, the Duchesse d'Étampes. A decade later, on the ceiling of the Louvre itself, Alexandre-Évariste Fragonard, son of the better-known Jean-Honoré, depicted the king receiving paintings brought from Italy by the artist Primaticcio.

François was largely responsible for founding the great centralized monarchy that reached its imperious apex in the reign of Louis XIV, one century later. And like Louis, François was a prodigious builder, patron and art collector who, in the assessment of his countrymen, liberated his country (and the Louvre) from the heritage of the Middle Ages.

By any reasonable computation, the chances of his mounting the throne of France had been incalculably small. Of the ten male heirs whom Anne of Brittany bore to his two immediate predecessors,

Charles VIII and Louis XII (she married both men), all had to die in infancy in order for François, from a collateral branch of the Valois dynasty, to become king. And even then he acceded to the throne mainly because his cousin, Louis XII, found him unobjectionable and handpicked him as his successor.

And yet, the fortuity of his accession was belied by the swiftness and sure-footedness with which he took command. Something of that spirit is revealed in Jean Clouet's portrait of François—one of the treasured possessions of the Louvre—from 1525, when he was thirty years old. If a single image could sum up the entire Renaissance in France, this might well be it. The very type of a modern prince, François is seen frontally and in half-length against a shallow field of pale-red silk, with the gold chain of the Order of Saint Michael around his neck. His dark beard contrasts with his pale flesh and with that long nose that earned him the nickname of François au Grand Nez. His attire is even more remarkable: he wears a black velvet cap with gold studs and ostrich feathers, while a pearl-colored *chamarre*, or long jacket, lends him an air of impressive bulk, falling over a shirt whose satin, silk and velvet stripes are interspersed with golden threads. A few years later, in another portrait in the Louvre, Titian depicted the monarch, now slightly stouter, wearing the same gold chain. But the Venetian master boldly portrayed him in profile, offering further proof of the king's prominent nose.

During the reign of François I, the Renaissance, as represented in the arts of Italy, began to make important inroads beyond the Alps. It was not Italianness as such, but rather modernity itself that, at his energetic prompting, began to be embraced ever more enthusiastically by the prelates and grandees of France. This dalliance had begun with Charles VIII's invading Italy in 1494 to regain the territories that, he claimed, were rightfully his through his grandmother, Marie of Anjou, daughter of Louis II of Anjou, king of Naples. Subsequent invasions were mounted by his two immediate successors,

Louis XII and François himself, who were eager not only to defend these dynastic claims on the Kingdom of Naples, but also to claim possession of the Duchy of Milan.

François' military adventures in Italy initially met with encouraging results: in 1515, after his triumph at Marignano, the twenty-one-year-old king invaded and annexed the Duchy of Milan. But when he embarked on a second Italian adventure a decade later, the outcome was catastrophic. At the battle of Pavia, in 1525, he himself was captured by the forces of Charles I of Spain. As if that weren't bad enough, Charles was the very man who, six years earlier, had bested him to win the coveted title of Holy Roman emperor. For nearly eleven months following this most ignominious of defeats, François was held captive in Madrid. He secured his release only by paying an enormous ransom—levied in large part on the citizens of Paris—and by handing over his two oldest sons as hostages. The younger of the two, Henri, later succeeded him as king of France.

Whatever the consequences of these battles in loss of life, territory and treasure, they hastened the introduction of the Italian Renaissance into the visual culture of France. Under Charles VIII and Louis XII, a number of Italian artists and architects were lured across the Alps, but they generally achieved little more than tactical interventions in a visual context that was still overwhelmingly medieval in spirit and Gothic in form: a marble arcade here, an Ionic column there. With François I, however, the embrace of the Italian Renaissance became almost carnal. He established the famed Collège de France, whose classical aspirations stood in open defiance of the more traditionalist theologians thundering out of the ancient Sorbonne. He also enlisted the services of Guillaume Budé, one of the greatest classical scholars of the age, to manage the royal library, whose growth François greatly fostered. But he revealed his greatest debt to the Italian Renaissance as an art patron and collector, and as a builder of sumptuous palaces.

Throughout history, monarchs have sought to display their magnificence through visual art, whether in grand buildings or the collecting and commissioning of masterpieces. In the early years of the sixteenth century, however, such ambitions acquired a new and unforeseen dimension. There had been famous artists in antiquity, but now, for the first time, the possession of works of famous artists became a measurable index of princely magnificence. A curious corollary of this new appetite was the full consciousness that, in the first half of the sixteenth century, the art of Italy had attained an importance unparalleled, perhaps, in any previous age. As an example of this new prestige, it was rumored that once, when Titian dropped a brush while he was painting the portrait of Charles I of Spain, the monarch himself bent down to retrieve it.

Few rulers pursued these masterpieces with greater energy or success than François I, who enlisted a large network of scouts and agents to hunt them down. Often these men were diplomats like Guillaume du Bellay, who had been posted to Venice and Rome. Sometimes they were native Italians, like the satirist Pietro Aretino— one of the most scurrilous men of the age—who acted as the king's go-between with artists and collectors, and was rewarded for his service with the eight-pound gold chain that he is depicted as wearing in several portraits. When an authentic piece of ancient sculpture was not available, François was satisfied with a marble copy or even a plaster cast. Thus the painter Primaticcio, who would later distinguish himself at Fontainebleau, made casts of the *Apollo Belvedere* and *Hercules Commodus* from the Vatican's collections, as well as Michelangelo's *Pietà* from Saint Peter's Basilica. These were eventually displayed in the Salle des Caryatides of the Louvre.

Given that even a king could not be assured of acquiring one of the masterpieces of Leonardo, Michelangelo, or Raphael—then as now the regnant gods of the High Renaissance—François did quite well for himself. Although he never succeeded in enticing

Raphael, Michelangelo or Titian to come to France (and it was not for want of trying), following his conquest of Milan, Fançois somehow managed to persuade Leonardo, widely seen as the greatest painter living or dead, to make the journey in 1516—accompanied by his disciples Andrea Salaì and Francesco Melzi. At this point, Leonardo da Vinci was sixty-four years old and would live another three years. François placed at his disposal the entire Château of Clos Lucé—half a mile from the royal residence of Amboise—where da Vinci eventually died and is now buried. In his trunks, da Vinci brought twenty of his inscrutable codices, the fruits of a lifetime of secret study, as well as three paintings, *Saint John the Baptist, The Virgin and Child with Saint Anne* and the *Mona Lisa*. François is thought to have purchased all three of these works directly from the master in 1518, the year before his death. Combined with da Vinci's *Virgin of the Rocks*, which François' predecessor, Louis XII, had acquired around 1500, these were among the very earliest works to enter the royal collections that would eventually become the Louvre Museum. Later the Louvre acquired two additional paintings by Leonardo da Vinci, which now bear the titles of *Bacchus* and *La Belle Ferronnière*, as well as a number of drawings, including the great *Drapery Study for a Seated Figure*. With these six paintings, the Louvre can fairly claim to own the greatest number of Leonardo da Vinci's paintings—and they are not abundant in any case—to be found anywhere in the world. So central are they to the Louvre—and so central is the Louvre to France—that Leonardo da Vinci now seems almost as integral to the national character as Napoleon Bonaparte or Charles de Gaulle. These masterpieces contribute so materially to the gross national product of the nation that the health of its tourist industry can be measured by how close a visitor can get to the *Mona Lisa*.

François had success with Michelangelo as well. Other than frescoes, Michelangelo's paintings are so rare as to be almost

nonexistent. Still, François got his hands on a painting of *Leda and the Swan*, although it went missing long ago and now survives only in copies. He also acquired three of Michelangelo's sculptures. One of these, a depiction of Hercules, likewise vanished centuries ago and is known today only through drawings. But the other two, often called *The Dying Slave* and *The Rebellious Slave*, are now among the most prized possessions of the Louvre. Together with four other nudes, they were meant to adorn the tomb of Pope Julius II, a project that went through six drastic revisions and occupied Michelangelo for nearly forty years. Because the final version of the tomb had no use for the six male nudes that Michelangelo sculpted for it, four were sent to Florence, where they now stand like an honor guard leading up to his statue of David in the Accademia

Michelangelo's Rebellious Slave, *created c. 1515 for the tomb of Julius II. In France since 1550, it entered the Louvre after being seized by the revolutionary government in 1793.*

Gallery. The remaining two, far more fully realized, were offered to François and, after several peregrinations, now inhabit the Galerie Mollien of the Louvre.

In contrast to the king's dealings with Leonardo and Michelangelo, from whom he acquired works created for others, at least two of the Louvre's Raphaels were made expressly for François. These had been commissioned by Pope Leo X when, following the French conquest of Milan in 1516, it occurred to him that it might be wise to get on the king's good side. And so Raphael painted *La Grande Sainte Famille de François 1er* (the Great Holy Family) as well as the jolting, life-sized depiction of *Saint Michael Routing the Demon*, thought to represent Leo's hope that François would mount a crusade against the Turks. Three other large works by Raphael in the Louvre—the early *Belle Jardinière*, *Saint Margaret* and *Self-Portrait with a Friend*—may have belonged to François, but were probably not made for him, while the *Portrait of Giovanna of Aragon* was, but with assistance from Giulio Romano. One of the Louvre's greatest acquisitions of all was Raphael's noble portrait of Baldessare Castiglione, author of *The Book of the Courtier*, but this painting entered the royal collections in the reign of Louis XIV.

None of these works by Raphael, Michelangelo or Leonardo, of course, went with François to the Louvre. For it remained, during his lifetime, a dark and medieval structure that was rendered no more agreeable by the fact that it was also a construction site, with all the disruption and sordidness that that condition involves. True, François did create, in 1529, a *cabinet de tableaux* in the Louvre, where he kept some few paintings from Flanders, although we cannot say which, or whether any of them are in the museum today. This appears to have been the first space resembling an art gallery ever established within the precincts of the Louvre. But the great Italian paintings, together with the bulk of the royal collection, would remain in François' favorite royal residence, the Palace of

Fontainebleau, and later in Versailles, until the formal opening of the Louvre as a museum in 1793.

* * *

If the acquisition of masterpieces was the sport of kings, it was only a small portion of François' service to visual art. Like so many earlier and later rulers, he loved to build things, and he pursued this passion with a vigor that would be matched only by that of Louis XIV and Napoleon III. Indeed, François built with such assiduity that he nearly bankrupted the state: he either initiated or fundamentally transformed a dozen palaces, each roughly the size of the Louvre in its sixteenth-century form. Among these were Chambord, Amboise, Blois, Saint-Germain-en-Laye and, most famous of all, Fontainebleau. More than any other French king, François established the Loire Valley and the Île-de-France as an enchanted region renowned throughout the world for a certain kind of kingly splendor. But as a result of this extravagance, he was eventually compelled to sell large parcels of Paris that belonged to the crown lands—among them the Hôtel de Bourgogne and Hôtel Saint-Pol, together with their extensive grounds—until he was left with only the Hôtel des Tournelles and the Louvre itself, and he may even have considered selling those as well.

In some instances—namely, in Chambord and Fontainebleau—François would live to enjoy the fruits of his labors. In others, however—and this was surely true of the Louvre—he merely sowed what later generations would reap. Although he, like his predecessors, continued to build in the Loire Valley, especially at Chambord, he shifted most of his attention to the Île-de-France region and to the area around Paris. Perhaps driven to rival the new palaces of Écouen and Chantilly (built by Anne, Duc de Montmorency), François

undertook to build three palaces near Paris: Saint-Germain-en-Laye, Villers-Cotterêts and the Château de Madrid, which once stood on the western edge of the Bois de Boulogne. So fully was he engaged in the planning and execution of these projects that the architect Jacques I Androuet du Cerceau claimed (regarding Saint-Germain) that "one can fairly say that he himself was the architect."[1]

Given this abundance of palaces at his disposal, one might have expected François to continue the largely nomadic life of the kings who preceded him. Their habit, for nearly a thousand years, had been to move through their realm along a relay of royal dwellings, showing themselves to the people while addressing the issues and adjudicating the legal disputes that urgently concerned their subjects. But by the second quarter of the sixteenth century, with the rise of the modern centralized bureaucratic state, this ceaseless travel became less necessary, and the monarch had an ever greater incentive to stay put. That shift would have enormous implications for the French monarchy in general and for Paris and the Louvre in particular.

It had hardly been self-evident, however, that François would choose Paris as his principle dwelling. By the end of his reign, the city had more than 350,000 inhabitants. As such, it was the largest and richest city in the kingdom, and the most populous in Europe, thanks to that prolonged peace that extended from the end of the Hundred Years War (c. 1453) to the beginning of the Wars of Religion (c. 1562). But the preeminence of Paris was by no means assured: only a few decades earlier, Louis XI had seriously considered moving the capital to Lyon, which had the advantage of greater proximity to the trade routes of Italy, Savoy and the Holy Roman Empire. Early in François's reign, as he pursued the nomadic life of his predecessors, he spent about a month of each year in Paris, usually January or February, and when he was in the capital he preferred to stay in the Hôtel des Tournelles, a royal residence on

the site of the present place des Vosges. But on returning from his eleven-month captivity in Madrid, following the disastrous Battle of Pavia, François decided to reassert his authority over his kingdom and especially over the often restive Parisians. On 15 March 1528, he wrote a letter to the magistrates of Paris that would prove to be of supreme historical consequence: "Since it is our intention henceforth to spend most of our time in our good city and fortress of Paris and the surrounding areas, more than in any other place in the kingdom, and knowing that the castle of the Louvre is the most comfortable and appropriate place for us to stay, we have therefore determined to have said castle repaired and put in order."[2]

This decision was novel to the point of being revolutionary. Not only was François rejecting the nomadic customs of his predecessors; henceforth he would live in the very midst of perhaps the largest city in Christendom. He would not live near the city, at the Château de Vincennes, for example, or Saint-Germain-en-Laye, or the Château de Madrid that he was then building, but rather in the very heart of *la ville*, the Right Bank, the most frenetic, populous and built-up portion of his kingdom.

And just as nothing was preordained in his choosing to live in Paris, it was hardly self-evident that François would decide to live in the Louvre. One could have made as strong a case for the Palais de la Cité, where most of his predecessors had stayed whenever they visited Paris, or the Hôtel des Tournelles. Furthermore, in the century and a half since Charles V had transformed the Louvre into a palace, it had fallen into dreary disrepair. As such it could hardly be a satisfactory prospect for a monarch who, with his own eyes, had beheld the splendors of Italy—its cities fundamentally transformed by new ideas about architecture and urbanism—and who had endured an opulent incarceration in the Alcázar in Madrid (where, to the surprise of many, he struck up a friendship of sorts with his captor and rival, Charles I of Spain).

Shortly before writing his letter to the magistrates, François had already begun, in February of 1528, to modernize the Louvre by demolishing the Grosse Tour, the donjon that had dominated the Louvre and Paris for more than three hundred years. With the possible exception of the bell towers of Notre-Dame, three-quarters of a mile to the southeast, this had been the tallest and most dominant fact about the Parisian skyline. By June, however, it was little more than a memory, except for the trace of its moat that apparently remained visible into the reign of Louis XIV, more than a century later. With that one act of demolition, François set in motion the 350-year process that would result in the Louvre as we know it today.

But the fruits of this decision would not become visible on the ground until the reign of his successor, Henri II. Other than demolishing the Grosse Tour, François enacted only modest changes and additions during his lifetime, among them building a tennis court on either side of the eastern gate that faced the city of Paris, near where the fountain now stands at the center of the modern Cour Carrée. More importantly, however, in 1523 he seized the Hôtel du Petit-Bourbon, a structure that was as big as the sixteenth-century Louvre and that stood immediately to its east, after its owner, the constable Charles III de Bourbon-Montpensier, betrayed French interests and went over to the Habsburg cause. Nearly a century and a half later, in 1660, after it had served as a theatre and a warehouse of the Garde-Meuble de la Couronne, which oversaw the king's furniture collection, it was razed to the ground to make way for the peerless Colonnade that now forms the eastern limit of the museum.

More importantly—although few Parisians appreciated it at the time—François closed the southern entrance to the palace, which faced the river just west of where we now find the early nineteenth-century Pont des Arts. At the same time, he placed a garden between the fortress and the river, presumably to embellish the view outside his window and to provide *un peu de calme*, then as now the

most sought-after commodity in Parisian real estate. What had been little more than a boat landing thus became a sturdy embankment, leaving only the eastern gate of the palace, on the rue d'Autriche, to open directly onto the city of Paris, which still lay almost entirely to the east.

According to the architectural historian Geneviève Bresc-Bautier, this one decision to close the southern entrance of the palace "would determine the orientation of Parisian development from the main gateway of the Louvre [westward] all the way to the hill of La Défense."[3] Today the Louvre stands in the dead center of Paris, roughly three miles from its northern, southern, eastern and western extremities. But in the early sixteenth century it lay at the western

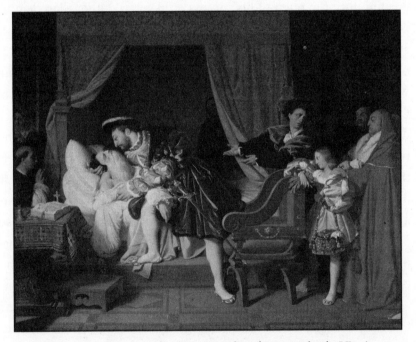

François I Receives the Last Breaths of Leonardo da Vinci
by Jean-Auguste-Dominique Ingres (1818).

limit of the city, facing what, despite some development just outside its walls, largely remained empty fields. Until François walled up its southern gate, the Louvre could just as easily have expanded north-ward in the direction of Montmartre, assuming that it expanded at all. But by asserting this new east-west axiality, François facilitated the creation, one generation later, of the Tuileries Palace and Gardens to the west, which in turn led to the creation of the avenue des Champs Élysées, the Arc de Triomphe and, ultimately, the new business district of la Défense, six miles away.

Given that François' plans for the Louvre were initially quite modest, there has been considerable debate as to why he waited nearly twenty years, following his decision in 1528 to inhabit the Louvre, before deciding to transform it into an entirely new and modern building. Historians often link the decision to a specific moment in his reign, the state visit of Charles, Holy Roman emperor and king of Spain, in 1540. In early modern times, as ever mightier monarchs ruled over ever more centralized nation-states, outward magnificence was essential to the projection of power and prestige. This was attested in various illustrious state functions and royal weddings held at the Louvre following François' return from his Spanish captivity. In 1530 François welcomed Charles, his former captor, on the occasion of François' marriage to Charles's sister, Eleanor of Habsburg (his first wife, Claude of France, having died six years earlier). Four years later the palace was the site of the marriage of François' second son, Henri, to Catherine de Médicis, both of whom would figure prominently in the history of the Louvre.

Throughout this period, however, the generally sordid and anti-quated nature of the Louvre was becoming increasingly apparent, and most acutely in 1540, when the Spanish king returned to the palace on his way to quell a revolt in the Flemish city of Ghent. Arriving in Paris on New Year's Day, after spending Christmas in Fontainebleau, Charles was received in style, with all the pageantry,

ingenuity and expense that the age demanded. In his mounted procession through the city, he passed under a series of fanciful arches along the rue Saint-Antoine that had been designed by Girolamo della Robbia. Then, like many a later tourist in the capital, Charles crossed the Seine to the Île de la Cité to visit Notre-Dame and the Sainte Chapelle, before returning to the Right Bank and heading westward toward the Louvre.

Prior to entering the palace, Charles was obliged to watch a jousting tournament that was held in his honor in the newly created garden by the Seine. When finally he reached the Louvre's courtyard—now the southwest quadrant of the Cour Carrée—he was doubtless astonished to see a statue of Vulcan, sixteen feet tall, spewing fire. At each corner of the court a giant disembodied hand held up a flaming torch. Proceeding to his lodgings in the northern wing of the palace, Charles found his room appointed with green-velvet wall hangings depicting scenes from Virgil's *Bucolics*, while his bed was covered in a blanket of crimson velvet spangled with pearls and precious stones.

But despite the impressive pageantry and the sumptuous appointment of his rooms, nothing could conceal from the emperor—or anyone else—the sorry state into which the Louvre had fallen, especially compared with Fontainebleau, where Charles had slept the night before. Not only did the Louvre look shabby, but it lacked the space to accommodate the many aristocratic guests who had arrived for the occasion. Indeed, several of the larger functions had to be moved to the Palais de la Cité, half a mile east and across the Seine. "The reception of the Emperor Charles Quint seems to have sounded the death knell of the old medieval castle, ill-adapted to the needs of a modern court."[4]

* * *

At this point, the restoration of the Louvre had become a matter of some urgency. The royal court had grown considerably under François and it would continue to grow, swelling to 1,725 men and women during the reign of his grandson, Henri III (1573–1589). The Maréchal des Lesdiguières, for whom the Porte Lesdiguières of the Louvre would later be named, doubtless spoke for many when he claimed that "a good courtier should not go a day without seeing the king."[5] In addition to noble courtiers, the royal household included valets, tailors, cooks, apothecaries and housekeepers, and many others besides. Under François, the Louvre became a hive of activity, buzzing with the curious who simply wanted to see the palace or lay eyes on the king. Provincials who happened to be in Paris would make a point of visiting the Louvre, while gossipmongers and protojournalists loitered about, waiting for any morsel of usable information to come their way. As in a modern city hall, policy was constantly being debated in the corridors of the Louvre, and stakeholders came to witness and applaud as the king signed legislation that was important to them.

In principle, then, it was easy to see the king: he lived most of his life in public, from his morning *levée* to his evening meal, which, in theory, he took alone, but with a multitude of people standing around. In practice, however, access was limited by the crush of people clamoring to get a look at him, a situation oddly reminiscent of the hundreds of modern tourists who, at any given moment, crowd around the *Mona Lisa* in the Salle des États, straining to see it from fifty feet away. Archbishop Bentivoglio, papal nuncio to France early in the seventeenth century, declared in exasperation that "to advance sufficiently far into the royal chamber that the king sees you, to stand by his side, is a mark of singular grandeur, and one of the great favors of majesty. At times I despair, since I can hardly find space, in an audience, to speak with the king."[6]

Of course, rules and limits guided these visits to the Louvre: only princes of the blood and visiting monarchs had the right to enter the grounds on horseback or in a carriage, although some rare exemptions were made for the aged and infirm. Except on feast nights, the gates of the palace were shut punctually at 11:00 p.m. and everyone had to leave, with the exception of the royal family, the captain of the guard, his lieutenant and twenty-five archers. The ushers and valets would return at 5:00 a.m. in summer and 6:00 a.m. in winter to sweep and clean the interiors, and one day a year—after François made the Louvre his main residence—the royal family and the court would decamp to Fontainebleau so that workers could clean the moats surrounding the palace.

* * *

Soon after Charles I had departed for Flanders, following the New Year's Day revels of 1540, François addressed the urgent issue of renovating the Louvre by seeking design proposals from two eminent Italian architects, Giacomo Barozzi da Vignola and Sebastiano Serlio, who were then living in France. These men fairly embodied the new mannerist movement in Italy, which rejected the clarity and directness of the High Renaissance, altering its formal language to produce bizarrely innovative architecture and willfully extravagant forms in painting and sculpture. Vignola, then at the outset of a glorious career, would go on to design some of the most emblematic mannerist monuments in Italy, among them the Villa Giulia in Rome and the Villa Farnese in Caprarola. Serlio, for his part, would design the Château Ancy-le-Franc, 120 miles southeast of Paris, and write the most influential architectural treatise of the sixteenth century, *I sette libri dell'architettura* (The Seven Books of Architecture). Although both men appear to have submitted designs

to renovate the Louvre, only Serlio's has survived. It does not seem to have found favor with the king, and the project languished until 2 August 1546, when François, less than a year before his death, decided to entrust the work to a novice, the French nobleman Pierre Lescot, Seigneur de Clagny.

Up to that time, Lescot's only architectural achievement had been the *jubé*, or rood screen, of the Church of Saint-Germain l'Auxerrois, which still stands directly opposite the east front of the modern Louvre. But the term *rood screen*—referring to an ornate partition between the nave of a church and its high altar— fails to account for what was in fact a substantial structure whose three broad marble arches may well have been the first example of pure classical architecture ever designed by a Frenchman. It is hard to imagine that François, living a stone's throw from the church, would not have seen and admired this screen as it was being built and that this admiration did not influence his decision to hire Lescot. In choosing him over two far more accomplished Italians, François may also have been moved by a nascent cultural nationalism. Indeed, by the time Lescot finished working on the Louvre, even if each element of his new building could be traced back to an Italian source, the structure as a whole looked impeccably classical, but also essentially French.

We know far too little about the life of Lescot, despite some fine-grained archival data related to his work on the Louvre. He was born in Paris in 1515 and he died in that city sixty-three years later, in 1578. Lescot was not prolific, and most of the projects he designed have been either destroyed or transformed beyond recognition. The *jubé* of Saint-Germain l'Auxerrois was demolished in 1750, while the Château de Vallery in Burgundy, the Hôtel Carnavalet in the Marais and the Fontaine des Innocents, just east of les Halles, can no longer be attributed to Lescot outright, even though they preserve some trace of his noble contribution.

Fortunately, the one exception to this dispiriting record is Lescot's finest and most important work, the western wing of the Cour Carrée, now known as the Aile Lescot. Today this building is as integral to the popular conception of the French Renaissance as the kingship of François I, the *Odes* of Pierre Ronsard, or the racy novels of François Rabelais. This project on which Lescot labored from 1546 until his death has been so reverently preserved that the side facing the Cour Carrée, the more important side, is essentially unchanged nearly five centuries on. Although so much of the Louvre has been revised over the course of centuries, there has been no serious attempt to alter Lescot's composition.

No other French edifice of the sixteenth century, not even the Palace of Fontainebleau in all its splendor, possesses the standing or prestige of the Aile Lescot. In all the other royal palaces built in France around the same time, classicism took the form of a mannerist extravagance, breathtaking at times in its audacity, but of limited influence on subsequent architects. The Aile Lescot, however, proclaimed a purer, deeper strain of classicism that would define Paris, and France itself, from the reign of Louis XIV down to the birth of modern architecture early in the twentieth century. For this building not only influenced the look of the Louvre for the next three centuries: it also, if indirectly, gave rise to French baroque classicism, which in turn inspired the Beaux-Arts idiom of Baron Haussmann that is so integral to what we imagine when we think of Paris today.

* * *

In one of his conversations with the poet Johann Peter Eckermann, Goethe makes the bizarre and beautiful claim that architecture is frozen music (*erstarrte Musik*).[7] This resonant phrase provides us with a good way to interpret the Aile Lescot, as well as the entire

Louvre complex and, perhaps, all of classical architecture. Like any intricate classical structure, the Aile Lescot consists of a number of themes, each a composite of smaller motifs that recur, with evocative variations, throughout the Louvre.

In its dimensions, the Aile Lescot replicates both Philippe Auguste's fortress and Charles V's palace, even integrating parts of those earlier structures into its invisible foundations: that is to say that its dimensions are roughly identical to those of the castle and palace that it replaced. It has three levels: a ground floor; a *piano nobile*, or *bel étage*, with state rooms and royal apartments; and finally the attic, squatter and humbler than the two floors beneath it. Atop this attic is what may well be the first mansard roof ever built, a hipped structure whose four sides tilt inward, forming an upper and lower segment.

Lescot initially designed a two-story building that, lacking the attic level and mansard roof, was far closer to contemporary Italian architecture than what we see today. The reason it was not built in that form is that François, before he died, got only as far as razing the western side of the palace of Charles V: he himself may have seen Lescot's designs, but he never lived to see the realization of any part of them. By the time construction actually began, the new patron, François' son and successor, Henri II, wanted something quite different from the classical purity to which Lescot had initially aspired.

Henri II was a very different man from his father. If François appears to have been in general a happy person, a religious moderate and a lover of art and beautiful women, Henri was prone to sullenness, provoked, some have conjectured, by his resentment at having spent several years as hostage to the king of Spain in the deal that ransomed his father in 1526. Not surprisingly, the persecution of French Protestants began in earnest during Henri's reign. And although he built palaces, as his father had, he built less energetically and had almost no interest in collecting art. He did have mistresses,

but the only one he appears to have truly loved was the famous Diane de Poitiers, twenty years his senior, who tolerated more than she welcomed his advances. If anything mitigates this dour portrait, it is that even if Henri did not show much affection for his wife, Catherine de Médicis, at least she appears to have loved him anyway.

More from stubbornness, perhaps, than from any aesthetic conviction, Henri was quite determined that the entire ground floor of the Aile Lescot should be a single great space, uninterrupted by columns. The resulting chamber survives to this day as the Salle des Caryatides, and it displays some of the Louvre's finest Roman sculptures. But the decision to build this vast space—which often served as a ballroom—provoked, in turn, a complicated sequence of modifications. The stairway, originally intended for the center of the structure, as in a traditional chateau, was moved to the northern end: this variation, in turn, forced Lescot to widen the pavilion in which it stood. To preserve the building's symmetry, however, the pavilion at the other end now had to be widened as well. But this change resulted in three rounded summits—crowning the central frontispiece and the pavilions at either end—that now stuck out in almost comical isolation. And so a third level, an attic, was extended across the top of the building, to fill in those gaps.

Like most of the Italianate architecture in France in the sixteenth century, the Aile Lescot appears to follow a different strain of classicism from that of the High Renaissance in Florence and Rome. The contributions of Charles VIII to Amboise, of Louis XII to Blois and of François himself to Chambord all employed the classical language—arches, columns, balustrades and the like—in an essentially anticlassical way. Even before François' annexation of the Duchy of Milan after the 1515 Battle of Marignano, the Italian style that filtered into the kingdom came from Northern Italy rather than points south. French patrons especially admired the Certosa of Pavia, whose classical language, instead of articulating structure,

was content merely to adorn it. Raised in the final and most extravagant phase of the Gothic style, contemporary French architects, to quote Anthony Blunt, "would hardly have taken to the cold intellectualism of Florentine Quattrocento architecture, which in their eyes would have been merely bleak."[8]

A generation later, François called in two of the most inventive Italian artists of the age, Rosso Fiorentino and Primaticcio, to renovate his favorite Palace of Fontainebleau. In a sense, however, the result of their brilliant interventions was oddly similar to earlier châteaus: a dazzling prettiness of surface achieved by translating the tone and energy of flamboyant Gothic into something that retained the form, but subverted the spirit, of classical architecture. France had lurched from the Gothic style directly into mannerism without ever encountering the intervening High Renaissance.

As regards the Aile Lescot, however, this reading is unsatisfactory. To superficial inspection, the wealth of sculptural décor across the top third of the structure initially seems to confirm this impression: but if we discount that sculpture—and it was included almost as an afterthought—we begin to appreciate the classical purity of the two lower levels, which are ultimately inspired by Donato Bramante's two-story Palazzo Caprini from around 1510, which once stood a few blocks east of Saint Peter's Cathedral in Rome. The Corinthian columns and pilasters interspersed among the arches at ground level are as perfect as anything produced in Italy at this time, and the same could be said for the composite columns and pilasters on the floor above. The overriding character of its façade along the Cour Carrée is one of serene balance that emerges from the harmonious union of the windows, with their powerful vertical thrust, and the equally powerful horizontal cornices that define each level in relation to the others.

But even in the pure classicism of its two lower stories, the Aile Lescot is really a hybrid of Italian influence and inveterate French

*Salle des Caryatides, designed by Pierre Lescot c. 1550 and
furnished with a stone vault by Jacques Lemercier c. 1625.
Now home to Roman copies of Greek statues.*

architectural habits. If much of the first two stories would not have
seemed out of place on the streets of Renaissance Rome, the three
avant-corps, or frontispieces, that advance from the building's center
and its sides are nothing more than a classical reenactment of similar
structures that were already common in the châteaus of the Loire
Valley. At the same time, the slanting roof accommodates the rainy
climate of the Île-de-France in a way that has no parallel in Italian
practice. But the three avant-corps have been so flattened that in a
certain light they almost seem penciled in. Such radical subversion
of the native habits of construction and design is nothing less than
the mannerist movement in action.

Recent critics have tended to depreciate Pierre Lescot's architec-
tural achievement in favor of his more flamboyant contemporary,

Philibert Delorme, who designed the Tuileries Palace that was once attached to the Louvre and was burnt to the ground by the Communards of 1871. This judgment fails to grasp what Lescot sought, and achieved, in the area of the Louvre that would later become the Cour Carrée as we know it today: a serene perfection through the use of the classical language of architecture. And that he should have done so without having seen an actual example of ancient or modern classical architecture—he visited Italy only after he had designed the Aile Lescot—is not the least astonishing aspect of this architectural masterpiece.

Unfortunately, despite its considerable beauty, most visitors to the Louvre will never see Lescot's façade, since they will almost certainly enter the museum by the *Pyramide* and leave by the Carrousel du Louvre. But until they have stood in admiration before the Aile Lescot, they have not fully and truly visited the Louvre.

* * *

Lescot's success can be attributed, in no small part, to his gifted collaborator, the sculptor Jean Goujon. His work adorns not only the interior and exterior of the Louvre, but also several relief sculptures that survive from the rood screen of Saint-Germain l'Auxerrois and are now in the museum, as well as from the Fontaine des Innocents near les Halles and the Hôtel Carnavalet in the Marais. Like Lescot, Goujon so fully embodies the Renaissance in France that nineteenth-century statues of both men, dressed in period attire, look down on the *Pyramide* from the *piano nobile* of the Louvre.

Like Lescot, Goujon visited Italy only after completing his work at the Louvre, and he appears to have spent the rest of his life in that country, dying in Bologna in 1567, at fifty-seven years old. But if Lescot had never seen a classical building before he designed

the Louvre, Goujon had surely seen the stuccoes of Fontainebleau. Goujon was not a classicist as Lescot was, but a committed follower of the mannerist movement. If Lescot is sometimes mistaken for a mannerist as well, that is mainly because Goujon's sculptures adorn his façades. A serene order reigns across the first two levels of the Aile Lescot, and its classical statues remain obediently in their niches. But at the attic level, where Goujon was given a freer hand, the figures writhe and gyrate more like frenzied dancers than like those embodiments of peace and war, history and victory, and fame and the glory of the king that they are summoned to represent. Although his depictions of Mars and Bellona derive from Michelangelo's seated Sibyls and prophets on the ceiling of the Sistine Chapel, Goujon was more interested in ornamental effect than in the sublimity and human depth that radiate from the works of Michelangelo.

Before the emergence of modernism, few sculptors cherished flatness over volume, surface over depth, more than Jean Goujon. The abstract grace of his surfaces resembles the tracings of a pencil or burin so delicate as to undermine any sense of corporeal force. His deep and insistent drill-work is richly satisfying as it draws out of the cold stone a thousand charming details, but these details are never allowed to accumulate into any force of life. Only rarely does he seek to convey real power, as in the *Allegory of War* that crowns the central frontispiece of the Aile Lescot and is one of his few surviving sculptures in the round.

Perhaps Goujon's most famous work of all is the group of four caryatids—columns in the form of classically robed women—that support the musicians' platform of the Salle des Caryatides, which fills most of the ground floor of the Aile Lescot. Their main source was the Erechtheion on the Acropolis in Athens, which Lescot would have known only from descriptions by architectural writers like the ancient Roman Vitruvius. Just as the foundations of

the new building reused certain structural elements of Philippe Auguste's Louvre, so this expansive chamber, originally a ballroom, recreates and enlarges a chamber that occupied the same space in the wing of Charles V's palace, before it was torn down to make way for the Aile Lescot. Many of the Louvre's interiors have changed since the sixteenth century, but this one, perhaps the most magnificent of them all, has sustained relatively little alteration. Standing forward like colossi from the chamber's northern wall, the four caryatids dominate the gallery at nearly three times larger than life, if their capitals and pedestals are counted. But no human warmth flows from these oddly armless figures. Their beauty is severe and otherworldly, and their draperies cling to them like cellophane, collecting into frenzied knots about the pelvis. Despite this accumulation of lines, their robes conceal little and are more an exercise in virtuosity than anything else. The same could be said for the balcony that they support, with its balustrade and its insistent repetition of minute, finely drilled leaf patterns. On the opposite side of the chamber stands a raised tribunal in the form of a *serliana*—two flat-topped openings flanking a taller arched opening where the king would sit in state, observing the dances that were often held in the Salle des Caryatides.

To the north of these much-loved sculptures, on the other side of the wall, is yet another masterpiece by Lescot and Goujon, the stairway known as the Escalier Henri II, completed in 1551. Not all stairways are equal in their functioning: the height of each step, the number of steps relative to the frequency of landings, the hardness of the stone or the pliancy of the wood all affect the comfort and speed of one's ascent. Although the Escalier Henri II may prove in this respect to be something of a challenge, as a whole it is a miracle of design, and Paris affords precious few examples of sixteenth-century architecture as beautiful or as well preserved. Perhaps most striking about the Escalier Henri II is that

it unites hedonistic opulence with an almost monastic austerity. As it rises up two levels and four flights from the ground floor to the attic of the Aile Lescot, its barrel-vaulted ceiling is richly and ingeniously carved by Goujon, but its sides have been left completely blank, allowing the pure, cream-colored limestone to speak for itself. Originally, its virginal surface was not inflected by so much as a handrail, although one was finally installed a few years ago. To anyone sensitive to the materiality of architecture, it is hard to resist passing one's hand across the glowing stone. Surely this is one of the most stunning acts of formal restraint prior to the rise of twentieth-century modernism.

But the barrel-vaulted ceiling of the Escalier Henri II is as lavish as the stairway is austere. On the flight of steps leading up to the *piano nobile*, the ceiling is filled with nude male figures, piping satyrs and assorted hounds. For all their riot, however, these forms never break free of the precise framing system that pens them in. In this respect they seem to anticipate the restrained classicism of Louis XIV, one century later.

* * *

Henri's contribution to the Louvre went well beyond the Aile Lescot. A drawing attributed to Lescot suggests that there were plans to replace the three remaining sides of the medieval Louvre with wings similar or identical to the Aile Lescot. Although there is no evidence that either François or Henri ever officially signed off on a project of such dimensions, it seems entirely plausible that that was where their thoughts were heading. The architect and writer Jacques I Androuet du Cerceau (who was in a position to know such things) states as much: "King Henri, finding himself well pleased with the sight of so perfect a building [as the Aile

Lescot], considered continuing it on the other three sides, such that the courtyard should be unrivaled."[9]

In any case, work was begun to replace the south side of the medieval Louvre with a structure whose elevation and façade were nearly identical to those of the Aile Lescot. Containing the apartments of the queen and of the queen's mother, Catherine de Médicis, it was completed by 1582, twenty-three years after Henri's death and twelve years after Lescot's. It had the curious distinction of not being constructed horizontally, with one story completed before the next was begun: instead, it materialized almost in vertical installments, extending from the basement to the attic, so that the impatient Catherine could move in at once. Unlike the Aile Lescot, the Aile Sud as we see it today bears little relation to its original form. Its width was doubled by Louis Le Vau in 1668 and the attic facing the court was removed by Louis XV's architect, Jacques-Germain Soufflot, in 1750, when its façade was brought into conformity with the east and north wings, which by then had been built. Four refined sculptures by Jean Goujon—similar in spirit to those of the attic façade of the Aile Lescot—had to be removed in the process, and can now be seen in the Pavillon Sully.

Another of Henri's projects that would prove to be of great importance for the future of the Louvre was the Pavillon du Roi, an entirely new structure that contained the apartment of the king and occupied the Louvre's southwest corner at the point where the new southern wing intersected with the Aile Lescot. As such, it communicated with the apartments of the queen. Although the Pavillon du Roi was mostly demolished in the mid-eighteenth century, it established a template that was fairly faithfully reproduced in the nearly twenty pavilions that now dominate the most crucial corners of the Louvre complex. All of them were fundamentally reconceived or built from scratch in the middle years of the nineteenth century, in a style clearly inspired by Lescot's original, but far more opulent and ornate.

The Pavillon du Roi elaborated on an architectural type that was fairly common in late medieval France: a squarish structure crowned by an imposing gable. Its closest precedent is the still extant Hôtel de Ville (greatly modified in the nineteenth century) that François I built a mile east of the Louvre. The Pavillon du Roi rose four stories, higher than the Aile Lescot, over an unadorned base articulated with rusticated corners. Its top-most story was a gabled belvedere whose three large windows on each side offered the king a stunning view of the Seine and the Left Bank, from the still fortified enclosure of Saint-Germain-des-Prés to the vineyards of the Plaine de Grenelle.

The Pavillon du Roi, at least from the exterior, was not a beautiful building. Nor, for that matter, was the entire western façade of the Aile Lescot, facing what is now the *Pyramide* and the Cour Napoléon. What we see today dates only to the middle of the nineteenth century, and even if it bears a strong relation to Lescot's original, its effect, on account of the dizzying opulence of its decor, feels fundamentally different. It is as if the architects of Napoleon III had translated sackcloth into silk. The original western exposure was plain, and not by accident: where we now find the Cour Napoléon once stood the Cour des Cuisines, the Kitchen Courtyard, to which François relegated all the less exalted functions of the royal household. That decision reflected the fact that, at the time of its construction, the Aile Lescot still stood very near the western, undeveloped limit of Paris, with the city largely oriented toward the east. Other than the Church of Saint-Thomas du Louvre, the Hôpital des Quinze-Vingts and the Hôtels d'Ô and de la Petite Bretagne, few important or noble structures arose west of the Louvre during the reign of Henri II. And so it seemed entirely natural that the royal dwelling should turn its back on this area, a rejection expressed—and most eloquently—in the drab adequacy of the façade, which would survive, entirely unchanged, down to the 1850s.

* * *

For most of the first half of the sixteenth century, France and Spain waged a proxy war on Italian soil, as each aspired to be the preeminent power in Europe. That conflict ended only in 1559, with the Peace of Cateau-Cambrésis. In celebration of this accord, Henri II and his wife Catherine de Médicis gave their fourteen-year-old daughter, Elisabeth de Valois, in marriage to Philip II of Spain, eighteen years her senior, on 22 June of that year. One week later, Henri's sister Marguerite de France, at the advanced age of thirty-six, was married to Emmanuel-Philibert, Duke of Savoy. To celebrate these mariages, in addition to festivities at the Louvre and the Hôtel des Tournelles, a joust was held on the rue Saint-Antoine in the Marais. Henri was not a man of deep or energetic culture, as François had been, but he shared his father's love of physical exertion, especially hunting and equestrianism. And so, despite his forty years, he could not resist entering the lists against the Comte de Montgomery, the captain of his Scottish Guard. In the violence of their collision, each man's lance was shattered, and a large splinter of Montgomery's lance entered the king's head above his right eyebrow, piercing his left eyeball. For nearly two weeks Henri lingered in excruciating pain between life and death, before succumbing to the injury at the Hôtel des Tournelles. In her sorrow, Catherine wore mourning clothes for the rest of her life, adopted the broken lance as her emblem, and tore down the Hôtel des Tournelles. Half a century later the place des Vosges arose in its place, one of the most enchanting public spaces in modern Paris.

In theory, control of the kingdom now passed to Catherine's oldest son, François II. But because he was only fifteen, and somewhat sickly, power was seized by the Guise family, the leaders of the extreme Catholic faction in the court. Catherine consented to this usurpation, perhaps because she was feeling too aggrieved by her husband's death to attend to affairs of state. But François died scarcely a year after his coronation, and because his successor,

Charles IX, was still a minor, the Guise faction was forced to retreat as Catherine assumed the regency of France. And so, even when Charles came of age five years later, Catherine remained an imposing presence in European affairs until her death, just shy of seventy, in 1589.

The power that Catherine obtained was remarkable for a woman whose early life had been full of struggles. The Medici name may impress us today, but it hardly impressed the French royal family, to whom she seemed little better than a commoner, the descendant of merchants. The main appeal of her betrothal to Henri, in 1533, when they were both fourteen years old, had been her family's wealth and the generous dowry that came with her: François I constantly needed money for his building projects and military campaigns. A secondary, but powerful appeal was the fact that she was the niece of Pope Clement VII. At the time of her marriage, however, there was no thought of her ever becoming queen: Henri did not become dauphin until three years later, with the premature and unanticipated death of his older brother François. Initially things did not go well for Catherine, whom the French courtiers considered plain: she had little access to the money promised in her dowry, and the papal uncle died a year into her marriage, making their consanguinity a dead letter. Henri, for his part, did not conceal his preference for Diane de Poitier, and it did not help that in the first decade of his marriage to Catherine, they failed to produce a single child, boy or girl, living or dead. (Thereafter, however, they produced ten children, seven of whom lived to adulthood.)

With the death of François II, the governance of France fell to Catherine at a time of greatest peril to the kingdom. The treaties of Cateau-Cambrésis had scarcely been concluded when the country became embroiled in a civil war that, for more than thirty years, would pit Catholics and Protestants against one another in murderous enmity. Although tensions had been mounting for decades,

open violence broke out in 1562, after a Protestant cabal, during the Conspiracy of Amboise, tried to assassinate François de Guise, the most virulent member of the Catholic faction. The resulting violence persisted until 1594, when the besieged Parisians finally opened their gates to the Protestant leader, Henri de Bourbon, following his conversion to Catholicism.

Among the most wretched episodes in that long conflict was the Saint Bartholomew's Day Massacre, which largely played out in or near the Louvre. This outrage was instigated by the marriage that took place on 18 August 1572 between Catherine's daughter, Marguerite de Valois, and Henri de Bourbon, later King Henri IV. By this point the religious conflict had raged for ten years and many people, including Catherine, hoped that the marriage would bring the factions together in peace. And so it was that, at the tensest moment of the conflict, the two leaders of the warring factions, Henri de Bourbon and Henri de Guise, stood together in the Salle des Caryatides. The aged Admiral de Coligny, a hero and symbol of the Protestant cause, was also in attendance, a mere two days after the Guise faction had tried unsuccessfully to assassinate him. They had better luck the day after the wedding, when they stabbed him to death and flung his corpse from the window of his house in the rue de Béthizy—now part of the rue de Rivoli, just north of the Louvre. In remembrance of that crime, the street opposite the Colonnade, the easternmost point of the Louvre, is now known as the rue de l'Amiral de Coligny.

But this was only the beginning of the violence. On the morning of 24 August 1572 a signal went forth from Saint-Germain l'Auxerrois, the church that still stands opposite the Colonnade, and for the next five days as many as two thousand Protestant men, women and children were murdered in the city of Paris. As news of the massacre spread beyond the capital, French Catholics took up arms and more than eight thousand Protestants are thought to

have died throughout the land. In her memoirs, Marguerite de Valois describes running to the Louvre through streets littered with naked and despoiled corpses. She was holed up in the bedchamber of the Pavillon du Roi with her new husband, who—strange to say—was completely safe on account of his princely rank, despite being the leader of the Protestant cause. Meanwhile, the captain of the guard, Nancay, went from room to room through the Louvre looking for Protestants to kill.

By this point, corpses were piling up in the courtyard of the palace, in what is now the southwestern quadrant of the Cour Carrée. Others were thrown into the Seine. It was said, in all likelihood falsely, that the young king Charles IX watched from the south wing of the Louvre as bodies floated by and that, whenever one of them showed any signs of life, he would shoot at it from his window. According to Agrippa d'Aubigné, whose poem "Les Tragiques" describes the persecution of the Protestants,

> *Ce Roi, non juste Roi, mais juste arquebusier,*
> *Giboyait aux passants trop tardifs à noyer!*

> *This king, not a good king, but a good marksman,*
> *Shot at those who, floating by, tarried in their drowning!*[10]

Rumors abounded that Catherine, the niece of two popes, masterminded the massacre of the Protestants. Subsequent historical inquiry has largely exonerated her—she assented to the controversial marriage precisely to unify a divided kingdom—but these rumors, often referred to as *la légende noire*, or the black legend, have persisted ever since.

That was not the only violence visited on the Louvre during the Wars of Religion. While Paris was besieged by the Protestant forces of Henri IV in 1591, the leader of the Ligue Catholique, the most

virulent of the pro-Catholic parties in Paris, arrested three Catholic members of the Parlement de Paris who were considered too conciliatory toward the Protestant cause. They were hanged from the rafters of the Salle des Caryatides and left there for several days, provoking considerable outrage throughout the city, even from Catholics. For a time the Salle itself was renamed the Chapelle de Saint-Louchart in honor of Jean Louchart, one of parliamentarians who had been hanged.

* * *

Throughout this protracted civil war, royal building projects were maintained. Until this time, despite a great deal of construction at the Louvre, its relatively small footprint occupied one-quarter of the modern Cour Carrée—as would remain the case until the 1660s. In all, the Louvre was perhaps one-twentieth the size of the complex structure we know today, stretching nearly half a mile from end to end. The process by which the kings of France made the conceptual leap from this small, quadrangular structure east of the rue Saint-Thomas du Louvre to one of the largest palaces on earth would engage nearly every French ruler from Henri IV in 1600, through the last of the Bourbons, to Bonaparte himself, before finally becoming a reality, after three centuries of fitful and imperfect progress, under Napoleon III.

The first material steps toward this expansion were taken early in the seventeenth century by King Henri IV and his son and successor Louis XIII, the first two members of the Bourbon dynasty. But the general dimensions of the expansion appear to date to the last two kings of the Valois dynasty, Charles IX and Henri III, and especially to their mother Catherine, who initiated several building projects that would greatly influence the future of the Louvre. Soon

after the tragic death of her husband in 1559, Catherine de Médicis resolved to build a palace, the Tuileries, with the proceeds from the sale of land on which the Hôtel des Tournelles, the site of Henri's death, had stood. The site she selected stood nearly half a kilometer west of the Louvre, beyond the great wall of Charles V, over the remains of four ancient tile factories (*tuileries*), from which its name derives. Additional parcels of land had already been bought by Catherine's father-in-law, François I, for his mother, Louise of Savoy. The palace no longer exists, but its famed garden, le Jardin des Tuileries, directly to the west, receives millions of visitors each year.

In the British Museum a drawing sheet by Jacques I Androuet du Cerceau from the early 1570s strongly suggests that Catherine was contemplating something vastly more ambitious than what she ultimately built, something that would far outstrip the Louvre at that time. Du Cerceau depicts a structure oriented along a north-south axis, with four main wings subdivided to form three massive courtyards, with a pavilion at each corner. In reality, only the western wing, facing today's garden, was ever built, ultimately stretching from the Pavillon de Flore to the Pavillon de Marsan at the eastern edge of the Tuileries Garden. Even though the palace was never completed as planned, simply to conceive of anything so ambitious seems to have spurred later kings to reimagine the Louvre on a far grander scale than that of the sixteenth-century Aile Lescot. Today the Palace of the Louvre, the part of the complex that forms the Cour Carrée, is four times the size of the original, quite possibly in response to the Tuileries, and that fact may well be the most enduring legacy of Catherine's long-vanished palace.

Its design was entrusted to Philibert Delorme (1514–1570), one of France's finest architects, and surely the most original to appear in that country since the anonymous builders of the great cathedrals of the Middle Ages. And yet, the entire ideology of French official architecture, at least down to the end of the nineteenth century, favored

something other than the boldness and originality that defined Delorme's career. If Pierre Lescot was an architect of impeccable restraint, whose refined surfaces consisted of repetitive, modular patterns and an almost scholarly use of the architectural orders, Philibert Delorme thought more in terms of the play of volumes, of dramatic contrasts in the size and shape of his massings, of jagged outlines arrayed in provocative symmetry. Delorme represents the road not taken by French architecture. As though through a kind of second sight, Lescot sought and attained the High Renaissance perfection of Bramante before he had ever been to Italy. But Delorme peers into the future, to those baroque masterpieces that Bernini and Pietro de Cortona would conjure into being nearly a century later: his great, still extant Chapel of Anet achieves an hallucinatory, almost apocalyptic grandeur in the spiraling disequilibrium of its interior dome.

The history of architecture is littered with the corpses of buildings that have been torn down or that have died, stillborn, before they could ever become reality. In the Tuileries Palace, Philibert

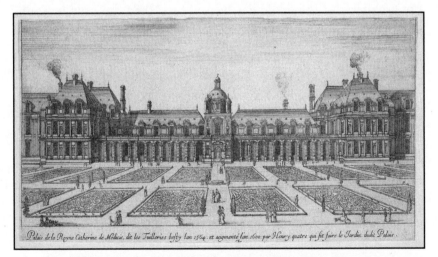

Israel Silvestre's depiction of the Tuileries Palace, largely
preserving the designs of Philibert Delorme, before
Louis Le Vau's additions in the 1660s.

Delorme's contribution suffered a threefold death: most of his plans were never realized; those that were built were promptly betrayed by lesser talents; and in the end, the entire building burned to the ground. At the same time, even if the Tuileries Palace had been built according to Delorme's exact specifications, it could never have lived in harmony with the Louvre we know today, or perhaps with any other manmade structure ever conceived. It was too eccentric, too sui generis. Consisting of only a ground floor and a fairly diminutive attic level, it was conceived more as a villa—such as Catherine might have remembered from her childhood in Italy—than as a palace. The jagged sequence of dormers on the attic, one squat, the other elongated, replicating and replacing one another seemingly ad infinitum, must have constituted one of the most bizarre architectural effects ever seen. The same is true of those ringed and ornamented columns that adorned its façade and seemed closer in spirit to silverwork than to masonry. These at least would live on in the later incarnations of the building and in other parts of the Louvre complex. Beloved of the architects of the École des Beaux-Arts, they can now be found throughout the capital and beyond.

For as long as the Tuileries Palace existed, there was always something of a forced marriage between it and the Louvre. Both structures were designed to stand perpendicular to the Seine, but the curve of the river caused the axes of the two buildings to differ slightly. Initially this wasn't a problem, since they were separated by nearly half a kilometer of huts, houses, churches and hospitals. Equally important, the great wall of Charles V stood with daunting solidity as a line of demarcation between the Louvre and its semi-city on one side, and the Tuileries on the other. This would remain the case until the reign of Louis XIII, when, in 1641, the fortification was razed. When the two palaces were joined by the Grande Galerie, around 1610 (before the fortification was torn down), the discrepancies became more evident. Today, if one stands right next to the

Pavillon de Flore at the southwest tip of the Louvre, this disparity becomes clear: at the point where the pavillion and the Grande Galerie meet, each seems almost violently torqued relative to the other. The architects of the Grand Louvre under Napoleon III did their job so skillfully that few visitors will ever notice this irregularity, but it remains as a reflex of the palace to which it was once attached.

Catherine herself soon grew weary of the Tuileries, however, and she abandoned it before she could spend a single night there. Instead she took up residence in the Hôtel de la Reine, near where the Bourse de Commerce de Paris now rises in les Halles. Over the course of the next century, the wing that Delorme had begun was brought to a provisional completion, but in a very different form from the one he had conceived.

Nevertheless, the Tuileries Palace would become, by the eighteenth century, the main Parisian residence of the French monarchy, and in the next century it was chosen as the principle residence of Napoleon Bonaparte, the last three kings of France and Napoleon III. Although, like most royal buildings in France, it had a difficult and protracted genesis, it immediately presented a challenge and counterpoise to the Louvre, half a kilometer to the east. Although it was far enough from the Louvre that it felt like a completely independent structure, it was close enough that, inevitably, there was talk of connecting the buildings. This is exactly what came to pass with the completion of the Grande Galerie around 1610. But no sooner was that union achieved than the kings of France, their counselors and every self-respecting architect of the realm for the next 250 years sought a grand consummation in the form of an equal but opposite wing to the north. This addition was completed on 14 August 1857. Tragically, and with almost cosmic irony, after centuries in the making the consummation of the Louvre lasted less than fifteen years before the Tuileries was sacked and destroyed by the Communards.

Even though the Tuileries Palace no longer exists, it survives as a kind of phantom limb in the context of the Louvre. For centuries it was a fact of Parisian life, as Parisians walked in its shadow, swerved round it in their progress from the Seine to les Halles, and traded rumors about what the great were up to within its walls. And then on a single day, 23 May 1871, it burned to the ground. So thoroughly has it vanished that most visitors to the Louvre—indeed, many Parisians as well—are entirely unaware that it ever existed. They are likewise unaware that the great and famous vista stretching from the *Pyramide* all the way to the Arc du Triomphe in the west was the fortuitous consequence of its destruction.

- 3 -

THE LOUVRE OF
THE EARLY BOURBONS

Visitors who enter the Louvre through the Carrousel, rather than the *Pyramide* a few hundred feet to the east, not only avoid the indignity of standing in line for an hour, but also encounter two immense walls that face one another in sullen antithesis, their yellowish stone the color of *crème anglaise*. These are the scarp and counterscarp of the fortifications of Charles V, the two sides of the moat that once guarded the city's Right Bank. Here, the waters of the Seine flowed in an artificial sluice that arced round the city all the way to the Bastille, two miles to the east. These are the most dramatic remains of the wall, as reconceived in beautifully dressed limestone during the reign of Louis XII, sometime around 1512. But if one knows where to look, one also finds that its imposing surface is marked by traces of bullet holes and the shattered impact of cannonry. These date to 1593 and Henri IV's siege of Paris, the last time that the fortifications of the Louvre would serve a defensive function.

According to those mystic theories of kingship that pervaded the *ancien régime*, the thirty-five-year-old Henri de Bourbon became Henri IV of France at the very instant when life departed the body of his predecessor, Henri III, the last of the Valois, on 2 August 1589. The new king was the brother-in-law and cousin of his predecessor. Other Valois kings had come to a bad end, dying either mad or imprisoned in foreign parts or, like Henri III's father, in a tragic

accident during a jousting match. But Henri III was the first French king to be assassinated, by a fanatical member of the Catholic League named Jacques Clément. Before Henri died of his wounds, however, he had the wherewithal to affirm Henri de Bourbon as his successor, which by rights the latter already was, given that the king had sired no legitimate male heir (or any other heir), and given that his brother François, Duke of Anjou, the last and least of Catherine de Médicis' sons, had already expired in 1584.

Other than some fortifications west of the Tuileries Palace's gardens and a few projects that were left unfinished—the Pont Neuf, the Tuileries Palace itself and the Petite Galerie of the Louvre—the thirty-year rule of Catherine de Médicis' sons had left few enduring marks on Paris or the Louvre. During the protracted civil strife known as the Wars of Religion—with the city in the hands of the Catholic League for the last five years of that conflict—architectural diversions seemed beside the point. But with the accession of Henri IV, something like peace, nervous and unstable, but still peace, descended on the kingdom, and work on the Louvre resumed. A somewhat maladroit painting in the museum's collection, attributed to Toussaint Dubreuil, depicts the new king as Hercules slaying the Lernean hydra. The luckless hydra, flattened underfoot, stands as a metaphor of the thirty years of open war that Henri IV had just ended.

But even after Henri became king, four long years would pass before he could claim the fealty of all of France. And no corner of the country held out longer, or resisted more ferociously, than Paris itself. For centuries the capital had been a source of hostility to the monarchy. To such sentiments could now be added its extreme Catholic resistance to Protestantism in general and to Henri IV in particular, given that he was the leader of the Protestant cause in France. Three times he would lay siege to Paris before the citizens finally opened their gates to him in 1594, and even then, they did so

only after he had publicly abjured Protestantism and embraced the Catholic faith. "*Paris vaut bien une messe,*" he is reported to have said on this occasion: "Paris is well worth a mass." Less well known is that Henri had already abjured and resumed his Protestant faith on a half-dozen occasions, which is why many Parisians doubted his sincerity this time around.

Today Henri is one of the best-liked kings of France, especially in personal terms. His only rival for that honor is François I, whom he

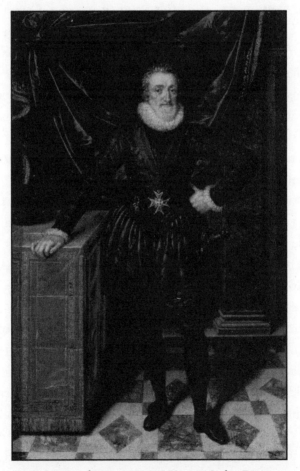

Portrait of Henri IV (1553–1610) by Frans Pourbus the Younger.

resembles in some respects. Henri differed from his four immediate predecessors, the son and three grandsons of François I, who were, in one way or another, weak or melancholic. Like François himself, Henri was an amiable and committed hedonist. "He is naturally very affable and familiar," wrote the English courtier Robert Dallington on meeting him in 1602, "and more (we strangers thinke) then fits the Majesty of a great King of France."[1] To his contemporaries he was known as *le vert galant*, a skirt-chaser, especially an older man who continues to run after younger women. One of the ways in which Henri earned this title was his nine-year affair with Gabrielle d'Estrées, whom he met when she was sixteen and he was in his late thirties, which, at the time, was well into middle age. She soon became his *maîtresse-en-titre*, a semi-official position at court, which meant that she was his foremost, but hardly his only, mistress. "Of noble birth, as well as great beauty and high intelligence," Alistair Horne writes, "Gabrielle represented probably the most serious attachment in the philandering life of the Vert Galant."[2] Over the course of their relationship, she bore him three children, whom he officially recognized. This naturally vexed his infertile queen, Marguerite de Valois, whom he had married the year before Gabrielle was even born. Their union was finally annulled in 1599, and Henri planned to marry Gabrielle, but she died, all of twenty-six years old, before the wedding could take place.

Gabrielle lives on, in a manner of speaking, in one of the oddest paintings in the Louvre, perhaps one of the oddest paintings ever made. Bearing the title *Gabrielle d'Estrées et une de ses sœurs* (Gabrielle d'Estrées and One of Her Sisters), this work of 1594 depicts the two women in half-length, sitting naked in a bathtub framed by a sumptuous red silk curtain. As a maidservant sews by the fireplace in the background, Gabrielle holds in her left hand the wedding ring that Henri has just given her, while her sister extends her hand to touch Gabrielle's right nipple. This odd gesture has been

interpreted as a reference to Gabrielle's being pregnant with Henri's child. But beyond this initial oddity, what most lingers in memory is the jarring incongruity between that carnal gesture and the blood-less, pulseless, alabastrine stillness of the two women.

Less than a year after Gabrielle's death, Henri signed a marriage contract in March of 1600 for the hand of Marie de Médicis, the daughter of Francesco I, Grand Duke of Tuscany, to whom Henri was massively in debt following his numerous military campaigns. Marie was two years younger than Gabrielle and thus twenty-two years younger than Henri (and, for that matter, Marguerite). Although the couple was married by proxy in October of that year, they did not actually meet until 9 December. Slightly more than nine months later, on 21 September 1601, Marie was delivered of an heir to the throne, the future Louis XIII. The marriage was not an especially happy one, however, since Marie was no more kindly disposed to her husband's mistresses, with whom she had to share the Louvre, than Marguerite had been. But she remained on surprisingly friendly terms with Marguerite herself, and she persuaded Henri to recall his former wife from exile. Eventually Marguerite built and took up residence in a stately *hôtel particulier* directly across the river from the Louvre, on land that Henri had given her in the Pré-aux-Clercs on the Left Bank, a move that greatly stimulated development in that part of Paris.

The awkward course of Henri's dalliances was literally set in stone, in the architecture of the Louvre. Starting in the reigns of Charles VIII and Louis XII at the end of the fifteenth century, it had been customary for French monarchs to sign their building projects with a monogram or cypher carved into the stone itself. This would remain the case down to the time of Napoleon III in the middle of the nineteenth century. A good example is the Petite Galerie, which links the Cour Carrée to the Grande Galerie: although its façade has been subsequently altered, the *piano nobile* originally bore the letters *HG*, for Henri and Gabrielle. But directly above them, the dormer

windows in the attic were inscribed *HM*, for Henri and Marie. This signifies that the *piano nobile* was completed by or before 1599, whereas the dormers were completed by or after 1601.[3] The work carried out between those dates, when Henri was, at least in theory, unattached, bears the initials *HDB*, for Henri de Bourbon.

* * *

During the Wars of Religion, whose violence was largely centered in the capital, the Parisians had built very little. Following Henri IV's successful entry into the city in 1594, however, there was suddenly building everywhere. "*Si vous revenez à Paris d'ici en deux ans,*" the poet François de Malherbe wrote a friend toward the end of Henri's reign, "*vous ne le connaitrez plus.*" ("If you return to Paris in two years, you will no longer recognize it.")[4] Some of the projects associated with Henri, among them the Pont Neuf and the Petite Galerie of the Louvre, had in fact been initiated by his predecessors. But if the Louvre's Grande Galerie and the rue Dauphine on the Left Bank were conceived by the later Valois, these projects were initiated and completed by Henri alone. And still other projects were his from start to finish, such as the prominent place Dauphine at the western tip of the Île de la Cité, the place des Vosges in the Marais and the Hôpital Saint-Louis in the Tenth Arrondissement. The earliest of these projects, the place des Vosges—originally the place Royale— was begun in 1605 and completed by 1612. Considered one of the first attempts at urban development in early modern Europe, it had a great influence on the subsequent evolution of Paris: it inspired the place Vendôme and place des Victoires under Louis XIV and the place Royale (now the place de la Concorde) under Louis XV. Unlike those later projects, however, all three of Henri's main urban developments were conceived in a vernacular idiom of red brick and

stone accents, rather than in the riper classicism of the Louvre. This humble material was less costly than the dressed stone that the monarchy usually favored, and perhaps was more suitable to a king who, on many occasions, seemed so indifferent to his personal grooming that he happily wore torn and soiled clothes.

The alterations to the Petite Galerie were but the first and most modest of the public works that Henri would carry out. In addition to his ambitious program of monuments, Henri had to address the more basic infrastructural needs of a city that had been worn down by five years of siege warfare, as well as mismanagement by the Catholic League. In his determination to establish Paris as a great royal city and a European capital, Henri sought the aid of his prime minister, Maximilien de Béthune, duc de Sully, whose name graces the Louvre's Pavillon Sully, also known as the Pavillon de l'Horloge, which was begun in 1624.

The Petite Galerie is so called only to distinguish it from the adjoining Grande Galerie. But even if it seems small in the context of

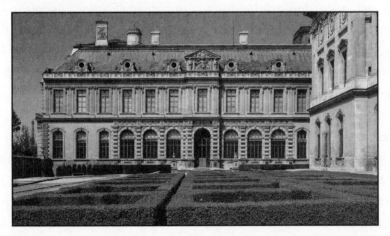

The Petite Galerie, begun by Catherine de Médicis c. 1565, enlarged by Henri IV c. 1600 and revised by the architect Félix Duban c. 1850. It houses the Summer Apartment of Anne of Austria on the ground floor and the Galerie d'Apollon on the floor above.

the Louvre, by almost any other standard of comparison it is a large and cavernous structure: begun by Catherine de Médicis in 1566 as a one-story structure connected to the Louvre by a covered passageway, it was enlarged and given a second story by Henri IV at the beginning of the seventeenth century and further expanded under Louis XIV half a century later. Its upper floor houses the extravagantly opulent Galerie d'Apollon, which displays the crown jewels of France, as well as other *objets d'art.*

Although the western façade of the Petite Galerie, looking out toward the Cour du Sphinx, was fundamentally transformed by Louis Le Vau in the 1650s, its eastern exposure retains much of its original form: a sequence of twelve linteled windows that are separated by Ionic pilasters and stand beneath a slate roof, enlivened by dormers.

On the second floor of the building stands the famous Galerie d'Apollon, which originally looked quite different from what visitors see today. At the very end of the sixteenth century, the gallery was created according to the designs of Étienne Dubois, Jacob Bunel and Martin Fréminet, the most prominent members of the so-called Second School of Fontainebleau. Like most French artists of the sixteenth century, they were still far inferior to their Italian models, although their work had a certain beguiling charm. Their two main monuments were the Chapelle de la Trinité in Fontainebleau and this upper story of the Petite Galerie. Although the chapel in Versailles is gloriously intact, nothing of the Louvre's original chamber survived the fire of 1661. There are, however, several drawings in the museum's collections that are thought to be studies for paintings in this earlier incarnation of the Petite Galerie. Its convoluted mythological program consisted of portraits of the more meritorious kings and queens of France, starting with Henri IV and Marie de Médicis and working backwards to Louis IX and Marguerite de Provence, the founders of the Bourbon branch of the Valois dynasty.

To these images were added characters from Ovid, among them Perseus and Andromeda, and Pan and Syrinx. No one could claim, on the evidence of their surviving work, that these painters were of the first rank. But although the décor created under Louis XIV and Napoleon III was undoubtedly more sumptuous, and although its artists were more renowned, there is reason to regret the loss of those earlier works and their replacement by the more standardized art that now covers the ceiling. Fréminet's depiction of Saint Martin, on view in the Louvre, is reason enough to wish that more work had survived from this largely forgotten Second School of Fontainebleau.

<p style="text-align:center">* * *</p>

The greatest building project that Henri IV ever undertook was the Grande Galerie. Begun soon after he victoriously entered Paris on 22 March 1594, it was largely completed by his death in 1610. Pharaonic in ambition and almost superhuman in scale, this structure is what most visitors think of when they think of the Louvre. It is an astonishing two-story building, nearly half a kilometer long and only thirteen meters (or forty feet) wide, that stretches along the Seine from the Cour Carrée all the way west to the Pavillon de Flore, where it once joined the now vanished Palais des Tuileries. The Grande Galerie is the repository of most of the Louvre's Italian paintings. But it is difficult today, both inside and out, to appreciate its monstrous immensity: viewed from the *Pyramide*, its size has been largely neutralized by the mid-nineteenth-century additions that now conceal its entire eastern half, while the entire western half was torn down and rebuilt according to slightly different designs in the 1860s.

Until the construction of the Grande Galerie, the Louvre had stood back from the Seine, almost as though it feared the river. Some

historians have suggested that military expediency induced Philippe Auguste to recess his fortress some three hundred feet from the water's edge, a decision that, to this day, continues to influence the form and function of the Louvre. But such defensive considerations meant less in 1600 than they had four centuries before; when the decision was made to link the Louvre to the Tuileries, it included running the connecting gallery along the Seine and extending the two palaces southward to meet it. The resulting structure was originally known as the Galerie du Bord de l'Eau, the Gallery at the Water's Edge. This is a far more accurate description than one would readily imagine today, when the late nineteenth-century Quai du Louvre and the lofty stone embankment of the Seine join to create a great physical and conceptual barrier between the museum and the water. But as recently as the early nineteenth century, one had only to step out of what is now the museum's Porte Barbet de Jouy to find oneself standing on a steep and irregular sandy beach that descended without interval to the water's edge. In contemporary engravings, a scattering of rowboats are beached just below those galleries that now display the works of Leonardo and Raphael. Such rough-looking characters as tend to inhabit the world's ports loiter nearby, and in the offing a man rides his horse through the shallows of the Seine.

* * *

If the Grande Galerie was built under the auspices of Henri IV, it was first conceived by the later Valois rulers, perhaps by Catherine de Médicis herself. No sooner had she begun work on the Tuileries Palace than plans were drawn up to connect it to the Louvre. Several early plans survive, the two best-known being the so-called first and second Plans Destailleur, dating to around 1600 and named for the nineteenth-century collector to whom they once belonged. The

second plan, which quadrupled the footprint of the Cour Carrée and linked it to an expanded Tuileries Palace by means of the Grande Galerie, largely resembled what was eventually built. For the next 250 years, this was to be the shape of the Louvre, before Napoleon III created the Nouveau Louvre of the 1850s.

In its dimensions, the Grande Galerie is prodigious: one is hard put to find anything quite like it in earlier or even in later architecture. The arcaded perimeter of the Piazza San Marco in Venice and the covered corridor running from the Uffizi to the Pitti Palace in Florence have been cited as precedents, but the former is scarcely one-third the size of the Grande Galerie, while the latter is mostly a chaotic tangle of tunnels. There are certain similarities with Fontainebleau's Galerie of François I, completed in 1530, and with the wings that connect the Vatican Belvedere to the Apostolic Palace— one of the largest and most ambitious building projects since the fall of Rome. Perhaps the truest antecedent, however, has been universally overlooked: nearly two and a half centuries before Henri IV undertook the construction of the Grande Galerie, Charles V built a curtain-wall along the Seine from the Louvre to the westernmost point of the walls of Paris, the Tour du Bois. This curtain-wall, which was torn down to build the Grande Galerie, was crowned with a walkway from which the inhabitants of the Louvre, especially the king, enjoyed looking out on the river. In a sense, Henri's building replaced and extended that earlier fortification, transforming it into a monument worthy of a king.

What is perhaps most striking about this part of the Louvre is that—before its nineteenth-century additions and alterations had been carried out—it consisted of two parts that were equal in length, width and height, but very different in style. Although we know that the Grande Galerie was the work of two very different architects, their exact identities remain elusive. The general scholarly consensus is that the eastern half, closer to the Cour Carrée, was the work of

Louis Métezeau (or Métézeau), while the half that was connected to the Tuileries was designed by Jacques II Androuet du Cerceau, the son of the eminent architectural theorist of the same name. And yet, it is possible that each of them was in fact the author of the work ascribed to the other, or that neither actually designed any part of the Grande Galerie. The best explanation we have as to why Henri IV did not simply engage one architect to design the whole thing in a uniform style is the imperious reason that he himself gave: *"Il y aura autant d'architectes que je le voudrai."* ("There will be as many architects as I want there to be!")[5]

Questions of authorship aside, and in the spirit of the age in which they were built, the two halves of the Grande Galerie can be seen as representing a civil war in the architecture of late mannerism, the dominant style in Western European architecture following the decline of the Gothic in Northern Europe and of the High Renaissance in Italy. This movement endured from about 1525 to about 1625, when the baroque experiments taking place in Rome began to make inroads into the rest of Europe. The eastern half attributed to Métezeau is floridly ornamental, its bejeweled style drawing inspiration from Northern Italy and the Spanish Netherlands. But with its giant-order pilasters and generally restrained details, the western half seems to have been inspired by Michelangelo's work on the new Basilica of Saint Peter's.

Despite the elaborate adornment of the Grande Galerie's façade, the interiors of its upper story were almost shockingly simple in conception: it was a single cavernous, unarticulated space, little better than a glorified tube or covered viaduct. Through this narrow passageway, which seemed to extend forever towards an infinitely remote vanishing point, the king passed from one palace to the other without being exposed to the sun or the rain. Even today, with its endless sequence of Italian paintings, the Grande Galerie seems overpowering in its extent: and yet what we see is only a little more than half of its full extent, since most of the western half houses the École du

Louvre and is thus inaccessible to the general public. And while the present space is articulated and enlivened by paintings and the paired columns added under Napoleon Bonaparte, for most of its existence there were no ornaments and little or nothing hung on the walls.

Henri, however, decided early on that the Grande Galerie would be more than merely a passageway. Because of the upward incline of the land closer to the Tuileries, the western half of the Grande Galerie sits roughly ten feet higher than its eastern counterpart. As a result, despite the uniform height of the roof, the lower portion of the eastern half had more space at its disposal, and Henri was determined to put it to excellent use. In 1600, the painters and sculptors of France did not yet enjoy the prestige they would begin to attain with the establishment of the Académie Royale under Louis XIV. But a stirring of new respect can be sensed in Henri's decision to provide twenty-seven artists and artisans with coveted apartments occupying the ground floor of the Grande Galerie's eastern half. In fact the monumentally tall ceilings permitted him to construct a sequence of individual apartments of three or even four levels. In so doing, he established a tradition that would remain in force for two centuries, until Napoleon Bonaparte finally ejected the inhabitants. From the beginning, there had been a patriotic element to Henri's decision: he envisioned the ground floor (as well as its mezzanine and entresol) as a kind of nursery that would develop France's visual culture and wean it from its addiction to imported Italian luxury goods. In letters patent signed in December of 1608, he declared his wish to assign spaces along the entire length of the building to "a number of the best artisans and the most accomplished masters who could be found in painting, sculpture, goldsmithing, clockmaking, *pietra dura* and numerous other excellent arts." These inhabitants were allowed, even encouraged to take on apprentices who might "establish themselves throughout the length and breadth of the kingdom."[6]

Even if artists and artisans received free lodging, their accommodations were not especially luxurious. The apartment's three or four levels (depending on how the artists chose to divide the space they were alotted) formed a warren of often windowless rooms. Running along a now vanished street known as the rue des Orties—the Street of Nettles—such north-facing windows as existed looked out on the drainage systems of the Cour des Cuisines, which collected all the refuse of the Louvre's kitchens and privies. (These spaces now face the interior Cours Visconti and Lefuel and are occupied by the Louvre's curatorial staff.) Nonetheless, for more than two hundred years the finest artists of France, among them Vouet, Chardin, Boucher, Oudry and Baron Gros, inhabited these apartments and laid the foundations for that French artistic hegemony that endured to the end of the Second World War.

Although François I had kept a small collection of Flemish paintings in his private chambers in the Louvre, Henri IV, nearly three generations later, built the first space in the palace dedicated to the display of visual art. At the easternmost extremity of the Grande Galerie, Louis Métezeau designed the Salle des Antiques, whose sumptuous marble floors and walls—among the first interior spaces so adorned in France—bore some resemblance to the early nineteenth-century décor that we see there today. In establishing this gallery, Henri was merely following the fashion of other European princes of the day, whose palaces were adorned with ancient statues, busts and smaller sculptures. Among the works on view in the new Salle des Antiques were an ancient depiction of *Diana at the Hunt*, given to Henri II by Pope Paul IV, the so-called *Bacchus of Versailles* and Baccio Bandinelli's modern—but still classicizing—*Mercury the Flutist*, which François I had acquired many years before.

Henri performed one other service to art, even though it affected the Louvre only indirectly and only centuries later. The son and grandsons of François I fell so far short of that monarch's

interest in the fine arts that they not only failed to collect any important paintings or sculptures, but allowed his magnificent collection to fall into decay through their heedless neglect. Some of the Louvre's finest Italian Renaissance paintings, even those of Leonardo and Raphael, were stored in the damp bathhouse of Fontainebleau. Henri found safer, drier quarters for these paintings in Fontainebleau itself, and he appointed a curator of sorts to ensure that they were well maintained.

* * *

One of the reasons for Henri IV's popularity is the fact that his reign was generally a period of peace and prosperity. The most material expressions of that prosperity were the architectural projects in the Louvre and elsewhere in Paris that Henri initiated and brought to completion, or nearly so, before his death. But perhaps we would have a somewhat different assessment of his rule if he had followed through with his plans to invade Spain, in response to Philip III's attempts to influence the successions of the German duchies of Cleves and Jülich. To this end Henri signed an alliance with Charles Emmanuel II of Savoie and, in his preparations for war, he arranged for the coronation of Marie de Médicis at Saint Denis on 13 May 1610. The purpose of this measure was to empower his wife—who until that moment had been merely the Queen Consort—to rule in his name while he was off prosecuting the war.

But it never came to that. One day after Marie's coronation, the fifty-six-year-old Henri was riding in a carriage along the rue de la Ferronerie, several blocks from the Louvre. His carriage paused for a moment for some debris to be cleared from his path. At that instant a fanatical Catholic named François Ravaillac leaped into the carriage and, before anyone could subdue him, managed to stab the

king repeatedly. By the time Henri was rushed back to the Louvre, he was already dead, the second French king in succession to be assassinated. And while this assassination is one of the most famous facts about Henri IV, it is less well known that during the course of his reign, twenty-four other attempts had been made on his life. Such were the persistent religious animosities of the age.

For two days Henri's body was displayed in the Chambre de Parade of the Louvre, where visitors came to view it and where it was aspersed with holy water. Thereafter the body was lowered into a leaden casket and was replaced, in accordance with medieval tradition, by an effigy of impressive verisimilitude, its head and hands made of wax. This effigy, together with the casket beneath it, was displayed in the Salle des Caryatides, where the king's bed had also been set up to enhance the verisimilitude, covered in a length of violet velvet interspersed with the fleur-de-lis, the emblem of the French monarchy. The king's effigy wore a white satin pourpoint, or vest, and a red velvet nightcap interwoven with cloth of gold. The many visitors who streamed past were encouraged to feel that he had not died, but that he merely slept. The realism of the effigy's face was widely admired, although some observers remarked on its excessive ruddiness. Somewhat at odds with this notion of sleep, two meals were set before the king's effigy each day, as had been the case when he was still alive. This immemorial ritual of lying in state, a ritual that Henri would be the last French king to undergo, went on for fully three weeks. Finally, on 29 June, the casket was laid to rest beside the mortal remains of the other kings of France in the Cathedral of Saint-Denis, nine miles north of the Louvre. There it remained until its violent exhumation during the antimonarchical convulsions of 1793, the bloodiest year of the French Revolution. Only recently, however, a mummified head has come to light that is rumored to be that of Henri IV.

∗ ∗ ∗

Henri's second wife, Marie de Médicis, seems to have been very different from her husband. If Queen Marguerite, his first wife, was as promiscuous as was rumored, at least she and Henri had that much in common. Marie, by contrast, was mostly pious and austere and, being of a jealous nature, she did not appreciate the amorous adventures of *le vert gallant*. In relative terms, however, theirs was not a bad marriage. Of the six children Marie bore him during their ten years together, five lived into adulthood, a very creditable average for that age. And when she herself died, thirty-three years after her husband, they were entombed together in Saint-Denis.

For an entire year following Henri's death, Marie and her son, now Louis XIII, remained holed up in the Louvre, deep in mourning. They are reported to have left the palace on only one occasion, to travel to Reims for Louis' coronation. But since he was only nine years old when his father died, power fell to Marie as regent of France. She continued to serve in that function until 1616, when the fifteen-year-old Louis reached his majority and forcefully took control of his kingdom. If the relationship between mother and son had long been strained and remained oddly cool, the extraordinary journals of Jean Héroard, Louis' private physician for the first twenty-seven years of his life, reveal Louis' deep love and admiration for his father. Three days after his father's assassination the young Louis declared to his governess, Mme de Monglat, *"Je voudrais bien n' être pas si tôt Roi et que le Roi mon père fût encore en vie."* ("I wish that I were not king so soon and that the king my father were still alive.")[7] It is quite clear that Henri was a devoted father, not only to Louis, but also to Louis' five younger siblings and even to three half-siblings whom Henri had had with Gabrielle d'Estrées. All of them were raised together in the Louvre. Héroard describes some exhilarating scenes in which Henri and the dauphin went for walks together in the Grande Galerie. On one occasion Louis rode a camel through it—perhaps the first camel ever seen in

France—and on another occasion he raced through the galleries in a cart pulled by dogs.

But Louis rarely expressed much affection for his mother. Soon after he reached his majority, Marie, who was inclined to meddle in state affairs, was exiled to the Palace of Blois in the Loire Valley, where for the next two years she lived almost as a prisoner. In 1619, however, she managed to escape, having persuaded her second son, Philippe d'Orléans, to incite the ever restive nobility to take up arms against her oldest child. Only in 1621 was she reconciled with Louis through the diplomatic skills of Cardinal Richelieu. A tentative peace endured between them until 1630, when Marie, fearing Richelieu's growing power and seeking to arrest it, ran afoul of the cardinal on the so-called Day of the Dupes, whereupon she was exiled from France for good. Thereafter she led a nomadic existence, wandering from one European court to another, passing through England and Spain on her way to Germany, where she died in Cologne in 1642, a year before her oldest son.

Marie's tumultuous life was given pictorial form on more than one occasion. The first attempt, depicting the glorious events of the house of the Medici, was conceived, it is now believed, by Nicholas Baullery, a painter who, on the basis of the three surviving works in the series, rises just barely into the ranks of the third rate. Although these images originally hung in Marie's bedroom in the southern wing of the Louvre, they have never been displayed in the museum, doubtless because they were judged to be of too poor quality. Instead they are scattered among several of the smaller, provincial museums of France, the usual fate of works deemed to fall below the standards of the Louvre.

They may be seen, however, as a sort of dress rehearsal for one of the Louvre's most illustrious treasures—and a monument of Western art—the *Marie de Médicis* cycle by Peter Paul Rubens. The twenty-four paintings in the series have been displayed in the

Louvre since the 1820s, and originally hung in the Grande Galerie. In 1897, however, they took over the nearby Pavillon des Sessions, as splendidly reconceived by Gaston Redon (the present décor, from the 1980s, gives no hint of this gallery's former splendor). Then, with the opening of the Aile Richelieu in 1993, the cycle moved to—and remains in—an elegantly postmodern space on the other side of the *Pyramide*.

To enter that space and see these Technicolor marvels, with their limitless allegorical detail and sinuous compositional complexity, is surely one of the most unforgettable moments of any visit to the museum. Rubens painted the cycle between 1622 and 1625 for the Palais du Luxembourg, which Marie had recently built on the Left Bank, at the northern edge of today's Jardin du Luxembourg. This painting cycle is one of the most ambitious of the entire baroque era and contains some of the largest paintings of the age. Although all of the canvases are a uniform thirteen feet high, their width varies to accommodate what would have been the specific architectural features of the interior of the Palais du Luxembourg's western wing, where they were displayed for two centuries before moving to the Louvre. The three broadest images are fully twenty-four feet across. Over three thousand square feet in all, the *Marie de Médicis* cycle was conceived for the sort of space that has been called a Hall of Princely Virtue: a large palace room whose walls are covered with the illustrious deeds of the ruling family that commissioned the art. Soon after Rubens's cycle was completed, Marie engaged him to execute, also for the Luxembourg, an identical number of paintings dedicated to the life of Henri IV. But little came of that commission beyond a few oil sketches that survive.

Peter Paul Rubens, a man of many parts, was known in his day as much for his political diplomacy as for his paintings, and all his skills in both arenas would be called into play in the completion of the *Marie de Médicis* cycle. For one thing, the visual center of these

paintings, Marie herself, had grown quite stout, and not even in a way that, then or now, could politely be called Rubensian. Furthermore, the events of her life—going to war with her own son, for example—were almost impossible to cast in anything like a glorious light for anyone involved. But that did not stop the Flemish master from summoning a full battalion of mythological and allegorical figures, Apollo and the Graces, Mercury, floating putti and the personifications of France and Truth, to supply the glory that the age—and certainly the patron—demanded. It has been said that the defining difference between the Renaissance and the baroque is the difference between poetry and oratory, and the *Marie de Médicis* cycle seems to bear out that claim. Despite Rubens's many artistic gifts, conveying the inner life of his sitters—a territory so richly mined by Velazquez and Rembrandt, his contemporaries—held little interest for him and, in the present instance, it would seem to have been absurdly beside the point. Rubens gladly flattered anyone who paid him to do so, and the native bent of his personality saw only the sumptuous exteriors of the people he portrayed, with their fraise collars and shimmering brocades. Through their profusion of rich vermilions and smoky golds, these paintings operate like machines to produce a single product, a certain kind of exhilaratingly gaseous glory. From her birth in the Pitti Palace, through her marriage to Henri, down to her fleeing from imprisonment in Blois and her eventual (if short-lived) reconciliation with her son, it is all here, presented for the viewer's consumption in a sustained, unwavering fever of exultation.

The quality of the canvases, however, varies considerably, since here, as in almost all of this master's larger commissions, many studio hands were called up to complete the work under his guidance. Thus, even if the typical richness of Rubens's textures shines forth in particular passages, far less heat emanates from the rest of it. In terms of both composition and execution, the two finest of these

paintings are *The Presentation of Her Portrait to Henry IV* and *The Meeting of Marie de' Medici and Henry IV at Lyons*, where Rubens's direct input was clearly greatest.

By commissioning Rubens's cycle, Marie wanted her Palais du Luxembourg to be recognized as the most splendid structure in Paris. In part, however, that ambition attested to her far dimmer view of the Louvre itself. Born into one of the wealthiest and most powerful families in Europe, she had grown up in Florence amid the splendors of the Pitti Palace. And so, when she first laid eyes on the Louvre on 15 February 1601, she was reportedly incredulous that the kings of France in general, and she in specific, should have to inhabit anything so tawdry and rundown. Eventually she was mollified by the suite of five rooms that Henri placed at her disposal, in direct communication with his apartment in the Pavillon du Roi. But years went by before she could wander at night through the halls of the palace without feeling a shudder of fear and revulsion.[8]

Following her husband's death, when she became regent of France, Marie hesitated to undertake much work in the Louvre, especially while she was occupying it. With all of her attention focused on the Palais du Luxembourg—the masterpiece of Salomon de Brosse—whose heavily rusticated façade was inspired by the Pitti Palace itself, Marie abandoned the Grand Dessin of the Louvre and the dream of a fourfold enlargement of the Cour Carrée. Her interventions were on a far more modest scale, such as paving the Grande Gallery with reddish terracotta tiles, bordered in black and white marble.

Like her cousin Catherine de Médicis before her, Marie was viewed with apprehension by the French, who saw her as a foreign interloper. Unlike Catherine, however, who eventually played a dominant role in the political life of France in the second half of the sixteenth century, Marie was never quite embraced by her subjects, and a suspicion lingered that she was encroaching upon royal

prerogatives. Thus, although Louis, prior to his majority, lived in the Pavillon du Roi, as had all the kings of France since Henri II, Marie saw to it that only the *grande chambre de parade* and the cabinet were placed at his disposal. In one sense, such space was amply sufficient for a child of ten. And yet it was widely viewed as falling beneath the dignity of the king of France, whatever his age.

Another source of friction came from Leonora Dori Galigaï and her husband, Concino Concini, two Italians who, following the death of Henri IV, succeeded in exerting a deep and malignant influence on the susceptible regent, whose intelligence was openly questioned both by her contemporaries and by subsequent historians. Mme Galigaï, as she was known, had been raised with Marie in the Pitti Palace and followed her to Paris. Although her epileptic fits had resisted all attempts at exorcism, she gained a reputation thereby for proficiency in the black arts, which she turned to profitable account once Marie became regent. Even more remunerative was the access that, for a fee, she could and did provide to Marie. She even contrived to have her husband, Concini, a man of little military experience, selected as maréchal de France. Nor did it pass unnoticed that he entered the Louvre on horseback, an honor reserved only for the royal family and princes of the blood.

As their influence and arrogance grew during the first few years of Marie's regency, the couple became ever more detested by the French nobility and the Parisian populace. Louis XIII himself seems to have been slighted by Concini and to have resented his mother's reliance on the pair. And so, as Concini was entering the Louvre one day, Baron de Vitry, the captain of the guard, seized and then shot him (reportedly on orders of the king) near where we now find the fountain in the Cour Carrée. Concini's body was buried in the Church of Saint-Germain l'Auxerrois, across the street from the Louvre, but it did not remain there for long: the citizens of Paris soon exhumed the corpse and dragged it through the streets, while

Concini's wife was first pilloried and then executed in the place de Grève, near the modern Hôtel de Ville. Shortly thereafter, Marie herself was exiled to the Château de Blois, one hundred miles south of Paris in the Loire Valley.

* * *

Louis XIII was very different from his father. The boundless extroversion and *joie de vivre* of Henri IV, his carnal appetites and unbridled energy, had no equivalent in the sullen life of his son. The nine-year-old boy who had been so affected by his father's death grew into a shy, introverted man who stuttered badly and was possibly homosexual. But even this latter aspect of his character, if indeed it was the case, appears to have expressed itself less in any libidinous exuberance than in an intense jealousy towards anyone he saw as an amorous rival. Still, for all his flaws, Louis possessed a competence and a sense of duty that posterity has generally forgotten. He was brave in war and, where his father had been spendthrift, he and his ministers managed the affairs of France with admirable prudence during the twenty-six years when he ruled the country in his own right.

It is a matter of some dispute whether Louis XIII had any great interest in the Louvre beyond keeping it from falling down. For most of his reign, he preferred to stay either in his palace at Saint-Germain-en-Laye or in the hunting lodge he built for himself in Versailles, the one that his son and successor would later expand into one of the wonders of the modern world. In both places he could hunt and so escape the dreary, drafty conditions of the early-seventeenth-century Louvre. When compelled to remain in Paris, Louis lightened the burdens of office by devoting himself to making jams and honing his skills at cutting his councilors' hair, apparently a pastime that he found relaxing. He is also said to have taken great

delight in the printing press that he installed in the belvedere of the Pavillon du Roi, from which several editions of the classics were pro-duced—the *Imitatio Christi* of Thomas à Kempis among them—that were prized by the bibliophiles of the day.

Even if Louis does not appear to have been keenly interested in art or architecture, during his reign, for the first time, the Palace of the Louvre expanded beyond the centuries-old boundaries of the fortress of Philippe Auguste. In 1624 the first crucial steps were taken to trans-form it from a small, almost provincial building of the mid-sixteenth century into a great and imperious palace suitable to the dawning age of absolutism. Although monarchs tend to receive most of the credit for what took place during their reign, it is surely important that this expansion coincided with the arrival of Cardinal Richelieu on the stage of world history. As first minister in Louis' *Conseil des Ministres* from 1624 until his death in 1642, Richelieu proved to be one of the most influential actors in the history of France. But to say that Louis was Richelieu's puppet or that the cardinal was the puppet of the king would be inaccurate. Their long and successful collabora-tion was more a meeting of minds, with each man finding in the other exactly what he needed in order to realize a shared vision of France.

One of the most commanding images in the Louvre is a full-length portrait of Richelieu by his favorite artist, Philippe de Champaigne. Here is the cardinal in his glory, rising up before a cur-tain of gold cloth and almost overwhelmed by the virtuosic folds of his scarlet robe and by the lace garment beneath it. In his right hand he holds a cardinal's biretta, but the main focus of interest, even more than the world-weary face, is his boney left hand, suspended in air as though grasping at some elusive abstraction. This image of Richelieu embodies our inherited conception of the man as being infinitely clever and in all things politic. Nor does it dispel the sense that religion was little more than a cloak tossed over Richelieu's boundless, worldly ambition. In truth, the cardinal never expressed

any great interest in sacred matters beyond what was routine for the religious age in which he happened to live. Originally hoping to become a soldier, he took up religion for the most practical reason in the world: Henri III had awarded his father the bishopric of Luçon, with its abundant revenue. Richelieu's older brother Alphonse had been expected to take over that title but, suddenly summoned by a deeper religious calling, he decided to become a Carthusian monk. And so Richelieu regretfully exchanged the career of a soldier for that of a bishop, but not before contracting gonorrhea at the age of twenty, while still preparing for a life at arms.

Whatever his qualities as a prince of the church, Richelieu achieved eminence as a statesman and soldier, notably in his victory over the Protestants at the siege of La Rochelle in 1628. But he was scarcely less eminent as a patron of the arts, and the argument could be made that his achievement in this regard was his most durable of all. In addition to serving as a patron of writers (especially Pierre Corneille, the founder of French classical drama), Richelieu was the force behind the creation, in 1635, of the Académie française, which was founded to centralize authority over the French language in Paris exactly as his political maneuverings sought to centralize the power of the state in the person of the king. The many thousands of volumes in his personal library, as well as nine hundred manuscripts bound in red morocco stamped with his coat of arms, would eventually become integral to the foundation of the Bibliothèque nationale de France, which resided until recently on the rue de Richelieu, just down the street from his palace.

But perhaps more impressive still was the cardinal's private art collection, which comprised more than three hundred paintings and numerous sculptures ancient and modern. Richelieu purchased from the royal family, and then gave back to the royal family, Leonardo da Vinci's *Virgin and Child with Saint Anne.* He also acquired Poussin's two *Bacchanales,* now in the Louvre, together with works by

Portrait of Cardinal Richelieu (1585–1642)
by Philippe de Champaigne.

Veronese, Titian and Durer. Among his large collection of sculptures were the ancient *Richelieu Bacchus*, a second-century Roman copy of a Greek original, and the two slaves of Michelangelo, which Richelieu likewise gave to the royal family, and which eventually found their way into the Louvre.

For all his worldliness, however, Richelieu, like Charles de Gaulle three centuries later, had grown up with *une certaine idée de la France,* a certain notion about what France was and what it could become. This was an abstract, even metaphysical vision of the country's greatness. In this regard, Richelieu's ambitions were purely secular: to create an efficient state unified around an absolute monarch and to tame both a hostile nobility and the greatest external enemy of France, Habsburg Spain, which threatened its northern

and southern borders. Neither Richelieu nor Louis XIII lived to see their shared dream become a reality—that would have to wait until the reign of Louis XIV—but this vision of national greatness would animate all the subsequent kings and emperors of France, and one could argue that it has survived intact deep into the Fifth Republic.

And it is plausible to see the expansion of the Louvre in the context of this dream. A man of Richelieu's deep visual culture could not have failed to conclude, as Marie de Médicis had done a quarter century earlier when she first laid eyes on the palace, that it was unworthy of a king of France. Although the Aile Lescot was universally admired, the Renaissance style of its western and southern wings sorted ill with the dreary remnants of the medieval fortress that dominated the northern and eastern sides. The transformation that the Louvre would soon undergo is largely associated with the architect Jacques Lemercier. Even though he played only a minor role in the initial conception of the work in 1624, by the time construction began in the late 1630s, he had become *premier architecte du roi* and so was, *ex officio*, the dominant French architect of that time.

Known as *le Palladio Français*, Lemercier is a pivotal figure in the history of French architecture. He is the medium by which it first encountered the Roman baroque style: having lived in Rome during the crucial years between 1607 and 1612, he saw firsthand the seminal work of Carlo Maderno on the façades of the Basilica of Saint Peter's and the Church of Santa Susana. Lemercier was an architect of supreme competence and skill, if not genius. As with Pierre Lescot, his work was distinguished by serene order rather than by the disruptive force and invention of Philibert Delorme. And though Lemercier's architecture is clearly French rather than Italian, he was the first Frenchman to purge his buildings of all provincial elements: for the first time since the age of the great cathedrals, French architecture, at least in theory, stood on an equal footing with that of Italy.

In Paris alone Lemercier designed—in addition to his work on the Louvre—the Church of the Val de Grace, in the Fifth Arrondissement, and the Oratoire du Louvre, which still stands just north of the Cour Carrée. Most of all, however, Lemercier was closely associated with Cardinal Richelieu, whose sumptuous palace—formerly the Palais Cardinal, now the Palais-Royal—he designed directly north of the Louvre. And in one of the boldest urbanistic experiments ever undertaken in France, Lemercier, at the cardinal's behest, designed from scratch the entire town of Richelieu, which still exists in the department of Loire et Cher.

Lemercier's work at the Louvre began in 1624, with his transformation of the Salle des Caryatides into what we see today. The beams of its flat wooden ceiling had begun to rot and subside, and so were replaced by a vaulted marvel of French stone carving, or *stéréotomie*. The ceiling's old polychrome design yielded to an austere monochrome that would define French official and even domestic architecture for much of the next three hundred years. Around the same time, Lemercier designed the Pavillon de l'Horloge, now more commonly known as the Pavillon Sully, next to the Salle des Caryatides, in the center of the western wing of the Cour Carrée. This commanding structure was based on the now-vanished Pavillon du Roi—which Pierre Lescot had designed for Henri II—but its surface treatment, richer and more robust than its predecessor's, served as a model for the Louvre's twenty other pavilions. At ground level this pavilion was pierced by a masterful passageway leading from the Cour Carrée into the Cour Napoléon, where we now find the *Pyramide*. Through its perfectly rounded oculus windows and unimpeachably classical columns with fluted shafts, it succeeds, like all truly good public architecture of the premodern world, in making us feel almost ennobled as we move through it.

After the completion of the new pavilion and the renovation of the Salle des Caryatides, work on the Louvre ceased until the end

of the 1630s, when Lemercier expanded the western wing of the Cour Carrée by creating a nearly exact replica of the Aile Lescot, with the Pavillon Sully standing midway between the old and new sections. So faithful was this replica that even the new relief sculptures by Jacques Sarazin closely imitated those of Jean Goujon from eighty years before. This expansion of the Aile Lescot came at the expense of the gardens that, since the fourteenth century, had stood just north of the palace of Charles V, and extended to the rue de Beauvais. Nothing remains of that street beyond the fact that the northwest pavilion of the Cour Carrée is still known as the Pavillon de Beauvais.

By expanding the Aile Lescot, Lemercier initiated the process of quadrupling the Cour Carrée to its present size. He began a northern wing that was to be identical to the western wing, but he had completed only the first three bays when, with the death of Louis XIII in 1643, all work suddenly ceased, not to resume for another generation. But even in its suspended state, this shift in size altered the entire spirit of the palace. The Louvre that Louis inherited was essentially a fortress that had been transformed into a palace, one that was not substantially different, in size and scale, from two dozen other royal or aristocratic dwellings in the Île-de-France and the Loire Valley. Thus its dimensions were those of an earlier period of French history when the king was the hierarchical head of a social and political system, in which he was paramount in theory more than in fact. If this condition of the Louvre were not already obvious to Louis, Richelieu's new palace a few hundred feet to the north would have made it abundantly clear. Indeed, when built in the late 1630s, the Palais Cardinal was larger than the Louvre. This anomaly was apparent to François Sublet de Noyers, another minister who worked closely with Richelieu on the expansion of the Louvre. In 1638, when he became *surintendant des Bastiments* (superintendant of buildings), he spoke of creating *le plus noble et le plus superbe*

edifice du monde, the noblest and proudest building in the world, one that would express the new status of the French monarchy in the age of absolutism.

At the same time as Lemercier was enlarging the Cour Carrée, the king and his ministers finally turned to address the question of the westernmost extension of Charles V's fortification, which had been constructed 250 years before and now seemed to collide with the Grande Galerie in a headlong perpendicular assault. Since the construction of Charles's wall, and its renovation under Louis XII around 1512, the Tuileries Palace and its garden had arisen to the west, and now stood completely exposed to an enemy attack. And so, starting in 1566, an extensive series of bastioned walls (the Fossés Jaunes, or yellow ditches, perhaps named for the color of the earthworks on either side of the walls) arose along the western edge of the Tuileries Garden. These newer fortifications were completed by Jacques Lemercier in 1641 and rejoined the wall of Charles V at the Porte Saint Denis, where we now find Louis XIV's great triumphal arch.

But with the completion of these new battlements, the earlier wall of Charles V—which ended just north of the Grande Galerie—was rendered useless. By razing it to the ground, the crown not only removed an eyesore and an obstacle to the harmonious union of the Tuileries and the Louvre: it also freed up the resulting territory for development, an irresistible opportunity for a king constantly in need of money. Over the submerged earthwork—which would not come to light again until the creation of the Grand Louvre in the 1980s—a new street, the rue Saint-Nicaise, became the latest thoroughfare of the Quartier du Louvre. It took its name from the fifth-century founder of Reims cathedral, who was also the patron saint of small-pox victims. The latter association seems to have been more important: a chapel in the hospital of les Quinze-Vingts (which occupied this part of the quartier from the late thirteenth to the late

eighteenth century) had been dedicated to Saint Nicaise and stood on the new street. Louis had given one of the lots to his old doctor, Jean Héroard, that indefatigable chronicler of the king's youth. But the doctor died before he could take advantage of the offer and the area developed so slowly that, by the middle years of the century, forty years after the fortification began to be dismantled, only three humble dwellings were built on the new street, the Hôtels de Roquelure, Warin and Beringhen.

A far more imposing structure, the Hôtel de Rambouillet, arose at this time on the other side of the hospital, on the rue Saint-Thomas du Louvre, and it would become famous in the history of French letters. It lay just to the south of the Hôpital des Quinze-Vingts and just east of that institution's modest cemetery, roughly where the Pavillon Turgot stands today. Within this expansive structure lived the Roman-born Catherine de Vivonne, Marquise de Rambouillet (1588–1665), renowned for her wit and beauty and taste. Christened *l'incomparable Arthénice* by the poet François de Malherbe, an habitué of her salon, she created a veritable Parnassus between the Cour Carrée and the Palais des Tuileries, a center of French literary culture for most of the first half of the seventeenth century. The focus of this salon was her *chambre bleue*, or blue chamber, so named for its blue walls, blue curtains and the blue upholstery of its sumptuous furnishings. Here she welcomed not only Malherbe and Madame de Sevigné, but also the playwright Pierre Corneille, the poet Vincent Voiture and virtually every other eminent French man and woman of letters of the age. The arcane and lofty style that they favored, especially the women, was mocked, but also celebrated and immortalized, in Molière's *Les précieuses ridicules* (The Affected Ladies). The hotel was torn down in the beginning of the eighteenth century in the expansion of the neighboring Hôtel de Longueville.

* * *

At exactly the moment when Jacques Lemercier was expanding the Palais du Louvre, a far greater artist, Nicolas Poussin, was at work, much to his disgruntlement, on the vault of the Grande Galerie. Today, with thirty-nine of Poussin's best paintings and countless drawings from each period of his long career, the Louvre possesses the finest collection of this artist's work to be found anywhere. Poussin (1594–1665) is often associated with Louis XIV, and the painter's final years did indeed coincide with the reign of the Sun King. But Poussin was really the creature of an earlier age, that of Richelieu and Louis XIII. Like so many French artists of his generation, Poussin studied in Rome, where he would live most of his life and where he clearly felt happiest. From that distance, in the late 1630s, he sent to Cardinal Richelieu the *Greater Bacchanales* and the *Lesser Bacchanales,* and to another collector, Paul Fréart de Chantelou, he sent his *Israelites Gathering the Manna*: all three of these paintings are now in the Louvre. "The arrival of these pictures in Paris must have caused a sensation," wrote the art historian Anthony Blunt. Before this time, "nothing of the purity and distinction of Poussin's compositions was known in Paris."[9] If Poussin was not the first great painter born in France, he was likely the first Frenchman to equal and possibly to surpass the great Roman masters.

In terms of raw chronology, Poussin was a baroque painter, but his general adherence to that mostly Roman movement is problematic. No Frenchman of his time was more intimately familiar with the spirit of the Roman baroque: he lived among its masters and he associated with them on friendly terms. But in an important sense, he was never one of them. He was a classicist who looked back in longing to the High Renaissance and especially to Raphael, who lived over a century earlier. But if Raphael was a universal artist, there was something willful and eccentric in Poussin's austere classicism: other than his direct imitators, he had relatively little influence on his contemporaries or on subsequent generations of

painters. His resistance to the open emotionalism of the baroque was unique to him.

Such contemporaries as Georges de la Tour and the brothers Le Nain were great painters, but they were not painters in the grand manner that the official lords of taste most admired at that time. At his best, the gifted Simon Vouet, who is amply represented in the Louvre, was able to equal, but not surpass, the finest Roman masters at their own game. But Poussin could indeed surpass them as often as not, and Richelieu, that discerning connoisseur, took note. Through his deputy François Sublet de Noyers, he sent Poussin an invitation, or more exactly a summons, to come at once to Paris to work for the king of France. But despite the many honors and emoluments dangled before him, including the title of *premier peintre du roi*, Poussin was reluctant to accept. For nearly a year and half he demurred, as Blunt tells it, until Sublet "wrote through one of his agents in Italy a more or less threatening letter, reminding the painter that he was a subject of the French king, and that kings have long arms."

Five months later, in December of 1640, Poussin showed up for work in Paris. At their first meeting Louis XIII declared, "*Voilà Vouet bien attrapé!*" which roughly translates to "That will show Vouet who's best!" Poussin himself related this declaration with evident satisfaction in a letter to Cardinal Antonio del Pozzo on 6 January 1641.[10] But then it was finally revealed to Poussin why he had been called to Paris in the first place. Given that Poussin, by this point in his career, had settled into making relatively small-scale paintings for the cognoscenti of Rome, one can imagine his shock on learning of the titanic project that Richelieu and the king had in mind for him: nothing more or less than a continuous sequence of paintings nearly half a kilometer in length, covering the Grande Galerie from one end to the other with the story of Hercules at the base of the vaults and with the life of the emperor Trajan on

the ceiling. (The side walls already contained a few landscapes—and were supposed to contain many more—by Jacques Fouquières, a thoroughly mediocre Flemish master who, having originally been promised the entire project, was none too happy to have to share it with Poussin.) No project of this immensity had ever been conceived in the previous history of Western painting, let alone entrusted to a single artist, and one who, into the bargain, desperately wanted to be somewhere else. Neither the Sistine Chapel's ceiling under Michelangelo nor the corridors stretching from the Vatican Belvedere to the Apostolic Palace—completed for Sixtus V by a battalion of painters in the 1580s—could match what was now being demanded of Nicolas Poussin largely alone. Had it been brought to completion, this project may well have represented the largest single commission undertaken in the five-hundred-year history of the Old Masters.

Though Poussin was nominally in command, the general program and many of its specific elements had been conceived by Lemercier, who decided to canton off the interior of the gallery in stiffly regimented bays that proceeded, without variation, for nearly two thousand feet. Poussin, despite his criticisms of Lemercier, seems to have found these strict divisions congenial to his somewhat august and Doric temperament. "Once again," Blunt wrote, "Poussin seems to be establishing a classical model in defiance of the great Baroque virtuoso decorators. The Grande Galerie] is his answer to Pietro da Cortona's Barberini ceiling,"[11] a work that appears literally to blow the roof off the Palazzo Barberini, as dozens of mythological creatures stream up into heaven. Poussin would have none of that anarchy, nor its unseemly mingling of naked bodies.

Things began well enough, with the kind words of Louis XIII echoing in Poussin's ears. A fine house on the southern rim of the Tuileries Garden had been placed at his disposal, and he declared himself quite happy with it. But Poussin, who was ever of a prickly

nature, quickly felt overtaxed. He complained to his friend Chantelou that each day he had to dash off drawings for the stucco artists or they would be left with nothing to do.[12] He soon came to feel that he was being taken advantage of: in addition to the Grande Galerie, he was asked to design tapestries, frontispieces for books and a depiction of the Virgin Mary for the Congregation de Saint Louis. To the same Chantelou he wrote dyspeptically on 7 April 1642 that "I have only one hand [to paint with] and a weak head and there is no one here to help or support me."[13] Scarcely a week later, his irritation boiled over into a bilious attack on Lemercier in a letter to Sublet de Noyers, which survives in a paraphrase by his friend, André Félibien. In it he speaks of "the faults and monstrosities which were already quite evident in what Lemercier has begun, such as the heavy and disagreeable weightiness of the work, the low-hanging nature of the vault, which seems to be falling down, the extreme coldness of the composition, the sad, impoverished and arid quality throughout." And Poussin was just getting started, following this assault with a battery of complaints against parts of Lemercier's design that were too thick or too thin, too large or too small, too strong or too weak, and all of it utterly lacking in variety.[14]

A few months later, claiming that he needed to fetch his wife, who was still in Rome, Poussin returned to the Eternal City and, to no one's surprise, he never set foot in the Louvre or Paris or France again. Although some initial attempts were made to recall him once he had absconded, none succeeded, and with the deaths, in rapid succession, of Richelieu, Louis XIII and Sublet de Noyer, his employment at the Louvre became a dead letter. In the event, Poussin had completed only the first seven bays of the Grande Galerie, with forty-three left to go. A fire ravaged his labors in the middle of the eighteenth century, and all trace of them was expunged at the beginning of the nineteenth, when Napoleon's architects fundamentally

reinvented the Grande Galerie's décor. Besides a few preparatory drawings, no trace of Poussin's contribution survives.

Poussin's criticisms of Lemercier's design of the interior of the Grande Galerie were probably well founded. The very nature of the gallery, half a kilometer long and thirteen meters wide, seems fated to thwart any attempt at a visually successful treatment. One might well question whether, even today, an effective solution has ever been found.

- 4 -

THE LOUVRE
AND THE SUN KING

Throughout the *ancien régime* in France, so much depended on the smooth transfer of power from the king, upon his death, to the dauphin. The production of a male heir was thus one of the most solemn duties of the monarch and almost the only duty of his queen. In the century or so before the marriage of Louis XIII and Anne of Austria, only one French king in eight, François I, sired a legitimate son without incident, while Henri II and Henri IV managed to do so only after considerable tribulation that convulsed the entire kingdom. Following three miscarriages early on, Louis and Anne had no conjugal relations for almost twenty years. And notwithstanding the fervent prayers that rose from the convents and monasteries of Paris, the queen, now in her late thirties and nearing the end of her reproductive years, was assumed to be barren. Such circumstances would be supremely inauspicious even for a couple on good terms. But Anne and Louis fairly loathed one another. On Louis' part this feeling, born of reports of the queen's dalliances with the Duke of Buckingham, was even more understandable in light of the widespread suspicions that Anne had sought to undermine her husband as he prepared to take up arms against her brother, Philip IV of Spain.

But amid this dispiriting spectacle of marital strife, there occurred, as it seemed to contemporaries, a miracle. Late in 1637, Louis spent several days in his hunting lodge at Versailles, leaving

Anne alone in the Louvre. On his return, he entered Paris on 5 December, intending to bypass the Louvre on his way to the Château de Saint-Maur, thirty miles to the east. He had come to the capital to visit Mlle de Lafayette, the subject of his (apparently platonic) affections, who had recently entered the convent of the Visitation Sainte-Marie, on the rue Saint-Antoine near the Bastille. But as Louis was leaving her, a ferocious storm broke out, impeding travel beyond the city limits. Night fell, and he decided to repair to the Louvre after all. This was no simple matter: the Pavillon du Roi was empty, since all of its furniture—as was customary at the time—had already been sent ahead to Saint-Maur. Thus, for Louis to stay in the Louvre at all, he would be more or less compelled to share the queen's apartment in the southern wing, where Greek antiquities are now displayed. With the rain pouring down ever stronger, one of the king's men went ahead to ask the queen's permission, according to protocol, which she granted. Soon the royal couple were dining together civilly, and afterwards they retired to the queen's bedchamber, one of the few heated rooms in the palace, where they passed the night. Nine months later to the day, on 5 September 1638, a boy was born, and he was called Louis Dieudonné, Louis the God-Given, a name that expressed the astonishment and relief of many French subjects, and perhaps of the king and queen most of all. No less surprisingly, another child, the future Philippe d'Orléans, was born two years later. The infant Louis, the frail product of this happy fortuity, would rule longer than any other monarch in European history, attaining a military and cultural glory that his predecessors could scarcely have dreamed of, let alone achieved.

"Never has there been such great rejoicing," Richelieu wrote at the time of Louis' birth, "as for this new favor that the kingdom of heaven has granted to the kingdom of France."[1] His joy was scarcely less than the king's, and surely as sincere. This birth meant that there would be no contested succession, and it enhanced the likelihood

that the next king, like his father, would advance the policies favored by Richelieu. These policies had been opposed by the vigorous duc d'Orléans, who until that moment had fully expected to succeed his sickly brother.

Although Louis XIV was conceived in the chambers of the Louvre, his relation to the palace was never simple. He was born in Saint-Germain-en-Laye, eleven miles northeast of the Louvre, and he died seventy-seven years later in Versailles, eleven miles southeast of the Louvre. Soon after his father's death, in 1643, the five-year-old king moved with his mother, now the regent, across the street to the palace of the late Cardinal Richelieu (henceforth, and in consequence, to be known as the Palais-Royal), where he lived from 1643 to 1652. At the time, the cardinal's palace was larger than the Louvre, not counting the Grande Galerie, which was really only a glorified passageway. Anne decided to make the move because she found the Louvre too run-down: the Grande Galerie had been reduced to a storage depot and was said to be infested with rats, while the northern wing of the palace itself remained an abandoned construction site, with only its first three bays completed.

But the royal family's nine-year occupation of the Palais-Royal was twice interrupted by the tumult of the Fronde, a popular and aristocratic uprising against the growing absolutism of the Bourbon dynasty. This pair of conflicts arose from 1648 to 1649 and again from 1650 to 1653: the earlier uprising was led by the citizens of Paris, the later by a disaffected nobility. Although there was no religious element to this conflict, as there had been during the conflicts that confronted Henri IV, the deeper causes were much the same: in large part the Fronde was the latest expression of the antagonism that the Parisians had always felt toward the crown, and of the nobility's immemorial fears regarding royal encroachment on their rights and privileges. The perilous stakes of this conflict were manifested on 6 January 1649, when, under shadow of night, Cardinal Mazarin, the

successor to Richelieu (who had died in 1642), burst into the young king's bedchamber and hastened him and his family out of Paris to the safety of Saint-Germain-en-Laye. At the back of everyone's mind was the civil war in England, where, scarcely three weeks later, Charles I, Louis' uncle by marriage, would be executed by his own subjects. So suddenly did the young monarch take flight that, when he reached Saint-Germain, he was forced to sleep on a bed of straw. His safety was ensured only after the Prince of Condé, having made short work of the Spanish in the Netherlands, succeeded in suppressing the second Fronde in 1652. With this latter victory, the nobility of France was eviscerated for all time to come. The citizens of Paris, for their part, would have to wait nearly a century and a half to exact their vengeance, following that fateful July day before the walls of the Bastille.

Soon after the royal family returned to Paris, Louis, now fifteen and reigning in his own right, set to work on the Louvre itself. Over the course of his long life, he would influence its appearance more than any ruler except Henri IV and Napoleon III. At the same time, however, he would repudiate the Louvre more emphatically than any other French monarch, when, in May of 1682, he moved with his entire court to Versailles. There, over the last thirty-three years of his reign, he exhibited such indifference toward the five-hundred-year-old Parisian landmark that he neglected to provide even a roof over the new Colonnade in the east, which he had built at such an expense of effort and wealth.

* * *

If the average Frenchman were asked whom he most admired among the kings of France, his republican indifference to such matters might relent to the degree of admitting a certain respect for Louis XIV, even if François I and Henri IV are apt to seem like more pleasant

companions. This general admiration for Louis is due to his having established that sense of France as a great nation and as a center of science and luxury and culture that survives largely intact to this day, in spite of all the intervening shifts in style and taste. His reign coincided with the age of Racine and Moliere in literature, of Lully and Couperin in music and of Poussin and Perrault in painting and architecture. It calls forth grandiose images of the Louvre and Versailles, the context in which he established what remains, to this day, the dominant and defining architecture of France. His standing also rests upon his astounding success, at least initially, on the field of battle, especially in Holland and Germany, and the victories that were ratified in the Treaties of Nijmegen.

But perhaps the most crucial factor in Louis' preeminence among the kings of France was a certain theatrical sense of life, a mastery of what today we would call public relations, that seems never to have occurred to his predecessors or followers before the rise of Napoleon Bonaparte and Charles de Gaulle, his only rivals in this respect. In the premodern world, lacking our abundant means of mass communications, word traveled slowly and sometimes hardly at all: even a fairly well-educated Parisian might have had little notion of the king's foreign or domestic policy or what the Parlement of Paris was doing. And yet, a monarch could communicate with his subjects by other means, less precise, but scarcely less effective, than any modern equivalent. Two of the most potent of these media were architecture and spectacle, and the young king proved to be a master at using both to his advantage. Surely they had been available to Louis' predecessors, but not in as conscious or effective a way. However magnificent the palaces of Chambord or Blois, their splendor was a private splendor and their magnificence only marginally greater than that of the palaces of the grandees who surrounded, and on occasion menaced, the king. But with the creation of the eastern entrance of the Louvre—perhaps the supreme expression

of classicism in France—and with the construction of the Palace of Versailles, Louis gave architectonic expression to the absolutism that formed the ideological foundation of his reign.

As he himself wrote to his son in an essay titled *Memoires pour l'instruction d'un dauphin*: "There are nations in which the majesty of the king consists, in large part, in his not letting himself be seen, and this may make sense among subjects accustomed to servitude, subjects whom one governs only through fear and terror. But that is not the spirit of our Frenchmen, and for all that we can learn from the recorded history of our nation, if there is one thing that distinguishes this monarchy, it is the free and easy access that the subjects have to their ruler."[2]

This love of spectacle had a direct effect on Louis' artistic patronage, and not always in beneficial ways. What Anthony Blunt wrote of Versailles and Marly, the two other grand palaces that Louis built, could apply, with some reservations, to his concurrent work on the Louvre. "To Louis XIV fine points of proportion, subtleties in the use of the Orders, or the exact quality of molding were matters of indifference. . . . [The result is that Versailles] presents a whole of unparalleled richness and impressiveness; but it offers little in either painting, sculpture, or architecture which is of the first quality in itself. Louis XIV aimed first and foremost at a striking whole, and to produce it his artists sacrificed the parts."[3] The one great exception to this is the eastern façade of the Louvre, a work of transcendent refinement. The external façades of the northern and southern wings, which were completed at around the same time, perfectly fulfill the role they were required to play, but they never sought or attained the brilliance of the east wing.

Central to Louis' thinking was the concept of *gloire*, glory. This quality, of course, has entranced rulers throughout history, but in the age of absolutism it took on a greater and a different urgency. With Louis, this beguiling radiance was less a consequence of worthy

deeds (although his deeds were assumed to be glorious) than the projection of an immanent and inalienable greatness. And so, associating himself with Apollo, Louis began to see himself as *le Roi Soleil*, the Sun King. Whereas several of his forebears had associated themselves with Hercules, Apollo was a different kind of god, a god of poetry and music, illustrious among all the others for his beauty and youth. And although one might not suspect it from the official portraits of Louis in his middle and old age, he was, early in his reign, unusually vain about his appearance.

Even though Louis was curiously indifferent to literature, he was so enamored of theatre and dance, and spectacle in general, that he not only consumed them with intense pleasure, but was also delighted to participate in them. In addition to inviting Molière and Racine to perform for him in the Salle des Caryatides and in the neighboring Hôtel du Petit-Bourbon, Louis created an entire theater in the Tuileries, la Salle des Machines, so called for the state-of-the-art mechanical stage effects that it was able to produce. But perhaps his greatest love was dance: starting in 1651, at the age of twelve, he performed in the *Ballet de Cassandre* and *Les Fêtes de l'Amour et de Bacchus*. Two years later, during Carnival, he appeared before the court in another ballet, *l'Étoile du Jour*, the Morning Star, in which he personified the sun routing the shadows of night. A drawing survives of him resplendent in his golden costume, with sunbeams radiating from his skirt, epaulettes and cuffs, as well as from his breeches and the buckles of his shoes, while on his forehead sits a diadem surmounted by a cascading sequence of ostrich plumes. This performance is thought to be the origin of his identifying with the sun.

But one spectacle above all others has passed into the legend of his reign. On 1 November 1661, Maria Theresa of Spain, whom Louis had married two years earlier, gave birth to a son and heir. Some eight months later, on 5 and 6 June 1662, the king celebrated this welcome event with an equestrian show contrived by Carlo Vigarani, who had

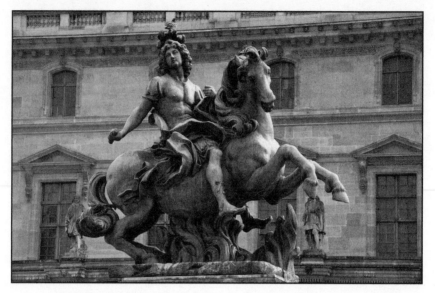

*Gian Lorenzo Bernini's equestrian statue of Louis XIV in
the Cour Napoléon, as recast in lead in 1986.*

also designed the Salle des Machines. Passing under a sequence of tri-
umphal arches fashioned from painted wood and done up in the most
extravagant classicism, thousands of horsemen, dressed as Persians,
savages, Indians and Turks, paraded from the Marais to the Tuileries,
accompanied by a clamor of trumpets and cymbals. As Louis him-
self led the Roman contingent, fifteen thousand Parisians watched
from risers set up near today's Musée des Arts Décoratifs, integrated
into the northern section of the Louvre. Few of those viewers would
ever forget the vision of their king mounted on his horse Isabelle, his
gold and silver raiments ablaze beneath the noontime sun. Through
word of mouth from eyewitnesses and through the etchings of Israel
Silvestre, report of this astounding event raced to every corner of the
kingdom and beyond—and that, of course, was the entire point: a
public relations coup comparable to anything seen in our own day,
it enhanced the standing of the monarchy in the eyes of a restive
kingdom, which, only a decade before, had risen up in open revolt.

The word applied to this spectacle was *carrousel*, from the Italian *carusiello*, referring to a tilting match or a large and virtuosic display of equestrian skill. And this event stamped the name forever on the parcel of land where it occurred, the space that extended east of the Tuileries Palace. To this day, the Arc du Carrousel, which stands between I. M. Pei's *Pyramide* and the Jardin des Tuileries, the nearby bridge known as the Pont du Carrousel, and the Carrousel du Louvre, a shopping center that lies under the modern Louvre, perpetuate the memory of that one event.

Almost exactly coincident with this spectacle, Louis' heliocentric longings were given material expression in the Galerie d'Apollon, which occupies the first floor of the Petite Galerie and now displays the crown jewels and other precious *objets d'art*. Although this chamber, roughly thirty feet wide and over two hundred feet long, was altered in the middle years of the nineteenth century, it largely preserves its appearance under Louis XIV, when it was reinvented by Charles Le Brun, after a fire in 1661 gutted the earlier chamber of Henri IV. Small only in relative terms, the Petite Galerie is almost as large as the Aile Lescot, and with its tall ceiling and relatively narrow width, it seems almost endless as the eye is drawn irresistibly past twelve east-facing window bays toward the solitary window that overlooks the Seine to the south. What we see today was completed by Félix Duban in 1851, but it brings to fruition Le Brun's vision of two centuries before. And even though these two men were the products of very different ages and visual cultures, their seamless collaboration across the centuries was the consequence of a shared ambition: to magnify the glory of France and its ruler, whether a Bourbon or a Bonaparte.

But in a sense, they sought to capture and distill the glory of glory itself, pure glory for its own sake, the obsession of both ages. A telling response to this obsession is communicated in a passage by the American novelist Henry James. As a young boy of thirteen, he was

brought to this gallery shortly after Duban had completed his work, and the experience stayed with him for the rest of his life. Writing more than half a century later in his autobiographical *A Small Boy and Others*, James remembered "the wondrous Galerie d'Apollon . . . [which seemed] to form, with its supreme coved ceiling and inordinately shining parquet, a prodigious tube or tunnel through which I inhaled little by little, that is again and again, a general sense of glory. The glory meant ever so many things at once, not only beauty and art and supreme design, but history and fame and power, the world in fine raised to the richest and noblest expression."[4]

Later in life, James would be haunted by a nightmare set in the Galerie d'Apollon, and one suspects that the vertigo that he felt in his youth has been shared by many subsequent visitors to this central chamber of the modern Louvre. There is something overpowering in its mass of dense and inscrutable allegories that explode simultaneously across the walls and ceiling of the gallery, but always within a structure of such all-mastering symmetry that the eye and mind are defeated and forced, more often than not, to retreat into an attitude of indifference, a dazed, diluted intuition of gilt and glory and naked gods. Part of the problem in our experience of the Galerie d'Apollon today is that we no longer know, or care to know, what to do with a cultural artifact of this sort. If seventeenth-century viewers, raised to decipher complex and interlocking allegorical systems, viewed the walls and ceiling as an invitation to revel in its layered meanings, their modern counterparts, even those conversant with biblical and mythological references, might well think that deciphering these dense allegories is scarcely worth the effort.

Yet, the underlying patterns of the Galerie d'Apollon are not unduly elusive, and it is necessary to perceive them in order to make sense of this astonishing interior space. First there is the division between the coved ceiling and the level beneath it, rising from the floor to the gilded cornice. Although the ceiling seems to be overrun

with paintings, in fact there are only eleven of them, ten of which include two large works at either end of the *galerie*, representing the triumphs of Cebele and of Neptune, as well as four smaller paintings devoted to the times of day and four more to the seasons of the year. At the very center is the largest and latest of the paintings, Eugène Delacroix's *Apollo Slaying the Serpent Python* (1851), around which the three other groups are arranged in precise correspondence. Mediating the space between the two levels are some very fine stuccos, depicting the nine muses and the captives of four continents, by François Girardon and the brothers Gaspard and Balthazar Marsy. Few parts of the Louvre exemplify so well that need to regiment an unruly universe, which was so essential to the ideology and culture of France in the *ancien régime*.

Although the stuccos are quite distinguished, the paintings are mostly second rate. In the history of French art, Le Brun's status as *premier peintre du roi* tended to mean that he was able fluently to

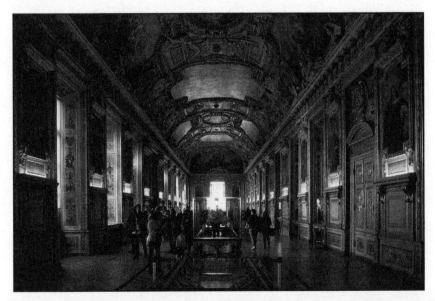

The Galerie d'Apollon as remodeled by Charles Le Brun 1661 and by Félix Duban c. 1851.

assimilate and tame the innovations of his more adventurous fore-
bears. This quality is at work in his three paintings on the ceiling of
the Galerie d'Apollon, *La Nuit ou Diane* (Night or Diana), *Le Soir
ou Morphée* (Evening or Morpheus) and, at the southern limit of
the chamber, *Le triomphe de Neptune et d'Amphitrite*. Surely they
are pleasant enough, and, superficially, they are even impressive:
but on closer view, they appear mumbled, weakly painted, and
somewhat ill-conceived.

Far more engaging are the depictions of the four seasons by
four French masters at work around 1775, Antoine Callet, Louis-
Jean-François Lagrenée, Hugues Taraval and Louis Jean-Jacques
Durameau, who were animated by no other ambition than to ravish
us through the beautiful and balletic nymphs who populate their
canvases. Untroubled by the weightier issues that engage the works of
Le Brun, these painters lived for a fleeting loveliness, and that much
they achieved. The newest addition is Delacroix's operatic depiction
of Apollo, robed in the sun's radiance, as he discharges an arrow at
the coiled monster that emerges from the darkened waters below.
Here Delacroix, a pioneer of the Romantic movement, has tried his
hand at the baroque, but the various figural groups fail to merge into
that ecstatic whole that is, so often, the secret of baroque painting.

* * *

One of the main avenues of magnificence available to princes in cen-
turies past was the acquisition of great art. And in the burnishing of
his *gloire*, Louis proved to be one of the most energetic collectors of
the age: the galleries of the Louvre, as we know them today, would
be unthinkable without the paintings he acquired three centuries
ago. The room in which the *Mona Lisa* hangs today, the Salle
des États, is the holy of holies of the Louvre Museum. Although

it did not exist before the middle of the nineteenth century, most of the forty or so masterpieces that it contains entered the royal collections under Louis XIV. All one has to do is look at the labels and, over and over again, one encounters these four simple words: *Collection de Louis XIV*. In the crassest monetary terms, no other room in the world exhibits a higher number of priceless treasures, mostly by the great Venetians—Titian, Veronese and Tintoretto— than the Salle des États. But even if Louis acquired more than five hundred paintings in his life, to say nothing of drawings and sculptures, it is difficult to determine whether he had good taste, or any taste, given that many of these acquisitions were purchased sight unseen through dealers and scouts whose judgment he trusted implicitly. What does come through is an unappeasable appetite for masterpieces. Even if subsequent scholarship has not confirmed the authenticity of all of these acquisitions (several were bought as works by Jacopo Bassano, Titian's great contemporary, but are now thought to be by his sons or artists in his studio), most of the attributions have held up very well. But the one quality that pervades them all—as well as the Raphaels and Leonardos in the next room and the nearly forty Poussins and two Rembrandts a quarter of a mile away in the Aile Richelieu—is a certain gleam of ineffaceable greatness, a quality to which contemporary collectors apply that cosmically vulgar term *blue chip*. Louis seems to have bought these works—much as a modern billionaire would—as much for the honor and prestige that they and their provenance reflected back on him as for any real aesthetic response.

Before Louis began to buy art in the 1660s, his collection was essentially what François I had bequeathed to his successors,[5] enhanced by a few acquisitions, mostly portraits, that had accrued over a century to monarchs more interested in building palaces and hunting lodges than in acquiring works of art. One of the main conduits for the paintings that Louis purchased on his own initiative

was the Cologne banker Everhard Jabach, who had moved to Paris in 1638. As so often happens in the assembling of art collections, Jabach's acquisitions came from various estate sales: those of Peter Paul Rubens in 1641, of the British collector the Earl of Arundel following his death in 1646, of Arundel's widow in 1654, and especially of Charles I of England following his execution in 1649. Among the paintings thus acquired were Titian's *Concert Champêtre* (which may have been painted by Giorgione) as well as his *Man with a Glove* and *Woman with a Mirror*. From Jabach, Louis also acquired Leonardo da Vinci's *Saint John* and Correggio's *Allegory of the Vices*. And yet, amid the voluminous register of these acquisitions, and despite their undeniable greatness, it is rare to find any hint of initiative or enterprise or independence of taste on the part of the king. Once again like a modern billionaire, he seems to have been successfully pursuing all the same masters that the other potentates of Europe were after.

There are, it is true, exceptions. Among the overwhelmingly mainstream Italian masterpieces that he bought, a few surprises will be found, such as Holbein's portrait of Erasmus and Caravaggio's *Death of the Virgin*, both of which Jabach had acquired from the collection of Charles I of England. Caravaggio's painting may be the oddest and most interesting work that Louis ever acquired. Today this Roman master is a name to conjure with; but when he died in 1610, his fame and influence dissipated almost immediately, and he was largely repudiated and forgotten until his rediscovery by the Italian scholar Roberto Longhi around 1950. For centuries, French official taste would have concurred in the assessment of Poussin—writing, as he often did, in Italian that Caravaggio *"era venuto per distruggere la pittura."* ("He came to destroy painting.") And if most of Caravaggio's works were controversial—by design—none was more so than his *Death of the Virgin*, from 1606. In it Mary emerges, sharply illuminated,

from the surrounding darkness amid grieving mourners who stand beneath a virtuosic length of crimson drapery. What makes this work so incendiary is that Mary has been rendered with none of the consoling embellishments of painterly convention, no haze of sanctity or hint of immortality: her body lies there looking most emphatically dead, and rumors abounded that Caravaggio's model may have been a prostitute and even his mistress.

Death of the Virgin is an example of what Louis, as a collector, usually avoided. Among Caravaggio's Roman contemporaries, Louis preferred such well-mannered, presentable artists as Guido Reni and Orazio Gentileschi, excellent painters, to be sure, but hardly firebrands like Caravaggio. In short, Louis' tastes were those of a conformist: he favored famous names over works to which, despite their obvious excellence, no illustrious authorship could be attached. He preferred works that were large, but not too large—he tended to avoid altarpieces—and he seems to have had little appetite for those smaller still lifes and landscapes that were produced for the merchants of Holland. In general, his paintings were bright and colorful, although exceptions were made for Tintoretto's tenebrous Venetian senators and for that one work of Caravaggio. The art that Louis favored and understood, in short, represented the bedrock of received taste in the middle years of the seventeenth century.

Like most of the collectors of his generation, Louis had little use for any Italian older than Leonardo da Vinci: he would thus have had little interest in Botticelli or Filippino Lippi, much less in such great fourteenth-century masters as Giotto and Duccio. To be sure, they are well represented in the Louvre, but they were acquired long after Louis' death. At the same time, Louis was an energetic collector of his compatriots, despite his general indifference to French painting before 1600. He acquired three masterpieces by Valentin de Boulogne (of the six that the museum possesses), which are admittedly as dark, but not quite as raw as the works of Caravaggio that

inspired them. Mostly, however, Louis favored the well-mannered and preternaturally accurate portraits of Philippe de Champaigne as well as the smooth and fluid mythologies of Simon Vouet and Laurent de La Hyre.

But the contemporary whom Louis admired most was Nicolas Poussin, who died in Rome in 1665, having never returned to France after his escape from the Grande Galerie in 1641. In total almost forty paintings by Poussin, as well as countless drawings, appear in the galleries of the Louvre, and most of them were acquired by Louis XIV. These works range from such early Venetian-inspired paintings as *Echo and Narcissus*, with its rich colors and full-bodied figures, to the tetralogy of *The Four Seasons*, Poussin's latest and most classical works, with their cool palette and almost geometric renderings of biblical and Virgilian landscapes. And yet, despite his reputation, Poussin was hardly a perfectionist: when it was necessary, he was happy to paint quickly and abundantly, and, as a result, there are marked fluctuations in the quality of his work. How much more remarkable, then, that Louis seems only, and unerringly, to have purchased the best.

Louis' love of collecting went beyond paintings. He acquired most of the ancient marble sculptures of Cardinal Mazarin, among them a famous statue of Agrippina, now in the Palais de Compiègne, as well as images of Adonis, Atalanta and the so-called *Hermaphrodite Mazarin*, all of which remain in the Louvre. After 1692, these sculptures were moved from the Palais Brion (connected to the Palais-Royal) to the Salle des Caryatides. In what has to be one of the oddest, most fortuitous conjunctions in the history of the Louvre, these pagan idols were displayed together with the twin statues of Charles V and his wife, Jeanne de Bourbon, which, only a few years earlier, had been extracted from the eastern façade of the medieval Louvre before it was demolished to make way for the expansion of the Cour Carrée.

More remarkable at the time, however, was Louis' acquisition of Jabach's entire collection of drawings, nearly six thousand of them. Although Jabach was hardly alone in collecting drawings at this time, it remained something of an avant-garde taste in the later years of the seventeenth century, and Louis' decision to acquire them suggests a greater degree of initiative than is conveyed in the paintings he purchased. Through this one acquisition (actually purchased in two installments over the course of the 1670s), the Louvre became the repository of what was and perhaps remains the greatest drawing collection in the world.

* * *

"Your Majesty knows well," Louis' new minister of finance, Jean-Baptiste Colbert, advised the young king in 1663, "that with the exception of dazzling martial feats, nothing reflects better upon the greatness and spirit of princes than buildings, and posterity measures princes by the yardstick of the proud structures that they built during their lives."[6]

Louis took these words very much to heart, not least, one suspects, because they coincided so fully with the bent of his nature and with his inexhaustible appetite for magnificence. In due course Louis would leave as great a mark on Paris as Henri IV. If Henri can boast of such residential developments as the place des Vosges and place Dauphine, Louis developed the place Vendôme and the place des Victoires, the latter being, in its perfect circularity, perhaps the finest public thoroughfare in all of Paris. And if Henri built the Hôpital Saint-Louis in the Twelfth Arrondissement, Louis was the patron of both the Hôpital de la Salpêtrière and Hôtel national des Invalides, a vast retirement home for veterans of his numerous military campaigns and one of the largest developments ever undertaken in the French capital.

Even more emblematic was the creation of *les grands boulevards*. Through his early martial success expanding French dominion into Germany and the Netherlands, Louis pushed back the borders of France to such an extent that the massive Parisian fortifications his father had built a generation earlier—together with those of Charles V—were no longer needed. And so these bastioned fortifications were torn down, and in their place arose tree-lined avenues—among the first of their kind—stretching from one end of the Right Bank to the other.

But Louis' greatest achievement in Paris was the Louvre itself. Before his architectural ambitions were diverted to Versailles, he succeeded in completing the process of quadrupling the Palais du Louvre, thus imparting to the Cour Carrée the dimensions that we know today. This had been the dream of the kings and queens of France for a hundred years at least. Aided by Colbert (1619–1683), a protégé of Cardinal Mazarin, Louis removed the last visible traces of the medieval Louvre above ground, including the footprint of Philippe Auguste's donjon, or Grosse Tour, which could still be seen, seared into the pavement well over a century after François I had ordered its destruction in 1528. Meanwhile the northern and eastern wings of the old Louvre of Philippe Auguste and Charles V had stood in ridiculous isolation for generations, battered and amputated in parts. These two wings were now razed to the ground, unloved and unlamented. Indeed, almost all memory of them would be lost for more than three hundred years, until the excavations of the 1980s brought them to light again. Louis also leveled the Hôtel du Petit-Bourbon, equal in size to the medieval Louvre, that had occupied the southeastern quadrant of today's Cour Carrée since the fourteenth century.

Colbert's admonition to the king to build great edifices underscores the immense role that he played in the reign of Louis XIV and in the evolution of the Louvre, in whose development he was every bit as active as the king. Beneath his impassive air of technocratic

managerialism, Colbert was indeed animated, no less than Richelieu had been, by *une certaine idée de la France*. Underpinning his mercantilism and his efforts to rectify the state's finances through the overhaul of its tax collection there lay a vision of French greatness that fully accorded with the most febrile dreams of the king. If this vision resulted in Colbert's creating the *Manufacture Royale de Glaces de Miroirs*, the Royal Factory of Mirrors—in order to discourage the importing of Venetian glass—it also led to the founding of the Paris Observatory, the Academies of Architecture and Music and the French Academy in Rome. But nothing engaged the minister's energies more fervently, perhaps, than the goal of bringing the Louvre, at long last, to completion. It is hardly irrelevant that as Mazarin's right-hand man, Colbert had gotten his start as *surintendant des bâtiments royaux*, overseer of the king's buildings.

With one supreme exception—the Colonnade—most of the work that was carried out on the Louvre under the Sun King was the work of one man, Louis Le Vau. Together with Jacques Lemercier, François Mansart and Jules-Hardouin Mansart, Le Vau pioneered that baroque classicism that, to this day, is so closely identified with Paris and France. Le Vau was a true Parisian: succeeding Lemercier as *premier architecte du roi*, he was born in the capital in 1612 and he died there in 1670. Over the course of his industrious life, he altered the city more than any other architect of his time. In addition to his work on the Louvre and the Tuileries, he designed the Palais de La Reine at Vincennes—on the eastern border of the modern capital—and the Hôtel Lambert on the Île Saint-Louis. But his masterpiece may well be the Collège des Quatre-Nations, that majestically domed structure that daringly curves along the Quai de Conti, facing the Louvre directly across the Seine.

Louis Le Vau was responsible for fully eight interventions in the Louvre Palace, mostly in the 1660s, not to mention five additional interventions in the Tuileries. And because of the sorry state

of the Louvre that he inherited, there was much work to be done. In a contemporary engraving by Israel Silvestre, the entire northern wing of the Cour Carrée, which Lemercier had begun a generation earlier, appears as an inglorious one-story stump scarcely three bays long. Its southern counterpart, which Pierre Lescot initiated in 1554, ended abruptly just west of the neighboring Hôtel du Petit-Bourbon. In addition, the remains of the twelfth-century fortifications of Philippe Auguste were still visible above ground. Within little more than a decade, however, the Petit-Bourbon and the remains of the medieval Louvre would all be gone, and in their place would arise something much like what we see today.

Le Vau's contributions to the Louvre began in 1655 with work on the Petite Galerie. There he created the rounded and still extant semipavilion, the Rotonde de Mars, that leads to the summer apartments of Anne of Austria on the ground floor and to the Galerie d'Apollon on the floor above. Five years later, in 1660, he completed the eastern half of the north wing of the Cour Carrée, which Lemercier had merely begun in 1639 and was soon forced to abandon. Also in 1660 Le Vau doubled the width of the Petite Galerie, in the process creating the courtyard known today as the Cour du Sphinx. That same year he designed the Pavillon des Arts—which opens out today to the Pont des Arts and the Seine—connecting Lescot's southern wing (which Le Vau preserved unaltered) with a new wing that he designed to the east of it in 1661. Also in that year Le Vau reconceived the eastern-most part of Henri IV's Grande Galerie as the Salon Carré, a chamber that would have a storied future in the history of Western art. Finally, in 1667, Le Vau completed the northern wing and doubled the width of the Cour Carrée's southern wing, which is now twice as wide as the other three. He may even have played a role in creating the great Colonnade—the eastern wing of the Cour Carrée and the grand entrance to the entire palace—which was begun in 1667 and substantially completed by 1674. But the

authorship of that masterpiece is one of the most vexed questions in the history of architecture.

Le Vau's initial work on the Petite Galerie, between 1655 and 1658, involved the creation of new apartments for Louis' mother, Anne of Austria. These were the *appartements d'été*, the summer apartments, with the new Rotonde de Mars serving as their grand entranceway. Unlike Louis XIII, whose relationship with his mother had been openly hostile, Louis XIV enjoyed a far closer and healthier relationship with Anne of Austria. As had been the custom since the days of Catherine de Médicis, the ground floor of the southern wing of the Louvre was occupied by the Queen Mother, while the floor directly above it was given to the king's wife, the reigning queen. The king himself occupied the Pavillon du Roi, which was connected to the western end of both apartments. But Louis decided to build his mother a second apartment on the ground floor of the Petite Galerie: it was known as the summer apartment because it mostly faced east and so received far less direct sunlight (especially on hot summer days) than her traditional apartment, with its persistent southern exposure. As was customary throughout the Louvre, this apartment's six rooms were laid out *en enfilade*, with one room succeeding another from the Rotonde de Mars in the north all the way to the Seine in the south. Like all of the palace's royal apartments, these rooms were designed to merge the private chambers of the royal inhabitant with the official or public rooms, where distinguished guests were admitted.

Unlike most of the Louvre's early interiors, however, this apartment has survived mostly intact, despite some modifications carried out under Napoleon. Although the apartment's length and width and height are identical to those of the Galerie d'Apollon on the floor directly above it, the cumulative effect as we see it today is entirely different. The Galerie d'Apollon is strikingly somber for a space consecrated to the god of sunlight. Relative to its length and depth, its windows—originally on both sides, before Le Vau broadened

the structure to the west—are insufficient for the space, especially now with the shades drawn to focus attention on the crown jewels. But in the summer apartment of Anne of Austria, the light out of the east catches in the gilded stucco of the ceiling and mingles with the translucent, watery lightness of its frescoes. Even the nocturnal scenes above the door in the final room, closest to the Seine, seem to be alive with brightness.

Something of Italy can be found in these chambers. Notwithstanding a few contributions by the painter Charles Errard, the frescoes that cover the walls and ceiling are mostly the work of Giovanni Francesco Romanelli, a student of Pietro da Cortona and one of the leading Roman artists of the day. Romanelli had been brought to Paris ten years before by his countryman Cardinal Mazarin, for whose *hôtel particulier* he had painted the vault of the central gallery. Although a number of murals adorn the Louvre's walls and ceilings, most were painted on canvas in the nineteenth century. Romanelli, however, painted in fresco, the same technique used by Giotto and Michelangelo, which accounts for the shimmering lightness of the summer apartment. In addition to allegories of the seasons, he took his subjects from the Old Testament and Roman history, with depictions of Mucius Scaevola before Porsena and the rape of the Sabine women. As so often in Louis XIV's Louvre, especially in the Galerie d'Apollon, the painted surfaces, whether frescoes or works on canvas, were set into an elaborate stucco frame whose frolicking satyrs and nymphs were created by Michel Anguier, together with Gaspard and Balthazar Marsy.

* * *

The entire orientation of the Louvre has changed since the time of the Sun King. Indeed, it has been completely reversed. Today we

are compelled to enter from the west, from the space beneath the *Pyramide*. In a sense, however, we are entering by the back door, by what used to be the Cour des Cuisines, or Kitchen Court. Most modern visitors never make it to the eastern façade, and so, miss the experience of a masterpiece equal to anything in the Louvre itself. In the majesty of its proportions, the power of its general impression and the refinement of its details, the east façade of the Louvre equals or surpasses any other building on French soil, from the great cathedrals to the châteaus of the Loire and anything that emerged in the days of Baron Haussmann and beyond.

When this part of the Louvre was being built in the 1670s, Paris still lay overwhelmingly to the east. The new structure was to be the grand entrance to the palace, the point of crucial interaction between the king and his subjects and any foreign eminences who visited the court. The northern and southern façades of the Cour Carrée, looking out on the rue de Rivoli and the Seine, respectively, are admirably presentable, but ultimately unremarkable. The western façade, toward the *Pyramide*, was originally even more lackluster, since it served as the back door of the palace, before being greatly improved by Hector Lefuel in the mid-nineteenth century. But the eastern façade, known as the Colonnade because of the paired columns that articulate the exterior, expressed a grandeur and kingly elevation fully commensurate with the *gloire* of Louis XIV. Each morning in fair weather, as the sun rises out of the east, it floods with light the fluted shafts of these columns, the sculpted pediment of the central temple front and its perfectly proportioned pavilions. And to the restive Parisians of the seventeenth century, who only recently had taken up arms against the monarchy of France, the beauty and solidity of this one structure would have communicated both the vanity of resistance to royal authority and the incalculable benefits of assent.

With so much seemingly at stake, the very best proposal for the eastern wing had to be chosen from many that were either solicited

or volunteered. For any of a hundred reasons, the project could have turned out to be merely good enough, like the northern and southern façades, or far worse. And so, in the early 1660s, a competition was held among the finest architects of France. In the ordinary course of architectural history, the debate over how to design a building drags on for decades, even centuries, and the result, like the façade of Saint Peter's Basilica in Rome, is apt to represent a discordant mix of artistic personalities. More often than not there is no great talent involved, and when such a talent does appear, there is every likelihood that the patron will opt for a safer and duller option. By every measure of probability, then, the Louvre seemed foredoomed to suffer a similar fate, except that somehow, providentially, it did not. What we see today succeeds so definitively that we are hard put to imagine how it could possibly have turned out better.

Initially, the implementation of the Grand Dessin of the Louvre was entrusted, almost as a matter of course, to Louis Le Vau in virtue of his status as *premier architecte du roi*. But his surviving design for the eastern façade clearly lacked the daring and drama of the curving façade of his Collège des Quatre-Nations. With its inexplicably tall and solid podium and equally inexplicable pavilions, it represented a clumsy combination of modern Italian motifs—wings articulated with arches and giant-order Corinthian columns—and such French vernacular elements as gabled pavilions covered in slate. In consequence, although there was little agreement on anything having to do with the design of this part of the Louvre, the general consensus was that the project should not be entrusted to Louis Le Vau. This attitude was summed up by Carlo Vigarani, the Italian scenic designer who had collaborated with Le Vau in the creation of the recently completed Salle des Machines in the Tuileries. "His Majesty," he wrote, "and Monsignor Colbert perceived that it was a waste of money to keep building according to the designs of a man who lacked theory and experience."[7]

And so the king and Colbert began to look elsewhere. Dozens of designs were solicited and eventually placed before a *petit conseil*, or small council, consisting of Le Vau himself, Charles Le Brun and Claude Perrault, a relative novice whose royal observatory, a decent but largely utilitarian project, had just begun construction, and survives to this day, in Paris's Fourteenth Arrondissement. And yet, this seemingly unpromising team, working in an architectural context hardly known for its love of novelty or risk, somehow agreed upon a design that was entirely different from all the others and almost certainly the best and most inventive of them all.

Several years would pass, however, before that design was chosen. In the meantime, the foremost architects of the realm entered the lists, one by one, with designs based on the bedrock premise, carried over from the western side of the Cour Carrée, that the structure should consist of two wings separated by a main central pavilion and bookended by two smaller ones. Most of the surviving designs were at least serviceable, and some had elements of grace and distinction. But their overall conception tended to be safe and undistinguished. One of the best and most harmonious designs was submitted by François Mansart, the gifted architect of the Val-de-Grâce (a church in the Fifth Arrondissement) and of the Palace of Maisons-Laffitte, ten miles east of Paris. But because his project would have required a radical shift in the proportions of the Cour Carrée, which had already been substantially completed, this design, like all the others initially submitted by French architects, was ultimately rejected.

And so the king and Colbert, in one of the oddest episodes in seventeenth-century French culture, turned their gaze to Rome. Three of the greatest Roman architects of the age—Gian Lorenzo Bernini, Pietro da Cortona and Carlo Rainaldi—accepted the invitation to contribute proposals for the east wing, each man perhaps believing that he alone had been approached to this end. Only Francesco Borromini, easily the rival of any of them, appears to have declined the invitation.

The problem, however, that all three of these men encountered was the overwhelming weight of local architectural tradition, which they surely did not respect and which they consequently refused to address. Each city has its own inalienable architectural signature and, in the seventeenth century, what looked perfectly natural in Rome was apt to seem slightly odd in Milan and downright preposterous in Paris. As it happened, none of these three Roman eminences was familiar with French traditions—only Bernini had briefly crossed the border into France forty years before—and their determination to plant a Roman building on Parisian soil was probably wrong from the start.

Carlo Rainaldi, the creator of the noble Santa Maria in Campitelli and much of Sant'Andrea della Valle, both in the Campo Marzio in Rome, conceived the east front of the Louvre as a highly ornamental wedding cake, the strong verticality of whose façade seemed clustered and encumbered with every classical ornament he could fling at it. Although Pietro da Cortona was a prominent and prolific painter, his greatest achievement was the design of several of the most inventive variations on church architecture ever seen. But all of that adventurousness, combined with an unerring sense of volume and ornament, strangely deserted him as he set to work on the Louvre. Three different versions of his design were sent to France, all of them dominated by a broad and massive dome that had all the grace of a collapsed gourd. None of the designs submitted by either of these men and sent from Rome appears to have been seriously considered.

That left Gian Lorenzo Bernini. If Rome was the undisputed center of seventeenth-century art, Bernini, the companion of popes, was the undisputed master of Rome, lording over the city exactly as Michelangelo had done a century before. Bernini arrived in Paris on 2 June 1665, at the relatively advanced age of sixty-six, and was given lodgings in the Hôtel de Frontenac, which, at the time, stood in the center of the Cour Carrée and was slated for

imminent destruction. Accompanied by his suite of retainers, Bernini entered Paris like a one-man army of occupation, embodying, by his very presence, the entire weight and prestige of Rome as the unrivaled center of visual art. And the Parisians, even the king, showed him all the timorous deference of provincials addressing a monarch of the metropolis. Bernini, however, did not return the compliment. Aside from a kind word about Poussin, whom he knew in Rome, Bernini had nothing good to say about the art or architecture of France.

Already in 1664, Bernini had sent ahead a project for the east wing of the Louvre that consisted of a two-story arcade raised up on a tall pedestal and articulated by giant-order Corinthian columns. The central drum—over which a smaller drum had been set—was flanked by swerving wings that ended in two sedate pavilions. The central drum was as bold a conception as Bernini's great oval church of Sant'Andrea al Quirinale in Rome. At the same time, Bernini's design was informed by an urban vision that was lacking in all of the other proposals. He intended this curving façade—so un-Parisian in form—to be answered by an equal and opposite curvature across the street, resulting from the removal of the church of Saint-Germain l'Auxerrois to form a great public square. As importantly, an avenue leading up to the east façade would bring the palace into direct communication with the heart of the metropolis. Two centuries later, Baron Haussmann contemplated a similar avenue, but he balked on the grounds that, as a conscientious Protestant, he could not tear down the site (Saint-Germain) from which the signal had been given for the start of the Saint Bartholomew's Day Massacre. If his or Bernini's plan *had* been carried out, however, our entire experience of the Louvre would be very different today, and perhaps more satisfying; the east façade, which for the past century and a half has been relegated to the status of a back door, would have become the grand entrance it was always meant to be.

When a second and then a third proposal—less at variance with French taste—were solicited from the great Bernini, Colbert and the king thought it advisable to lure him to Paris. Bernini ultimately came, but his Parisian sojourn seems, at least in retrospect, to have been doomed from the start. He neither knew nor cared to know a word of French, and any communication with him had to be laboriously enacted through an interpreter. His arrogance astonished everyone. Of Guido Reni's *Annunciation*, which Louis had recently acquired and which now hangs in the Grande Galerie, Bernini informed his hosts that it was worth more than Paris itself. He then paid the king of France a backhanded compliment: "Sire, for someone who has never seen the buildings in Italy, you have good taste in architecture!"[8]

Bernini was not, however, quite as diplomatic with those of lower rank than the king. This was vividly brought home to Charles Perrault, Colbert's right-hand man overseeing the expansion of the Louvre and the author, incidentally, of such fairy tales as *Sleeping Beauty, Little Red Riding Hood*, and *Cinderella*. He was also the brother of Claude Perrault, the great architect who ultimately designed the Colonnade. Paul Fréart de Chantelou, who was Bernini's handler and interpreter while the architect was in Paris, kept an extensive diary of the visit. He recorded how, on 6 October 1665, Charles Perrault was explaining, within earshot of Bernini, certain faults with the latter's design for the Louvre. Although Bernini spoke no French, he assumed that Perrault was insulting him and he flew into a rage. He wished M. Perrault to understand that "it was not for him to make such problems; that he [Bernini] would listen to comments about the practical issues of the design, but that, regarding the design itself, such corrections must come only from someone more skilled than he [Bernini pointed to himself]." As for Charles Perrault, "in this matter he was not worthy to clean the soles of [Bernini's] shoes." After expressing his

intention to go directly to Colbert to inform him "of the insult he had received," Bernini concluded, "That a man of my sort, whom the pope honors and holds in high regard, that I should be treated like this—I will complain of it to the king! Even if my life is at stake, I want to leave, to go away tomorrow! I don't know why I shouldn't take a hammer to my bust [the one he was making of the king, now in Versailles], after the insult I have received. I am going to see the nuncio!"[9] In the event, he never went to see either the king or the papal nuncio, and Perrault—or at least his brother—was destined to have the last laugh.

It was clear from the start, however, that there would be friction between the Roman master and his Gallic patron. "*Qu'on ne me parle de rien de petit*," Bernini instructed all and sundry, in Chantelou's translation of his Italian. ("Let no one speak to me of little things.") This was interpreted to mean that Bernini wished to recreate the Louvre from scratch. It is interesting that Louis did not reject this idea out of hand, although he did express his "inclination to preserve what his predecessors had done."[10] One source of disagreement concerned the siting of the royal apartments. Bernini wanted them to occupy the new eastern wing, directly above the clamorous Parisian street, whereas Louis, like many another Parisian since, and unlike many a Roman or Neapolitan, craved peace and quiet. Bernini's wish to add a fourth level to the structure, beyond the three bequeathed from the Aile Lescot, was met with equal coldness. Part of the problem was that Bernini's conception of architecture differed fundamentally from that of his French hosts. Before the rise of architectural rationalism in the late eighteenth and early nineteenth centuries, the inhabitants of a given building accommodated their lives to the building type, rather than the other way round. Bernini fully shared this older notion, and aside from things like grand entrances and stairways, he considered the distribution of the rooms as a matter too trivial

to concern him. He also wanted flat roofs, because they pleased his Roman eye, with no appreciation of the fact that the rainy Parisian climate called for curving roofs (such as predominate in the city to this day). That being the case, we can imagine with what eagerness Bernini received Colbert's injunction to facilitate the discharge of excrement or the placement of latrines in suitable places, "such that the stench should never make the apartments unpleasant to inhabit."[11]

By flattering Bernini's imperious vanity, the king and Colbert succeeded in keeping him mostly in line, to the extent that after rejecting his first proposal, they prevailed upon him to produce two more. And if many accounts of his Parisian sojourn suggest that his ultimate failure resulted from his refusal to bend to the requirements of the site or the preferences of his patron, these subsequent plans suggest otherwise. One suspects that his projects did not ultimately prevail because they failed to impress his patron at a gut level of aesthetic response. Bernini had designed in Paris exactly the building he would have designed in Rome, a palace with the rough mural power of his Palazzo di Montecitorio or the Palazzo Chigi-Odescalchi, which Bernini undertook on his return to Rome in 1665 and which in fact incorporated elements of his third Louvre proposal.

But Bernini's time in Paris was not entirely wasted. The language in which he conceived his façades, with giant-order columns extending two stories up, influenced Le Vau's articulation of the Louvre's northern and southern exterior façades as well as the great Colonnade facing east. At the same time, in his capacity of sculptor, Bernini created two imposing images of Louis XIV. One of these, a splendid bust from 1665 that seems to float on billowing robes, stands in the Salon de Diane at Versailles and is conspicuous for its virtuosic drill-work in rendering Louis' hair and lace cravat. Far more ambitious was an equestrian monument of Louis, similar to

Bernini's own statue of Constantine the Great in the Scala Regia of the Vatican. Intended to stand between the Louvre and the Tuileries, it did not reach Paris until 1685, five years after Bernini's death. Once it arrived, however, it met with the king's immediate disapproval—a sentiment that many subsequent observers have shared—and was soon relegated to an obscure corner of the vast park of Versailles. There it underwent a further indignity when the features of the king's face were transformed by François Girardon into those of the mythical Roman hero Marcus Curtius. A lead reproduction was cast in 1986 and now stands in the Louvre's Cour Napoléon, not far from the spot for which it was originally intended.

But neither Bernini nor the king nor Colbert nor anyone else understood that something had happened during the Roman master's Parisian sojourn. Nothing less than a transubstantiation of sorts had occurred, whereby the poles of Western art began to shift subtly, but irreversibly, in the direction of Paris and away from Rome. Surely several generations would pass before Parisians understood, in the middle of the next century, that they had wrested from Rome its preeminence in the visual arts, a preeminence that they would continue to enjoy for centuries, until finally it shifted to New York City in the aftermath of the Second World War.

If this shift could be located in a single instant, it would be Bernini's returning empty-handed to Rome. But if there is one monument, one architectural event that manifests that transformation, surely it is the eastern façade of the Louvre. Because of its brilliant and insistent use of Corinthian columns two stories tall, Parisians usually refer to it as la Colonnade du Louvre, or simply la Colonnade. The Colonnade is not only the finest portion of the Louvre, it is also, in the estimation of this critic, as fine a piece of architecture, classical or otherwise, as will be found anywhere in the world.

All the other projects for the east wing of the Louvre looked more or less like some variant on what had been seen before. The

Colonnade, however, looks like no previous building. Rejecting all curves, it is radically flat in a way that no building had been since the fall of Rome. It is completely self-contained, with all of its parts unified into a tightly compacted whole. The broad central pavilion, solid and majestic and crowned with a triangular pediment, projects slightly from the rest of the structure, as do two smaller pavilions at either end. The design is dominated by eighteen paired, freestanding Corinthian columns that serve as a screen for the loggias on either side of the central pavilion and rise over a base of flawlessly dressed stone, whose windows reproduce those of the Petite Galerie. A stuttered sequence of balustrades along a roof, doubtlessly inspired by Bernini's designs, accentuates the flatness of the whole project, a flatness that runs counter to the most inveterate traditions of French architecture.

This one building would influence French architecture into the twentieth century, imposing upon it an *esprit géométrique*, to use Pascal's almost exactly contemporary term, that it did not possess before. It is not easy to find another building that succeeds quite as well as the Colonnade, or that succeeds in quite the same way: it is grand without being grandiose and reserved without being severe. It seeks neither to seduce by its grace nor to endear itself through any display of humility. And yet, with a kind of architectonic *noblesse oblige*, it ravishes us through the perfection of its proportions and details, and it manages, however improbably, to communicate some measure of human scale and human warmth.

The fact that it has always been called the Colonnade may seem peculiar: although it does indeed have columns, they are not apt to appear as its single outstanding motif. Many colonnaded buildings were built in antiquity: the Parthenon in Athens and the Temple of Hadrian in Rome, among others. But despite the revival of classical architecture in the 1400s, no architect since antiquity had thought to integrate a row of columns into a building façade. That is why its

use in the second story of the Louvre's east wing must have seemed like a prodigy.

The building, largely completed by 1674, became instantly famous. Louis sponsored a competition that invited poets from across Europe to write Latin epigrams in its honor. The esteemed English poet Andrew Marvell rose to the challenge, sending in six two-line poems, of which the first made reference to a recent fire in the Escorial, the royal palace of Spain:

> *Consurgit Luparae dum non imitabile culmen*
> *Escoriale ingens uritur invidia.*

> *While the inimitable roof of the Louvre rises up, the great Escorial burns with envy.*[12]

But Marvell, who had never seen the actual Colonnade, was wrong about its being inimitable. Indeed, its influence on subsequent architecture, down to the First World War, was almost incalculable and almost always beneficial to the majesty and harmony of those later buildings. Its influence can be found in the two identical buildings that flank the rue Royale on the northern side of the place de la Concorde, as well as the Grand and Petit Palais half a mile away, to say nothing of Grand Central Station in New York City or Carrère and Hastings's Cannon House Office Building and Russell Senate Office Building in Washington, DC.

* * *

Strangely enough, even though the Colonnade was the most famous architectural project in France and possibly in all of Europe in the seventeenth century, and even though it was conceived and

brought to completion in the full light of history, we cannot say with certainty who designed it. The short and traditional answer has always been that it was designed by Claude Perrault, whose brother incurred Bernini's ire by suggesting improvements to the Italian architect's designs. Subsequent scholars have put forward the names of Charles Le Brun, Louis Le Vau and the younger architect François d'Orbay, or have suggested that the design evolved through the collaboration of Le Brun, Le Vau and Perrault, who made up the *Petit Conseil* that had been charged with overseeing the design phase of the project.

But given the simple perfection of the result, there is little reason to believe that it was the work of the committee in concert, even though, if Perrault was indeed its author, Le Brun and Le Vau would surely have offered suggestions. And whereas no other architect is known to have claimed authorship, Perrault was quite emphatic in doing so. Gottfried Wilhelm Leibnitz, the German philosopher, happened to reside in Paris at the time when the Colonnade was being built and he was in almost daily communication with Perrault. Leibnitz spoke of a competition of sorts that was held among the three members of the *Petit Conseil*. "Finally," Leibnitz relates, "M. Le Vau abandoned his plan and consented to that of M. Perrault, such that only two designs remained, those of M. Perrault and of M. Lebrun. . . . The king (sharing the opinion of M. Colbert) preferred M. Perrault's. . . . And it is according to that design that the work is now being carried out."[13]

The manner in which this momentous decision was made is of some interest. According to the memoirs of Charles Perrault, the assistant to Colbert and Claude's much younger brother, a meeting was held in the *petit cabinet* of the Palace of Saint-Germain-en-Laye: the king and Colbert were present, together with Charles Perrault and the royal captain of the guard. Colbert unfurled the two designs that the triumvirate of Le Brun, Le Vau and Claude Perrault had

sent, one by Le Vau (not Le Brun, as in Leibnitz's account), the other by Perrault. "The king considered both of them attentively," Charles Perrault wrote:

> *after which he asked M. Colbert which of the two he considered more beautiful and worthy of execution. M. Colbert replied that if he were in charge, he would choose [the one by Le Vau]. This choice astonished me. . . . But no sooner had M. Colbert expressed his preference for that design than the king said, "As for me, I choose the other one, which seems more beautiful and majestic." I could see that M. Colbert had acted as a skillful courtier, who wanted to give all the honor of the choice to his master. Perhaps it was a game played between the king and him. However that may be, that was how the matter was decided.*[14]

Most of what we know about Claude Perrault comes from a brief and posthumous biography written by his brother. Charles claims that although the prime minister solicited designs from Bernini and several additional architects, his brother's design "was chosen over all the others, and then executed in the manner in which we see it today."[15] It is unlikely that this claim, published two decades after the building's completion, would have been stated so forcefully if it could be easily refuted. Initially there had been some resistance to Perrault's plan, and later to the idea of his authorship, because his formal training had been in medicine rather than architecture or any of the other fine arts. Furthermore, he appears to have brought to completion only one other, far more modest building, the Paris Observatory, which still stands. Quite aside from his brilliance at the Louvre, Claude had two attributes that must surely have influenced the decision to choose his plan. As a man of science, his knowledge of engineering was virtually

unrivaled among the architects of France or anywhere else. Also, he was known for his formidable erudition, which subsequently resulted, at Colbert's request, in an important translation and commentary of Vitruvius, the Roman architectural theorist. Both of these attainments served him well in completing the Colonnade. "When this design was unveiled, it was very well received and . . . astonished the eyes of even those most accustomed to see beautiful things," his brother wrote. "But it was thought to be impossible to build and the design was considered more suited to a painting, for it was only in a painting that one saw anything comparable. . . . Nevertheless, it was executed without misplacing a single stone on its broad flat roof."[16]

If Claude Perrault's most famous achievement was thus in the fine arts, he ended his career—as he had begun it—as a man of science: he died at seventy-five in 1688 while dissecting an apparently diseased camel in the Jardin des Plantes, which is still located on the left bank of the Seine, in the Fifth Arrondissement.

* * *

Although not one visitor to the Louvre in a hundred, perhaps in a thousand, will ever see this masterpiece of Western architecture, it is an even greater irony that the Colonnade was not yet finished when Louis XIV decided to move with all his court to Versailles, despite Colbert's strongly advising against that move. Although the move did not occur all at once, it was largely completed by 1682. We cannot say for certain what induced Louis to abandon a project on which he had lavished so much effort and wealth. Perhaps, recalling the days of the Fronde, he preserved a lingering suspicion of the Parisians. Perhaps he felt that he shared the Louvre with a dozen of his forebears, but that Versailles was essentially his alone, a blank

slate that his theatrical imagination could transform into the greatest stage set of the age. Implicitly, then, these two palaces, of roughly the same size, were competitors. But despite certain similarities, the differences between them are larger and also instructive. If the Louvre had evolved over five centuries by the time Louis abandoned it, the palace and most of the grounds of Versailles were completed in roughly one generation and entirely according to Louis' wishes (even though he incorporated and built around his father's original hunting lodge and even though later rulers added to what he built). Such was the speed of construction and so prodigious was the length of his reign, that Louis was perhaps unique among the kings of France in living to see to completion a great palace that he himself had begun.

Encountering Versailles, we discover important things about the Louvre that we might otherwise never suspect. Perhaps because the Louvre is so fully integrated into the life and urban fabric of Paris, it never achieves that haunted remoteness, that sense of almost hallucinatory immensity that characterizes both the Palace of Versailles and its miles upon miles of flawlessly landscaped grounds. Versailles is the progenitor of all those urban centers, from Karlsruhe to Brasilia, that have been created from above, virtually out of thin air, to overawe humanity with their power and symmetry. It is no accident that Washington, DC, was designed by Pierre L'Enfant, who was brought up in Versailles. Indeed, it is almost impossible fully to understand those slicing diagonals and tridents and circular termini that stretch from the Capitol to the Lincoln Memorial and from the Lincoln Memorial to the White House, without having visited Versailles. But nothing of such potent artifice can be found at the Louvre. Despite its size, it never overpowers the visitor. Although it is one of the largest man-made structures in the world, it never loses its human scale. And in consequence it reveals a benignity and generosity for which, perhaps, it has never received the credit it deserves.

- 5 -

THE LOUVRE
ABANDONED

When Louis XIV moved to Versailles in May of 1682, taking his multitudinous court with him, it must have seemed to many Parisians as though a great sleep had descended on the city, one that would endure, almost uninterrupted, for more than a hundred years. But Louis' decision merely ratified what had been a reality for several decades: he had never cared for the Louvre when it was littered with the remains of the medieval palace, and he cared for it still less as an interminable construction site. And so, even before moving to Versailles, he decamped first to the Tuileries and then to Saint-Germain-en-Laye.

To a greater or lesser degree, the expansion and embellishment of the Louvre had occupied all the kings of France for over a century and a half. Now it ground to a halt, so suddenly that most of the northern and eastern wings of the Cour Carrée stood as hollow shells: although their structures were completed, they lacked doors, floors, ceilings and window panes. And this would remain the case until the time of Napoleon Bonaparte early in the nineteenth century. The seventy-two-year reign of Louis XIV would end, followed by sixty years of Louis XV and nineteen of Louis XVI; the war of the Spanish Succession would be won, the Seven Years War would be lost and the Revolution would stagger to its murderous consummation; and through it all, the Palace of the Louvre would remain an abandoned construction site, with

puddles of rain and heaps of snow marring those sublime spaces that now house the treasures of Egypt's Middle Kingdom and the masterpieces of Chardin and Boucher. And so it went for every hour of every day, for almost 130 years.

Some seventy years into that dereliction, the querulous Voltaire could take it no longer. In 1749 he wrote an essay in which he claimed that "passing before the Louvre, we sigh as we look at the façade, that monument to the grandeur of Louis XIV, to the ambition of Colbert, to the genius of Perrault, concealed behind the buildings of Goths and Vandals."[1] This sentiment was echoed in *L'ombre du grand Colbert* (The Shade of the Great Colbert), an extraordinary volume written in the same year by Étienne La Font de Saint-Yenne (1688–1771), an unfairly forgotten art critic and gifted polemicist who was one of the first public intellectuals to agitate for transforming the Louvre into a museum. His book is an allegorical conversation between the Louvre, the city of Paris and Colbert himself, who returns from the grave to behold in horror the "contempt of the nation for the most beautiful piece of Architecture that the mind of man has yet conceived."[2] The frontispiece depicts the Colonnade, obscured by repulsive, low-lying structures before which several figures recoil in horror. The author, explaining the image, writes that the city of Paris "appears as a suppliant before the bust of Louis XV, to whom she shows the deplorable state of the Louvre, its proud façade dishonored by a multitude of ignoble and indecent buildings. . . . At her feet the spirit of the Louvre lies in the dust, about to expire from sorrow, prostrate and crushed beneath the weight of insult and humiliation."[3]

What Voltaire and La Font de Saint-Yenne were referring to is made manifest in the famous Plan Turgot, a map of Paris that was created between 1734 and 1739 and that offers an unrivaled bird's-eye view of the city in the early years of Louis XV's reign. Today, knowing how to display our urban attractions to best effect, we

can only marvel at what Parisians were prepared to tolerate in the degradation of their city. Although most of them would have shared Voltaire's belief that the Colonnade was the defining monument of the previous one hundred years, nearly a century would pass before, starting in 1764, they would be able to see this monument as we see it today. An entire street of low-lying sheds, huts and shacks stood in a chaotic welter in front of the Colonnade, curving westward at the northeast corner of the building to form a cul-de-sac. At the same time, an unfinished building, abandoned and left to the elements, will inevitably start to rot from within, and that was already happening with the Colonnade. As rust corrupted some of the concealed metal armatures at its summit, a piece of the cornice broke off, destroying a good part of the royal stables directly below.[4] Meanwhile—again according to the testimony of the Plan Turgot—a half dozen lean-tos and even a few trees occupied nearly a fifth of the Cour Carrée at the point where its fountain stands today.

Progress began to be made only when Abel-François Poisson, the marquis de Marigny, was elevated to the office of *directeur*

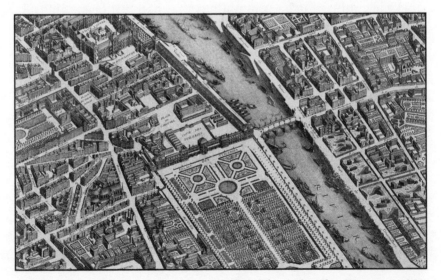

Image of the Quartier du Louvre in a detail from the Plan Turgot (1739).

général des Bâtiments du roi, which he held from 1751 to 1773. The younger brother of Madame de Pompadour, Louis XV's first official mistress, Marigny was destined to have a great effect on Paris in general and the Louvre in specific. Finally in 1756, an effort was made to emancipate the Louvre from the clutter of third-rate structures that surrounded it, by removing the buildings in the center of the Cour Carrée (known by this point as the Old Louvre). But because even a king could not simply seize and demolish the property of his subjects, Louis began in 1758 to buy up all those buildings just north of the Cour Carrée and east of the Colonnade that he did not already own. In the same year, he ordered the destruction of what remained of the Petit-Bourbon, the palace that had stood for centuries just east of the Louvre. Two years later the royal stables were demolished, followed by a neighboring building that belonged at the time to the postal service. Even then, however, there was talk of monetizing this newly cleared area by attaching seventy-five small shops to the Colonnade. This would have destroyed the entire effect of the monument, but perhaps in a slightly more orderly fashion than the confused mass of buildings that had just been removed. Fortunately, the new plan came to nothing and, instead, two landscaped parterres—units of a formal garden—were placed in front of the Colonnade, although these too did not last very long.

Once the façade had been liberated, to the universal satisfaction of the citizens of Paris, Marigny and his architect Jacques-Germain Soufflot confronted the irksome issue of what to do with the Cour Carrée. Going back a century, it now resembled a collision of two utterly incompatible architectural styles. But for the intervention by Soufflot, who is best known as the architect of the great Panthéon that looms over the Left Bank, this quintessential Parisian space would look very different today. The entire western wing had been conceived according to Pierre Lescot's original design for François I, as was the entire southern wing and the first three bays

of the northern wing. But when, in the late 1660s, Claude Perrault designed the court façade of his Colonnade, Lescot's mannerist idiom had come to seem out of date and even debased. With this in mind, Perrault kept the first two levels of Lescot's design, but got rid of the attic and added a flawlessly classical third level in the Corinthian order, resulting in three stories of exactly equal height. He extended this conception into the part of the northern wing that was completed in 1667. But a century later, for the sake of symmetry and consistency—the paramount strivings of French classicism—either his arrangement or Lescot's would have to be sacrificed. Although the more economical choice would have been to maintain Lescot's attic throughout, Perrault's solution was far closer to the canon of the reigning taste. Thanks to the efforts of Soufflot and Marigny, Perrault's design prevails to this day on the entire north, south and east façades, while the western side alone, out of reverence for Lescot, preserves his initial design.

Soufflot is responsible for two further revisions of the Cour Carrée: in the northern wing, he created the passage under the Pavillon de Marengo, an inspired variation of Lemercier's passage beneath the Pavillon de l'Horloge. Soufflot also broadened the pavilions at either end of the Colonnade, a modification made necessary by Louis Le Vau's decision to double the width of the southern wing of the Cour Carrée. Such interventions, of course, were tactical rather than strategic, and yet they represent the bulk of the work carried out on the Louvre over the entire course of the eighteenth century.

* * *

Louis XIV's reign was so long and he himself was so long-lived by the standards of the age, dying just shy of seventy-seven, that he outlived three dauphins: his son, his grandson and the older of

his two great-grandsons. The circumstances in which his younger great-grandson inherited the throne of France were extraordinary even by the standards of a dynasty whose succession had been troubled for centuries. Louis XIV seemed to have the rare good fortune of three generations of male issue who could ensure a smooth transfer of power. He himself had sired six legitimate children, but only the first, Louis, survived into adulthood and was called *le grand dauphin* to distinguish him from his own son, Louis, *le petit dauphin*. But *le grand dauphin* was destined to predecease his father, dying just before he turned fifty, in 1711. The very next year, however, *le petit dauphin*, his wife, Marie Adélaïde, and his two sons—that is to say, his entire family—contracted measles. He and Marie Adélaïde died within six days of each other in February of 1712. The older son, Louis, Duke of Brittany, died at the age of five on 9 March as a result of the disease and also of the then-prevalent treatment of bleeding the patient. His two-year-old brother, soon to become Louis XV, was saved from a similar fate only because his governess, Madame de Ventadour, forbade the royal doctors to bleed him as well.

But because Louis XV was only five years old when his great-grandfather died and he became king in 1715, a regent had to be appointed, as had been the case with Louis XIII and Louis XIV. Ordinarily this would have been the young king's mother; but because Marie Adélaïde had died as well, the regency fell to a prince of the blood, the deceased king's cousin Philippe, duc d'Orléans. Louis XIV had been very apprehensive, however, at the prospect of Philippe's regency and went so far as to call him a *fanfaron des crimes*, someone who boasted openly of his transgressions, a reference to the duke's reputation as an atheist and free-thinker. Something of this spirit may be inferred from a portrait of the duke—painted by Jean Santerre—together with his famous mistress la Parabère, posing naked as Adam and Eve three months *after* he became regent.

During the eight years of the regency, from 1715 until Louis XV officially came of age at thirteen in 1723, Paris and the Louvre resumed, however briefly, their earlier status as the center of power and royal ceremony. Throughout this period the young monarch resided in the Tuileries Palace, where he received the embassies of Peter the Great of Russia in 1717 and of Mehmet Efendi, the ambassador of the Ottoman court, in 1721. With the arrival of Peter the Great, the Académie française had to move from its lodgings in the Louvre, and to do so at once, so that the tsar could take over the apartment of Anne of Austria and the ground floor of the southern wing of the Cour Carrée. The Garde-Meuble de la Couronne (the institution charged with maintaining the king's furniture and making it available for official guests) quickly got together all the sumptuous chairs and beds and tapestries at their disposal. But these exertions were mostly wasted on the rugged tsar, who, finding the accommodations "too well lit and too well furnished," preferred to stay in the Hôtel Lesdiguières, a far humbler dwelling near the Bastille.[5]

Two years later, in 1719, the nine-year-old Louis XV had to move from the Tuileries while work was being done there, and so he took up residence in the southern wing of the Cour Carrée. While there, he is said to have enjoyed watching boat races on the Seine from the windows of the Grande Galerie, and to have attended meetings of several of the learned societies resident in the Louvre. These learned societies—the Académie francaise and the Académie des Beaux-Arts among others—were condemned to an unstable and unenviable existence, residing in whatever part of the palace was not needed by the crown. In consequence, they were constantly being bounced around the Louvre. And if, with Louis XV's return to the Tuileries, they imagined that they could finally settle into their assigned places, they were to be disappointed yet again. By 1719 another war had broken out between France and Spain, or, no less exactly, between the nine-year-old Louis XV of France and his uncle Philip V of Spain, who

was born in Versailles, had spent half of his life there, and thus was more French than Spanish. In hopes of securing peace between the two countries, it was decided that Louis should marry Philip's eldest daughter, the infanta Mariana Victoria. At least initially, it did not appear to be an insurmountable problem that, at the moment when Louis officially received the infanta in the Louvre, on 2 March 1722, he was twelve years old and she was three.

While her governesses inhabited various quarters of the southern wing of the Cour Carrée, the infanta was given the summer apartment of Anne of Austria, the same accommodations as had been prepared for Peter the Great five years before. But if the emperor of all the Russias found these accommodations too rich for his blood, the three-year-old infanta does not appear to have entertained any such compunctions. In fact, for her pleasure and amusement, a landscaped parterre was designed just beyond her window by Robert de Cotte, and it is still there, to the left, as one exits the Cour Carrée and heads towards the Pont des Arts. This garden was adorned with statues of Diana's nymphs by Simon Mazière that are now on view in the Cour Marly in the northern half of the museum. To this day the garden is still known as the Jardin de l'Infante, and, although modified in the mid-nineteenth century, it remains the one tangible trace of her brief sojourn in the Louvre.

When Louis moved back to Versailles a few months later, the infanta went as well. As might be expected, however, the king could hardly have had much to talk about with his fiancée, even though, by all accounts, she was a sweet, pretty and spirited child. Their engagement, which is apt to seem strange to our contemporary sensibilities, apparently seemed scarcely less so to Louis himself. And so, three years later, now fifteen years old and ruling in his own name, he was persuaded by his advisers that it would be well to sire a male heir as soon as possible. Since this, obviously, could not be done with Mariana Victoria, who was still only seven, he

sent her back, still unwed, to Spain, and he promptly married Marie Leczinska, the impecunious daughter of the ousted king of Poland. If Mariana Victoria was eight years younger than Louis, his new bride, at twenty-two, was seven years older. Their union seems to have been rather a success: the couple produced ten children in as many years, although only two were male and only one of those two lived into adulthood. This son, Louis, Dauphin of France, was destined to predecease his father, but not before he himself had sired four sons, of whom three would eventually become kings of France: Louis XVI, Louis XVIII and Charles X. As for the infanta, she eventually married Joseph I of Portugal and became queen of that nation.

* * *

Louis' brief return to the Cour Carrée, when he was a boy, represented the last time that a king of France would inhabit the Palace of the Louvre. Thereafter, it was clear to everyone that the palace no longer pulsated with that sense of cosmic urgency that it had had when the king still lived there. Now the Quartier du Louvre was but one Parisian neighborhood among many, seeking some function to define it. This search would consume the energies of the crown and the citizens of Paris for the rest of the eighteenth century. And yet, throughout that period, the Louvre and its environs were hardly idle. Rather they evolved into a complex, vibrant, densely populated ecosystem. Mercers and fruit sellers jostled one another in little stalls along the western entrance to the palace, while booksellers and print dealers did a brisk business under the arches of the Pavillon des Arts.

Although the Quartier du Louvre was made up of that dense knot of streets that stood between the place du Carrousel and today's Cour Napoléon, it was far more than that: it included the sheds that

blocked the Colonnade and, perhaps most surprising of all, several houses great and small that had sprung up—with the blessings of a monarchy ever eager for cash—in the Cour Carrée even before Louis XIV and his court moved to Versailles. These structures stood where today we find the fountain in the center of the Cour Carrée, on land from which François I's tennis court had only recently been cleared away. Also, within the Louvre complex itself a number of apartments were leased to nobles and artists. One of the largest and most exalted of these apartments, surely, was that of Philippe Mancini, duc de Nevers: it occupied over eight thousand square feet of the eastern half of the Cour Carrée's south wing, at the point where it connects to the Colonnade. Meanwhile, some years later and at the opposite end of the Louvre complex, Marie Antoinette took an apartment in the Pavillon de Flore, at the southern end of the Tuileries Palace and the southwestern extremity of the Grande Galerie: she was apt to use it whenever the opera at the Palais-Royal ended too late for her to make the eleven-mile trip back to Versailles. At the opposite end of the Tuileries Palace, the Pavillon de Marsan, now occupied by the Musée des Arts Décoratifs, was home to several of her ladies in waiting, among them the Comtesse de Polignac, the Marquise de la Roche-Aymon, the Princesse des Berghes and the Comtesse d'Ossun.

But the great majority of the tenants of the Louvre complex were far less illustrious. Many belonged to that group known collectively as *les Suisses*, often retired soldiers who were charged with the upkeep of the palace and its grounds and who, despite their name, were not usually Swiss. But if the Louvre seemed increasingly shabby at this time, the cause was less the people lodged within it than the occupants of the one-story dwellings that collected, like barnacles, wherever they could insert themselves: in front of the Colonnade, in the moat along the western façade of the Aile Lescot, in the center of the Cour Carrée, or along the warren of streets west of the Cour

Carrée, where an unpaved dirt surface sloped sharply downward towards what is now the Pavillon de Richelieu.

The condition of these dwellings is revealed in the cityscapes of Philibert-Louis Debucourt and Pierre-Antoine Demachy. Although neither of these painters is well known or deserves to be better known, they left behind an invaluable, almost journalistic record of the Louvre, not in its glory, but in its day-to-day decay. In Debucourt's depiction of the western façade of the Cour Carrée, where we now see the *Pyramide*, a row of huts ran along the western exposure of the Aile Lescot and continued along the Aile Lemercier. Each of these shops consisted of a gray slate roof bristling with dormers and chimneys slanting backwards from a squat base. Among the tradesmen who inhabited them were a *limonadier*, a bonnet-maker, one of the king's arquebusiers and a dentist known by his last name, Caperon.[6] If such lowly structures did not debase this section of the Louvre, that was only because Jacques Lemercier had intentionally designed it to be a kind of service entrance for a palace that had turned its back on the unruly, inchoate city emerging to its west. The stalls would remain in place into the early years of the nineteenth century, while the western façade of the Cour Carrée would not acquire its present splendor until the reign of Napoleon III.

But perhaps the most interesting occupants of the quartier were its painters and sculptors.[7] One of the glorious oddities of the Louvre is that much of the art on view—at least that of French artists—was produced in the very building in which it is now displayed. For many years visual artists had tended to settle on the Right Bank of Paris: but when the Académie took up residence in the Louvre, the palace itself, together with its immediate environs, became the de facto center of visual art in France, and would remain so through the French Revolution. Since the reign of Henri IV, twenty-seven coveted workshops and apartments in the Grande Galerie had been placed at the disposal of artists and artisans for

their entire lives—during good behavior—and these became available to new occupants almost exclusively on a tenant's death. Even then it was not unusual for these spaces to pass from one generation of a family to the next. But as the eighteenth century progressed, artists began to move into other areas of the Louvre, especially those parts of the Cour Carrée that had a roof. Some of these artists were among the most renowned painters and sculptors of the age. The great Jean-Baptiste-Siméon Chardin lived there, next door to the landscape painter Hubert Robert, together with such neighbors as Jean-Baptiste Greuze and Maurice Quentin de La Tour, Jean Honoré Fragonard and Jacques-Louis David. The northern wing of the palace, at least the first three bays that had the benefit of a roof, proved especially popular with the sculptors Jean-Jacques Caffieri, Augustin Pajou, the elder Coustou, Jean-Baptiste Pigalle and Étienne Maurice Falconet. That means that the most important French sculpture of one of its golden ages, with many examples now on view in the Louvre's Aile Richelieu, was created in the first three bays of the northwest corner of the Cour Carrée.

The quality of these artists' dwellings had very much to do with the success they had achieved in their careers. The baronial splendor enjoyed by the history painter Charles-Antoine Coypel—his numerous rooms were stocked with rare wines and bejeweled snuff boxes—was expressed in the sedan chair in which he was carried through Paris by the four servants who shared his apartment. By contrast, his half-nephew, the sculptor Edme Dumont, lived in one of the makeshift lodgings at the center of the Cour Carrée, described in one official communication as "a hovel, a complete rat's nest without any furniture."[8] After he got married, Dumont moved into better lodgings, and his epic representation of Milo of Croton—a wrestler famed in antiquity—is now on view in the Louvre's Pavillon Richelieu.

For these more bohemian artists, existence in and around the Louvre could be decidedly tawdry. Demachy, the scene painter, together

with the history painters Charles-Louis Clérisseau, Hugues Taraval and Louis Jean-Jacques Durameau, lived in the Louvre itself during their student days at the Académie, and while there, they became the object of a curious complaint. A caretaker at the palace wrote to the authorities that he could not keep the building clean since these students continued to make their "soil" in the corridors, while "leaving it to their servants to throw the excrement out the windows."⁹

A sense of the tumultuous lives of these artists may be inferred from the case of Jean André Rouquet, who occupied apartment ten of the twenty-seven that were placed at the disposal of artists in the Grande Galerie. Rouquet (1701–1758) worked in enamels, a popular medium at the time, and one of his miniatures, a portrait of Marigny, is now part of the collection of the Louvre. Rouquet had been assigned his apartment in 1754, after he returned from several years in England. But he soon suffered a series of adversities, from the death of his wife to a bout of apoplexy, that appear to have pushed him into madness. As his behavior became ever more erratic, he developed a drug addiction that he maintained by selling off his furniture. On one occasion he tried to set fire to his lodgings, filling the hallways of the Grande Galerie with smoke. Soon he was throwing bottles out of his window onto the rue des Orties below, followed by furniture. Eventually, in 1758, he was committed, but not before depositions were taken from a number of his neighbors, among them such eminent painters as Jean Restout, Maurice Quentin de La Tour and Chardin himself.

Throughout the period of his absence—because he was expected to return in fairly short order—his belongings were scrupulously preserved in anticipation of his eventual return. But he never did return. After his death, his apartment in the Grande Galerie remained vacant for six months before it was eventually given to Louis Tocqué, one of the finest portraitists of the *ancien régime*, who moved in with his wife, his eleven-year-old daughter, a valet and a cook. Mme Tocqué

decorated all four floors of the apartment with a refinement that stood in stark contrast to Rouquet's ramshackle tastes. According to David Maskill, "The depositions from Rouquet's fellow artists are evidence of their genuine concern for a neighbor whose actions threatened the delicate balance of individual autonomy and collective responsibility which characterized life at the Louvre."[10]

Although comity was usually preserved in the Quartier du Louvre, the area was not entirely free of violence. Ferdinand-Joseph Godefroid, a restorer of the king's pictures, lived directly across from the Colonnade in the cloister of Saint-Germain l'Auxerrois. On 16 April 1741, he was returning home from dinner in a cabaret on the rue Saint-Thomas du Louvre, near where we now find the *Pyramide*. He had just passed under the entrance of the Tour de l'Horloge and was about to leave the Cour Carrée by the passage in the Colonnade when he began to argue with another member of his dinner party, Jérôme-François Chantereau, a thirty-year-old painter whose works recall Watteau's. Although Chantereau and Godefroid were friends, they were hot-headed and had been drinking. Their altercation centered around a painting by the seventeenth-century Roman master Carlo Maratta that belonged to Chantereau, but whose authenticity Godefroid had questioned. An altercation ensued and, in short order, Godefroid lay dead on the floor of the Cour Carrée. Chantereau remained on the scene, refusing to flee despite the urgings of his companions. Eventually he was exonerated when it proved impossible to determine who had started the fight. After Godefroid's death, his widow, also a restorer, moved into an apartment on the top floor of the Colonnade (the southern section that was partially roofed), where we now find the paintings of Fragonard and Greuze. Although this apartment was nothing more than an artist's studio and sleeping quarters, it was taken over, at the death of Mme Godefroid, by her son, who was a painter.

* * *

When the king moved permanently to Versailles, the five great *académies* of France rushed to fill the void left by the absence of the monarchy and the court. The earliest and most famous of these learned societies, founded by Louis XIII, was the Académie française. Created under Richelieu in 1638, it took up residence in the Louvre as of 1671, and thus its presence coincided with the king's, although briefly. It was followed by the four other societies, which had been created under Louis XIV: the Académie des Inscriptions et des Belles-Lettres (founded in 1663 and in the Louvre by 1685); the Académie de Peinture et de Sculpture and the Académie d'Architecture (founded respectively in 1648 and 1671 and installed in the Louvre in 1692); and finally the Académie des Sciences (founded in 1666 and installed in the Louvre in 1699). These five academies would remain in the palace until the Revolution, when they moved to the Collège des Quatre-Nations, now the Institut de France, Louis Le Vau's masterpiece directly across the Seine. For more than a hundred years, then, some of the most brilliant luminaries of French art, literature and science wandered the halls of the Cour Carrée, but few if any of the locals or tourists who now inspect the masterpieces of early nineteenth-century French painting on the second floor of the Aile Lescot realize that they are literally following in the footsteps of Racine and Corneille, of La Fontaine and Boileau.

Meanwhile, in the southwest corner of the Aile Lescot, at the point where the palace joins the Petite Galerie and through it the Grande Galerie, the Royal Academy of Painters and Sculptors convened, as well as the Royal Academy of Architects. In their early days, these two academies had moved around the Louvre several times. When Louis XIV decided that he needed the space for himself, the academies moved across the street to the Palais-Royal, until they were granted permission to return in 1692.

The reputation that the Académie des Beaux-Arts subsequently acquired as the bedrock of centralized, state-sanctioned official

culture scarcely does justice to the revolution it represented in the very conception of the painter and sculptor in society. Even though the men and women of the sixteenth century began to suspect that there was something transcendently special about Leonardo, Raphael and Michelangelo, even though the Emperor Charles I of Spain once famously bent down to retrieve a paintbrush that Titian had dropped, that lofty regard did not generally extend to the rank and file of visual artists. Just because Michelangelo was divine did not mean that his followers, no matter how eminent they became, deserved substantially more respect than a frame-maker, a gilder or a sign painter.

In previous centuries, French painters and sculptors, like their peers throughout Europe, labored within the context of guilds, to which they gained entry by being granted a *maître*—roughly a master's degree. This conferred a certain legal status on them, but scarcely more honor or respect than was accorded to any other menial worker. Even the great Leonardo da Vinci, so zealous in his defense of the honor of painting, dismissed sculptors as scarcely better than bakers. As late as 1600, this was the condition of artists throughout Europe, except perhaps in Italy, where their status was beginning to change. With the founding of the Accademia di Bologna in 1575 and the Accademia di San Luca in Rome in 1593, visual artists demanded to be seen as liberal artists, practicing an art every bit as free, rather than servile, as the arts of poetry and music. Even in the generally conservative empire of Spain, Diego Velazquez solicited and obtained, after a lifetime of petitions, entry into the Order of Saint James, a minor order of nobility. French artists who visited Italy, especially Rome, observed this evolving status of their Italian counterparts and began to resent the treatment they sustained at home.

With such changes very much on their minds, the painter Charles Le Brun, the sculptor Jacques Sarazin and the architect Charles Errard established in 1648, with the blessing of the regent, Anne of Austria,

the Académie Royale de Peinture et de Sculpture. If the four other learned societies in the Louvre were convocations of equals, the Académie Royale de Peinture et de Sculpture was mainly a teaching academy whose members imparted theory and practice to students who were not yet members as such. As was to be expected in a highly stratified society like that of eighteenth-century Paris, there were strict hierarchies among painters. Reflecting the precise orders of nobility, history painting—which included large-scale historical and religious narratives—was the most prestigious of the genres, followed by portraiture. Far below, in descending order, stood genre painting—anonymous scenes of daily life—landscapes and, the lowest of all, still lifes. The writer and architect André Félibien spoke for all of his contemporaries when he declared, in a speech to the academy in 1667, "He who paints perfect landscapes is higher than another who paints only fruits, flowers and shells . . . and since the form of Man is God's most perfect creation on earth, it is equally certain that he who imitates God in painting human figures is far more excellent than all the others."[11] Only history painters and portraitists could thus become professors in the academy.

To become a member, the aspiring artist was required to demonstrate his ability by submitting a painting or sculpture known as a *morceau de réception*, or reception piece. Each year, by the dozens, these works entered the Louvre, and the most illustrious of them stayed there, eventually becoming part of the (not yet created) museum's collection of old master paintings and sculptures. Less accomplished submissions ultimately found their way into regional museums all over France. In 1667 sixty-one works were presented for the judges' consideration.[12]

Some of the finest paintings now on the walls of the Louvre started life in this way. Perhaps the most famous of these submissions is Antoine Watteau's *Pèlerinage à l'île de Cythère* (commonly but inaccurately translated as the Embarkation to Cythera), depicting

the Parisian beau monde in the early years of the regency. Dressed in their silks and brocades, they stand atop a hill whose lush greenery frames a body of water in the middle distance. Watteau had entered the academy in 1714, at the relatively young age of thirty, but he dithered for fully three years—despite several reprimands—before he produced and submitted this masterpiece. Because Watteau's depictions of the aristocracy at play conformed to none of the five categories proclaimed by Félibien, a special designation had to be invented especially for him, *maître des fêtes galantes* (approximately master of gallant revelries). The *Pèlerinage à l'île de Cythère* is so obviously and immediately enchanting that one would be hard put to imagine how it could incur any ill will. Eight decades after it was painted, however, according to one oft-told story, the young students of the academy, filled with revolutionary animus, directed their spitballs at this emblem of the discredited aristocracy, resulting in its removal from the Louvre. It returned only in 1816, when the academy and its uncivil charges had been sent across the Seine to their present location at 14 rue Bonaparte.

No less remarkable a painting is *La Raie* (the Sting Ray), by which, in 1728, Chardin won membership in the academy. As with Watteau's submission, the academy had never seen anything quite like this painting: dominating the center of the composition is the titular ray, suspended from a meat hook in such a way that the gills of its exposed underbelly take on the ghastly aspect of a laughing face. The sea creature is flanked by a darkly gleaming earthenware jug and by a cat that prepares to leap at a dead fish lying on the stone tabletop. If the academicians' generally conservative spirit craved more traditional fare, they found it six years later in François Boucher's *Renaldo and Armida* of 1734, a voluptuous rendering of a famous love scene from Torquato Tasso's epic *Gerusalemme liberata* (Jerusalem Liberated). Boucher, the archetypal rococo painter, was not yet at his best in this work, but still very good: his improbably

adolescent lovers inhabit a stage set whose complex classical architecture is filled with dimpled putti.

The main event of the academy's year—and an event of greatest importance for the future of the Louvre—was its annual Salon, perhaps the first exhibition of its kind ever mounted. Initially, the reason for mounting an annual exhibit was to show off the school to the academy's *protecteur*, the minister Colbert, on the occasion of his one official visit of the year: there was no plan to place the work before the public. But at some point before the first Salon, in 1667, the decision was made to open the show to anyone who wished to see it. Surely the sort of public exhibition that we take so much for granted today would eventually have emerged in any case: an annual display of paintings had been held under the portico of the Roman Pantheon as early as the later sixteenth century. But in point of historical fact, this sort of exhibition appears to have been first institutionalized, if not invented, by the Académie

Jean-Siméon Chardin's The Ray *(c. 1725), a* morceau de reception, *or reception piece, by which he gained membership in the Royal Academy of Painters.*

de Peinture et de Sculpture and nurtured in the chambers of the Louvre.

The decision to open up the exhibition to the public was a first step in the eventual transformation of the palace into a museum. That art should have been brought before the public was, of course, nothing new: urban statuary and the altarpieces of ten thousand churches prove it. But that this art should have been presented for a limited period so that the public could debate its merits had no real parallel in earlier culture. One of the incalculable consequences of this decision was the birth of art criticism as we know it today: the merits of each work were debated not only by the public, but also in print, by such newly formed art critics as Denis Diderot and La Font de Saint-Yenne.

When the directors of the academy decided to stage the Salon exhibition, it is quite likely that they had no idea whether anyone would even show up beyond a few of the local collectors and intellectuals, and perhaps they were as surprised as anyone when the exhibition, generally held in August, evolved into one of the paramount cultural events of the year. Although the Salon was first mounted in 1667, it was formalized as an annual exhibition only in 1737, and it was in that year, for all intents and purposes, that the Salon really began. In that year as well it moved from the Galerie d'Apollon to the Salon Carré, literally "the large square room," even though it is in fact rectangular. The Salon Carré is roughly as long as the Galerie d'Apollon, but nearly three times wider. More importantly, the chamber's soaring height made it possible to stack paintings one atop another, with five or even six paintings commonly rising up in a single row. Although this style is rarely encountered today, since it is hardly the ideal way to see paintings, it continues to be called the "Salon style," after the Salon Carré. Similarly, it was from the Salon Carrée in the Louvre that the term "Salon" came to be associated with the annual or periodic display of recent art.

The Salon in the Louvre would have many imitators over the years, from the annual Summer Exhibition at London's Royal Academy, inaugurated in 1769, to the Venice Biennale, inaugurated in 1895, and the Whitney Biennial, inaugurated—initially as a yearly exhibition—in 1932.

The Salon Carrée is a large space, but not excessively so: if as many as sixty thousand visitors saw the annual show during its four-week run—and that was often the case—then on average some 250 people would have occupied it at any one time. (On a crowded afternoon today, at the height of the summer tourist season, one might expect to see a quarter of that number.) The crush of visitors must have been exhausting, and with the paintings stacked all the way to the ceiling thirty feet above one's head, the conditions for examining a work of art could hardly have been comfortable or pleasant.

Unsuspected by the thousands of visitors who jostled one another to see these Salons, the academy offered, within the context of the *ancien régime*, an unparalleled zone of social freedom. The writer Pidansat de Mairobert spoke of "this mixing of all ranks and orders of society, every sex and age. . . . It is perhaps the only public place in France where everything offers the precious liberty of London."[13] Louis Carrogis Carmontelle, an artist and man of letters, described the scene of the Salon of 1785:

> *The Salon opens and the crowd jostles to get in. A multitude of movements bestir the spectator. One man, compelled by vanity, only wants to be one of the first to express his opinion. Another man, guided by boredom, only wants to see some new spectacle. One man treats the paintings as nothing more than commodities, and tries to guess how much they will fetch, while another hopes that it will give him something to prattle on. The art lover looks with passionate but uncertain eye; the painter with a piercing but jealous eye;*

*and the vulgarian with a laughing but stupid eye; the lower
classes, accustomed to base their tastes on those of a master,
wait to hear the opinion of a man of breeding before deliv-
ering their own.*[14]

Although no king of France ever visited the Salons during
the ancien régime, Marie Antoinette is known to have done so
four times.[15]

As for the artistic experience itself, the critic Sebastien Mercier
wrote, "You see paintings 18 feet long that reach the ceiling and
thumb-sized miniatures chest-high. The sacred, the profane, the
grotesque, all subjects historical and mythological are depicted and
arranged pell-mell. It is pure confusion. And the spectators are as
dazzlingly variegated as the art they contemplate."[16] The only way
to make sense of it all was to acquire a catalog; and although the
exhibition was free to the public, the exhibition catalog cost twelve
sols in 1771 (roughly eight American dollars today), with most of
the proceeds going to the academy. Since there were no wall labels
for the paintings or sculptures, only a number that corresponded to
an entry in the catalog, it was by means of the catalog alone that
visitors could learn the name of the artist and the subject of the
work. A typical example from the catalog in 1761 refers to the scene
painter Pierre-Antoine Demachy: "By M. de Machy, Academician.
Interior of the new church of Sainte-Genevieve [later renamed the
Panthéon], after the plans of M. Soufflot. . . . It is 5 feet tall and
4 feet wide."[17] By 1787, fully twenty-two thousand catalogs had
sold within the space of the single month of the Salon's duration.
And if we suppose three readers for every copy—the estimate of the
authors of the *Histoire du Louvre*—some sixty-six thousand view-
ers, or roughly a tenth of the population of Paris, attended the Salon.

An essential player in the tumultuous drama of the annual Salon
was the *tapissier* (literally translated as *upholsterer*), the academician

who decided what would be hung and where, a largely thankless task that combined the skills of a diplomat with those of an art critic and a master of jigsaw puzzles: he had to fit several hundred discordant paintings onto a single wall. Among the eminent artists assigned this duty, no less a master than Chardin served in this role for seven consecutive years. Writing of the Salon of 1761, Diderot declared, "This tapissier Chardin is a rascal of the first water: he is never happier than when he pulls off some fine mischief. It is true that this mischief always redounds to the profit of the artist and the public, to the public because it is able to enlighten itself by comparing the juxtaposed paintings; to the artists between whom he provokes an entirely perilous battle."[18] There is a widespread misconception that all of the works in the Salon were for sale: although some were, most had already been sold and were displayed only by permission of the collector. And while most artists fought to appear in the Salon, some of them, most notably Fragonard and Greuze at the height of their careers, refused to participate at all.

* * *

The great consequence of these annual Salons was the forging of a public space for art that would result, by the end of the eighteenth century, in the foundation of the Musée du Louvre. It has been well said that with the establishment of the Parisian Salon, art entered the public realm.[19] But if the Salon proved to be of fundamental importance in the decision to turn the Louvre into a museum, the process by which that transformation occurred was long and complicated. The great unanswered question of eighteenth-century Paris concerned what should be done with the Louvre. Even if the eighteenth century left few visible, architectonic traces in the Louvre as we know it today, nevertheless the sundry uses to which it was put

represented "a fundamental step in the appropriation of the palace by the city."[20] What Louis XIV had thrown away, the Parisians now seized and made their own: what had been a royal palace would be reborn as a palace for the citizens of Paris. At various points over the succeeding generations, the kings of France and even Napoleon Bonaparte took up residence in the Tuileries. But hereafter both the Palace of the Louvre—the structure around the Cour Carrée—and increasingly the Grande Galerie would belong to the citizens of the capital. Already, from the boxes of the theater in the Tuileries, the Parisian beau monde watched the first performances of Beaumarchais's *Barber of Seville* and heard for the first time Haydn's six *Symphonies Parisiennes*. And there as well, on 30 March 1778, one of the most inspiring moments of the Enlightenment took place. After twenty-five years of exile, the eighty-three-year-old Voltaire was allowed to return to Paris to attend a performance of his play *Irène,* two months to the day before his death. So rapturous was his reception that, in the middle of the play, a mob of admirers broke into his box to crown him, and afterwards his bust was brought onstage and that was crowned as well.

Soon the foremost architects of France began nurturing extravagant visions of *un temple des arts, des sciences et du gout*—a temple of the arts, sciences and taste—in the words of the architectural theorist Jacques-François Blondel. Louis XV entertained the idea of transforming the palace's grounds into a great public square in his honor, with his equestrian statue in the center. His three predecessors had each been honored in this way: Henri IV in the place Dauphine, Louis XIII in the place des Vosges and Louis XIV in the place Vendôme. In 1748 a competition was held to solicit suggestions regarding the design of the plaza and its location. The place du Carrousel, standing between the palaces of the Louvre and the Tuileries, was an obvious choice. Germain Boffrand designed a triumphal arch to replace the central pavilion of the Tuileries. An obscure architect

of whom nothing is known beyond his last name, Legrand, suggested the area in front of the Colonnade—which would have been an excellent idea. Even the Cour Carrée was considered. But Louis ultimately chose Ange-Jacques Gabriel's plan for the area immediately west of the Jardin des Tuileries. Completed in 1763, it is now known as the place de la Concorde, and the equestrian statue that once rose there, like all of Paris's other equestrian statues to royalty, was melted down during the Revolution.

About a generation later, in the early 1780s, Louis XV's grandson and successor, Louis XVI, revisited the idea of developing the space between the Louvre and Tuileries Palaces. By this time, the emerging neoclassical style had provoked a fundamental shift in every domain of Western culture, from art to literature and music. Inspired by a new and direct contact with ancient Greece and Rome and especially by recent excavations in Pompeii and Herculaneum, this movement presumed to substitute an archaeological understanding of the past for the humanistic conception that had reigned since the Renaissance. This was the style in which the young king decided to build a new opera house that would either stand in the middle of the vast space between the two palaces or be attached to the Pavillon de Marsan, at the northern end of the Tuileries, directly facing the Grande Galerie. A number of bold designs were submitted, but in terms of sheer ambition none surpassed that of Étienne-Louis Boullée, surely the most radical architect of eighteenth-century Europe. His design was based on the Pantheon in Rome, but was fully four times larger. Surrounded by Corinthian columns, each with a corresponding statue at the summit above the entablature, it was accessed by a magnificent stairway, flanked by sculptures of horses. This brave and brazen vision, like most of Boullée's flights of fancy, came to nothing, and no opera house was ever built within the precinct of the Louvre. Yet the neoclassical style that these designs announced was destined to have a great influence on the palace—though mostly

on its interiors—when work finally resumed two decades later under Napoleon Bonaparte.

<p style="text-align:center">* * *</p>

When the Louvre opened as a public museum on 10 August 1793, many Parisians were delighted, but few were surprised. Though born in the midst of the Reign of Terror, it had been conceived under the *ancien régime* nearly half a century earlier. If the word "museum" is ancient, the idea it conveys is an eighteenth-century invention and a product of the Enlightenment. In the middle years of the century, this concept was very much in the air. Art had been displayed in a semi-public way in the Belvedere of the Vatican since the end of the fifteenth century, and princely collections like those of the Corsini and Barberini families in Rome and of Philippe d'Orléans in the Palais-Royal, had long been accessible to artists and connoisseurs who could present a letter of recommendation from a respectable source. But the crucial idea that a collection should be presented to the general public on a regular basis had little currency before the end of the eighteenth century.

The earliest institution to resemble a modern museum may well be the Ashmolean at the University of Oxford: it came into existence on 24 May 1683 when a two-story building, housing the collections of Elias Ashmole and of John Tradescant, father and son, opened its doors to any member of the public who could pay the entrance fee. Between that date and the Louvre's inauguration 110 years later, a scattering of museums emerged around Europe: among the most eminent were Rome's Capitoline Museums in 1734, London's British Museum in 1759 and Florence's Uffizi ten years later. But if the Louvre was not the first museum, or even the first art museum, in the world, still it established almost single-handedly the paradigm

for all of those great encyclopedic and national museums that arose in Europe and America in the generations that followed.

One of the first public intellectuals to advocate for transforming the Louvre into an art museum was Étienne La Font de Saint-Yenne. In the same work from 1748 in which he lamented the sorry state of the Louvre, La Font de Saint-Yenne addressed the shade of Colbert and recalled all the masterpieces that Colbert had encouraged Louis XIV to buy: "And do you imagine that these riches are displayed for the admiration and joy of the French people . . . for the curiosity of foreigners, for the study and emulation of our own school [of painters]? Know then, oh great Colbert, that these beautiful works have not seen the light of day, having passed from the honorable place they once occupied in the chambers of their owners to an obscure prison in Versailles, where they have lain dying for the past fifty years and more."[21]

The only mitigation was the availability, just across the street from the Louvre, of one of the finest private art galleries in the world. The collection of the duc d'Orléans in the Palais-Royal contained nearly five hundred masterpieces of European painting and, by itself, would qualify even today as one of the great museums of Europe. Here students of the *académie* could come to study and even copy the finest works of the old masters. In 1750, the king's new inspector of buildings, Lenormant de Tournehem, asked for and received permission to bring ninety-nine of these works before the Parisian public. At first he considered placing the paintings in the Grande Galerie, but this space was in poor shape and, more materially, had been assigned as a map room to the king's army. So he decided to display the paintings across the Seine in the Palais du Luxembourg, starting on 14 October 1750. Among the works on view were Raphael's paintings of Saint Michael and Saint George, as well as his *Belle Jardinière*. Visitors could also admire Titian's *Madonna with a Rabbit*, Rubens's *Kermesse* and Caravaggio's portrait of Alof

de Wignacourt. All of these works were eventually bought by Louis XV and are now part of the Louvre. The exhibition's duration was open-ended; due to its great popularity, it remained on view through 1779. And because the recent openings of the Capitoline Museums in Rome and the British Museum in London had been widely reported, many Parisians assumed that the Luxembourg exhibition was merely the harbinger of some more permanent accommodation: for twenty-nine years, they had lived with a great museum in their midst, and from that point on the question was not if, but when, the Louvre would come to serve that function.

But the greatest impetus for founding the Louvre Museum came with the accession of Louis XVI, on the death of his grandfather in 1774. Louis himself may not have shown any great interest in founding a museum, or even in visual art in general, but he made an inspired choice when he appointed Charles-Claude Flahaut de La Billarderie, Comte d'Angiviller, as the *directeur général des Bâtiments du roi* (Director-General of the King's Buildings). D'Angiviller cared greatly about the question. Both in architecture and in painting he was an energetic supporter of the neoclassical style that was just then beginning its triumphant progress through Paris. Working together with the head of the *académie*, Jean-Baptiste Marie Pierre, an accomplished history painter, d'Angiviller was determined to establish a museum in the Grande Galerie. There was a sense of added urgency to this ambition, given that the Palais du Luxembourg would henceforth be off limits, having been bestowed by the king on his brother, the Comte de Provence, who much later became king himself as Louis XVIII.

In anticipation of its opening, d'Angiviller began frantically buying art, but in a fundamentally different way from such great royal collectors as François I and Louis XIV: he was now buying art specifically for that great and as yet unrealized museum of the future. And he was doing so with a sense of real urgency. The collection of

Crozat, one of the finest private collections in eighteenth-century France, had slipped through the fingers of Louis XV in 1772 when it was bought by Catherine II of Russia: its many masterpieces are now among the most treasured possessions of the Hermitage. Thereafter, whenever the great *hôtels particuliers,* the stately homes of the Parisian nobility, were sold or faced demolition, d'Angiviller and his middlemen would be sure to step in.

There was an element of incipient nationalism to d'Angiviller's purchases: together with Pierre, he was determined to promote the art of France. In March of 1775, they acquired two painted ceilings by Jean Jouvenet from the Hôtel de Saint-Pouange, near the Louvre. The next year, with the death of the owner of the Hôtel Lambert on the eastern point of the Île Saint-Louis, d'Angiviller eagerly bought up works by Eustache Le Sueur, François Perrier and Pierre Patel, which are now grouped together in a single room on the second floor of the Aile Marengo in the Louvre. In the same year, the Carthusian monks who occupied the western half of today's Luxembourg Gardens sold d'Angiviller all twenty-two paintings from Le Sueur's *Life of Saint Bruno* (regarding the founder of the Carthusian order).

D'Angiviller was equally determined to build up the Louvre's collection of Dutch and Flemish painters, which had been greatly neglected until that point. Louis XIV had indeed purchased one painting by Rembrandt and a few landscapes by sundry other artists. But those purchases were seen as somewhat exceptional. And so d'Angiviller dispatched Pierre to Flanders to buy paintings, and so he did, returning to Paris with Rembrandt's *Pilgrims at Emmaus* and Jan Lievens's *Visitation of the Virgin.* Soon the collections of Augustin Blondel d'Azincourt and Jean-Baptiste de Montholé entered the royal holdings. Among the treasures acquired from the sale of the Comte de Vaudreuil's collection were Rubens's portrait of his wife, *Helene Fourment and Her Children,* and Rembrandt's *Portrait of Hendrickje Stoffels,* depicting the woman with whom he lived

following the death of his wife, Saskia. That same sale also brought several works by the Sevillian master Esteban Murillo at a time when only three works by Spanish artists were in the royal collection, and those had been purchased by Louis XIV a century before. Admittedly Velazquez's *Portrait of the Infanta* was among them: but a true and committed appreciation of Spanish art would not emerge before the early nineteenth century, when Napoleon's plunder from the Peninsular War took the Parisian art world by storm.

D'Angiviller did not neglect the king's drawing collection either. Already vast due to the acquisition, a century earlier, of the Jabach collection, it was now enhanced by the purchase of more than a thousand drawings, mostly Italian, from the legendary collection of the publisher and art historian Pierre-Jean Mariette. D'Angiviller would gladly have bought the entire collection at once, all nine thousand items, but Mariette's heirs could not be persuaded to part with them on those terms.

When the American War of Independence ended on 3 September 1783 with the Treaty of Paris, the French government could look forward to the repayment of some of its loans to the American colonies. From that money, thirteen million livres were eventually placed at the disposal of d'Angiviller over a period of six years. He put the money to good use, restoring the Grande Galerie in anticipation of opening the new museum. Around the same time, he resolved that the Grande Galerie should be lit not only by the windows on either side but also by an *éclairage zénithal*, where daylight streamed through an opening in the roof, as we see it today. This method of lighting, although it would become increasingly common in museums over the next century, was a radical innovation at the time. Even more revolutionary, however, was the idea of constructing it with iron, a new material for architecture that had the added benefit of being more fire resistant than wood, the traditional material for trusses of this sort. Before undertaking a work of such novelty

and ambition over the 440-meter length of the Grande Galerie, the academicians decided to make a trial of the new technique in the Salon Carré. The masonry work was begun on 15 May 1789 and the ironwork was installed over two weeks at the end of June. Few visitors today, as they pass through this cardinal point of the Louvre museum, realize that they are standing beneath one of the world's earliest examples of modern architecture, well over two centuries old and entirely invisible from below.

"The establishment of the museum is surely not far off," d'Angiviller said on that occasion.[22] And he was right in that assessment. What he had not anticipated, however, was that he would not live to see the fruits of his labors. Two years after the Parisian mob stormed the Bastille, d'Angiviller went into exile, never to return to Paris or the Louvre.

- 6 -

THE LOUVRE
AND NAPOLEON

When Napoleon Bonaparte seized power in the coup d'état of 9 November 1799, he was widely seen as the inevitable consequence of the French Revolution, whose ambitions he did so much to embody and betray. Louis XVI had been executed six years before, the Terror had swelled and then subsided, the Directory came and went, and now this scion of minor Corsican nobility could gaze with an air of uncontested ownership from his new apartment in the Tuileries half a mile east to the Palace of the Louvre. He was not yet emperor—that eminence would come five years later—but already he lived like one, and already it pleased his wife Josephine to hang the *Mona Lisa* on one side of her bed and Holbein's portrait of Erasmus on the other.

The Louvre and its environs proved to be of singular centrality to Bonaparte's ambitions. His path to power had been immeasurably aided on 5 October 1795, when, a few hundred feet from the Pavillon de Marsan at the western end of the Louvre, he subdued a royalist revolt beside the Church of Saint Roch on the rue Saint-Honoré, thus ushering in the phase of the Revolution known as the Directory. Soon he embarked on his first Italian campaign of 1796–1797, followed by his Egyptian campaign of 1798–1801, and from both of these foreign adventures he brought back thousands of works of art that continue to swell the collections of the Louvre. Even his coup d'état, the famous eighteenth Brumaire, occurred

when he stormed the Palais des Tuileries and compelled the deputies to appoint him first consul.

For fifteen years, from the coup to his fall from power in 1815, Napoleon lived mostly in the Palais des Tuileries, when he was not leading armies into battle or reposing in one of the palaces of the ousted monarchy. His first full taste of the Louvre's charm had occurred on 20 December 1797, when, following his return from the victorious first Italian campaign, he attended a lavish banquet in his honor in the Grande Galerie. A painting by Hubert Robert records the scene, in which a single table, impossibly long and covered in flawless white linen, seems to stretch out between dull, greenish-gray walls toward a vanishing point in infinite space. Such banquets would not be repeated often, however, since both the food and the smoke of the candelabras were seen as posing a threat to the gallery.

Three years later Napoleon was very nearly assassinated, on Christmas Eve of 1800, near the present Pavillon de Rohan. He had entered a carriage in the Cour des Tuileries—where a lawn now fans outward toward the Tuileries Garden—and was heading north to the opera in the theater of the Comédie Française, in order to hear Haydn's oratorio *Die Schöpfung*. Preceded by his *cavaliers de la garde consulaire* and followed by the carriage of Josephine and her sister, Napoleon rode east to the place du Carrousel, then north along the rue Saint-Nicaise. Unbeknownst to him or his men, a group of Chouans, members of the royalist resistance in Brittany, had armed a crude device known as a *machine infernale*—a barrel filled with gun powder, bullets, and nails—that they detonated from a distance by means of a fuse attached to a sawed-off shotgun. But through some miscalculation, the detonation was delayed, allowing Napoleon and his party to pass unharmed. The explosion, however, shook the entire Quartier du Louvre, at the time one of the busiest and most populous parts of the city. As many as twenty-two men,

women and children died, and many more were injured. A number of houses in or near the place du Carrousel were also destroyed. Ironically, this violent and inadvertent clearing of the area helped greatly in laying the groundwork for the massive construction of the Louvre's northern half, which was about to begin.

Some ten years later, Napoleon experienced a far happier event in the Louvre, when he led his second wife, Marie-Louise, in a wedding cortege from the Tuileries Palace through the Grande Galerie to the Salon Carré, where they exchanged vows. Along the entire length of the Grande Galerie, according to a contemporary drawing by Benjamin Zix, thousands, perhaps tens of thousands, of bystanders came to watch as the imperial couple passed. Despite all the tourists who now traverse that space at the height of the summer season, this event may well have drawn the largest crowd ever assembled in the four-hundred-year history of the Grande Galerie.

* * *

Few of the Parisians who stormed the Bastille twenty years earlier could have imagined that they were witnessing the birth of a new era in human history, and none could have known that an obscure second lieutenant, all of twenty at the time, would come to hold dictatorial power over their lives, with the Louvre as the center of his operations. The attack on the Bastille, though it eventually changed the world, had little immediate effect on Paris or the Louvre. Scarcely a month later, in August of 1789, tens of thousands of visitors thronged the Salon Carré, as they always did, to see its annual or biennial Salon. But this time they would have been more apt to admire the new glass skylight that had been installed six weeks earlier—a miracle of modernity—than to reflect on the events of the month before. Such traces of disquiet as could be found

in the Salon of 1789 were subtle enough that few visitors noticed. Hubert Robert, who could complete a canvas in a single sitting, exhibited a work depicting the assault on the Bastille, painted one week after the event. Now in the Musée Carnavalet, it depicts the ugly old fortress, its brick façade rising against an evening sky filled with storm clouds, while rubble fills its waterless moat and Parisians stand about marveling at what they had just brought to pass. At the same time, one of the most famous French portraits of the age, Jacques-Louis David's depiction of Antoine-Laurent Lavoisier and his wife, now in the Metropolitan Museum, was withdrawn from the Salon at the last minute for fear that it might be vandalized: although the aristocratic Lavoisier is known today as the "father of modern chemistry," he was also a commissioner of the Royal Gunpowder and Saltpeter Administration, and much of his gunpowder had been stored in the Bastille.

Other than those works, however, the images on view were much as one would expect from previous Salons. Joseph-Marie Vien exhibited *Love Fleeing Servitude,* one of his typically charming allegories involving an airborne Cupid. Jean-Baptiste Regnault's equally typical *Deposition,* a work of austere piety now in the collection of the Louvre, made its debut on this occasion, as did several of David's most illustrious compositions, among them *The Lictors Bring to Brutus the Bodies of His Sons* and *Paris and Helen,* both of which now hang in the Louvre's Salle Daru. Although attendance numbers for these annual Salons were not taken, we know how many catalogs were sold. The number for 1789 was 18,200, a drop of more than 15 percent from the 22,000 sold two years earlier, but only slightly lower than in the two Salons before that: it is a fair guess that this drop was related to the recent convulsions in the capital. If we assume one catalog for every three people who attended, then roughly fifty-five thousand members of the public, a perfectly respectable figure, visited the exhibition in the four weeks of its run.

In due course, however, as the Revolution expanded and its implications grew more apparent, the art of the Salons became more assertively political. In the Salon of 1791, David displayed the preparatory sketches for his *Oath of the Jeu de Paume*, depicting the moment when the members of the constituent assembly, having gathered in Versailles, vowed not to disband until they had written a constitution. Two years later, he did not present any work at the Salon, although, in the neighboring Cour Carrée, he did exhibit his great *Death of Marat*, depicting the assassination, scarcely a month earlier, of the famous revolutionary. As for the Salon of 1795, David was again absent, this time for the excellent reason that he was imprisoned following the fall of his ally Robespierre. By the end of the decade, the exhibition's flattery of the ascendant Bonaparte was manifest and unapologetic. Even before his coup d'état, his bust appeared in the Salon of 1798, while the Salon of 1801 included Baron Gros's *Bonaparte on the Pont d'Arcole* and Regnault's *Death of General Desaix* (commemorating one of Bonaparte's most trusted deputies).

<div align="center">✳ ✳ ✳</div>

No part of Paris witnessed as many of the Revolution's great events as the Quartier du Louvre and the area just beyond it, stretching from the revolutionary clubs of the Palais-Royal west to the guillotines of the place de la Concorde. Across the street from the Louvre, in the courtyard of the Palais-Royal, the orator Camille Desmoulins, on 12 July 1789, leapt up on one of the tabletops of the Café de Foy and incited his fellow citizens to take up arms against the crown. A few blocks west, the Jacobins conspired in what is now the Marché Saint-Honoré, while their adversaries, the more moderate Feuillants led by the Marquis de Lafayette, met in a monastery a few blocks

further west, on what is now the rue de Castiglione. The two factions would initially come together in fierce debate in the Manège, formerly a royal riding academy that stood just south of the monastery, on what is now the rue de Rivoli, opposite the Tuileries Garden.

In early October, about a month and a half after the storming of the Bastille, a famine seized the capital. The women of Paris, escorted by General Lafayette and twenty thousand soldiers of uncertain loyalties, marched on Versailles, eleven miles to the west, to present their grievances to the king. Amid flaring tempers, the royal family was induced to return to the capital. By the time they arrived at the Tuileries, they found that it had changed greatly. Under high ceilings, makeshift mezzanines accessed by makeshift stairways had been slapped together and fitted with makeshift stove pipes and doorways. To complete the degradation, the odor of cooking and privies wafted through the halls, and clotheslines were strung from windows whose glass panes, as often as not, had been knocked out and replaced by oiled parchment or old newsprint.

Suddenly everyone had to clear out to make way for the royal family and the multitudinous court that was descending on Paris in a train of nearly a thousand carriages. Since there was not enough space for all of them in the Tuileries and the Louvre Palaces, lodgings were found in the Grande Galerie, in the stables of the Grande Écurie and, across the river, in Les Invalides. Once inside the palace, Louis was periodically brought to the windows of his apartment to wave to the crowd of gawkers who had gathered in the Jardin des Tuileries. Marie Antoinette—according to ancient protocol—occupied the floor beneath him, while their children were placed in the *appartement de la reine* on the ground floor of the southern half of the Tuileries. There were only two children now, since the dauphin, Louis Joseph, had died only three months earlier at the age of seven—it had not been an easy year for the royal couple. Other members of the royal family found lodging in the Pavillon de Flore

and the Pavillon de Marsan, at the western end of the Louvre.

For the next two years, the royal family were virtually prisoners in the palace. And it was from the Cour des Princes, between the Pavillon de Flore and the site of the present Arc du Carrousel, that the royal family tried to escape on the night of 20 June 1791. The plan called for the Comte de Fersen, a Swedish aristocrat dressed as a coachman, to pick up the royal children and their governess in a carriage too ramshackle to arouse suspicions. From there he would continue to the rue de l'Échelle, a few hundred feet northeast of the palace, where the king and then the queen, disguised as their own servants, would arrive separately. Their plan was to travel to Varennes and slip unobserved into Flanders. The children were successfully evacuated, and the king, together with his sister, Madame Royale, joined them as planned on the rue de l'Échelle. But Marie Antoinette lost her way amid the labyrinth of medieval streets that stood between the Tuileries and the Louvre and so, confused and afraid, she reached the carriage two hours late. That delay was their undoing: the duc de Choiseul, who was supposed to meet them with a squadron of hussars near the border and escort them out of the country, assumed that they were not coming and left his post. When they finally reached Varennes without guards, they were identified by the locals and returned, under duress, to the Tuileries.

A few months later, the monarchy of France, as it had existed for eight centuries, ceased to be. Louis would continue to function as king, but as of 4 September 1791, he was no longer the king of France, the sovereign embodiment of the French state, but rather the king of the French, and thus a servant, however exalted, of the French people. According to the same logic, the Louvre and the Tuileries, which had been designated as *les bâtiments du roi* (the buildings of the king) became *les bâtiments de la nation*. Even though the two architects charged with maintaining the Louvre and the Tuileries,

Maximilien Brébion and Jean-Augustin Renard, retained their posts, the very decrepitude of those buildings (combined with the fact that their long-debated union was still unachieved) was taken as proof of the culpable incompetence of the old order. As the oratorical Betrand Barère charged: "The Louvre and the Tuileries are monuments of greatness and of indigence. The genius of art has traced their contours and raised their façades, but the dissipating indifference of several kings and the towering avarice of many ministers have disdained to bring them to completion."[1] Accordingly several projects were drawn up at this time for the completion of the Louvre complex. The most interesting, in that it presaged what eventually came to pass, was by Jacques Guillaume Legrand and Jacques Molinos. Their plan proposed—hardly for the first time—a new northern wing corresponding to the Grande Galerie to the south. As importantly, their paired-down architectural language anticipated the form in which that wing would eventually materialize, fifteen years in the future, under the imperial architects of Napoleon I.

Tensions between the king and the legislature came to a head on 11 June 1792, as the latter was deliberating in the nearby Manège: Louis vetoed first the legislature's decision to exile refractory priests and then its attempt to establish a military camp just beyond the borders of Paris. He feared that these forces might be used against the citizens. In response to his vetoes, a mob of *sanscullotes*, members of the Paris working class, showed up before the garden façade of the Tuileries Palace and tried to pry open the wrought-iron gate separating the public part of the garden from the king's private garden. At that point, on the other side of the palace, the king's *cannoniers* defected and turned their weapons against the eastern gates. As the citizens poured into the Tuileries, they found the king cowering beside one of the windows of his first-floor apartment. They compelled him to drink a toast to the health of the nation while he wore the red bonnet of the Revolution.

Remarkably, the palace sustained no damage on this occasion. That would not be the case two months later. On 10 August 1792, amid rumors that munitions were being amassed in the Tuileries to use against the people, the *sansculottes* armed themselves again as they approached the palace from the west. There they were met by a contingent of four thousand members of the National Guard, Swiss Guard and gendarmerie. As the Swiss Guard began to fire on the mob, the king was compelled to sign an order for them to stand down. At this point the *sansculottes* poured into the palace once again, provoking a melee that resulted in the death of 380 of their members and twice as many of the palace guards. While the western façade of the Tuileries sustained little damage beyond a few bullet holes, the lodgings of the Swiss Guard on the eastern side were burnt to the ground. Traces of the charred remains came to light during the excavations of the 1980s. In all, nearly 1,200 men died on that one day at the southern end of the Louvre.

But that was only the beginning of the violence. On 21 January 1793, Louis was beheaded in the place de la Revolution (today's place de la Concorde), opposite the entrance to the Hôtel de Crillon. The guillotine had been set up near where we now find the statue of a seated female figure from fifty years later, representing the city of Brest. Marie Antoinette died in the same place and by the same means nine months later, on 16 October. In the thirteen months of the Reign of Terror—from June 1793 to the end of July one year later—more than 2,600 men and women were thus executed in the place de la Revolution. And if Louis Capet, as the king was known, was one of the very first to suffer this fate, one of the very last was the author of the Terror himself, Maximilien de Robespierre, who was decapitated on 28 July 1794, exactly a year and a day after he had achieved his malignant eminence.

✳ ✳ ✳

There was a curious continuity between the cultural ambitions of the *ancien régime* and those of the revolutionary order that replaced it. More than a century later, the Soviets would make a point of repudiating what they saw as the effeteness of Old Russia, with its Fabergé eggs and Gallic manners. But relatively little of that antagonism can be found—at least at a cultural level—between the old and new orders of revolutionary France. Coypel and Boucher, the standard-bearers of rococo, had become anathema to some of the more radical painters of the latest generation, and, as we have seen, spitballs, discharged by the students of the *académie*, menaced the surface of Watteau's *Pèlerinage à l'île de Cythère*. But the austerely neoclassical idiom that reached its apogee in Jacques-Louis David had been fostered and widely admired in the Salons of the *ancien régime*, and all sides appear to have been in general agreement regarding the future of art and especially of the Louvre as an art museum.

David, the Jacobin ally of Marat and Robespierre, foresaw the Louvre as a nursery for the future greatness of French art: from the floor of the assembly, he enjoined its members "to call forth the spirits of the great masters. May their learned and immortal masterpieces speak powerfully and constantly to the artist inflamed with a love of his art!"[2] In this he was scarcely less vehement than d'Angiviller, who, in the dying days of the old order, had fought so valiantly to transform the Louvre into a temple of art.

In any discussion of the Louvre's future role as a museum, however, the prevailing opinion was that the palace should be occupied not just by the visual arts, but also by governmental ministries and learned societies. Indeed, this position dominated all discussion of the subject until the Ministry of Finance finally left the northern part of the Louvre in 1993. But this point of view was expressed most clearly on 26 May 1791, when, after half a century of debate, delay and dashed hopes, the constituent assembly issued the momentous

decree that formally transformed the palace into the museum that we know today: "The Louvre and the Tuileries," the decree read, "will be united to form the National Palace, intended for the inhabitation of the King and for the gathering of all the monuments of science and art and the principle establishment of public instruction." Around the same time, scores of smaller museums were projected throughout the country in many of the provincial departments.

The Louvre's initial designation as a *muséum* rather than the now standard French *musée* attests to how novel the word and even the concept still were. In its first half century or so of existence, the Musée du Louvre, as it is known today, would change its name several times. It would be known as the Musée Napoléon, the Musée Royal and the Musée Napoléon III before it assumed its present name. At its birth, however, it was the Musée Central des Arts.

Whatever high-flying phrases attended the foundation of the Louvre Museum, the man tasked with putting them into action, in effect its first director, was Jean-Marie Roland de La Platière, a pragmatist of few words. Belonging to the more moderate Girondin wing of the National Convention, he was determined to have the museum up and running as soon as possible. Given their differing personalities and politics, it was inevitable that Roland would eventually come into conflict with the radical David. Whereas David was mainly concerned that the art be made available to other artists, Roland insisted that "it should be open to everyone and everyone should be able to place his easel in front of any painting or sculpture he chooses." He saw the opening of the museum in frankly political terms: "I believe that the museum will have so great an effect on people's spirits, will so elevate their souls and so stir their hearts, that it will be one of the most powerful means of illuminating the French Republic."[3]

As Roland's words suggest, the creation of the Louvre Museum was an event at once exuberantly populist and unapologetically

elitist. It aspired to bring the highest visual culture into the public realm, which necessarily included the lowest rungs of society. All visitors were welcome as long as they comported themselves with dignity: they had to be sober and under no condition must they try to poke the canvases. It was implicitly assumed that something enriching and ennobling would come from being in proximity to five hundred of the finest paintings ever made. At the same time, and for the same reason, neither the curators nor the public itself would have ever assumed that there was any point in exhibiting popular art or art of the second rank: only the best would do.

And yet, few museums in the world ever opened in more perilous circumstances than the Louvre on 8 November 1793. The date was chosen to coincide with festivities celebrating the new constitution. At the same time, the Reign of Terror was in full swing: in what amounted to a coup d'état, the Montagnards began arresting members of the Girondin faction and would soon start executing them, even as they were now executing aristocrats in the place de la Concorde. Meanwhile, reactionary unrest in the Vendée had turned into a full-blown civil war and, beyond the Rhine, the united armies of the old order were marshaling against the young republic.

There was nothing at all beautiful about one's arrival at the new museum. Passing through a labyrinth of irregular streets, the visitor entered the Cour du Louvre, still full of ramshackle houses and shops. From there one moved through a long, ill-lit passageway before entering what is now the Cour du Sphinx and ascending the narrow stairway that Maximilien Brébion had designed a generation earlier to facilitate access to the annual exhibitions in the Salon Carrée.[4] The museum, of course, was far smaller than it is today, occupying only the half of the Grande Galerie that is closer to the Louvre Palace. It was separated from the western half, closer to the Tuileries, by a makeshift partition. Once visitors reached the actual galleries, they found them to be far more somber than what we see

today. Because the glass ceilings that had been planned would not be completed for another decade, the art was so poorly lit that it could be fully appreciated only on the brightest days. In his *Interior View of the Grande Galerie* from about 1795, Hubert Robert, perhaps the best source for how the museum looked at its inception, depicts the galleries in a way that hardly seems inviting: there was no ornament along the walls, and low wooden fences separated the public from the art. The darkened vault of the gallery was painted a somber bluish-gray, the lateral walls, a dull slate green. Although light filtered in from both sides of the Grande Galerie—these side windows would be mostly suppressed during the 1850s—the strong glare on sunny days made it harder to see the paintings: because they were hung Salon style, usually three high, a close inspection was almost impossible.

Gabriel de Saint-Aubin's view of the Salon of 1753, in the Salon Carré of the Louvre. The stacking of paintings six high is associated with these periodic exhibitions and is accordingly known as "Salon Style."

In addition to the 538 paintings on view, 48 sculptures were hauled up from the depot in the Salles des Antiques, just beneath the Salon Carré: all but nine were ancient or modern portrait busts, reflecting the imperial Roman coloration of the age. The *Mona Lisa* was still in Versailles—having not yet achieved anything like the transcendent status it would acquire at the end of the next century—but another of Leonardo da Vinci's female portraits, *La Belle Ferronière,* was on view. So too were Raphael's *La Belle Jardinière* and *La Grande Sainte Famille,* Veronese's *Pilgrims at Emmaus,* Le Brun's *Family of Darius at the Feet of Alexander* and Guido Reni's three depictions of the labors of Hercules. Thus although all painting genres were represented, history painting, still deemed the most prestigious, predominated in the new galleries.

The Louvre was not open to the public every day. Working with the Republican calendar promulgated in 1793, the directors of the museum divided each month into three ten-day periods. In each of these, the museum was open to artists for the first five days, followed by two days of closure, dedicated to maintenance of the premises, and then three days when the public was allowed to visit, from nine o'clock in the morning to seven o'clock in the evening. Sixty veterans of military campaigns were assigned duty as guards, not only to ensure the safety of the works of art, but also to make certain that no one entered the museum in an intoxicated state or with a dog, and that children were not separated from their parents. An attempt was also made to keep visitors moving generally in the same direction. Above all, the guards were needed to protect the art, often images of the repudiated, reactionary Roman Church and portraits of the discredited nobility. These were a likely, even legitimate target for the sort of revolutionary zeal that, until recently, had been openly encouraged by the council itself.

Not many months after the Louvre's inauguration, the Vicomte de Roland, together with many other Girondins, became the subject

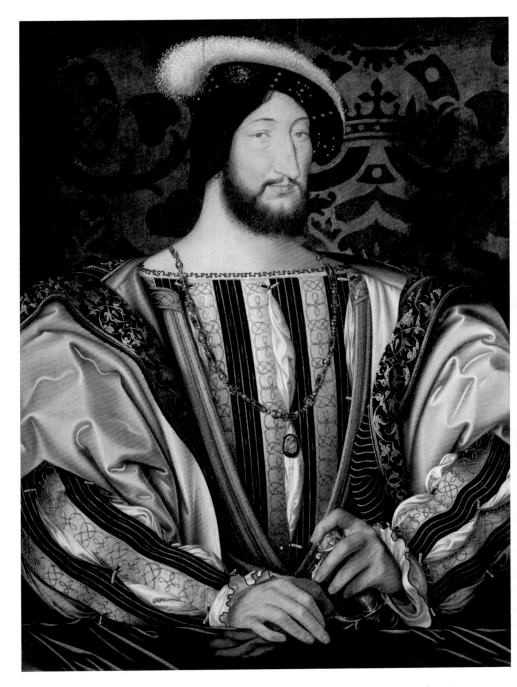

Jean Clouet's *Portrait of François I* in his mid-thirties, from around 1530.

Illustration of the month of October from the *Très Riches Heures du Jean, Duc de Berry*, circa 1414. In the background is the earliest known image of the Louvre after its transformation into a palace under Charles V (ruled 1364–1380).

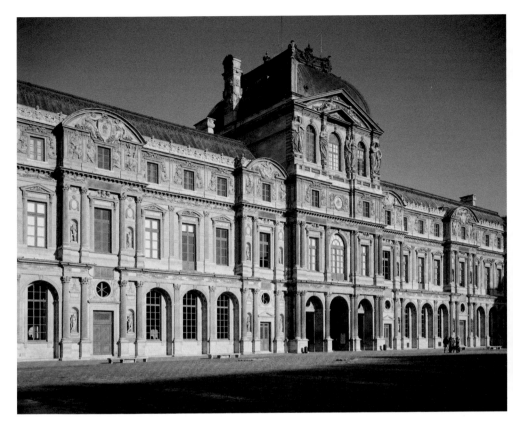

This image depicts the earliest portions of the Louvre that remain above ground: on the left the Aile Lescot, begun by François I, c. 1547, and on the right the Pavillon de l'Horloge (also called the Pavillon Sully) and the Aile Lemercier, both from the reign of Louis XIII, c. 1640.

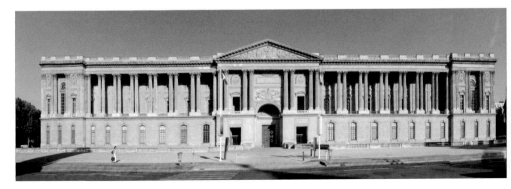

The Colonnade, the eastern entrance to the Louvre, was completed in the 1670s, under Louis XIV, according to designs by Claude Perrault.

Veronese's *Wedding Feast at Cana* (1562–3). The largest canvas painting in the Louvre, it was plundered by Napoleon from the church of San Giorgio Maggiore in Venice in 1797.

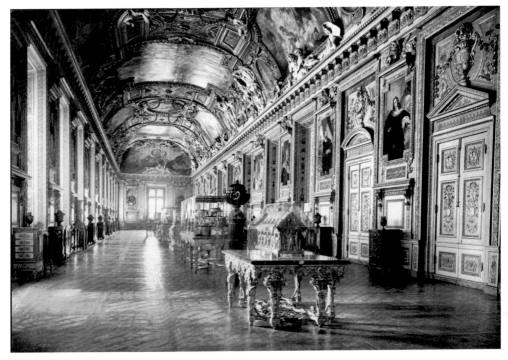

The Galerie d'Apollon, on the first floor of the Petite Galerie, was conceived in its present form by Charles Lebrun in 1661 and completed by Félix Duban in 1851.

The Appartement du Ministre, designed by Hector Lefuel in the mid-1850s.

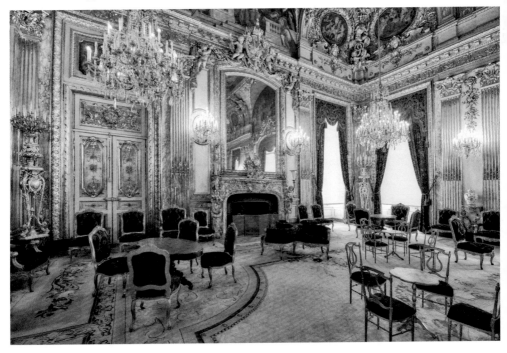

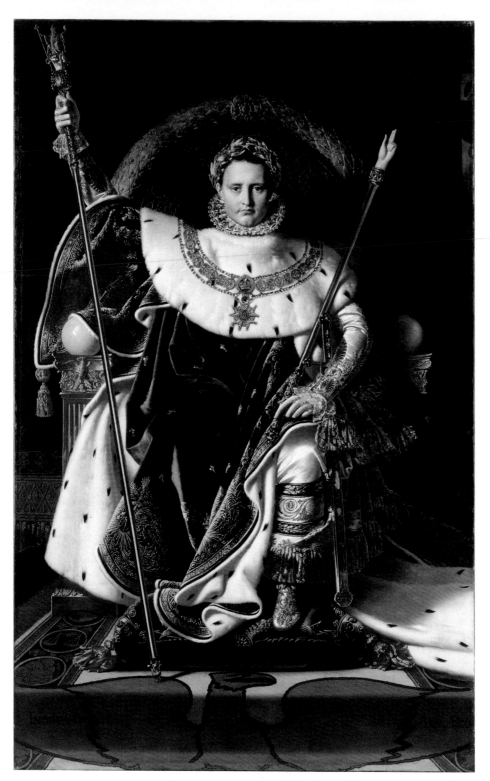

Napoleon I on His Imperial Throne, completed by the twenty-six-year-old Jean-Auguste-Dominique Ingres in 1806.

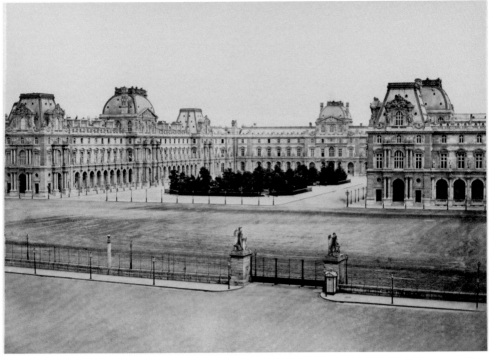

Édouard-Denis Baldus's image of the newly completed Nouveau Louvre around 1857, taken from an upper floor of the Tuileries Palace.

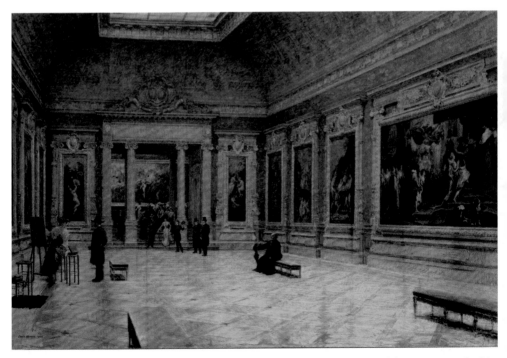

A view of the Pavillon des Sessions by Louis Béroud in 1904. Conceived by Hector Lefuel in the 1860s, this room is seen after Edmond Guillaume redesigned it around 1890 to display Rubens's Marie de Médicis cycle (1622–25).

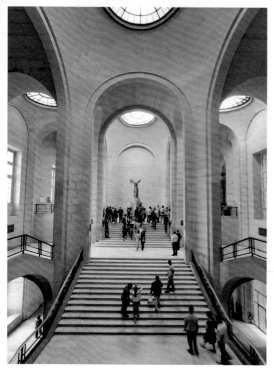

The Escalier Daru, formerly the Louvre's grand entrance, as redesigned by Albert Ferrand in 1934, with the *Winged Victory of Samothrace* at the top.

The Hall Napoléon, completed by I. M. Pei in 1989, is the main entrance, directly beneath the Pyramide, to the Grand Louvre of François Mitterrand.

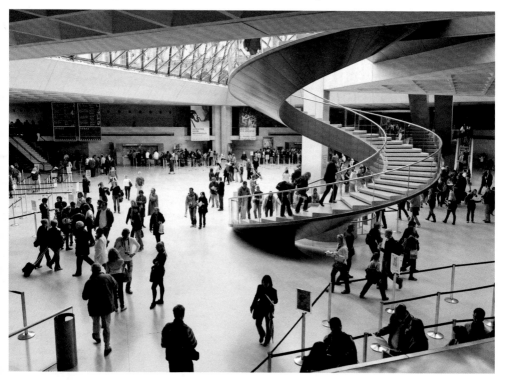

of persecution by the now triumphant Montagnards of the Jacobin faction. Roland took his own life, while his politically active wife was sent to the guillotine. The painter David, a close associate of Max-imilien de Robespierre, assumed Roland's place as director of what would become known, between 1794 and 1797, as the Muséum National des Arts. A committed revolutionary, David oversaw the suppression of the Academies of Architecture and of Painting and Sculpture, which he saw as bastions of the old order. He made other changes, however, that were less ideological. Because doubts had emerged regarding some of the restoration work on paintings in the collection, especially Raphael's *La Grande Sainte Famille*, David established a new conservatory to oversee such procedures. But his tenure proved brief: during the so-called Thermidorean Reaction, which began on 27 July 1794 with the execution of Robespierre and other Jacobin leaders, the more radical members of the Louvre were removed and, in the case of David, arrested. Their positions were filled by such stalwart artists of the *ancien régime* as Hubert Robert, the architect Charles de Wailly, the sculptor Augustin Pajou and Fragonard (who had also served under David). Each of these members of the Louvre's inchoate staff was compelled to learn, as he went, lessons that no previous schooling or experience could pos-sibly have imparted. For even if the Louvre was not the first art museum in history, it was one of the first and it was surely the largest ever created.

And yet, despite the convulsive circumstances that attended its creation, the success of the new museum was immediate. As the annual or biennial Salons had proved, the Parisian public felt a great pent-up hunger for visual culture. Although a similar appetite existed for literature and theater, opera and dance, that appetite had long been satisfied—for a certain price—within the existing struc-tures of Parisian cultural life. But the ability to see art, especially great art, was far more limited, if not impossible beyond the Salons.

There was the modest open-air exhibit of art in the place Dauphine, as well as the annual display of paintings that the Goldsmith Guild had commissioned for the Cathedral of Notre-Dame. And of course there were the many altarpieces that could just be made out in the darkened corners of the local churches. But most of this work, in addition to its generally middling quality, was French, fairly new, and somewhat limited by its ecclesiastical subject matter. The incomparable collection of the duc d'Orléans had indeed been displayed in the Palais du Luxembourg, but that was nearly twenty years in the past. And despite the fact that Paris possessed some of the finest art collections in Europe, they were accessible almost exclusively to the well-born: the students of the academy, to say nothing of the general mass of society, rarely saw any of them.

But when the Louvre finally opened on 8 November 1793, all of that changed. For the first time, any man or woman in Paris could stand before some of the loftiest examples of human artifice ever assembled in one place. It is easy to imagine the powerful effect that the public felt, before the age of photography, on encountering for the first time the beauties of the Florentine High Renaissance, the sinuous mannerism of Correggio and Parmigianino, the brooding human depths of Rembrandt van Rijn.

A few years later, on 15 August 1797, the Louvre initiated a practice, almost inadvertently, that would prove to be of the highest importance to the future of museums throughout the world. A special and temporary exhibition opened in the Galerie d'Apollon, consisting of 427 drawings from the museum's collection, arranged according to schools and specific artists. Although this exhibition was presented as nothing more than a collection of drawings brought before the public, it may well be the first example of the sort of special exhibition that now stands at the core of what most museums, including the Louvre, do and are, enabling them to reinvent themselves from one season to the next.

The Louvre's influence was felt in other ways as well. For the past two hundred years, the institution has been so intimately associated with art that we tend to overlook the important role it played in the birth of the World's Fair exhibitions that we know today. The *Exposition des produits de l'industrie française* (The Exhibition of the Products of French Industry) was held for two consecutive years, 1801–1802, in the Cour Carrée, as a direct ancestor of all those universal expositions that would draw worldwide attention in the latter years of the nineteenth century and that gave us, among other things, the Eiffel Tower in 1889. To accommodate the exhibition, long wooden colonnades were set up in the four corners of the Cour Carrée, recalling the porticoed walkways of ancient Athens and Rome.

* * *

In the time of Napoleon Bonaparte, the Louvre was made up of two great, separate and unequal kingdoms. The first and more important consisted of the grand tradition of European painting, essentially the painting of Italy, France and the Lowlands from the time of Raphael down to the work of contemporary artists. The second kingdom was the collection of antiquities: this meant, in theory, the sculptures of Greece and Rome, but in practice the sculptures only of Rome; Greece remained a largely undiscovered country at the end of the eighteenth century, and the golden age of archaeology—in which the Louvre played so prominent a role—was still several generations in the future. Napoleon chose two men, Vivant Denon and Ennio Quirino Visconti, to shape the institutional development of the Louvre, the former overseeing its paintings, the latter its ancient sculptures.

The most visited part of the modern Louvre is the Aile Denon, named in honor of Dominique Vivant, Baron Denon (1747–1825),

whom Napoleon Bonaparte chose to be the first director of the museum: occupying the Louvre's southern half, the upper story of the Aile Denon, in addition to comprising part of Grande Galerie, dates to the 1850s and displays the museum's Italian paintings from 1300 to 1800, as well as the larger French paintings of the early nineteenth century. Denon, in addition to being an able draftsman and engraver, also achieved renown as a writer and art critic. Long before the demise of the *ancien régime*, he had earned a minor literary reputation from a brief work of fiction, *Point de Lendemain*, a tale of youthful amorous adventure. While serving as a diplomat in Italy, Denon nurtured his deep understanding of visual art. Bonaparte met him through his wife Josephine and was sufficiently impressed that he asked Denon to join his Egyptian campaign. Denon was officially part of the literary and artistic section of the Institut d'Égypte, a learned society that Napoleon formed to study the culture of ancient Egypt, which, until then, had been almost entirely unknown to the West. The result of Denon's participation was the two volume *Voyage dans la basse et la haute Égypte* (Journey in Lower and Upper Egypt), which is often credited with sparking that taste for Egyptomania that conquered much of Europe in the first quarter of the nineteenth century.

But above all else, Denon was a compulsive collector who, both in his private and official capacities, passed through life acquiring all manner of oddments. Anatole France attested to this voracious, all-conquering appetite in a vivid description of Denon's apartment at No. 7 Quai Voltaire, directly across the Seine from the Grande Galerie. His taste in the old masters was astonishingly broad for that time, embracing everyone from Ruysdael and Giotto to Fra Bartolomeo and Guercino. "The good man had kept them with much taste and no preference," the author relates.[5] Denon also collected Chinese porcelain and Japanese bronzes, a fifteenth-century reliquary, the ashes of Heloise (beloved of Abelard), a few hairs from

Robert Lefévre's portrait of Vivant Denon (1747–1825), director of the Louvre from 1802 until Napoleon's fall in 1815.

the moustache of Henri IV, some bones of Molière and La Fontaine, a tooth of Voltaire and a drop of Napoleon's blood.

Such being his acquisitiveness, one is not surprised by how zealously Denon raided the palaces, monasteries and private homes of Europe in his determination to enhance the holdings of the Louvre, which he directed from 1801 until the fall of Napoleon in 1815. Denon ingratiatingly suggested that the Louvre be renamed the Musée Napoléon, and so it was until the regime's collapse. Even tombs were not safe from Denon, who soon came to be known as the *aquila rapax,* the rapacious eagle. Although most of the art he seized was eventually returned to its rightful owners, following Napoleon's defeat at Waterloo, some of the best works, among them Giotto's *Saint Francis Receiving the Stigmata*, remain in the Louvre to this day.

There was no province of art that did not engage the universalizing instincts of Vivant Denon, but his duties at the Louvre were

focused almost exclusively on European painting from the Italian primitives to the nineteenth century. The other half of the Louvre's mission, in practice if not in theory, was to display Greek and especially Roman antiquities. This field called upon the unrivaled expertise of Ennio Quirino Visconti (1751–1818), who had distinguished himself in his native Rome by cataloging the collections of the Museo Pio-Clementino in the Vatican. If Denon was an aesthete and an impresario of sorts, Visconti was a scholar and archaeologist who had conducted pioneering excavations at the Tomb of the Scipios in Rome and at the Villa of Hadrian, just outside the city. A native Roman himself, Visconti rose quickly through the ranks: after his pioneering research on the antiquities in the Museo Pio-Clementino, he became curator of Rome's recently formed Musei Capitolini. When Napoleon invaded the city in 1798, he exiled the pope and established the short-lived Republica Romana. Visconti, who had long harbored republican sympathies, became one of its six consuls. But when the papacy was restored in 1800, Visconti fled to Paris, where he spent the rest of his life, arranging the Louvre's collection of ancient art, the Musée des Antiques. Half a century later, his son, the architect Louis Visconti, would devise the master plan for the Nouveau Louvre of Napoleon III.

* * *

Of the Louvre's many paintings by Hubert Robert, none is more disconcerting than his *Imaginary View of the Grande Galerie in Ruins* from 1796, which depicts the building as a classical desolation, recalling the Palace of Domitian on the Palatine Hill in Rome: the entire roof of the Grande Galerie has been shorn off to reveal open sky, while the ground is littered with fallen debris, and peasants wander among shattered antique torsos. But in the center of the picture is a

puzzling sight: a young artist sketches the *Apollo Belvedere*, among the finest sculptures to survive the fall of Rome and one of the most famous works associated with the Vatican Museums. Why it should appear in a scene of Paris, even one as fanciful as this, becomes clear in another painting by Robert, perhaps from the same year, *The Draftsman of Antiquities*. Here the viewer encounters another part of the Louvre (the modern Cour du Sphinx) mercifully intact, again with the *Apollo Belvedere* and other ancient masterpieces, among them *The Old Centaur*, which is indeed part of the Louvre's collections. The sculptures, including the one of Apollo, are displayed with no ceremony and in no order, for this is an accurate depiction of the warehouse that the Louvre had become. Robert was content to act as a journalist, dutifully recording what he saw in front of him. This work bears witness that the French Republic (which was initially in such financial straits that it had to extract gold threads from the tapestries of François I) would soon overrun Europe, pillaging as it went and conveying its ill-gotten booty directly into the galleries of the Louvre. Although most of these works would ultimately be returned, such restitution was still twenty years in the future: for now, the Louvre became the greatest repository of art, ancient and modern, that the world had ever seen or would ever see again.

By fair means and foul, these treasures accumulated in the chambers of the Louvre. Scarcely one hundred days after the storming of the Bastille, the constituent assembly voted, on 2 November 1789, to nationalize the property of the clergy. A year later, on 1 December 1790, that same body passed another law calling for important cultural artifacts to be removed from churches and convents and, soon enough, from the homes of those members of the nobility who had escaped into exile (or were subsequently executed). By the middle of that decade, more than thirteen thousand works had been seized from the collections of ninety-three aristocrats. Among these were two royal princes, Philippe Egalité, duc d'Orléans and the Prince of

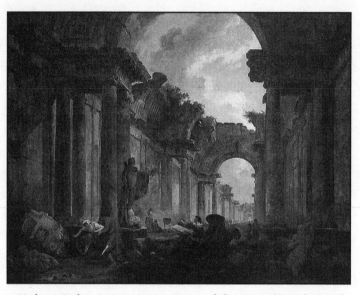

*Hubert Robert's Imaginary View of the Grande Galerie of
the Louvre in Ruins (1796), painted amid an ongoing debate
about how to adorn the gallery. Napoleon seized the* Apollo
Belvedere, *in the center, from the Vatican, to which it would
be returned twenty years later.*

Condé, as well as such renowned collectors as the Baron de Breteuil,
the duc de Brissac and Charles de Saint-Morys, whose collection of
French, Italian and Northern drawings was said to number more
than twelve thousand. The labels beside many of the paintings in the
Louvre bear witness, even today, to the predations of two centuries
past. Next to the provenance one finds the words *saisie révolu-
tionnaire*, or revolutionary confiscation. Each of those works was
acquired through an act of aggression mitigated only by the emulsi-
fying passage of years. The works thus confiscated were then placed
in depots around the country. In Paris itself, two of these depots
stood on the Left Bank: the Convent of the Petits Augustins, whose
remains were subsequently integrated into the École des Beaux-Arts
on the rue Bonaparte, and the Hôtel de Nesle, which stood directly
across the Seine from the Louvre and no longer exists.

But at least these treasures were valued and spared. Religious sculptures and liturgical objects fared far worse. The medievalism that dominated European taste for much of the nineteenth century and that was so integral to the rise of nationalism was not yet the cultural force it would soon become. For now, neoclassicism reigned supreme and expressed itself in a virulent anticlericalism. Many of the finest works of medieval sculpture, among them the western portal of Notre-Dame de Paris, were damaged or obliterated as the citizens vented their hatred of the church. The royal tombs at Saint Denis—six miles north of Paris's modern boundaries—were ransacked and all the bones scattered. The tombs themselves, masterpieces of the French Renaissance and a matter of relative indifference to the attackers, were sometimes spared, but such bones as could be retrieved were relegated to a mass grave.

As always in such assaults, gold chalices and jeweled robes were nothing more than expensive objects that could be profitably melted down or otherwise monetized. Some few of these religious heirlooms, especially those that were deemed of essential value to the French nation, survived the onslaught. A sword named *Joyeuse*, thought to be the one that Charlemagne carried into battle and that was afterwards used to crown the kings of France, arrived at the Louvre in 1793 and remains there to this day. Whatever its origins, it underwent numerous modifications over the centuries and would soon do so again: when Napoleon I crowned himself emperor in 1804, he insisted not only that *Joyeuse* be part of the ceremony, but also that it bear his initial, N. When he in turn was exiled in 1814, the restored Bourbon king, Louis XVIII, replaced that noxious letter with the fleur-de-lis, the traditional emblem of the French monarchy.

Today the sword belongs to the Louvre's Département des Objets d'Art, as does another masterpiece of medieval art that was seized from the treasury of Saint Denis early in the revolution. This is the so-called *Vase d'Aliénor*, a vase that Abbot Suger of Saint Denis

gave to Louis VII in the first half of the twelfth century and that eventually came into the possession of Eleanor of Aquitaine. The body is formed from solid rock crystal, while its silver-gilt neck and base are encrusted with jewels. Even more imposing, perhaps, and surely better known, is the porphyry vase known as *Suger's Eagle*, mounted in gold around the mouth, body and base, in such a way as to suggest the head, wings and talons of an eagle. These three masterpieces of medieval art resisted the usual fate of jewel-encrusted golden objects only because they were understood to be of supreme historical consequence.

These seizures took on an almost industrial dimension when, a few years later, the armies of France—mostly under Bonaparte, but even before him—overran the kingdoms and principalities of Europe and then advanced into Egypt and the Levant. Indeed, these military campaigns may be unique in the history of warfare in that their goals had almost as much to do with the acquisition of visual art as with the conquest of territory. If the seizure of fine art had been one of the inevitable consequences of the ancient Roman campaigns, now it was nothing less than the stated aim and policy of the French high command. The Comité d'Instruction, the body convened to oversee the seizure of precious art, ordered the creation of what it politely called *agences d'évacuation* and *agences d'extraction*, which essentially oversaw the removal of all portable economic and cultural assets from the conquered nations. The Comité d'Instruction further advised that "artists and learned literary men be sent in secret, following in the footsteps of our armies . . . and carefully remove monuments of art and science and bring them into France."[6]

One of the most vociferous advocates of this policy was Jean-Baptiste Wicar, a rather middling neoclassical painter who had studied under David and now applied the most twisted logic to justify such wholesale rapacity: "Liberty commands us to confiscate the remains of [Rome's] splendor. It is for us that time has preserved them. . . .

Only we can appreciate them."[7] Another of David's pupils, the even less gifted Jacques-Luc Barbier, vindicated such pillaging in the name of both civilization and humanity itself. In accordance with the universalizing logic of the *Déclaration des droits de l'homme* (The Declaration of the Rights of Man), he contended that "the immortal works left to us by Rubens, Van Dyck and the other founders of the Flemish School are no longer in a foreign land. Brought together with care by the representatives of the people, they have now been deposited in the fatherland of art and inspiration, in the fatherland of liberty and sacred equality, in the French Republic."[8]

Translated into action, this lofty oration resulted in pulling down and carting away two large altarpieces, *The Raising of the Cross* and *The Descent from the Cross,* from the Cathedral of Our Lady in Antwerp. These were the work of Peter Paul Rubens, an artist especially admired by the French and thus especially in their crosshairs. He was but one of many Flemish artists whose works were seized, together with those of Van Dyck, Jordaens and Rombouts. Next the French forces swept through Holland, seizing nearly two hundred paintings from the collection of the *stathouder* Frederic William V, Prince of Orange, after he fled their advancing armies. The rapacity of the French extended to architecture itself: the Palatine Chapel in Aachen, one of the most perfectly preserved monuments of the age of Charlemagne, was despoiled of its *verde antica* columns. Several of these were integrated into the interior architecture of the summer apartments of Anne of Austria, where they remain, unnoticed and all but unacknowledged, to this day.

But the real goal of the French armies, at least in regard to cultural booty, was Italy, and Rome most of all. "If our victorious armies penetrate into Italy," wrote Abbé Grégoire, a Catholic priest and ardent revolutionist, "then the seizure of the Apollo Belvedere and the Hercules Farnese would be the most brilliant conquest. It is Greece that decorated Rome: but should the masterpieces of the Greek republics

adorn a country of slaves? The French Republic ought to be their ultimate resting place."[9]

On 2 March 1796, Napoleon Bonaparte, a twenty-six-year-old soldier who, three years before, had done the state some service at the blockade of Toulon, was placed at the head of the Army of Italy. On a personal level, Napoleon appears to have quickly acquired a taste for art. Less than two months after his promotion, by which point he had already conquered much of Italy, he wrote: "In the treaty we have just concluded, I had wanted to include a beautiful painting by Gerrit Dou, owned by the King of Sardinia, but I didn't know how to work it into an armistice." He needn't have worried. Another general, Bertrand Clauzel, heard of this wish and, some two years later, he acquired the painting for the Louvre, where it remains to this day. Soon Napoleon invaded the Veneto, where he seized Mantegna's *Virgin of Victory* and Carpaccio's *The Preaching of Saint Steven*, both of which remain in the Louvre, having never been returned.

While in Venice Napoleon removed the four horses from the façade of the Basilica di San Marco and sent them to Paris. To be sure, six centuries before the Venetians themselves had stolen the horses from Constantinople's Hippodrome during the Fourth Crusade. These horses were destined to sit in Paris for more than a decade, atop the Arc du Carrousel and flanking a statue of Napoleon dressed in antique robes (they have since been replaced with reproductions). Also in Venice, Napoleon carted off Veronese's *Wedding Feast at Cana*, which, at twenty feet high and more than thirty feet across, is the largest painting on canvas in the Louvre, dominating the south end of the Salle des États and facing the *Mona Lisa*. From Venice the Grande Armée descended into Rome, where it made off with Raphael's late masterpiece, *The Transfiguration*, as well as Poussin's *Martyrdom of Saint Erasmus*, the *Apollo Belvedere*, the *Laocoön*, the *Capitoline Brutus* and much besides. The army commanders, aided by the scholars in their train, seem to have

had an unerring instinct for all that was most beautiful or, failing that, most famous and valuable.

It took time, however, for these treasures from Rome and the Veneto to reach Paris. The fastest route, surely, was sailing around Spain and up the Atlantic Seaboard, but this was also the riskiest path, given the perils of the ocean. And so, the precious cargo passed from Civitavecchia to Marseille, hugging the shore all the way. From there it traveled up river along the Rhône, Saône and Loire among others. Once they reached Paris, on 27 July 1797, these master-works were assembled into perhaps the most astounding spectacle the world had ever seen. As had been customary in the triumphal processions of ancient Roman generals, these imperial spoils were drawn by the thousands along the quays of the Left Bank from the Jardin des Plantes to the Champs de Mars. Together with live lions, bears and camels, the great bronze horses of Saint Mark, together with the *Laocoön*, the *Apollo Belvedere* and hundreds of paintings and rare works of silver and gold, were carried into the fields where, nine decades later, the Eiffel Tower would rise.

Here a wooden Altar of Liberty had been set up for the occasion. Despite its temporary nature, it was a large and imposing struc-ture whose two curving porticoes, inspired by Bernini's Saint Peter's Square, flanked a curving, central grandstand. Before the grandstand stood an equestrian statue and, below that, in stunning isolation, the so-called *Capitoline Brutus*, one of the finest bronze sculptures to survive the fall of the ancient world. Made probably toward the beginning of the first century before Christ, it was taken from the Capitoline Museums in Rome (where, following its return, it can still be seen today). Although there is no reason to suppose that it depicted either of the two historical Brutuses, the fact that both had dispatched tyrants in the name of liberty and the Roman Republic proved enchanting to the citizens of revolutionary France. And as these treasures progressed through the city, panels—once again in a

strict reenactment of Roman republican precedent—described them to the populace. One panel informed the throng of onlookers that "Greece gave them up and then Rome lost them. Their fate has changed twice before. It will not change again."

This triumphalism infected the new museum as well. The birth of the modern museum around 1800 also saw the birth of the modern museum label. In this as in so many other respects, the Louvre was a pioneer, even though it sometimes struggled to find its way. Regarding the *Apollo Belvedere*, for example, Ennio Quirino Visconti's label informed visitors that "[Pope Julius II] had it transported to the Belvedere of the Vatican where, for three centuries, it won the admiration of the Universe. Thereupon a hero [Napoleon Bonaparte], guided by victory, came to remove it and to place it forever beside the banks of the Seine."[10]

If these astounding acquisitions initially inspired the greatest excitement and pride, the backlash came soon enough. The renowned critic and theoretician Antoine Quatremère de Quincy wrote a tract titled "Letters on the Damage Caused to the Arts and to Science by the Removal of the Art of Italy, the Dismembering of Its School and the Despoiling of Its Collections, Galleries and Museums, etc." In it Quatremère de Quincy expressed his belief that "the spirit of conquest in a republic is entirely subversive of the spirit of liberty." For all his eloquence and principles, however, he did little to change minds. Despite his persuading fifty eminent men of culture to undersign a letter of protest, one of Napoleon's cronies, Gaspard Monge, dismissed them all as nothing more than "little dogs barking at the chariot of a victor."[11]

Although Denon had signed one of Quatremère de Quincy's petitions, he seems to have changed his mind when, several years later, he was placed at the head of the Louvre. Few public figures were more zealous in acquisition than Denon. After the Battle of Ulm, in 1805, had given Napoleon control over much of the region

north of the Rhine, Denon wrote to him that "there should be in France some trophy of your victories in Germany," and he suggested, among much else, paintings of the German school, "in which the Museum is completely lacking."[12] Accordingly, Napoleon seized 299 paintings from the collection of the Elector of Hesse and more than 150 from the Museum Fridericianum. In the space of eight months, he sent south along the Rhine more than 850 paintings, hundreds of ancient statues, as well as countless drawings and entire collections of medals and ivories.

By the time Napoleon turned his sights upon the Holy Roman Empire, the Austrians were well aware of Denon's rapacity and had sent many of their treasures east to Hungary for safekeeping. Even so, Denon made off with nearly four hundred paintings, including Pieter Bruegel the Elder's great *Winter* and the *Wedding Feast*, now in Vienna's Kunsthistorisches Museum.

Spain, which Napoleon initially conquered in 1808, presented different problems. During the first phase of the Peninsular War, he had given the Spanish throne to his older brother, Joseph, who suddenly proved reluctant to part with the masterpieces that had fallen so suddenly and pleasantly into his possession. But that did not stop Denon from trying. Again he wrote the emperor, in much the same terms as he had regarding Germany, seeking "to add to the collection [of the Louvre] twenty paintings of the Spanish school, in which the museum is completely lacking, and which would be for all time a trophy of this latest campaign."[13] He himself could not be there to select them, and the list of three hundred paintings, drawn up by Francisco de Goya, among others, ultimately disappointed him. Although these included three works by Francisco de Zurbarán from the Cartujo of Jerez, as well as Antonio de Pereda's fine *Dream of a Knight*, Denon dyspeptically wrote that "one can easily see by the choice how easily His Majesty, the King of Spain [Joseph Bonaparte], was duped by the people he charged with the selection."

Although the booty from Germany, Austria and Spain had been won within a context of war, Italy, by the time Denon arrived, had already been pacified for a decade and thus could present no plausible pretext for further rapine. And yet, on 13 September 1810, three imperial decrees went forth ordering the suppression of monasteries and convents in Liguria, Piedmont and Tuscany, as well as other regions. And so Denon descended upon the conquered lands and set to work. As a meager testament to his restraint he volunteered that "I shall never ask for the works of painters who are already in the museum, my goal being to find the works of artists who are very rare and not to dispossess the cities of all of their paintings."[14]

There were two important consequences of these seizures. One had to do with the science of art restoration. Many of the works were treated in the studios of the Louvre, which was at the forefront of this essential new discipline. "The fame and quantity of works that came into the hands of the Louvre's teams," write the authors of the *Histoire du Louvre*, "contributed to perfecting the techniques [of restoration] and promoted a better appreciation of the role of the restorer." Indeed, when the seized paintings began to return to their rightful owners after Waterloo, many of the owners were pleasantly surprised to find them in such good condition. The director of the museum of Brunswick, Johann Frederich Ferdinand Emperius, commented that his paintings had returned in a state "that was certainly no worse, and in some cases far better, than the state in which they left us."

The second noteworthy consequence was a new, even revolutionary, appreciation of the Italian primitives, a term which, early in the nineteenth century, included everyone before the High Renaissance, from Botticelli as far back as Giotto and Duccio. Today, when these artists are counted among the pinnacles of Western painting, it is hard to imagine with what indifference, if not distaste, they were viewed in the generations between Raphael and Vivant Denon.

Such fifteenth-century painters as Filippo Lippi, Andrea Mantegna and Sandro Botticelli exhibited skills in composition and perspective that were comparable to those of Raphael and his contemporaries, and so they were tentatively acceptable to the taste of the *ancien régime*. But what was one to make of the true primitives, Cimabue and Barna da Siena and Simone Martini, whose seemingly crude and schematic renderings in two-point perspective or no perspective at all must have appeared almost savage to eighteenth- and early-nineteenth-century viewers? For the Parisian public, the revelation of such works must have seemed as shocking and uncanny as that of Pablo Picasso's *Demoiselles d'Avignon*, with its aesthetic of African masks, almost exactly a century later.

In 1814, Denon displayed examples of these "primitives" in a massive exhibition that is not entirely unknown to art historians, although its incalculable importance in Western culture has been misunderstood or overlooked. Although it was devoted primarily, but not exclusively, to the earlier Tuscan school—Giotto, Cimabue and the like—in fact, many later painters were included. Some of these artists, like the Sienese mannerist Domenico Beccafumi, were younger Italian contemporaries of Raphael. But the exhibition extended its purview even further to contain the seventeenth-century Spanish baroque masters Zurbarán and Ribera. The common quality in this exceedingly heterogeneous mix was that the paintings, taken together, represented all that had been excluded from the official narratives of Western art for nearly three hundred years. The introduction to the show's catalog explained that "a large part of the paintings in this exhibition consist of works prior to the High Renaissance, elevated to its highest point of splendor by Raphael, Titian and Correggio."

The author of the catalog—presumably Denon himself—cajoled and flattered the visitor into receptivity to these unusual, and therefore possibly offensive, works: "There is reason to believe that the austerity of the primitive painters will have little attraction for those

viewers who, having been raised on a particular type of perfec-
tion, admire only those objects that seem to correspond to it. . . .
But the true connoisseurs who, always few in number, can discern
the real value of each object, will surely find the greatest interest in
a chronological sequence of paintings that offers them the means to
study the most original works of the history of art and the march
and development of the human spirit."[15] For the first time that we
know of in any land or at any time, art was being brought into the
public realm precisely because it differed from anything that most
of the public had ever seen before and because it ran contrary to
everything that that public had been taught to admire. This one
exhibition surely did not cause, but it just as surely reflected, a great
shift in Western culture: it represented the first moment in which
that change became manifest. The selfsame quest for what is new,
perhaps radically new, continues to define the art that is being made
today and the very language in which we speak about it.

* * *

During the decade of its fleeting existence, France's First Repub-
lic was too busy fighting for its life to devote any part of its scant
resources to the beautification of the Louvre. But by the time Napo-
leon seized power as First Consul in 1799—thus ending the Republic
and the Revolution in one blow—conditions had stabilized to the
point where such projects could be contemplated. Decisive in all
things, Napoleon now undertook the completion of the Louvre com-
plex nearly a century and a half after Louis XIV had abandoned
it, leaving it in a state of perilous suspension. Although these two
rulers differed in almost every respect, they shared the conviction
that governing was stagecraft on the grandest of scales and that
there was no greater stage than a palace or an entire city. Even if

Napoleon, like his predecessors, failed to unify the Louvre and the Tuileries, he was the first to undertake the great northern pendant to the Grande Galerie, the endeavor that his nephew Napoleon III would bring to completion half a century later. In the meantime, he contributed greatly to the Louvre's physical and institutional growth as a museum and, through the same process, he fundamentally transformed the center of Paris into what we recognize today. Napoleon, like Louis XIV, had more respect for buildings, especially large and impressive buildings, than for the finer points of architecture. "*Ce que je cherche avant tout, c'est la grandeur,*" he once said, adding, "*Ce qui est grand est toujours beau*": "What I seek before all else is grandeur. Whatever is grand is always beautiful."[16] But there is something fundamentally untranslatable in the emperor's use of the French word *grandeur*, which can mean *grandeur* or, simply, *bigness*. He appears to have had both of these meanings in mind.

His first intervention in the museum was modest in scale, but important: he ordered the creation of a new and grander entrance, leading to the antiquities on the ground floor of the Louvre and to the paintings on the floor above. Before this addition, visitors entered the museum through the cluttered and uninviting courtyard that is now the Cour du Sphinx, at the eastern end of the Grande Galerie, a makeshift entrance to what was still a makeshift museum. Thanks to this new intervention, however, visitors for the first time could enter the museum in style through the Rotonde de Mars, the northernmost part of the Petite Galerie, created by Louis Le Vau in 1655.

Jean-Arnaud Raymond, the architect in charge of this revision, changed little of Le Vau's façade other than to furnish it with a severe lintel supported by two Doric columns, in keeping with the neoclassical taste of the time. Such changes, however, have left no trace, since the exterior was altered again during the massive building program undertaken by Napoleon III in the 1850s. But the interior of the Rotonde de Mars remains largely as Raymond left it,

with a new painting on the ceiling, Jean-Simon Berthélemy's *Man Formed by Prometheus, or the Origin of Sculpture*, later retouched by Jean-Baptiste Mauzaisse. Paintings were also added to Romanelli's seventeenth-century originals in the summer apartments of Anne of Austria, directly south of the Rotonde de Mars. Such, then, was the meager record of the consulate's interventions in the palace and museum of the Louvre.

But that was little more than a prologue to the far more extensive changes that Napoleon would make after he became emperor in 1804. Most of this subsequent work was carried out by his court architects Pierre Fontaine and Charles Percier. Working as a team, they were among the most prolific Parisian architects of the first half of the nineteenth century and they fully embodied the Empire phase of neoclassical design. They had studied together at the Académie des Beaux-Arts, and thereafter they lived and worked in such close alliance that the two men are buried together in Père Lachaise Cemetery. Their association with the Louvre began in 1801, when they fortified the Tuileries Palace, demolished buildings in the place du Carrousel, and installed a gate between it and the Cour des Tuileries directly to the west. By 1804, Fontaine, aided by Percier, was made the official architect of the Louvre and the Tuileries, a position that he held, astonishingly, for almost half a century until he retired in 1848, with all his faculties intact. He was so long-lived that although he began his career under Louis XVI, by the time he died at ninety-one, he had lived to see the beginnings of Baron Haussmann's transformation of Paris and Louis Visconti's transformation of the Louvre.

Napoleon expected great things from Percier and Fontaine. In 1810, with the birth of his son and only legitimate child, Napoleon conceived of an immense palace, equal in size and splendor to the Louvre, that would overlook the Colline de Chaillot, where the Palais du Trocadéro now faces the Eiffel Tower in the Sixteenth

Arrondissement. Although the plans were drawn up and ready to go, Napoleon was deposed before the work could ever begin. By this point, however, Percier and Fontaine had already effected great changes to the Louvre and the area around it, especially the area directly north of the Tuileries Garden. Much of today's First Arrondissement, the core of modern Paris, is a direct consequence of this initiative. Five convents stood directly north of the Tuileries Garden, from which they were separated by a simple wall of compacted dirt for the entire half mile from the place de la Concorde to the Pavillon de Marsan. Percier and Fontaine began by piercing the southern part of these properties with a broad avenue known as the rue de Rivoli, in honor of one of Napoleon's earliest Italian victories. The architects replaced the dirt wall with the elegant wrought iron gates we still see today, and, on the northern side of the street, they designed a seemingly endless arcade whose Spartan structures rose three stories over an arcaded base, with two penthouse levels added later. In the process, the architects razed two important buildings that stood in the way of the new avenue, the royal stables and royal riding academy, which had served as the legislative chamber of the First Republic. But the new avenue had extended only as far as the rue de Rohan when the emperor fell from power, and it would not reach its ultimate destination in the Marais for another half century.

Among the many tasks that Napoleon assigned Percier and Fontaine, certainly not the least was providing a roof for those parts of the Cour Carrée that had stood exposed to the elements since the 1660s. The pair also completed the work that Soufflot had begun half a century earlier to bring the northern and southern façades of the interior courtyard—whose exterior shells had been completed by Louis Le Vau one and a half centuries before—into conformity with the eastern wing; the western wing, the masterpiece of Pierre Lescot and Jacques Lemercier, remained largely unaltered. In this way, the Cour Carrée assumed the form we see today, not only through the

aforementioned architectural enhancements, but also through an extensive sculptural program on the north, south and east wings, in a reverent, if not quite exact, imitation of Jean Goujon's friezes for the Aile Lescot.

One of Percier and Fontaine's earliest and most important projects at the Louvre was the construction, starting in 1804, of the *galerie neuve*, or new gallery, the northern pendant to the Grande Galerie that had been dreamed of since the days of Charles IX nearly 250 years before. This addition faithfully reproduced the appearance of the Grande Galerie. But here the architects ran into a problem: since that earlier structure consisted of two very different halves, they had to choose which to reproduce. As they began all the way in the west and worked eastward (that is, from the Pavillon de Marsan in the direction of the Cour Carrée), they decided that the south-facing side of the new structure should reproduce Androuet II du Cerceau's original from around 1610. Clearly its elegant giant-order pilasters, spanning the entire façade, were congenial to French neoclassical taste. Ironically, du Cerceau's original was torn down in the 1860s, leaving only Percier and Fontaine's western half to remind us of what was lost. In any case, here again Percier and Fontaine had barely reached the halfway mark—the Pavillon de Rohan—when Napoleon was defeated at Waterloo and all work ceased. Today, the eastern half of the northern wing is part of the Louvre Museum, while the western half has been occupied since 1905 by the Musée des Arts Décoratifs, an entirely autonomous institution.

Percier and Fontaine had a much freer hand on the new structure's northern façade, fronting the rue de Rivoli. There is a very clear stylistic break between their building and its continuation, half a century later, under Hector Lefuel. The juxtaposition—one could almost say the collision—of the two styles expresses the conflict between the severe neoclassicism of the First Empire and the extravagant mannerism of the Second. There is something unlovely

about Percier and Fontaine's façade; indeed, it may be the least suc-
cessful part of the entire Louvre complex. Heavy in mural presence,
sober in design and now darkened by decades of exhaust fumes, it
instantly deflects any interest or affection. Although it aspires to the
same Spartan austerity as the rue de Rivoli itself, it has just enough
ornament to betray that avenue's noble simplicity. On its two main
levels, the rounded tops of the ground-floor windows harmonize
with the curved niches on either side of them, but clash with the
more austere design of the windows directly above them. The result
is an awkward rhythm across several hundred meters of the rue de
Rivoli. And the fact that the niches west of the rue de l'Échelle never
received their intended statues only accentuates the dreariness of this
stretch of Paris.

But Percier and Fontaine's talents, though surely distinguished
in architecture, were more evident in their interior designs. Few
architects made greater contributions to our experience of the Lou-
vre, of standing before the paintings and sculptures themselves. In
the fullness of time they would be responsible for the spatial articu-
lation of the Grande Galerie that we see today, as well as the design
of the Musée Charles X and the Collection Campana in the south-
ern wing of the Cour Carrée, together with the grand stairways at
either end of the Colonnade at the eastern end of the palace. Percier
and Fontaine loved rich polychrome marble designs—supremely
in the Arc du Carrousel—but they suppressed that preference in
the Colonnade stairways, surely out of respect for the solemn dig-
nity of Charles Perrault's monochromatic masterpiece. Largely
identical, these two stairways present an uninterrupted length
of wall whose pale stone is allowed to speak for itself, while the
regimented balustrades, Corinthian pilasters and paired columns
enhance that sense of sobriety. The only important ornaments are
the reliefs of male and female forms—personifications of commerce
and the spirit of war among them—mingling with the Olympian

gods. To most visitors, this splendid décor will appear to be just another stairway, and if they are indifferent to the architects, they will surely be indifferent to the sculptors who designed the friezes. And yet two of these northern bas reliefs are well worth acknowledging. They are the work of Barthélémy-François Chardigny, who was working on them on 3 March 1813, when he fell to his death from one of the scaffolds.

In 1806, Napoleon ordered the removal of all the artists, artisans and shopkeepers who had occupied the lower level of the Grande Galerie for fully two centuries, since its construction under Henri IV. Their removal was deemed necessary for several reasons, not least the self-evident fact that the Louvre was now performing a vastly greater public role than it had even a generation before, when its only function was to welcome visitors to the biennial Salon. Given this press of new visitors, the old stairway that Maximilien Brébion had created in the 1750s seemed woefully obsolete. In its place, Percier and Fontaine created, between 1807 and 1812, one of their finest works, a grand entrance to the museum that rose from the Rotonde de Mars to the point where we now find the *Winged Victory of Samothrace*, before it diverged, as its more recent replacement also does, towards the Galerie d'Apollon on the left and the Salon Carré on the right. Most of this great passageway has vanished, but enough remains to provide a powerful sense of its former splendor. Between the Escalier Daru and the Salon Carré stand three rooms, the Salle Percier, Salle Fontaine and Salle Duchâtel, which are reserved for Italian Renaissance frescoes: their décor is the very embodiment of the Empire style and an implicit rejection of the Republican severity that this pair of architects had displayed on the rue de Rivoli. One enters these spaces through polychrome Serlian arches with black Tuscan columns and capitals etched in gold. These columns support vaulted ceilings with reliefs and paintings set in gilded frames, while a checkered black-and-white marble

floor spreads out beneath one's feet. Just before entering the Salon Carré, visitors pass under *The Triumph of French Painting: Apotheosis of Poussin, Le Sueur and Le Brun*, a mural completed by Charles Meynier in 1824. Although few tourists will notice it as they rush to see the Quattrocento masterpieces in the next room, its nationalistic message would have been lost on none of Meynier's contemporaries.

The issue of how to make the Grande Galerie, nearly half a kilometer in length, visually coherent and appealing had defeated many generations of architects and artists, starting with Louis XIII's ill-fated attempt to have Poussin paint all 460 meters of the ceiling. Given its staggering length, especially relative to its narrow width, this space is without parallel in Western architecture. It seems prodigiously long even today, despite the fact that one sees only about half of its true length: the western half was divided from the eastern half through the creation of the Pavillon des Sessions under Napoleon III in the 1860s. Percier and Fontaine, inspired by an earlier plan of Charles Wailly, created six paired arches to span the width of the gallery, supported on either side by paired Corinthian columns of red marble. The problem with these interventions, which remain in place today, is less their inherent quality than their relative scarcity; they stand too far apart from one another to generate that sense of energetic continuity that was clearly sought. Far more successful is Percier and Fontaine's treatment of the Galerie des Batailles in Versailles (designed thirty years later for King Louis Philippe), despite its being only half the length of the Grande Galerie.

Percier and Fontaine had greater success in 1808 with the design of the Arc du Carrousel, which stands about a thousand feet west of the *Pyramide* and forms part of that spectacular axis that stretches to the Arc de Triomphe, three miles away. The two arches were conceived at the same time, and largely in commemoration of the same events, Napoleon's victories in Austria, even though the far larger Arc de

Triomphe, designed by Jean Chalgrin, was not completed until 1836, long after Bonaparte's defeat, exile and death. As we see it today, the Arc du Carrousel has been stripped of the original context that defined it, and rises in isolation beside the vehicular traffic to the east. Initially, however, its effect would have been very different: it stood just beyond the rue Saint-Nicaise, which coincided with the medieval fortification torn down under Louis XIII. The Arc du Carrousel was intended to demarcate the Cour des Tuileries, which was part of the palace, from everything to the east. It was so positioned that anyone entering or leaving by the gate was compelled to pass under it.

The arch commemorates, specifically, the Battle of Austerlitz (1805), Napoleon's single most important and strategically brilliant

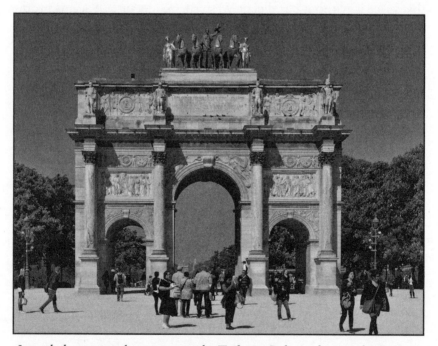

Intended as a grand entrance to the Tuileries Palace, the Arc du Carrousel was created between 1806 and 1808 by Charles Percier and Pierre Fontaine. The arch was originally crowned by a statue of Napoleon, flanked by the four horses of the Basilica di San Marco in Venice.

victory, which ended the so-called War of the Third Alliance waged against Russia and Austria. Among the friezes integrated into its surface are *The French Army, Embarking at Boulogne, Threatens England*; *The Kingdoms of Bavaria and Wurtemburg Are Created*; and *All of Italy Submits to the Laws of Its Liberator* (i.e., Bonaparte himself). This monument was based on the ancient Roman arches of Septimius Severus and Constantine in or near the Roman Forum. Here, as in those antecedents, two smaller arches flank a tall central arch, although the addition of lateral entrances to the outer arches appears to have no Roman precedent. Facing east and west, eight Corinthian columns on tall pedestals are crowned with life-sized sculptures of soldiers from Bonaparte's Grande Armée. The bright, pinkish shafts of these columns, however, quarried in the Caunes-Minervois region of Southern France, reveal a chromatic boldness entirely foreign to surviving Roman models. Finally, on the roof of the arch stands a chariot in which the classically robed embodiment of truth is drawn by four splendid horses, with a similarly draped female form on either side. Originally the four horses were those that Napoleon had taken from the Basilica di San Marco in Venice, and the charioteer was none other than Napoleon himself, dressed in classical attire. After Waterloo, however, Napoleon was deposed and the horses returned to Venice, but not before the sculptor François Joseph Bosio created, in 1828, the copies one sees today. One final design of Percier and Fontaine deserves mention: the Chapelle de Saint-Napoléon. Consecrated to a made-up saint in a tentative first step toward creating a new imperial cult, it stood directly opposite the Rotonde de Mars. But it had not progressed very far when Napoleon was deposed, and it has now been integrated into the Cour de Khorsabad.

- 7 -

THE LOUVRE
UNDER THE RESTORATION

If the Musée Napoléon—as the Louvre was known in the days of Bonaparte—glowed with the borrowed brilliance of its imperial plunder, the Musée Royal that succeeded it seemed, at least initially, to be a sad and dreary place, now that most of that plunder had been returned to its rightful owners.

Thirty-three convulsive years and three undistinguished kings stood between Napoleon's defeat at Waterloo and the improbable rise to power of his nephew, Louis Napoléon Bonaparte, in 1848. These years, however, would prove to be of vital importance in the institutional evolution of the Louvre. Following the disastrous Russian campaign of 1812, the allies of the Sixth Coalition offered Napoleon generous terms of surrender that would have enabled him to remain emperor. But he delayed in accepting their offer and it was soon withdrawn. After the Battle of Leipzig in October of 1813, however, the terms of surrender were far less favorable. In this bloodiest of all Napoleonic conflicts, forty-five thousand Frenchmen perished or were gravely wounded and twenty-one thousand more were captured. Napoleon's own generals mutinied, compelling him to abdicate at Fontainebleau on 4 April 1814. Yet even then the terms offered by the victorious allies were relatively generous, at least regarding the art that Bonaparte had systematically plundered: the Treaty of Paris on 30 May made no provisions at all for restitution of this stolen art. As Napoleon's chief architect, Pierre Fontaine, wrote in his journal,

215

"Yesterday the [Russian] Emperor Alexander visited the Tuileries, the museum and the Louvre [i.e., the Cour Carrée]. The King of Prussia was here the day before. I accompanied both sovereigns. . . . I think that their affability is an auspicious sign. Already the city of Paris can take great comfort in their clemency."[1]

After Napoleon's defeat, the Bourbon monarchy returned to power, first under Louis XVIII (1814–1824) and then under Charles X (1824–1830), both of them brothers of the executed Louis XVI. At the beginning of this Bourbon Restoration—despite what was announced publicly—Louis XVIII began secret negotiations regarding the return of the plundered art, as long as it did not belong to the Louvre or the Tuileries. Over the vigorous objections of Vivant Denon—whom Louis would soon fire—thirteen crates of art were returned at once to the Duke of Brunswick, while the great linguist and philosopher Wilhelm von Humboldt negotiated the restitution of one hundred sculptures and forty paintings to the king of Prussia. In general, however, the matter of restitution was not pressed too vigorously, since the princely stakeholders were delighted to witness the defeat of the revolutionaries and the restoration of the Bourbons. As for the reinstated king, now that he found himself in possession of the finest art collection the world had ever seen, he suddenly proved resistant to the idea of restitution. "The glory of the French armies," he declared, "remains undiminished. The monuments of their valor endure and the masterpieces of art belong to us hereafter through rights more stable and more sacred than those of victory."[2]

But the clemency and patience of the allies largely vanished during the so-called Hundred Days, that brief interval between Napoleon's return to power on 20 March 1815 and his catastrophic defeat at Waterloo on 8 July. Even if such rights seemed—to Louis, at least—to be more sacred than those of victory, the rights of victory began mightily to impress the allies who had just decimated

the Grande Armée. General Friedrich von Ribbentrop—an ancestor of Hitler's foreign minister of the same name—reached Paris at the head of the Prussian army and marched into the Louvre to demand full restitution of the plundered art. He even threatened Denon with imprisonment if he did not comply. At the same time, another Prussian general, Gebhard von Blücher, arrived with his armed cohorts to bear away the plunder stored in the royal palaces of Compiègne, Saint-Cloud and Fontainebleau. Presently the German principalities of Brunswick, Mecklenburg, Schwerin, Bavaria and Hesse-Kassel demanded restitution as well, followed by Spain, the Netherlands and Austria, with its Italian satellites. Because some of the Louvre's greatest trophies—the *Laocoön*, the *Apollo Belvedere* and Raphael's *Transfiguration*—had technically been acquired through the Treaty of Tolentino (despite its being signed under extreme duress), the pope dispatched the renowned sculptor Antonio Canova to retrieve them, aided by a contingent of English and Austrian soldiers. Regarding this protracted process of restitution, the critic and novelist Stendhal, in an astounding display of moral obtuseness, expressed his belief that, in fact, the French were the true victims. Having visited Canova's studio in Rome a few years later, he made the extraordinary claim that the Italians "stole from us what we had won by treaty. But Canova wouldn't see reason. Raised as he was in Venice under the previous dispensation, the only right he could understand was that of force: treaties were nothing more to him than an empty formality."[3]

Some of the works were deemed too fragile to be sent back—oddly, since they had not been too fragile to reach Paris in the first place—and in such instances an exchange was improbably offered and even more improbably accepted. In this way, Veronese's *Wedding Feast in Cana* (from the refectory of San Giorgio Maggiore in Venice) remained, and remains, in the Louvre, while the Accademia in Venice received in compensation Charles Le Brun's *Meal in the*

House of Simon, surely one of that artist's best works, but hardly a fair trade. Through this concern for the safety of the objects, the Louvre held onto Giotto's *Saint Francis Receiving the Stigmata* and Fra Angelico's *Coronation of the Virgin*. Denon could do nothing but look on and complain, eloquently but ineffectually, that "this assemblage of the efforts of the human spirit throughout history, this flaming chapel in which talent was endlessly judged by talent, this light, in fine, that leaped perpetually through contact with all the most gifted artists, has now been extinguished, extinguished beyond recall!"[4] By 15 November 1815, more than five thousand paintings, sculptures and objets d'art, the majority of the works seized since 1794, had been restored to their rightful owners.

Thus, when the Louvre finally reopened on 24 April 1817, in celebration of the third anniversary of Louis XVIII's entry into Paris, its galleries were blighted by empty spaces that had to be plugged with works that Napoleon had purchased from Camillo Borghese, the husband of his sister Pauline. The Salle du Laocoon no longer contained the *Laocoön*, which had been returned by then to the Belvedere Octagon in the Vatican. Plaster casts were installed in some of the galleries, most notably casts of the Elgin Marbles, which the British Museum had acquired the previous year. These plaster casts were established museological practice at the time, and no whiff of insufficiency or fakery applied to them, as might be the case today; still, the irony of their presence in the Louvre could hardly have been lost on visitors. But a still crueler irony was the commissioning of casts of the four *Horses of San Marco*, which had once occupied the glorious summit of the Arc du Carrousel, but had now been sent back to Venice.

* * *

If restitution was the first issue that the Bourbons had to address at the Louvre, scarcely less important was the removal of any and all traces of Bonaparte's regime. On the Colonnade, all the *N*'s were thus replaced with the paired *L*'s (for Louis XVIII) that we see today. In a frieze carved into its central pediment, Napoleon's bust had appeared on an altar before which classically robed maidens paid honor to him: the Bourbons, perhaps in the interests of economy, thought better of removing this frieze altogether and limited themselves to covering Napoleon's idealized head with a sculpted wig that transformed him into Louis XIV, as he remains to this day. Bonaparte's statue atop the Arc du Carrousel was, of course, immediately removed. This monument was so galling to the Bourbons that, when Louis XVIII first returned to the Tuileries after Napoleon's initial abdication in 1814, he arrived by the side entrance of the Pavillon de Flore because he refused to pass under the Arc du Carrousel. Two years later he ordered Fontaine—its architect—to demolish the structure, but ultimately was satisfied with several modifications to its friezes and inscriptions. For all their diligence, however, the Bourbons could not catch everything: in the southern pavilion of the Cour Carrée, one can just make out carved bees, one of Bonaparte's emblems, coexisting with groups of paired *L*'s.

At the same time as they were removing these offensive traces of Bonaparte, the Bourbons commissioned and installed a host of unapologetically royalist works. A fairly typical example is Merry-Joseph Blondel's allegorical painting of *France in the Midst of French Legislators and Legal Scholars, Receiving the Charter from the Hands of Louis XVIII* on the ceiling of the former Salle des Séances du Conseil d'État in the Aile Lemercier. (In this depiction, France is personified by a woman.) Other works in the same chamber, such as Paul Delaroche's *Death of President Duranti* and Antoine Thomas's *President Mole on the Barricades*, despite their historicist references,

carried a pressing and very contemporary message by honoring the earlier Parisian parlement's resistance to mob rule.

All of these changes, however, were cosmetic and superficial. With regard to the museum's staffing and its governing philosophy, a deep continuity existed between Napoleon's Louvre and that of the resurgent Bourbons. Obviously, Vivant Denon had to go, since he was far too closely associated with Bonaparte, but that was not the case with the other curators and the rest of the staff. Percier and Fontaine, Napoleon's court architects, stayed on, and work on the sculptural adornment of the Cour Carrée, initiated by Napoleon, continued with little interruption under his royal successors.

For most of the Restoration and for the first two years of the July Monarchy, from 1816 to 1832, the director of the Louvre was Comte Auguste de Fourbin, who instituted changes that enhanced the visitor's experience in important ways. Today we expect museums to be open, if not every day, at least most days. Such was not the case in the first quarter of the nineteenth century, when the Louvre was open to the public only on Sundays, with access being granted to staff and students during the rest of the week. Toward the end of his reign, however, Louis XVIII ordered that it be open to the public on Friday and Saturday as well. Fourbin also enlivened the galleries, which had traditionally been rather drab, by covering the walls with colored fabrics from the royal factory in Beauvais: crimson predominated in the Flemish and Italian rooms, blue in the French rooms and green in the various *salles des antiques*. All of them, crucially, were accented with the fleur-de-lis. Another enhancement was the simple matter of seating: benches and tambour seats, made of polished walnut, were now introduced for the comfort of visitors. Space, however, remained a problem: whenever the Salon was on view, much of the collection had to be temporarily removed.

The guards, generally nameless and unsung, were essential to the functioning of the institution: usually dressed in military attire,

*A depiction of Père Fuzelier, one of the
earliest guards of the Louvre. Attributed
to Jacques-Louis David.*

they not only protected the works of art, but also ensured that the
museum was kept clean. They swept the galleries and stairways,
dusted off the statues and even, when necessary, moved the paint-
ings. A touching portrait in the Louvre's collection, attributed to
the school of David, is thought to depict an older guard known as
Le Père Fuzelier. In the portrait, he sits in a simple wooden chair
against a darkened backdrop, his rumpled dark blue uniform high-
lighted with gold braid, a scarlet vest and a white cravat. At the time
when this was painted, around 1805, there were thirteen guards.
That number increased steadily as the museum expanded, so that by
the reign of Louis Philippe, the guards numbered sixty-seven men.
Their wives, meanwhile, were charged with the sale of the invaluable
guidebooks: since wall texts and labels were generally lacking, these
alone provided visitors with the title and author of each work.

* * *

Today the Louvre is a universal museum, or nearly so; it displays the art of many cultures and many lands, although not all. From the very inception of the institution, this universalism has been essential to its stated mission. But in practice, the Louvre was really dedicated, at least initially, to only two forms of visual culture, Roman sculpture and old master paintings. During the Restoration, however, the museum's collections not only became far larger, but also began to embrace other, non-Western cultures, those of ancient Egypt and Assyria, for example, and of Islam.

In theory, a number of early museums had been universalist, mainly in the sense that they lacked focus and, being cabinets of curiosities more than anything else, they put on view whatever entered their collections: such was the case with the early British Museum and the Ashmolean in Oxford. At the dawn of the modern museum, specialization had not yet evolved in any important way: the Accademias of Venice and Bologna mostly contained Venetian and Bolognese art respectively, not out of any desire to celebrate local masters, but out of the simple necessity that such works were the ones most likely to come their way. The transcendent, almost arrogant ambition of the Louvre—to serve not only as repository but also as arbiter of the collective visual culture of mankind—must be appreciated in this light. Such had indeed been its stated ambition from its foundation in 1793, but only with the Bourbon Restoration did its curators undertake to display the totality of art systematically and in depth.

The first half of the nineteenth century was the period of Europe's great cultural awakening to a world vastly larger, more varied, and more interesting than anyone could have imagined only a generation before. When the Louvre was first established as a museum, most of its curators and visitors would have implicitly endorsed David Hume's precept that "mankind are so much the same, in all times and places, that history informs us of nothing

new or strange in this particular. Its chief use is only to discover the constant and universal principles of human nature."[5] Obviously one could see with one's own eyes that not all visual cultures were the same, but this inconvenient fact was sidestepped by dismissing as inconsequential anything before Raphael that was not Roman or Greek. But in the next generation two great revolutions occurred in the West's relation to its past. The first, connected to the rise of nationalism in politics and of Romanticism in art, favored the particular over the universal, in a complete rejection of Hume and the tradition he embodied: Western Europeans began to seek out the most irreducibly specific elements of their own past, which in 1820 meant the Middle Ages. Instantly allied to this historical conviction was the corresponding geographical quest for hard data about other cultures, from Siberia to Tierra del Fuego. It is no accident that this age saw, simultaneously, the birth of archaeology and anthropology. One can hardly exaggerate the revolutionary nature of this shift in human consciousness. Literally one generation before, in the initial throes of the Revolution, Frenchmen had violently destroyed the masterpieces of their medieval and early modern heritage as being alien and unworthy of their interest. Now, under Louis XVIII, the rubble to which several of the tombs at Saint-Denis had been reduced in those convulsions was cherished, studiously restored and safeguarded in the Louvre itself.

Some medieval works had been integrated into the royal collections before this time. When Louis XIV razed the last remnants of the medieval Louvre, he was careful to preserve the statues of Charles V and his wife, Joanna of Bourbon, which are now on view in the Aile Richelieu. More typical, unfortunately, was what occurred in November 1793, when the inhabitants of Saint-Denis gathered the treasures of their ancient abbey in six large carts and hauled to them to the Convention: there the delegates saved a few objects of obvious historical value before sending the rest to the mint, across

the Seine, to extract the gemstones and melt down the silver and gold. And so, in 1824, when the collection of Edmé Durand, one of Napoleon's generals, became available for purchase one generation later, the museum leaped at the chance. As the curator Forbin wrote at the time, "Since the fortuities of war have deprived the museum of the trophies that it had accumulated, there has never been a better chance to restore all the splendor to this great institution."[6] Comprising more than seven thousand objects and costing 480,000 francs, this collection brought into the Louvre many Egyptian, Greek and Etruscan objects, as well as medieval enamels and Renaissance ceramics in the style of the sixteenth-century master Bernard Palissy. Many other important works of medieval art were acquired four years later when Forbin purchased the collection of the Lyonnais painter Pierre Révoil, for sixty thousand francs.

A comparable shift occurred in the museum's relation to classical antiquity. Although Greece had long been, at least in theory, the center of their cultural homing, few Europeans had ever seen an actual artifact from that distant and alien country, and fewer still had visited the place. Other than a group of Greek inscriptions that Ennio Quirino Visconti had included in the Louvre's Musée des Antiques, as well as some marble oddments that the French ambassador to the Ottoman court had acquired in the 1670s, ancient art in the Louvre was uniformly Roman art. In this regard, the English and the Germans had gotten a jump on the French: the British Museum, soon after its creation, purchased the entire collection of Greek pottery assembled by Sir William Hamilton, the British ambassador in Naples, and by 1801 Lord Elgin was negotiating the purchase of the Parthenon marbles (which the same museum would acquire in 1816). Napoleon, in his days of power, had been so sensitive to this lack of genuine Greek antiquities in the Louvre that he dispatched a small expeditionary force to take possession of the copious collection that the Comte de Choiseul-Gouffier had acquired while serving

as French ambassador to the Ottoman court from 1784 to 1791. Unfortunately, while the collection was en route in 1803, the British, once again at war with France, intercepted it in Malta, which is why it can now be found in the galleries of the British Museum.

On hearing of Lord Elgin's desire to sell his famous marbles, Napoleon, eager to have them for the Louvre, offered him more than the British Museum had. But Elgin, perhaps moved by patriotism, preferred that his treasures remain in the British Isles. By comparison with the British Museum's exemplary collection of the Parthenon Marbles—now housed in their own gallery—the Louvre has only two nugatory fragments: a single metope—a sculptural façade ornament—and five feet of the temple's eastern frieze. Curiously enough, these were acquired long before Lord Elgin ever reached Greece: in the 1780s, agents of Choiseul-Gouffier had been granted permission by the Turks to carry off any part of the Parthenon that had fallen off and was lying on the ground.

Sculpted c. 115 BC, the Venus de Milo *is the most famous work in the Louvre, after the* Mona Lisa. *Unearthed on the island of Melos in 1820, it was donated to the museum one year later.*

But these early misfortunes and insufficiencies were soon forgotten when, in 1821, France acquired what was perhaps the greatest Greek statue unearthed since antiquity, the *Aphrodite of Melos*, better known as the *Venus de Milo*. Today it is second only to the *Mona Lisa* as the most famous work in the Louvre, an object that all visitors to the museum feel compelled to view. Dating to the end of the second century BC, this masterpiece of Hellenistic art was acquired, like most Greek antiquities of the day, by an ambassador to the Ottoman court, specifically the marquis de Rivière, who brought it to France in 1820: the next year he offered it as a gift to Louis XVIII, who immediately donated it to the Louvre. Its acquisition was especially welcome since it filled a gap left by the humiliating restitution of the *Medici Venus* to the Grand Duke of Tuscany (it is now in the Uffizi Gallery in Florence). Because this sculpture, once equal in fame to the *Apollo Belvedere* and the *Laocoön*, is not nearly as well known today as it was in the early nineteenth century, it is difficult to understand how much the Louvre's prestige had been enhanced by its acquisition and how diminished by its loss. But now, suddenly and unimaginably, it was replaced with something far greater, the *Venus de Milo*, which was not, like the *Medici Venus*, a Roman copy of a Greek original, but an exceedingly rare and ravishing masterpiece unearthed in Greece itself, the *fons et origo*, the source and origin, of classical culture. Although more than a dozen important types of Venus statues have survived from antiquity, none of them, neither the *Medici Venus*, the *Esquiline Venus*, nor the *Venus of Cnidos*, can match the sheer presence and sense of lived-in physicality of the *Venus de Milo*. At the time of its acquisition, there had been every expectation that a modern sculptor would supply its missing arms, according to the taste and custom of the time. But no such work was ever carried out, beyond repairs to the goddess's nose and some of the pleats of her robe.

One other part of the Louvre's Greek galleries grew considerably during this period: its pottery collection. It is easy today to take these humble vases for granted, since Greek pottery can now be seen in museums everywhere. But in the period around 1800, they struck Western Europe like a revelation. If Greek sculpture at this time was exceedingly rare in Western Europe, suddenly the newly discovered vases were almost absurdly abundant, offering a direct entrance into Greek life that no earlier classical scholar could ever have imagined. Whereas ancient sculptures were almost always official acts of commemoration, each of these pots, even the feeblest of them, seemed to bring the viewer in direct contact with antiquity as it was actually lived. At the same time, the loose and fluid lines drawn on the surface of these vases formed an aesthetic completely at odds with the official aesthetic of most ancient sculpture: whereas all the ancient art discovered to that point had been naturalistic in its obedience to observable reality, there was something schematic and at times almost abstract in these far humbler artifacts. Napoleon's scouts and looters had enthusiastically hunted after them, but once the process of restitution began, only thirty-seven remained in the Louvre's possession. That changed in 1817 with the acquisition of 574 vases from the collection of Joseph François Tochon. Still others, belonging to Napoleon's first wife, Josephine, were sold to the museum by Eugène de Beauharnais, her son and heir. To these were eventually added the collection of Napoleon's younger brother, Lucien, after his death in 1840. The feverish pace with which Greek antiquities were acquired during the Restoration did not, however, survive long into the July Monarchy. Eight years after the *Venus de Milo* arrived in the Louvre, the Greek people won their independence from the Ottoman Empire and, with a new sense of national identity, they greatly restricted the exportation of antiquities. Hereafter, most of the Greek sculptures that entered the Louvre would come from the methodical

excavation of archaeological sites in cooperation with the new Greek government.

* * *

It redounds to the glory of France, uniquely among the invaders of the age, that they came not merely to conquer and exploit but also to study and learn. Phalanxes of philologists, art historians and natural scientists accompanied Napoleon's Egyptian expedition (1798–1801). One of them, Vivant Denon, did more to publicize that ancient culture than anyone before him. Unfortunately for the French, a committed interest in the ancient culture did not always lead to archaeological rewards: when the unconquerable British navy sailed into Alexandria in 1801, it not only routed the French but seized all the ancient artifacts left behind in a hasty and disorganized retreat. But for that the Rosetta Stone—whose trilingual surface was crucial to deciphering hieroglyphics—would now be on view in the Louvre rather than the British Museum.

And yet the man responsible for deciphering the Rosetta Stone was not only a Frenchman, but also a curator of the Louvre. Jean-François Champollion (1790–1832) was born into humble circumstances in the southern village of Figeac in the south of France. A child prodigy, he taught himself the Coptic language in the belief—contrary to prevailing opinion—that it was related to the language hidden in the hieroglyphics of the Rosetta Stone (which he studied from published facsimiles). His hunch proved to be correct. On 14 September 1822, after years of study and constant fear that other scholars were closing in on a solution, Champollion ran across the Seine to his brother's house on the rue Mazarine and declared, *"Je tiens l'affaire!"* ("I've got it!"). He then fell into a "cataleptic" swoon and remained bedridden for five days. In

recognition of his towering achievement, Champollion was invited to become the head of a newly formed department at the Louvre, the Monuments Égyptiens et Orientaux, also known as the Musée Égyptien, which the king, Charles X, inaugurated on 15 December 1827. The next year, Champollion finally realized his dream of visiting Egypt, where he acquired for the museum the bronze statue of Karomama, the relief of Sethi I and the basalt sarcophagus of Diedhor, among other works. At Champollion's prompting, the Louvre purchased the collection of Egyptian papyri of Henry Salt (formerly British consul general in Egypt), an acquisition that transformed the museum, in one stroke, into perhaps the preeminent repository of papyri in the world.

If, in the first half of the nineteenth century, the visual arts of Greece and Egypt were poorly known, at least they were known to some degree. By contrast, the civilizations of ancient Mesopotamia were entirely unknown, beyond a few inscrutable references in the

*Léon Cogniet's portrait of Jean-François Champollion
(1790–1832), who deciphered hieroglyphics and was
curator of the Louvre's Egyptian collections.*

Old Testament. That changed completely in 1843, when the French consul in Baghdad, Paul-Émile Botta, began to excavate the ancient city of Khorsabad, near Mosul in modern Iraq. In consequence, thirty-seven sculptures were sent to the Louvre, resulting in the creation, during the waning days of the July Monarchy, of the Musée Assyrien. This collection, which is now in the Cour Khorsabad in the northern wing of the museum, was soon enriched even more by twenty-seven cases of objects from the subsequent excavations that Victor Place carried out in Khorsabad between 1852 and 1854.

So great was this sudden appetite for what were seen as exotic cultures that the Baron de Férussac proposed a museum of *les arts premiers*, of *les peuples sauvages*, the savage races of the Americas, Africa and Oceania. Soon the baron had acquired ninety-one objects, many from the collection of Vivant Denon, that made their way into the Louvre, fully half a century before Pablo Picasso— that champion of primitive art—was even born. Although most of these works have now been transferred to the Musée du Quai Branly-Jacques Chirac, some few African objects, subsequently acquired, can still be found near the Porte des Lions at the western end of the Grande Galerie.

* * *

The general tenor of the Bourbon Restoration was, of course, conservative if not reactionary. Of their return to power, the statesman Talleyrand famously said that they had learned nothing and had forgotten nothing. Nevertheless, it was during this period that, with the encouragement of the king, the Louvre became the battleground between classically trained academic painters and the protovanguardists of Romanticism. Some of the most radical cultural achievements of the age—Gericault's *Raft of the Medusa*

(1819) and Delacroix's *Dante and Virgil* (1822) and *The Massacres at Scio* (1824)—had their first public airing in the Salon Carré, side by side with such models of academic rectitude as Ingres's *Grande Odalisque* of 1819 and his *Apotheosis of Homer* of 1827.

Perhaps the epitome of the Romantic movement in painting is Delacroix's *Liberty Leading the People*, from the Salon of 1831. This painting, now in the Salle Mollien of the Louvre, is a response to the uprising that brought down the Bourbon monarchy during *Les Trois Glorieuses* (The Three Glorious Days, from 27 to 29 July 1830) following the decision of the king, Charles X, to dissolve the legislature, abridge freedom of the press and alter the electoral system to favor his conservative supporters. In Delacroix's most famous painting, he depicts an unnecessarily bare-breasted young woman in a Phrygian cap, leading the proletariat and the bourgeoisie onward against the forces of repression and reaction. Only a few hours after Charles X published his repressive measures, barricades arose throughout the city and a makeshift militia of twenty thousand armed citizens was marching on the Louvre and the Tuileries, forcing a far smaller contingent of guards to retreat. Soon the insurgents invaded the Tuileries Palace, where, according to Chateaubriand, a writer of royalist sympathies, "the furniture was ripped to shreds and paintings hacked with sabers . . . [while] a corpse was placed on an empty throne in the *Salle du Trône*."[7]

Such was the body count on both sides that the cadavers were buried hastily in the garden parterres in front of the Colonnade, where they remained for fully ten years. A popular print of the day depicts a dog, Médor, known as the *chien du Louvre*, who long afterwards haunted the gardens in fidelity to his master buried beneath. In 1840, the bodies were exhumed and placed under the Colonne de Juillet in the place de la Bastille, where they remain to this day. A rumor made the rounds that through inadvertence, several of the mummies brought back from Egypt to the Louvre

were included among these corpses, but that is probably nothing more than a canard.[8]

* * *

During the thirty-three years of the Restoration and July Monarchy, few modifications were made to the exterior of the Louvre. But one modification of its interior spaces was significant both for its design and for the murals that resulted from it. The entire second floor of the Cour Carrée's southern wing saw the opening of two contiguous galleries, the Musée Charles X and the Musée au bord de la Seine, now known as the Galerie Campana. Just as a frame is sometimes as important as the painting within it, so a gallery is sometimes as important as the art it displays. Even if most visitors will pass through the Louvre's chambers without giving them a second look, few neoclassical spaces in Paris are as splendid, as interesting or as well preserved. And since most of the Louvre's finest interiors have been fundamentally altered or degraded over time, the fact that these two galleries, designed by Percier and Fontaine, should have survived intact is surely worthy of celebration. Each contains nine rooms laid out one after another, with four chambers on either side of the central Salle des Colonnes, so called for the energetic use of columns in its décor.

Because the eastern half of the gallery initially held Champollion's collection of Egyptian antiquities, he hoped that the décor would exhibit Egyptian motifs. Instead, and predictably, these rooms exemplify the neoclassical idiom that was Percier and Fontaine's stock-in-trade: the entrances were marked by arched doorways and flanked by Ionic pilasters whose gilded capitals contrasted with the faux rose marble of the walls. What most appealed to contemporary taste, however, was the richly painted décor. Pierre Fontaine liked to

call these galleries *les deux royaumes ennemis*, the two warring king-
doms, because of the powerful differences in their décor, due in large
measure to their having been completed about a decade apart. On
the ceilings of the two galleries a battle is being waged between the
two strains of official painting that dominated the Restoration and
July Monarchy, the allegorical and the historicist. The former style,
more conservative, predominates in the Musée Charles X, completed
in 1827, while the latter predominates in the Galerie Campana, from
several years later.

Typical of the spirit of the Musée Charles X is Charles Marni-
er's ponderously titled *The Nymphs of Parthenope, Carrying the
Penates Far from Their Shores, Are Led by the Goddess of the Fine
Arts to the Banks of the Seine*. Translated into "nonallegorese," this
title—whose verbosity and status as a complete sentence typify the
age—informs the viewer that a number of ancient artifacts from
Southern Italy were brought to Paris. The painting in question is
hardly a masterpiece, but it is ably composed and rather delightful
in its overblown way. Much the same could be said for other works
in the gallery, by François Joseph Heim, François Edouard Picot and
Baron Gros.

Such faint praise, however, will not do for *The Apotheosis of
Homer*, completed in 1827 by Jean-Auguste-Dominique Ingres. It
is doubtful that any one work has ever defined the cultural canons
of its time as emphatically as this painting, which was conceived for
the ceiling of the westernmost room of the Musée Charles X. Seated
before an Ionic temple, Homer is crowned by a winged personifica-
tion of victory and flanked in perfect symmetry by forty-four of the
most eminent members of the European canon, among them Virgil,
Shakespeare, Mozart and Poussin. A faithful copy now occupies the
ceiling, while the original hangs, with many other works by Ingres,
in the Salle Daru of the Aile Denon. At least in theory, few works of
art are more retrograde to our contemporary tastes than this: it is

unapologetic in its elitism and Eurocentricity, for the simple reason that it would never have occurred to the artist or to any member of his public that an apology was called for. The composition is unrelentingly rational and symmetrical, the drawing precise to the point of dryness, a quality made all the more evident when the painting appeared in the Salon together with Delacroix's tumultuously "modern" *Death of Sardanapalus*. And yet it is by Ingres who, through some kind of alchemy, is at once the most representative academic painter of the age and perhaps the only one who transcends the many limitations of that style to break through to greatness. Ingres also designed the Homeric frieze that runs along the architrave and under the coved ceiling of the Musée Charles X: the actual painting of these gray figures, which emerge from a vermilion background, was assigned to Charles and Auguste Moench.

Jean-Auguste-Dominique Ingres's Apotheosis of Homer *(1827), created for the ceiling of the western entrance to the Musée Charles X.*

Just south of this space, the Galerie Campana opened in 1833, named for the man who collected many of the works on view. Although conceived under the Restoration, the gallery was completed under the July Monarchy. If the paintings of the Musée Charles X were subordinated to the décor, here they have gained the upper hand, even as they reveal far greater coherence and charm. The design is dominated by dark green walls and a golden fringe that leads into the solid gold coloring of the cornice. As with the Musée Charles X, the extensive painting program extols the visual arts, especially in France. But instead of the allegories that played out on the ceiling of the Musée Charles X, here energetically historicist images seek to reenact the past "as it really was." None of the paintings approaches the perfection of Ingres's *Apotheosis of Homer*, but they still give pleasure. Among them one finds Jean Alaux's *Poussin Arriving from Rome Is Presented to Louis XIII by Cardinal Richelieu*, and *François I Receives the Paintings and Sculptures Brought from Italy by Primaticcio*, by Alexandre-Évariste Fragonard, the son of Jean-Honoré Fragonard.

One other immense commission was never completed and never installed, as initially intended, in the Louvre itself. For the Galerie d'Apollon, Forbin ordered an ambitious series of twenty-four paintings—twelve on either side of the gallery. They were intended to illustrate the varied history of the Louvre Palace through the centuries. Only seventeen were executed, between 1833 and 1841. The series began with *Dagobert Embarking before His House in the Louvre*. (It was long believed, erroneously, that the Louvre had been founded by Dagobert in the early seventh century.) Other scenes depicted *Philippe Auguste Ordering the Construction of the Great Tower [of the Louvre]*, *The Saint Bartholomew's Day Massacre* and *Colbert Introducing Perrault to Louis XIV*. The series ended with *Napoleon and his Architect Fontaine on the Staircase of the Louvre*, despite the fact that the aged Fontaine was still very much alive and

working in the museum at the time when this work was painted—an almost unprecedented honor paid to a living architect.

But the mere fact that such a commission was conceived and largely completed attests to the new-found status of the Louvre, both as a building and as an institution. At the same time, the fact that art history now took its place beside history itself reflected the radically new priorities of France in the middle third of the nineteenth century. This new conviction would acquire ever greater force in the coming years, when the architects of the Second Empire completed a massive expansion of the Louvre that would place the institution squarely at the center of the cultural life of France and of Europe.

- 8 -

THE NOUVEAU LOUVRE
OF NAPOLEON III

On 14 August 1857, the emperor of France, Napoleon III, held a banquet for nearly five hundred construction workers who had achieved for him something that had eluded kings and councilors for nearly three centuries: the unification of the Tuileries and the Louvre. In the brand new Salle des États, the very chamber where one now finds the *Mona Lisa* and Veronese's *Wedding Feast at Cana*, these humblest of France's citizens supped on its finest wines and fare. Napoleon III did not attend the banquet itself, but earlier in the day he had shown up to thank these men from a throne set up in the equally new Salle Mollien, whose sprawling rectangular length now houses Delacroix's *Liberty Leading the People* and Gericault's *Raft of the Medusa*. "The completion of the Louvre," he told them, "has not been a passing caprice, but the realization of a great project sustained by the instinct of the nation for more than three hundred years."[1] The very next day, the reborn museum formally opened its doors to a dazzled world.

The transformation of the Louvre had occurred with almost incredible speed. Surely some finishing touches still had to be applied, and surely important structural modifications would continue to be made for another decade and more. But in a culture where major architectural projects were measured in generations, if not centuries, the speed with which Napoleon III completed the most ambitious building program of the nineteenth century compelled the

admiration of the entire world. The poet Théodore de Banville spoke for many when he compared the Louvre to a giant awakening from his sempiternal slumber:

> Longtemps triste et courbé, le géant se redresse . . .
> Achevé, tout brillant de jeunesse et de gloire,
> Regardant l'univers ainsi que la cité,
> Notre Louvre est debout, grand comme notre histoire,
> Colosse harmonieux dans son immensité!

> [Long sad and stooped, the giant rises up. . . . Complete and brilliant in its youth and glory, looking out on the universe and on the city, our Louvre stands tall, as grand as our history, a colossus harmonious in its immensity!][2]

Over the twenty-two years of Napoleon III's rule, the Louvre Museum underwent a complete transformation of its body and soul, a transformation that affected both its physical presence and its institutional identity, and that coincided with the vast enhancement of its collections. This change was the greatest and most important the museum would ever see, rivaled only by the creation of the Grand Louvre of the 1980s.

* * *

In the eight hundred years of the Louvre's existence, no one man has exercised a greater or more beneficial influence on its form and function than Napoleon III, who ruled France as president and then as emperor from 1848 to 1870. Regarding the exterior of the Louvre, everything we see today, other than the *Pyramide* and the Cour Carrée, was created or fundamentally transformed by the architects

of Napoleon III. Even the most visible external façade of the Cour Carrée, the one directly behind the *Pyramide*, was entirely reconceived and immeasurably enhanced under the aegis of the emperor.

Napoleon III, however, did not initiate the project to complete the Louvre: with the fall of the July Monarchy in February of 1848 and the immediate declaration of the Second Republic, the new government, led first by Alphonse de Lamartine and then by Louis-Eugène Cavaignac, resolved to carry out the work. Nevertheless, it fell to Napoleon III to see the project through to completion. And as great as were his labors at the Louvre, they were only a small part of a far larger modernization of Paris—completed in collaboration with Baron Haussmann—that would transform the capital into a lodestar of urban planning for nearly a century to come. Nonetheless, however great Haussmann's influence was on nineteenth-century Paris, his jurisdiction halted before the walls of the Louvre, and he played no role in its transformation under the Second Empire.

Louis Napoleon Bonaparte (1808–1873), was the nephew of Napoleon I and the son of his younger brother, Louis Bonaparte, king of Holland from 1806 to 1810. Louis Napoleon's mother was Hortense de Beauharnais, the daughter of Napoleon's first wife Josephine by her first marriage. His life was novelistic in the frequency and degree of its upheavals. Born in Holland, he was destined to spend most of his life outside of France, from which he was exiled three times. The first occasion followed the Battle of Waterloo, when he and anyone with the last name of Bonaparte was compelled to leave the country. Only seven years old at the time, he was taken to the German part of Switzerland before entering secondary school in Bavaria. Just as Napoleon I never lost his Italian accent, so Louis Napoleon is reported to have spoken French with a pronounced German intonation to the end of his days. When he was fifteen his mother took him to Rome, where he acquired a taste for political intrigue after joining the Carbonari, a group of secret societies

opposed to Austria's oppressive and antidemocratic rule in northern Italy. These activities resulted in his banishment from Rome and his return to Switzerland after a brief sojourn in France. For several years he spent his time writing pro–republican and Bonapartist tracts against Louis Philippe. In 1836, in an ill-considered reenactment of his uncle's power grab in 1814 (the so-called Hundred Days), Louis Napoleon entered France through Strasbourg and attempted to persuade the city's garrison to join him in a march on Paris. The coup d'état failed abjectly, and Louis Napoleon fled to Switzerland, before embarking on a voyage to Rio de Janeiro that eventually took him to Manhattan—where Washington Irving introduced him to the cream of New York society—and from there to London. During his ten years in the British capital Louis Napoleon developed an interest in

*Hippolyte Flandrin's portrait of the
Emperor Napoleon III (1862).*

urbanism, and especially in the development of public parks, that he would put to such excellent use when he returned to France in 1848 and won election as the first and only president of the newly created Second Republic.

In February of that year the July Monarchy collapsed for much the same reason as had the Bourbon Restoration in 1830: economic hardship provoked dissent that was then brutally repressed. Since one percent of the population, the propertied class, had the right to vote, a disaffected and unemployed populace had no other means of venting its grievances than through riot and armed revolt. When the end came, during a year of revolutions throughout Europe, it came swiftly. On 24 February, the aged Citizen King, Louis Philippe d'Orléans, facing a mutiny of his troops in the place du Carrousel, slipped into British exile and died in Surrey two years later. And as always happened on such occasions, it was not the Louvre but the Tuileries, the official home of the ruler, that bore the brunt of the mob's fury. This was the event so dramatically narrated, twenty years after the fact, in Flaubert's *L'Éducation sentimentale*. At the time, no one could have imagined that it would be little more than a dress rehearsal for the final and most traumatic assault on the Tuileries, during the Paris Commune of 1871.

Throughout the heady months of 1848, Louis Napoleon watched these events unfold from the safety of London. But once the presidential election was announced for December of that year, he declared his candidacy and returned from exile. He won the election with nearly 75 percent of the vote. Despite his profoundly republican and populist convictions, however, Louis Napoleon never wanted to be merely president of the Second Republic. From the start he intended to revive the empire of his uncle, to whose power he appears to have felt an almost hereditary entitlement. Louis Napoleon was by far the most popular politician in France in the early 1850s, but the constitution of the Second Republic forbade

anyone to serve as president for two consecutive terms. And so, on 2 December 1852, the anniversary of Napoleon I's coronation as emperor and also of his great triumph at the Battle of Austerlitz, his nephew dissolved the National Assembly and declared martial law in Paris and its environs. Over two hundred of the assembly's deputies were eventually arrested, even as a scattering of barricades rose up around the city in opposition to the new emperor. But the uprising was easily crushed, with the death of some three or four hundred resisters. Victor Hugo, who initially supported Louis Napoleon as president, now became one of his most bitter enemies and went into exile for twenty years, first to Belgium and then to the Channel Islands. Whatever the propriety of the national plebiscite that took place three weeks afterwards, it appears to have confirmed the French electorate's strong support for the coup d'état.

* * *

The Louvre that emerged over the course of the Second Empire is perhaps the most conspicuous example, and surely one of the finest, of what Charles Garnier—the architect of the Paris Opera—called *le style Napoléon III* and what today is generally known as the Beaux-Arts style. In addition to defining Paris in the second half of the nineteenth century, this style would influence cities from Saint Petersburg and Rome to Buenos Aires and New York. In one sense, it was as much an historicist style as the contemporary Gothic Revival. And yet it looked back, not to the Middle Ages, but to the High Renaissance and especially the French baroque of Louis Le Vau, Claude Perrault and Jules Hardouin-Mansart, the architects of the Louvre and Versailles. Although contemporaries appreciated its reenactment of an earlier style, it also aspired to a timeless universality that transcended the historicism that was the Gothic Revival's preeminent charm.

But there was a third element of the style that was political and ideological. The fact that the nineteenth-century Louvre recalls the architecture of Louis XIV and Louis XV means that it also recalls the most adamantly and efficiently monarchical era in French history. As such it was a repudiation of the neoclassical style of Louis XVI, Napoleon I and the three kings of the Restoration and July Monarchy. With its pared down, flattened aesthetic and sparing use of ornament, neoclassicism rejected French precedent and invoked an almost mythic Roman republican style. But by 1850 this aesthetic had played itself out, together with the political ethos to which it gave material expression. Even if the French of the Second Empire remained largely republican, they now longed for the grandeur and pageantry of the *ancien régime*. As such, they favored the maximalist volumes of the older architecture, together with a renewed richness and plasticity in the adornment of the façades. Even the décor and furnishings of interior spaces looked back to the later years of Louis XIV and the reign of his successor. In some instances, the revival surpassed the original in charm and amenity, if not in ultimate aesthetic consequence. The very fact that this style was rooted in imitation meant that it could never produce anything as fine as the Aile Lescot or the Colonnade. But Hector Lefuel's reimagined façades of the Pavillons de Flore and de Marsan, at the westernmost edge of the Louvre complex, were indisputably better than their seventeenth-century originals.

The February Revolution of 1848, which ousted Louis Philippe, also resulted in the retirement of Pierre Fontaine, who had served one emperor and three kings as *architecte du Louvre*. He was eighty-seven when he resigned his post and still in full possession of his faculties. Astonishingly, he had occupied that eminence since 1801, when Bonaparte was still first consul. Now a younger generation came forward. Three men were involved in creating the Nouveau Louvre of Napoleon III: Félix Duban, Louis Visconti and Hector

Lefuel. Whereas Duban's contribution was limited to several of the most important interior spaces, the general conception of the Nouveau Louvre was the work of Visconti. But when he died unexpectedly in 1853, before work had progressed very far, the far younger Lefuel took command, preserving Visconti's general plan but altering and enhancing many specifics of the design.

* * *

Louis Visconti single-handedly solved the riddle of how to unite the Louvre's two distant and incompatible palaces in such a way as to create, despite their axial anomalies, that sense of symmetry so crucial to official French taste. At the time of his selection, Visconti—the son of Ennio Quirino Visconti, the Louvre's curator of ancient art under Napoleon I—was one of the most eminent architects in France. He had recently completed the expansion of the Palais du Luxembourg as well as the Hôtel de Pontalba, now the palatial American Embassy. In addition to Napoleon's tomb in les Invalides, Visconti designed some of the capital's finest fountains, among them those of Saint-Sulpice, Gaillon and Louvois.

Almost from the moment when Catherine de Médicis began to build the Tuileries Palace in the 1560s, more than a hundred architects, including the great Bernini himself, came forward over the three succeeding centuries to solve the enigma of uniting it with the Louvre. There were numerous conceptual and procedural challenges: how, for example, to clear away the vast urbanized area that lay between them, and having done so, what to do with the resulting space. And yet, conceptually, if not legally or financially, those problems were relatively simple. The far greater challenge was how to harmonize the obviously incompatible structures that already existed. Both of the palaces stood perpendicular to the Seine, but

due to the shifting contours of its banks, they had never been and could never be parallel.

In this respect, the area west of the Cour Carrée recalls a number of other great and ancient public spaces, especially the Piazza San Marco and Saint Peter's Square: due to its ad hoc evolution over many centuries, it taxed even the greatest architects to conceal the resulting irregularities. With regard to the Louvre complex, this irregularity would seem more pronounced today if the Tuileries Palace were still standing. And yet, even today, telltale signs of these anomalies remain, but so subtle that few visitors ever see them. Since Percier and Fontaine's Arc du Carrousel was meant to serve as a gateway to the Tuileries Palace and so was orientated toward that building, it is not quite centered along the same axis as the *Pyramide*. As a result, it stands at a slight angle to the mass of the Louvre. More materially, we have already seen that the Pavillon de Flore, the southwestern-most point of the Louvre, seems almost violently torqued at the point where it meets the Grande Galerie at a variance of roughly one degree north. But because the Tuileries was significantly wider than the Louvre in its northward extension, terminating in the Pavillon de Marsan, the degree of that variance is even more noticeable in the northern counterpart to the Grande Galerie, along the rue de Rivoli.

Most of the other architects who had tackled this problem, going back almost three hundred years, had offered a variation on one of two solutions. The first was to create an endless plaza with nothing between the two palaces, thus laying bare the disparities and hoping that they would not appear too disconcerting. The second was to distract viewers by interposing a number of large structures between the palaces and, by blocking the view, to make each palace all but invisible from the perspective of the other. The problem with the first solution was that it did little to address the irregularity, while creating a vast and incoherent space where most visitors

would feel disorientated. The problem with the second was that it would destroy any possibility of producing a great public plaza. It would improve to some degree upon the disordered mass of buildings that were already there, but essentially by replacing one form of clutter with another.

And then there was Visconti's solution: even as he achieved the union of the palaces through roughly parallel wings, he created two large annexes, one attached to the northern wing, the other to the southern. In this way he created a smaller, though still extremely large, space between the wings, with the two halves in perfect symmetry. This magnificent solution achieved three things: it greatly expanded the Louvre's available building stock; it created, entirely on its own terms, the context in which symmetry could be achieved, and then it achieved that symmetry; and finally, the very expedient that doubled the available building stock also reduced the public space to a still vast, but now far more human scale. But for that measure, the combined Cour Napoléon and place du Carrousel would likely have formed the largest plaza in the Europe, if not the world, three times the size of San Marco's in Venice and utterly alienating in its immensity. From the air one can see that Visconti's two annexes are slightly different in form, but the pedestrian on the ground could pass through them for years and never notice anything amiss.

The realization of Visconti's plan is referred to as the Nouveau Louvre, in reference specifically to those parts of the building that were created from scratch between 1852 and 1857. If the Cour Carrée was largely unaltered in the process, no other part of the Louvre remained unchanged. An E-shaped configuration added to the Grande Galerie formed, from east to west, the three courtyards of the Cour du Sphinx, the Cour Visconti and the Cour Lefuel. Its mirror image in the north resulted in the Cour de Khorsabad, the Cour Puget and the Cour Marly. To each of these corresponded

Théophile Vauchelet's portrait of Louis Visconti (1791–1853),
author of the general design for the Nouveau Louvre,
depicted on the right.

a sumptuous pavilion, the Pavillons Daru, Denon and Mollien in
the south and the Pavillons Colbert, Richelieu and Turgot in the
north (the first three named after councilors to Napoleon I, the latter
three after councilors to the Bourbons). When the northern half was
joined to the northern pendant of the Grande Galerie, Henri IV's
250-year-old dream of combining the Louvre and Tuileries into one
great structure finally became reality.

* * *

Before work could actually begin, the area between the two pal-
aces had to be cleared of any remaining buildings in the Quartier
du Louvre. For the most part, these structures were no longer the
stately *hôtels particuliers* of the upper classes, the Hôtels Rambouil-
let and de Longueville, nor the Hôpital des Quinze-Vingts, which
had moved to the Twelfth Arrondissement shortly before the French

Revolution. Instead they were often ramshackle one- or two-story dwellings a step up from a hovel or a hut. By this time, most of the houses had been cleared away from the place du Carrousel and the Cour des Cuisines, soon to be transformed into the Cour Napoléon. One hundred years before, this area had been among the most densely inhabited in the city. Now only a narrow strip of human inhabitation remained, thrust northward through the gap between Percier and Fontaine's still unfinished Aile Rivoli and the Pavillon de Beauvais in the northwest corner of the Cour Carrée. But even this little space was teaming with life.

Alfred Delvau, a spirited chronicler of Paris under the Second Empire, left a vivid portrait of the place—"that caravansery of bric-a-brac, that labyrinth of boards and zig-zag of boutiques"— as it was before its transformation into the Nouveau Louvre. His depiction is tinged with the bittersweet remembrance of what has vanished beyond recall: "It was charming once upon a time, this place du Carrousel . . . as charming as disorder and as pictur-esque as ruins. If it offended the friends of regularity, it mightily delighted those who prefer the Forest of Fontainebleau to the Tui-leries Garden. It was indeed a forest, with its tangle of shacks fashioned from wooden board, its wattle and daub cottages inhab-ited by a crowd of handicraftsmen and small industries." Among the *brocanteurs*, or junk dealers, he describes the shops that sold cockatoos and parakeets, boa constrictors, turtles, rabbits and Norwegian swans.[3]

Delvau recalls with special affection a dive known as le Cabaret de la Mort, where he and his impecunious friends gathered, not to drink, but to regale themselves with endless talk. And yet, in a mat-ter of years, this sordid place—"some curtains over windowpanes, a few jars set on a board, three bad tables and a few old stools"— would be improbably reborn as the northern half of the Nouveau Louvre. It is tempting to indulge the fancy that something of that

lost bohemian paradise still lingers among the splendid bowels of the palatial structure that replaced it.

But a still more energetic bohemia existed within the confines of the Louvre, only a few hundred feet to the south, in the Impasse du Doyenné. This was perhaps the first true bohemia in Paris, emerging fully a decade earlier than the better-known version that Henri Murger immortalized in his *Scènes de la vie de bohème* (1851), which in turn inspired Puccini's opera and even the musical *Rent*. Yet it is beyond question that the earlier *bohème*, arising in the general vicinity of today's *Pyramide*, was the more brilliant of the two: it included some of the most eminent poets of the later Romantic movement, among them Théophile Gautier, Gérard de Nerval and Arsène Houssaye, all in their early twenties and as yet unknown to fame. The parties they threw became legendary, and at any moment one of their more eminent and established elders, Delacroix or Corot, for example, might show up to join them.

For Gautier and his clan, the destruction of the Impasse du Doyenné in the creation of the new Louvre was indistinguishable from

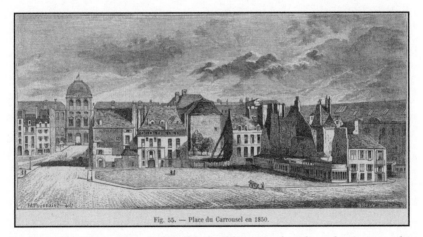

Fig. 55. — Place du Carrousel en 1850.

Engraving of the relatively humble buildings in the place du Carrousel in 1850. In the background is the central pavillion of the Tuileries Palace. Within a year they would all be razed to the ground.

the loss of their youth. In one of his most charming poems, Houssaye reminds Gautier of that earlier time, now so thoroughly gone that the part of Paris where it played out now no longer even existed:

> Théo, te souviens-tu de ces vertes saisons
> Qui s'éffeuillaient si vite en ces vieilles maisons
> Dont le front s'abritait sous une aile du Louvre?
>
> [Théo, do you remember those green seasons that so quickly passed away in the old houses whose façades were sheltered under a wing of the Louvre?][4]

Declaring the street "*la mère-patrie de tous les bohèmes littéraires*" ("the motherland of all literary bohemias"),[5] Houssaye recalled this vanished paradise: "There has never been a friendship so free or so happy, a true delight for the heart and the mind. Each of us was singing when, as blithe companions, we set to work, Théo on *Mademoiselle de Maupin*, Gérard on *The Queen of Sheba*, Ourliac on *Suzanne* and I on *La Pécheresse*."

Nerval, as well, remembered the Impasse as a place of unalloyed happiness. "It was in our shared lodgings in the Rue du Doyenné that we became friends. . . . The old salon of the Rue du Doyenné, restored through the solicitude of countless painters who were our friends and have since become famous, rang out with our gallant rhymes, often mingling with laughs of joy and the mad songs of the nymphs."[6]

Nerval elaborated on that phrase "restored through the solicitude of countless painters." This referred to paintings of a frankly erotic nature that some artist friends had emblazoned across the paneled walls of their apartment. Nerval related how he happened to return to the area a few years later, shortly before it was torn down, and managed to buy some of the panels on the cheap from

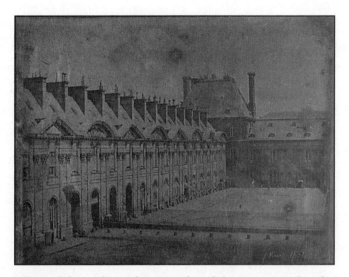

*One of the earliest photographs of the Louvre, taken by
Girault de Prangey in 1841 from one of the upper floors
of the Hôtel de Nantes. As with all daguerreotypes, the
image is reversed: it depicts the Louvre's northern
wing along the rue de Rivoli.*

the awful proprietor, who lived on the ground floor. The latter had
covered the offending panels in tempera, claiming that otherwise he
could not rent the place out to *les bourgeois.*

But all of this was soon to vanish, so soon that by 1850, the
second year of Louis Napoleon's rule, only one structure remained
standing in the old Quartier du Louvre: the Hôtel de Nantes. This
was not an *hôtel particulier,* a private home for the wealthy, but a
hotel in the modern sense of the word. It was one of the few struc-
tures that had survived in the immediate vicinity of the blast that
almost killed Napoleon I on the rue Saint-Nicaise on New Year's
Eve, 1800. Half a century later, in 1850, in the time of Napoleon's
nephew, the building was finally demolished, despite the fact that
its ornery proprietor had long held out against all pressure and sua-
sion. This simple, squarish tower rose up eight stories (a laborious
climb in the days before elevators) and offered not only furnished

rooms but a drinking establishment at street level. More than forty years after its demolition in 1850, Baron Haussmann, in his memoirs, recalled how this isolated structure rose up like a bowling pin, *comme une quille*, over the voided plain that the place du Carrousel had by then become. Some of the earliest photographs ever taken of the Louvre, daguerreotypes from the early 1840s, were shot by Girault de Prangey from an upper story of the hotel, where he stayed whenever he came to Paris.

* * *

When the sixty-two-year-old Visconti died in December 1853, it was not initially clear who would succeed him as *architecte de l'empereur*. Eventually, however, that honor passed to Hector Lefuel who, at forty-three, was nearly twenty years his junior. Despite the brilliance of Visconti's floor plan for the Nouveau Louvre, the treatment of the façade was not as favorably received. At the same time, even if his designs were not as functional as Lefuel's variations on them, at least they had the virtue of a certain originality, even eccentricity relative to the official architecture of the day. Soon after the second phase of the 1848 revolution, during the so-called June uprising, Visconti created the earliest surviving drawings for the project. Of these drawings, now in the Archives Nationales, two especially offer insight into his ideas. Both, in their way, are strikingly idiosyncratic, almost recalling, in this respect, the assertive idiosyncrasy of Philibert de Lorme's initial designs for the Tuileries nearly three centuries before. The earlier of Visconti's two designs, dating to July of that year, conceives a structure whose two stories are of equal height and inspired in part by the Petite Galerie, with a rusticated arcade at the base that, like the upper story, is articulated by pilasters that serve to emphasize the flatness of the façade as a whole. Half a year

later, however, in February of 1849, Visconti wisely added a third story at the attic level, while preserving a general flatness. It seems likely that these renderings were never carried out because they conflicted with a new taste that was just coming into being: their flatness was closer to the neoclassical idiom that was just then dying out.

By the time of Visconti's death, work on the Louvre was well enough along at ground level that his successor, Hector Lefuel, had to abide by his general plan. Thus Lefuel preserved the arcades that, at ground level, run along every available wall of the Cour Napoléon. Although not common in earlier Parisian architecture, these arcades seemed to acknowledge the one along the western exposure of the Tuileries, while the blind arches on the east façade of the Cour Napoléon recall the west façade of the Cour Carrée. (There was also the powerful precedent of the rue de Rivoli, one block north.) But once beyond the ground floor, Lefuel had considerably more freedom in his designs, and so he provided the more aggressive volumes and richer surface treatment that the newer generation demanded. These qualities are apparent in the bulkier ground level arcades that were eventually built, separated by engaged columns— Corinthian, of course—rather than the flattened Doric pilasters that Visconti had wanted. A greater sense of volume emerges from the upper stories, which are recessed slightly to form an elevated terrace. In contrast to the openness of the arcade, these upper stories offer a far more emphatic sense of the wall.

But the real boldness of Lefuel's design appears in the seven new pavilions of the Cour Napoléon (three on each side, with a completely revised Pavillon de l' Horloge in the center). In their inflated fullness, these slate-covered roofs float majestically over the Cour Napoléon like so many tethered aerostats, even as they recall those hoopskirts that contemporary women of fashion were just beginning to favor: perhaps some arcane affinity existed between these two objects of contemporary taste. This grandiose aesthetic is enhanced

by some of the largest dormer windows in the world, teeming with inscrutable allegories. It is further expressed in the detached columns on either side of the central portal at the base and in the central window on the floor above. Although among the newest parts of the Louvre, these paired columns and the oculus windows at their sides explicitly invoke the Aile Lescot, the oldest part of the Louvre, dating to the 1550s. But the difference is crucial: what were originally half-columns attached to the wall now became full-bodied and emancipated, virtual manifestos of *le style Napoléon III*.

On the rue de Rivoli, at the other end of the Passage Richelieu, stands the Pavillion de la Bibliothèque, which makes a powerful claim on the attention of American visitors. It was designed in a form similar to that of the pavilions of the Cour Napoléon, but its more mannerist style matches the rue de Rivoli façade of the Louvre. This pavilion was not originally part of the museum, but led to a vast library and to the Ministry of State (later the Ministry of Finance). There is ample reason to believe that its author was largely, if not entirely, the American architect Richard Morris Hunt, who, forty years later, would design the finest portion of the Metropolitan Museum of Art—the central entrance along Fifth Avenue—as well as the main building for Chicago's legendary World's Columbian Exhibition of 1893.

A native of Brattleboro, Vermont, Hunt was born into wealth in 1827 and spent most of his early years traveling around Europe with his widowed mother and his four siblings. He has the distinction of being the first of many Americans to graduate from the École des Beaux-Arts, and he would prove to be the conduit by which the École's style came to dominate American cities in the decade on either side of 1900. In addition to studying there, Hunt worked in Lefuel's atelier, and he saw the older man as a mentor. In April of 1854, while the work on the Nouveau Louvre was in full swing, Lefuel invited him to join his staff as *inspecteur des travaux*, at an

annual salary of two thousand francs. Lefuel was so pleased with Hunt's work at the Louvre that thirteen years later he claimed, in a letter to Hunt's new wife Catherine, that "[my own] best work was done when Dick worked with me, and he can justly claim a big share of its success. I do not hide from you those circumstances of which his own modesty does not permit him to speak."[7]

In 1857, to honor the unification of the Louvre and the Tuileries, the academic artist Victor Chavet painted an image of the complex as seen from the west, from the perspective of a buoyantly airborne viewer. In the painting, two angels aloft hold up a shield depicting Napoleon III in profile, while a third, seated at the base of the composition, unfurls a banner. The painting depicts the Grande Galerie and its northern counterpart as being identical in form and nearly identical in décor, extending westward in perfect order and symmetry. As this painting suggests, many Parisians, and perhaps the major participants most of all, assumed that the work was done. But, for better or worse, a series of events over the next two decades would give the lie to that assessment.

Originally, the ceremonial center of the new Louvre complex was the Salle des États, where we now find the *Mona Lisa* in the southern half of the museum. Here, Napoleon III held his banquet for the construction workers. But over time the monarch, afflicted by gout, kidney stones, obesity and much besides, wearied of walking nearly half a kilometer from his apartment in the Tuileries Palace to that august chamber, and so he ordered that a second, similar space, the Pavillon des Sessions, be built midway between those two points. For practical and aesthetic reasons, the entire western half of the Grande Galerie was accordingly torn down between 1863 and 1865: and so, what we see there today, although it surely recalls Henri IV's building, did not exist before the middle of the nineteenth century. During that period the façades on both sides of the Grande Galerie's western half were altered, the Pavillon des Sessions was built, and

the Pavillon de Flore, all the way at the western end, was likewise torn down and reinvented in a style more congenial to contemporary taste. Ironically, the only trace of the original façade of the Grande Galerie's western half is a small patch that remains on the north side of the Louvre, where Percier and Fontaine recreated it at the beginning of the nineteenth century.

In the second half of the 1860s, Napoleon III decided that the area just east of the new Pavillon des Sessions should also be torn down to create a triple arcade that would serve as the grand entrance to the Louvre as one approached it from the south. Known as les Grands Guichets (the Large Gates), it was originally intended to play an important role in Haussmann's radically new conception of Paris: it was to form part of a great north-south axis that would lead from the Gare Montparnasse down the newly created rue de Rennes, over the Pont du Carrousel and through the Grands Guichets into the Louvre. From there it would cross the place du Carrousel northward through a structure identical to the Grands Guichets and into the new avenue de l'Opéra all the way to Palais Garnier. Unfortunately, the rue de Rennes never quite made it to the river, petering out at the boulevard Saint-Germain, and the northern complement of the Grands Guichets was never built. Because that great thoroughfare never materialized, its series of surviving urban interventions are so disconnected that few modern Parisians have any sense of the grand strategy that was supposed to unite them. As for the Grand Guichets themselves, for all their size and elegance of design, they are largely unnoticed by most visitors to the museum. Created for carriages and pedestrians, they are now used by cars and a few intrepid, lost, or ill-advised tourists. And they are hardly alone among the monuments and plazas of Paris that have fallen victim to the car culture of the twentieth century.

Even with the completion of the Grands Guichets, however, Lefuel was not finished with the Louvre. After the Tuileries Palace

was burned to the ground in 1871 by radical members of the Paris Commune following the fall of the Second Empire, Lefuel rebuilt much of the Pavillon de Flore in the south, as well as the corresponding Pavillon de Marsan in the north. At this point he doubled the width of the Rivoli Wing (now home to the Musée des Arts Décoratifs) and he planned to add a large pavilion to it, identical to the Pavillon des Sessions in the south. But that addition was never built, and a bare wall of exposed rubble remains at the point where the pavilion was supposed to start. While the northern counterpart to the Grands Guichets was never built, two additional passageways were added to the one that already existed. Thus the slender, orderly, symmetrical wings in Victor Cachet's airborne depiction no longer correspond to the realities on the ground.

When all was said and done, the vast labors undertaken at the Louvre during the Second Empire and the early years of the Third Republic created six acres of newly built structures. These, combined with those already in existence, brought the total to eleven acres, or more than twelve acres if the Tuileries Palace is included. Meanwhile, a thousand linear feet of the Grande Galerie were reconceived at this time, together with the 650-foot-long façade of the Ailes Lescot and Lemercier directly behind the *Pyramide*. Since the founding of the Renaissance Louvre around 1550, this west-facing façade had always seemed like a debased afterthought. Overlooking the Cour des Cuisines, it was free of almost all ornament. To make matters worse, along its northern side the earth slanted precipitously downwards, emphasizing that sense of tawdriness. But all of that changed in 1857, when Lefuel transformed the façade into one of the finest (and now most photographed) parts of the Louvre.

Thanks to the creation of the Nouveau Louvre, the museum now had more than 130 rooms to display its ever-growing collections. But most of the new building stock was put to very different uses, at least initially. The northern half of the Louvre complex housed a

library, the Bibliothèque du Louvre, as well as the Ministry of State, together with the minister's vertiginously opulent private apartment. In 1871, however, that ministry was replaced by the Ministry of Finance, which remained there until 1989. Although some of the rooms of the southern annex were allocated to the display of art, the Pavillon des Sessions and the Salle des États played an official and ceremonial role through the early years of the Third Republic. Beyond that, Napoleon III intended to create in the Louvre a *cité militaire*, a citadel in which the ground floor of the Grande Galerie, together with that of its new northern pendant, would serve as barracks for soldiers. As for the southern buildings of the Nouveau Louvre, they would house the Ministries of the Interior and the Police, as well as the government's printing and telegraphy centers.

No less importantly, they were to contain two cavalry squadrons. Today, on the ground floor of the Nouveau Louvre's southern half stand the Salle du Manège (literally, the riding hall) and the nearby halls devoted to antiquities and Greek inscriptions: all of these spaces are clad in bright red brick that seems oddly vernacular compared to the pale and elevated classicism of the rest of the museum. Through the windows to the west, in the Cour Lefuel, is something even stranger, an elaborate stairway shaped like a horse shoe and based on a similar stairway in Fontainebleau. It was designed to accommodate a mounted rider, specifically a member of the emperor's cavalry squadrons. In the end, the cavalry never inhabited this part of the palace, and it is quite evident that, despite all the cost and effort that went into the construction of the Nouveau Louvre, its imperial patron had not thought through the uses of the building at the moment of its design. But although the cavalry's loss was the museum's gain, the disposition and design of many of the building's spaces reveal that they were originally intended for very different uses from the ones they serve today.

* * *

Paris has been intimately associated with photography since the earliest days of the art. And so it seems fitting that the Louvre was the first great construction site in history to be documented by means of this new technology, and some of its first and finest practitioners, among them Gustave Le Gray and Charles Marville, were there at the creation. But no one recorded the progress of the Louvre more diligently than Édouard Baldus, who, for more than a decade, arrived at the site each Sunday to record what had been accomplished over the previous week. His images of shattered, colorless stones scattered across the Cour Napoléon put one in mind of the ground encircling the Great Pyramid of Cheops, if not the surface of Mars. To this day it is jarring to see such wanton devastation visited on some of the most sacred monuments of French culture, to witness the utter ruin of the older Pavillon de Flore or to behold the western half of the Grande Galerie in a state of near annihilation. But nothing is more jarring than the almost total lack of human beings, either because the image was taken on the Sabbath, when no work was allowed, or because living things, unless they stood very still, would not register in the long exposures needed by an art still in its infancy.

Many men worked on the site, even if their names are mostly lost to history. And the fact that Napoleon III should have thought to express his gratitude by throwing them a banquet in the Salle des États goes far to redeem many of the less appealing aspects of his reign. The construction site that Visconti set up and that Lefuel, his successor, largely perpetuated, had an air of almost military discipline: there was no workers' canteen, for example, lest they be distracted from their labors. The emperor, who visited the construction site on an almost daily basis, was most eager to see the project completed in time for the Exposition Universelle of 1855. Although that proved too tasking even for a team as efficient as Lefuel's, it nevertheless lent an air of urgency to their labors. Most of the time the workforce consisted of five to six hundred men, but when some

Édouard Baldus's photograph of around 1855, depicting the Cour Napoléon during the construction of the Nouveau Louvre. In the background, behind the Arc du Carrousel, stands the Tuileries Palace.

part of the project called for swifter results, two thousand men might be called up from the available reservoir of manual laborers in Paris and its immediate environs.

Things did not always run smoothly. Reports of drinking on the job filtered out and occasionally the police were called in to chase away brandy sellers who haunted the site like sutlers at a military encampment. Chicanery was encountered on occasion: when three stonecutters falsified their schedules to receive more pay, they were sent to prison for as much as four years. And nothing was easy about the work. Although a medical center was set up in the Cour Napoléon, twenty-five workers perished in the course of building the Nouveau Louvre, and more than twelve hundred sustained injuries. In each case, however, their families were compensated. More than once the draught horses that conveyed materials around the site

were mistreated to the point where Visconti alerted the police to "the inhumanity of the carters toward their horses."[8]

Ironically, the shanty town of the older Quartier du Louvre, with its warren of streets and dead-ends, had given way to an encampment whose own drab sheds, slapped together from brick and discarded wood, were centered around a makeshift avenue stretching from the Pavillon de l'Horloge down the center of the Cour Napoléon to the place du Carrousel. The amount of debris created by the construction on the Louvre was almost incalculable and tended to accumulate along the banks of the Seine before being noisily carted away, to the infinite irritation of the affluent inhabitants of the area. In order to allay their anger, this debris was eventually sent in barges up the Seine to the Île aux Cygnes, in what is now the Fifteenth Arrondissement, or to the Bassin de la Vilette in the Nineteenth.

One of the most conspicuous elements of Second Empire architecture was its extensive use of limestone for important public buildings—understandably, given the emperor's devotion to seventeenth-century precedent—rather than the brick that figured so prominently in French provincial architecture and in the nineteenth–century architecture of England and Germany. Most of the quarries from which this stone was extracted were the same as under the *ancien régime*: those of Val-d'Oise, Conflans and Soissons, among others, as well as the quarries of Lorraine that were newly cost-effective with the establishment of the railways. Polychrome marble, used as accents in chimneys, columns and pavement, arrived from Languedoc in Southern France and from Corsica.

Given this extensive use of the same stone that Henri II and Louis XIV had used, modern visitors are apt to perceive no difference between the Louvre's earlier and later parts, and are also apt to imagine that the entire site was constructed in the same way. But even if many ancient masonry techniques were still used in Second Empire Paris—in contrast to the later limestone-clad steel frames

of the Metropolitan Museum in New York City or the National Gallery in Washington, DC—underpinning much of that new construction were equally new methods. Seemingly a traditionalist, Visconti was determined to use new techniques wherever possible, especially ironwork, and to this end he surrounded himself with men who had experience building railways and train stations. Thus the ballooning roofs of the seven pavilions of the Cour Napoléon, although to all appearances inveterately French, were created using a largely experimental metal armature. The floors of the new sections were likewise fortified with a metal skeleton, supported with terracotta and plaster, while pasteboard was used extensively in the walls of the Appartement du Ministre as well as in the reconstituted western end of the Grande Galerie. The surfaces in many parts of the ministry offices in the Louvre's northern half illustrated a new material called Kamptulicon (an ancestor of linoleum), formed from rubber and powdered cork, while the metal accents, to be found in the railings, keyholes and such, are the ripe product of electrolysis.

*　*　*

Never was more attention paid to interior space than during France's Second Empire, and never were interior spaces more lavishly thought through than in the Louvre of Napoleon III. Although much of this work has been lost, much has survived. Every molecule of the Louvre's Second Empire interiors feels charged with meaning and formal consequence, and each room is the product of hundreds of discrete acts of aesthetic judgment. Painting, sculpture and the abstract language of architecture are summoned to generate this meaning, whether historical or mythological. As a culture, as a civilization, we have lost the ability to appreciate such densely layered allegorical machinery. Some of the finest of these interiors were completed

during the four years of the Second Republic, from 1848 to 1852, by Félix Duban. This architect had already designed the main building of the École des Beaux-Arts and had worked with Eugène Violet-le-Duc on renovations to the Sainte-Chapelle. The experience thus acquired would be put to good use in Duban's restoration work on the exteriors of the Louvre's Petite and Grande Galeries, which were literally falling apart in places. We would think far more today of Félix Duban if his interior spaces had been as well preserved and as carefully restored as Lefuel's Appartement du Ministre in the new northern part of the Louvre. He was responsible for the fundamental redesign of three of the museum's most important spaces in or near the Petite Galerie: the Galerie d'Apollon, on the first floor of the Petite Galerie; the Salon Carré, at the eastern end of the Grande Galerie; and finally the Salle des Sept-Chieminées (the Hall of the Seven Chimneys), in what was formerly the Pavillon du Roi in the southwest corner of the Cour Carrée. In these spaces Duban, more than any other architect, invented the classic Beaux-Arts interior that would reach its consummation in the Appartement du Ministre.

By the end of the July Monarchy, in 1848, these interiors were in a dangerous state of decay. Duban's mission was not only to restore them to their former grandeur, but to infuse them with a greater glory than they had known before. Today the Galerie d'Apollon is mercifully intact, preserving nearly all the improvements that Duban contrived. But the Salon Carré has been greatly diminished through its tasteless transformation in the postwar years, which were dominated by an aesthetic completely opposed to that of the Second Empire. As for the Salle des Sept-Chieminées, it has been only partially debased, but in a sense has suffered an even less enviable fate through its demotion to a passageway between the Grande Galerie and Musée Charles X.

After the fire of 1661, the Galerie d'Apollon was redesigned by Charles Le Brun. But when Louis XIV moved permanently to Versailles, Le Brun abandoned the Louvre as well, having painted only

three of eleven planned canvases. During the eighteenth century, artists gradually produced some of these missing works, but other than that the gallery suffered nearly two centuries of neglect, serving as a storage room for the Académie des Beaux-Arts and suffering the adolescent antics of its young students. Meanwhile plaster ornaments were falling from the ceiling, and the paintings themselves were badly damaged by humidity. Around the time when Duban was beginning his work on the space, the Louvre's director, Philippe-Auguste Jeanron, was showing it to potential contractors when the rosettes on the ceiling started to rain down on them, forcing them to make a hasty exit.[9]

After Duban reinforced the structure and regilded the ceiling, he turned his attention to commissioning a painting for the center of the ceiling, perhaps the most important painting in the entire chamber. For this he turned to Eugène Delacroix, the leader of the Romantic movement, who created *Apollo Vanquishing the Serpent Python*. Although this is one of his largest and most ambitious works, its hesitant union of classicism and romanticism jars with the more formal paintings that surround it. Along the walls are half-length portraits of painters, sculptors and architects who played a role in creating the Louvre: Poussin, Pierre Lescot, Louis Le Vau, even Visconti himself, as well as monarchs from Philippe Auguste to Louis XIV. Added in the mid-1850s, these are not paintings, as they appear to be, but tapestries from the factories of les Gobelins. What is so striking about their arrangement is the equivalency they imply between visual artists and monarchs: together with the paintings on the ceiling of the Galerie Campana from twenty years before, they represent nothing less than a revolution in the role of visual culture in nineteenth-century Europe, presaging the almost idolatrous regard in which we hold the visual arts today.

By the time he finished, Duban had brought this iconic space to a degree of virtuosic completion that it had never known before.

Today the charmless, characterless wall coverings and mid-room partitions of the Salon Carrée and Salles des Sept-Cheminées retain little trace of the splendor they once had, when somber wood wainscotings at the base of the walls provided a sober ballast to the sculptural riot on the roof. Although these chambers, like the Galerie d'Apollon, made extensive use of stuccoed sculptural forms, paintings play no part in the décor. This was standard practice at the Louvre, lest the paintings on the ceiling distract from those on the walls. A well-known depiction of the Salon Carré, by the American artist (and inventor of Morse Code) Samuel F. B. Morse, was made in 1831 and graphically illustrates how much drabber the room seemed before Duban intervened. In Morse's version, the walls were covered from floor to ceiling in paintings and the floors paved with grayish-brown tiles. There is little else to see. Nothing prepares us for the airborne ballet that Duban choreographed. At the four corners of Duban's new chamber, Pierre Charles Simart and his associates sculpted Atlas figures (*Atlantes*) who raise above their heads escutcheons with the letter N for Napoleon III. Each of these seminaked creatures is flanked by lithe angels drawn from Florentine mannerism, while a motionless female figure, inspired by the sibyls of the Sistine Chapel's ceiling, sits in the midst of this ecstatic dance and surveys the spectacle with an air of sullen disapproval.

* * *

One magnificent exception to the general degradation that the Louvre's Second Empire interiors suffered in the twentieth century is the apartment of the Ministre d'État in the northern half of the Nouveau Louvre. Because far fewer tourists visit the northern half of the Louvre than its southern counterpart, most will never see these rooms, which were first revealed to the public—and it was

indeed a revelation—after the Ministry of Finance was dislodged in 1989 and the necessary repair work was completed in 1993. This suite of splendid rooms occupies the entire first floor of the Pavillon Turgot, the westernmost of the three pavilions in the northern half of the Nouveau Louvre; rising over what had been the Hôtel de Rambouillet and the Hôtel de Nantes. Like most of the Louvre's interior spaces, it is arranged one room after another. For more than a hundred years, these rooms, like those of Miss Havisham's house in *Great Expectations*, were shut and sealed and their tasseled curtains rarely parted to admit the light of day. For most of that lost century, they were little more than a rumor to anyone beyond a few art historians and high functionaries in the Ministry of Finance. But for that abandonment, these chambers would almost certainly have suffered the same vandalism as the Salle des États and the Salon Carré. Instead they survived long enough for the mid-century modernist aesthetic to play itself out and for a new style, that of postmodernism, to create a new tolerance for such magnificent excess. Certainly some touch-up work was required and some of the furniture had to be reupholstered, but that intervention was less remarkable than the fact that the furniture had survived in the first place.

When the apartment reopened to the public in 1993, it was called, for no particular reason, les Appartements de Napoléon III, encouraging all who entered to imagine that the emperor himself had slept and entertained there. That was hardly the case. Napoleon III, like so many royal predecessors, lived in the Tuileries, in even greater splendor. Today it seems self-evident that all of the Louvre should be consecrated entirely to art; but in the Second Empire that proposition was hardly self-evident, and only a third of the Louvre complex was allocated to the museum. Rather, the Louvre was meant to serve many functions, one of which, at least initially, was to provide lodging for high functionaries like the Ministre d'État and his family. Other important figures lodged in the Louvre included the

emperor's chief equerry, who lived above the stables of the Salle du Manège, and Émilien de Nieuwerkerke, the museum's director, who was famous for the lavish soirees he held in his apartment on the north side of the Cour Carrée.

If it seems well-nigh miraculous that the Appartement du Ministre d'État survived modernism, far more miraculous is the fact that it survived the wrath of the Communards in 1871. On 25 May of that year, they burned the Tuileries Palace to the ground, while the Bibliothèque du Louvre, next door to the apartment, was likewise destroyed, leaving no trace today beyond its magnificent staircase. And yet the apartment, with all its fine stucco details and silk upholstery, sustained only the lightest singeing of one of the bedrooms that stood farthest from its official rooms. According to the official inventories, a few pieces of furniture went missing as well.

When the early-twentieth-century modernists waged war against the ornamental excesses of the previous century, this apartment was what they had in mind. These are the sort of rooms that moved the Viennese modernist Adolf Loos, in 1907, to publish his polemical *Ornament und Verbrechen*, Ornament and Crime, which famously equated the two. For much of the ensuing century, that equivalency enjoyed nearly doctrinal authority among the modernists. Hector Lefuel might have been scandalized by such opinions had he lived to hear them, but he would not have cared greatly. And while it was certainly true—and this was Loos's real point—that there was something pretentious and overblown about such décor, he was attacking a style that, fifty years after Lefuel, had thoroughly played itself out. But in the Louvre we see that style in its prime. Like the Nouveau Louvre itself, the style of these rooms is *Napoléon III*: that is to say that it is historicist and acutely conscious of earlier precedents, which it joyously exploits whenever it can. But its use of earlier styles and motifs is entirely made up and arbitrary, though so well done that the visitor might never guess. At the same time, that sense

of pastiche, even fakery, that defines so much of French academic painting and sculpture is nowhere in evidence here. As Lefuel conceived it, the décor is a fever dream of monarchical glory: in the grand salon at the corner of the pavilion, as well as in the adjoining salon-theatre and the great dining room, the styles of Louis XIV and Louis XV promiscuously collide. Scholarly accuracy is a matter of total indifference: no chamber in the world, whether in Versailles, the Palacio Real in Madrid, or the Palazzo Pitti in Florence, ever looked quite like this.

The official rooms, with ceilings forty feet high, might be called neo-baroque, with their paired columns that invoke the Colonnade of the Louvre, but elements of Florentine mannerism crop up whenever Lefuel felt like it. Inserted into the gilded ceiling is an elaborate allegorical painting that is no less delightful for being so poorly conceived. Created by Charles Raphael Maréchal, it recalls Le Brun both in its forms and in its title: *Wisdom and Force Present to the Imperial Couple the Great Designs on Which They Will Establish the Greatness of the Reign of Napoleon III.*

Several ministers and their families lived in this apartment. If the work was largely carried out under Achille Fould, the main beneficiary was his successor Alexandre Colonna-Walewski, a statesman of French and Polish descent, rumored to be the natural child of Napoleon I and his mistress Countess Marie Walewska. Alexandre's wife, Marie-Anne Walewska (herself the mistress of Napoleon III), was one of the most admired *salonnières* of the Second Empire, and some of her greatest parties were held in these chambers. It was not uncommon on such occasions to see private carriages lined up for blocks along the rue de Rivoli, beside the rue de Rohan. To celebrate the minister's assumption of his office, a masqued ball was given on 11 February 1861. According to *Le moniteur universel,* the Princesse de Metternich showed up as a toreador, the Princesse de Trubetskoi as a butterfly, M. de Gallifet as a red devil and his

wife as a tulip.[10] During Carnival celebrations two years later, Mme Walewska, dressed as the Muse des Beaux-Arts, welcomed to dinner over eight hundred guests, who arrived at eleven o'clock in the evening, according to *Le monde illustré*, and remained until five o'clock the next morning. Other soirees were more high-minded. Typically, such occasions might include the performance of scenes from Molière's *Le Misanthrope*, followed by Franz Liszt at the piano or a song recital by Pauline Viardot, one of the great mezzo-sopranos of the age, the beloved of both Alfred de Musset and Ivan Turgenev.

* * *

While the northern half of the Louvre complex housed the majority of its government ministries and ceremonial spaces, the southern half also played a major role in state affairs. Its most grandiose space was surely the Salle des États. More than sixty meters long and twenty wide, it was intended to accommodate 260 deputies and 160 senators, as well as ministers and distinguished members of the military, the church and industry, when Napoleon III delivered his annual address. From the galleries along the eastern and western sides of the chamber, several hundred spectators with no official rank, especially women, listened to the emperor as he spoke from a throne raised on a dais at the northern end of the room, with his back to where we now find Veronese's *Wedding Feast at Cana*.

The space was used for other events as well. A banquet was staged here on 14 August 1859 in celebration of the Battle of Solferino, in which, three weeks earlier, Napoleon III had defeated the armies of Austro-Hungary and pledged himself as guarantor of the liberty of the Italian Peninsula. With a combined three hundred thousand soldiers fighting on both sides, this was the largest conflict

on European soil since the Battle of Leipzig nearly half a century before. Following as it did the French victories in the Crimean War two years earlier, it represented the pinnacle of Napoleon's international prestige. Three long tables filled the room from north to south, while the emperor, together with a few guests of honor, dined to the sounds of the choir of the Paris Opera.

At the time, that massive chamber looked very different from what we see today. Protruding ten feet from the east and west walls, arcades of Corinthian columns held up the galleries from which visitors could hear the emperor's discourses. The light that illuminates the chamber today is almost entirely artificial, although some natural light descends from the ceiling: originally, however, light poured in from large windows above the galleries, surmounted by oculus windows. Thus the side walls were mostly pierced. In fact, those windows are still there, but they have been suppressed and covered for more than a century. With the exception of a few feet of canvas that has been removed, nothing survives of the sprawling painting on the ceiling, a typically complex depiction of *France Surrounded by Divers Allegories*, perhaps the largest single painting in the Louvre at the time of its creation. It was the work of Charles–Louis Müller, a largely forgotten academic painter. The layout of the chamber followed the so-called basilican plan, best preserved today in the Roman church of Santa Maria Maggiore. This early Christian association was enhanced, along the southern wall, by another of Müller's works, a towering depiction of the emperor himself, his right hand raised in a manner recalling early depictions of Christ the Redeemer.

But the Salle des États did not retain its original functions for very long. To its west toward the Pavillon de Flore, at the end of today's Grande Galerie stands another large chamber, the Pavillon des Sessions, where the Grande Galerie expands to double its original width. This second chamber, even larger than the Salle des États

and intended to serve the same function, is now home to some of the museum's finest Italian and Spanish baroque and rococo art.

* * *

If most of Lefuel and Duban's interiors would now be unrecognizable to their creators, one part of the Second Empire Louvre, its stairways, has been almost perfectly preserved. We rarely think of architects as great stairway designers, and modern architecture, with its omnipresent elevators, has been the death of this once vital discipline. With very few exceptions, such as Leonardo da Vinci's great spiral staircase at Chambord and Louis Le Vau's now demolished Escalier des Ambassadeurs at Versailles, we tend to dismiss these glorious and essential elements as nothing more than a means of circulation. But such indifference does a grave disservice to the architects of the Louvre in general and to Lefuel in specific. Throughout the nineteenth century, during the glory days of Beaux-Arts classicism, the grand stairway stood at the conceptual core of a building, something to which everything else was subordinated. To mount or descend one of these stairways was a privilege, and one felt somehow ennobled in the act.

Eight great staircases adorn the Louvre, and four of them were conceived by Lefuel. The two oldest, those of Henri II and Henri IV in the western wing of the Cour Carrée, remain perfectly intact and were designed respectively by Pierre Lescot and Jacques Lemercier in the sixteenth and seventeenth centuries. At the north and south ends of the Colonnade, Napoleon's architects Percier and Fontaine designed a pair of identical stairways that are masterpieces of pale neoclassical sobriety. These architects also designed the first grand stairway for the Louvre as a museum, a masterpiece in its way, rising from the Rotonde de Mars up to the Salon Carré.

But with the creation of the Nouveau Louvre in the 1850s, that older stairway was replaced by Lefuel's Escalier Daru. This project, completed only in 1883 by his successor, Edmond Guillaume, was identical in shape and size to the present Escalier Daru that leads up to the *Winged Victory of Samothrace*. But its surface drama and gaudy mosaics were instantly controversial and subsequently were replaced by the far simpler version that we see today, completed by Albert Ferran in 1934.

Lefuel's three other stairways, however, remain exactly as he intended them. The most grandiose, the Escalier Mollien, is found in the southwestern corner of the Nouveau Louvre. It was designed to facilitate access to the Salle des États, when that chamber was still the governmental core of the new Louvre. The Escalier Mollien ascends to a landing that displays the famous sculpture known as the *Diana of Fontainebleau*, before bifurcating left and right. Above it, the ceiling seems to be propped up on all four sides by mostly freestanding Corinthian columns. In the midst of sculptures by Jean-Baptiste-Jules Klagmann and Theophile Murgey, Charles–Louis Müller has painted the naked allegorical figure of a woman in *Glory Distributing Crowns to the Arts*.

Lefuel's two remaining staircases are somewhat more sober in conception. The Escalier du Ministre in the northern wing led up to the Appartement du Ministre. Despite its wrought-iron railing with gilt accents, few curves soften the contours of its monochrome limestone cage. The only element of color comes from the elegant landscape paintings set into the walls of the landings, charming if oddly superfluous scenes of the Tuileries, only a few hundred feet away.

But Lefuel's most original work is the Escalier de la Bibliothèque, now known as the Escalier Lefuel, which was nearly destroyed during the Paris Commune in 1871. This is Lefuel's most striking act of personal initiative in the Louvre and perhaps in his entire career. While the dimensions of his exterior work on the Louvre

were largely determined by the general designs he inherited from Visconti, the Escalier Lefuel is a one-off, without real precedent in earlier architecture. In the Escalier Mollien, the architect's use of the classical language remains safely within the bounds of Beaux-Arts propriety. But here, in a part of the Louvre complex that most contemporaries never saw and that most tourists never visit, Lefuel reinvented the staircase as an architectural concept, and his intention was nothing less than to astound viewers with something never before seen. The stairway is divided into two flights of steps, and the fact that it is clad in marble endows it with a special splendor. Despite a general mood of classicism in its balustrades, the traditional orders are nowhere to be found, the vaults spring from their pillars with almost Gothic extravagance, and the stairs themselves take on a woozy elasticity. Of all the classical structures built in the Beaux-Arts idiom, none exhibits so great an indifference to that respect for precedent that most of Lefuel's contemporaries upheld without question. It is almost as though, in the Escalier Lefuel, we are watching the birth of the art nouveau movement, still over a generation in the future.

* * *

The term *statuomanie*, or *statuemania*, was coined—in jest—to describe a peculiarly insatiable love of sculpture, and especially statues, that consumed the Western world in the second half of the nineteenth century. Any building of any size or importance unfurled a vast sculptural program across its façade and its interior spaces. The appetite for public monuments was so great that municipalities almost seem to have gone looking for things to commemorate simply to have an excuse to build a monument and then populate it with statues. Never before and never again would sculptors be held in such

high demand, and no one project provided more work for them than the Nouveau Louvre under the Second Empire. By the hundreds these sculptural groups were commissioned. Each pediment of each pavilion had to have its multifigured program. Columns were not columns but caryatids. The dormer atop each slate-covered gable was guarded by a garrison of Grecian deities in flowing antique robes. Armies of *ornamentistes* carved swags, corbels and clustered fruits in low-relief across any part of the façade that lacked a full-bore statue of its own.

The "period eye" of the age was trained to notice, even to seek out, these sculptural adornments, over which the eye of the modern observer is apt to glide with dull indifference. Nevertheless, visitors to the Cour Napoléon, as they wait in line to enter the *Pyramide*, cannot fail to notice that they are being watched by eighty-six stone figures, each about ten feet tall, that man the terraces of the first floor like some overdressed swat team. Collectively known as *les hommes illustres*, these "famous men"—and they were all French men—represent one of the most ambitious sculptural programs of the Second Empire. The only sculptural project of comparable extent is the 140 statues of saints atop Bernini's colonnade in Saint Peter's Square in Rome, which was the direct precedent and inspiration for the Cour Napoléon and itself looked back, past the Biblioteca Marciana in Venice, to such Hellenistic monuments as the Grand Altar of Peragmon.

The idea for this project originated with Félix Duban in 1849.[11] While Visconti, who succeeded him, conceived of a series of portrait busts, his own successor, Lefuel, arrived at the sequence of statues that we see today. In the eighteenth century, d'Angiviller had envisaged a more modest project to honor the great warriors of French history. But by the middle of the nineteenth century, cultural figures were the new heroes of the bourgeois Second Empire, and so all the men honored were artists, writers and statesmen, together with a few natural scientists. Many of these eminences had a connection to the Louvre itself: Lescot, Goujon, Poussin and

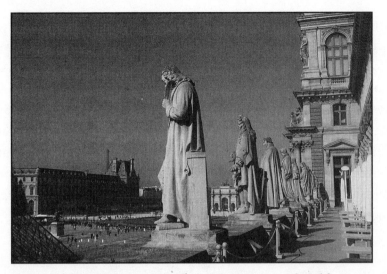

*Several of the 86 statues of "Illustrious Men," sculpted between
1853 and 1857, that look down on the Cour Napoléon.
The one closest to the camera depicts Voltaire.*

Perrault had worked in or on the palace. Sully and Mazarin had
presided there as ministers, and such literary eminences as Racine
and Bossuet attended the Académie française in the Aile Lemercier.
Chronologically, these figures go back as far as Gregory of Tours,
the sixth-century historian of the Franks, and are as recent as the
sculptor Jean-Antoine Houdon, who died in 1828. The painter
Jacques-Louis David, who died in 1825, would have been a nat-
ural choice for inclusion, but because he was associated with the
beheading of Louis XVI, it was thought better not to include him.
With some exceptions, literary figures, scientists and statesmen
occupy the northern half of the Cour Napoléon, while visual artists
occupy the southern half.

The statues, though originally intended to be marble, were ulti-
mately executed in granite, as a cost-saving measure. They stand on
podiums that bear their last names, making it easy to identify them
even from below and at a distance. In keeping with the spirit of

historicism that defined the middle years of the nineteenth century, each statue is dressed in a chronologically precise costume, and every effort has been made to portray accurately the face of the person depicted. In truth the sculptures are not very good: the seated figures of eminent men that d'Angiviller had commissioned in the final quarter of the eighteenth century were uniformly better. These later sculptures enhance the Cour Napoléon more through period charm than through any excellence of art. Although most of the sculptors were held in high regard in their day, now only François Rude and Auguste Préault enjoy a slightly broader renown.

* * *

Just as the body of the Louvre was physically transformed over the course of the Second Empire, the soul of the museum, its institutional character, also underwent an essential evolution at this time. This change can be seen in one of the simplest but most important elements of the museum's functioning, the way in which it hung its paintings. As late as the July Monarchy—as evidenced in the Samuel F. B. Morse canvas—paintings were hung in a way that would be almost unimaginable today, stacked as many as six high, making it impossible to examine them in detail. Indeed, given the nature of the old masters in the Louvre, not to be able to come within ten inches of their surface is almost certainly to miss something essential.

Perhaps even more self-defeating was the museum's tendency to hang works with an eye to the visual effects created by their juxtaposition. Earlier curators had spoken of the display of paintings as a *parterre émaillé de fleurs*, an enameled bed of flowers, without giving any thought to chronology, style or national origin, as is the norm today: it was almost as if the composite effect of these works of art amounted to one supreme and all-encompassing work of art.

This principle of displaying art persisted until Philippe-Auguste Jeanron assumed the directorship of the Louvre in 1848. Although his tenure lasted barely two years, this largely forgotten figure did more to alter the running of the Louvre than any of his predecessors and most of those who would follow him. In Édouard Baldus's portrait photograph of the man, Jeanron looks weary and slightly disheveled, and, since he was still in his early forties when it was taken, far older than his years. For most of his life Jeanron was known as a painter, and not an especially good one. He worked in a style somewhere between the Romantic and realist idioms, producing pleasant works that were perhaps superior in sentiment than in execution. Even his accepting the directorship of the Louvre occurred only after several more eminent men, among them the critic Théophile Thoré-Bürger—discoverer of Vermeer—and the sculptor David d'Angers, had declined the offer.

And yet Jeanron altered the Louvre's display of its art in radical ways. "It is necessary," he wrote, "to impose certain strict principles to serve as the basis for a new ordering, one that is more liberal, more learned and more dignified: to inventory, to conserve, to describe, to classify, to communicate and to display."[12] Perhaps the most important of these ambitions was that of classification. Henceforth, the paintings were to be displayed in an almost scientific manner, according to their place in the history of art. The public was to be delighted, but also instructed. In this seemingly simple and self-evident idea lie the origins of the modern art museum: it governs how art is displayed throughout the world. And yet, although the Louvre has been committed to honoring former curators and directors—as attested in the Pavillon Denon, the Porte Jaujard and the Porte Barbet de Jouy—there is no part of the museum named for Jeanron, and no street or avenue in Paris or, perhaps, anywhere else has been named in his honor.

The same could be said for Émilien de Nieuwerkerke, one of his successors, who ran the Louvre longer, but left little mark on

it other than to perpetuate and institutionalize Jeanron's reforms. Under Nieuwerkerke's direction and that of his successors over the eighteen years of the Second Empire, the Louvre's collections continued to grow, either through purchase and the fruits of archaeological expeditions or, most spectacularly, through donations from private collectors. Works of art were purchased at auction and from dealers, but more often directly from the owners or their heirs. And if the proprietors were themselves French, they might be persuaded, on patriotic grounds, not to drive too hard a bargain, and certainly not to sell to such competing national museums as London's ever-acquisitive British Museum and National Gallery.

In theory, the amount of money that the curators had for annual purchases was a meager one hundred thousand francs, a fraction of what the curators of the National Gallery had to play with. In those days, however, even that amount of money could buy a good deal of first-rate art. Rembrandt's great and graphic *Boeuf Écorché*—depicting a strung-up carcass of beef—was bought in 1857 for only 5,000 francs, while the museum paid 7,500 francs for the superb *Lacemaker* by Vermeer, an artist who was only beginning to emerge from obscurity. In general these purchases, whether by Jeanron, Nieuwerkerke or a later director, were uncannily shrewd compared with the more hit-or-miss purchases of the monarchs of the *ancien régime*. Even when the curators seemed to be in error, they proved—by the subsequent verdict of art history—to have been triumphantly right. In 1856, for example, the *Codex Vallardi* was purchased as one of Leonardo da Vinci's notebooks at a time when only a handful of scholars had ever seen them. Today, with the dissemination of reproductions, even an uninitiated observer could see in a second that the codex is not by da Vinci. In fact it is by Pisanello, an infinitely odd Tuscan master who died around the time of da Vinci's birth in 1452. In its way, however, this is as important an acquisition as if it had indeed been by da Vinci, not only for its beauty and eccentricity, but

also for the light it sheds on the evolution of Italian painting from the Gothic style to that of the Renaissance.

If more money was needed than the allotted one hundred thousand francs, it could usually be found, often through the largesse of the emperor himself. In 1858, the museum was given the chance to buy a number of Spanish baroque works, which at the time were only beginning to be appreciated and to this day are comparatively underrepresented in the Louvre. Among these paintings were Murillo's *Birth of the Virgin* and *The Miracle of Saint Diego*, as well as Zurbarán's two scenes from the life of Saint Bonaventura. These works had been brought over from Spain in 1811—during the Peninsula War that Napoleon waged against the Spanish Bourbons—by Jean-de-Dieu Soult, one of his generals. But when Soult died in 1851, the Louvre managed to find the three hundred thousand francs his heirs demanded.

By far the greatest purchase of the Second Empire was the Campana Collection, 1,835 of whose paintings, gold, bronzes and antiquities—out of 15,000 items in the original collection—were bought in 1861 through the senate's vote to provide 4.8 million francs to that end. Giampietro Campana, who became the marquis of Cavelli in 1849, amassed a collection so vast in scope that it had to be held in several homes and warehouses around Rome, the city of his birth. Eventually, however, his voracious appetite for new acquisitions got him into trouble. In 1857 the Pontifical State arrested him for embezzlement, a crime that would ordinarily have resulted in twenty years in prison. Instead he was exiled, while his collection was confiscated and put up for sale. The South Kensington Museum in London—today the Victoria and Albert Museum—bought some of his majolica wares, while the Hermitage in Saint Petersburg purchased eight hundred objects, mainly ancient Etruscan and Roman vases. Most of the paintings, however, remained in the collection, and more than five hundred of them eventually reached France.

As usual, the best of these, slightly more than two hundred, stayed in the Louvre, while the rest were divided among sixty-seven regional museums around the country. Among the most important works acquired by the Louvre was one of Paolo Uccello's three depictions of the Battle of San Romano (c. 1440). Other artists in this sale were the important early Tuscans Giotto and Bernardo Daddi, the Quattrocento painters Filippino Lippi and Cosmè Tura, and, from the later sixteenth century, Paolo Veronese. With the exception of Veronese—an established classic already well represented in the museum—most of these paintings filled crucial gaps in the Louvre's holdings. The curators also bought several hundred of Campana's Greek and Etruscan vases—another area in which the museum had been deficient—and these are now on view amid the beautiful green-walled chambers of the Galerie Campana, parallel to the Musée Charles X on the first floor of the Cour Carrée's southern wing.

* * *

And yet, two of the most brilliant collections ever to enter the Louvre cost that institution nothing at all, and were assembled, not by wealthy or shady aristocrats, but by humble members of the middle class who saved their money and purchased art with an innate and almost supernatural discernment.

Alexandre-Charles Sauvageot funded his extraordinary taste by holding down two jobs. For nearly thirty years, from 1800 until his retirement in 1829, he was second violinist in the orchestra of the Paris Opera. At the same time, he was a *commis*, or junior official, in the city's customs department, a position he held until 1847. After retiring from that post, this confirmed bachelor spent the remaining thirteen years of his life amid the treasures he kept in an unassuming flat in the Ninth Arrondissement. According to the

brothers Goncourt, who knew him well and visited his apartment on many occasions, he acquired his treasures not by frequenting the expensive galleries and auction houses of Paris, but by passing among the flea markets and *brocanteurs*, or junk dealers, of the boulevard Beaumarchais and the boulevard du Temple.[13] Just as there are avant-garde artists, so there are avant-garde collectors, and Sauvageot was one of them, with a vision of art that stood in advance, if not in open defiance, of the dominant tastes of his age. When, around 1800, he started buying domestic objects of the Middle Ages and early Renaissance—locks and keys, wax figures, enamels, old clocks and bronze medals—he had the field almost entirely to himself. But by his old age, the generally historicist culture of France, and of Europe in general, had come to share this rare passion, and many collectors would have been happy to pay him handsomely to part with his entire hoard. But through a strong civic and patriotic impulse, he turned them all down, and in 1856 he gave the entire collection to the Louvre, with the exception of his extensive personal library. By that one acquisition, the Louvre came to possess one of the world's finest collections of medieval and Renaissance decorative art.

Even more extraordinary, perhaps, was the collection of Louis La Caze, who was a more traditional collector in that he bought old master paintings whose great cultural value would be understood only several decades after he had acquired them. La Caze had trained as a painter, perhaps under the grand neoclassicist Girodet, and, to judge from his self-portrait of 1843, he was undeniably gifted in this art. But he chose medicine as his profession and distinguished himself during the cholera pandemic of 1832 by proving the non-contagious nature of that disease. His success in his professional life afforded him the means to collect art. A childless bachelor like Sauvageot, La Caze was in his early twenties when, in 1820, he began to frequent the *brocanteurs* and auction houses, and eventually he

brought home to his apartment at 116 rue du Cherche-Midi the works of Velazquez and Watteau, who was held in relatively little esteem at the time, as well as such Dutch genre painters as Jan Steen and the brothers Isaak and Adriaen van Ostade. His discernment was as remarkable as his persistence and good luck in collecting the works of neglected masters. He was also generous in opening up his apartment to the public one day a week. "In his home Manet, Degas [and] Fantin-Latour discovered all the older paintings that the Louvre did not display," according to the *Histoire du Louvre*.[14] Some of what are, today, among the most famous and widely reproduced works at the Louvre were part of his donation: Watteau's *Gilles*, Ribera's *The Clubfoot*, Fragonard's *The Bathers*, Hals's *La Bohémienne* and Rembrandt's *Bathsheba at Her Bath*, together with many others, every bit as illustrious. In all, his donation comprised nearly six hundred paintings.

* * *

During the Second Empire the Louvre made important acquisitions in Greek and Roman artifacts, but also in field of Assyriology, which had not even existed a century earlier. Victor Place contributed greatly to the invention of the discipline with his excavations at Khorsabad in Northern Iraq. These yielded the three-winged bulls in the Cour de Khorsabad of the Nouveau Louvre. Another archaeologist, Auguste Mariette, with his almost uncanny sense of where things were buried, discovered the Serapeum of Memphis in Lower Egypt: guided by little more than a few paragraphs from the early Greek geographer Strabo and the historian Dionysius of Halicarnassus, he understood that he had discovered the ancient Necropolis of Saqqara and the Pyramid fields near Memphis. Later he excavated the necropolises of Meidum, Abydos and Thebes, as well as Karnak

and Tanis. As a result of these excavations, the Louvre acquired some of its best-known antiquities, among them the *Apis Bull*, the so-called *Sphinx of the Dooms* and the *Seated Scribe*.

But the most eminent discovery of all was made in 1863, when Charles Champoiseau unearthed the *Winged Victory of Samothrace*, which entered the Louvre the following year. When the grand stairway known as the Escalier Daru was completed in 1883, the statue was placed at its summit, where it has remained ever since. After the *Mona Lisa* and the *Venus de Milo*, this one masterpiece is the most famous work in the Louvre, and for more than a century, in the days when visitors entered through the nearby Vestibule Denon, it was almost the first work of art they saw. Embodying all the bold theatricality of Hellenistic sculpture, this depiction of Nike, the goddess of victory, stands at the prow of a ship, her wings spread wide. The monument clearly commemorates a naval victory, but scholars are uncertain as to which exact battle is commemorated or when the work was made: dates range from the middle of the fourth to the end of the first centuries BC.

Once again, this discovery was made by a member of the French diplomatic corps assigned to the Ottoman Empire. On 13 April 1863, while excavating the so-called Sanctuary of the Great Gods on the island of Samothrace in the northern Aegean, Champoiseau discovered a nearly ten-foot-tall female figure sculpted from white marble, including the detached wings of the goddess and a number of other fragments. At the same time, he came upon fifteen gray marble blocks near the statue, although he did not yet realize how they related to the female figure or that they formed the prow of a ship. He decided to leave them in the ground, but sent the statue one month later to France. It reached Toulon in seven months, but did not arrive in Paris until 11 May 1864. There restoration work was carried out and the sculpture was finally put on display in the Salle des Caryatides in 1866, where it remained until 1880.

In 1873, an Austrian archaeologist, Aloïs Hauser, reexamined the gray marble blocks that remained on Samothrace and correctly determined that they formed the prow of a ship, which he reconstructed in the form we know today. Champoiseau returned to the site on two occasions, first to claim the sculpted prow and then to seek the rumored head of the goddess, which has never been found. In 1950, American archaeologists from New York University, under the direction of Karl Lehmann, revisited the site and unearthed the palm of the statue's right hand. Two fingers that the Austrian excavators had given to the Kunsthistorisches Museum in Vienna in the 1870s were now reunited with the palm, which, since 1954, has been displayed in a case near the statue.

* * *

In general, Napoleon III respected the severe methodological rigor introduced by Jeanron and upheld by subsequent curators. But he was not above using the Louvre's collections for the sake of populism and propaganda, especially to assert a continuity between his reign and that of his royal, as opposed to his republican, predecessors. To that end he opened in the Louvre the Musée des Souverains (the Museum of Sovereigns) in 1852. It would remain there until his removal from power in 1870. Its goal was to place before the public—in five rooms along the ground floor of the Colonnade—objects that had belonged to the great rulers of France. Starting in the time of the Merovingians, these objects ranged from the gold bees of Childeric to bibles once owned by Charles the Bald, a grandson of Charlemagne, and books that had belonged to Charles V, the king who transformed the Louvre from a fortress into a palace in the fourteenth century. The queens of France were also represented with a variety of objects: a small box formerly in the possession of

Marie Antoinette, Catherine de Médicis' communion book and several books of hours that had belonged to Anne de Bretagne and *la reine Margot*. All of these objects, of course, naturally led up to the relics of the Bonapartes. Prominently displayed were the famous hats of Napoleon I and a rattle that had belonged to his only legitimate son, the so-called king of Rome. These royal relics constituted a populist spectacle more than a serious act of curatorship, and it is easy to imagine that the increasingly professional staff of the museum had to hold its collective nose in this particular part of the Louvre.

One other highly popular display, although it did not last long, was a sequence of six gigantic cylinders, or drums, set side by side, resembling dynamos in an electric factory or tanks in a water-distribution plant. These reproduced in plaster all one hundred feet of Trajan's Column in Rome. Nearly twenty feet tall and almost fourteen feet across, the six cylinders occupied the entire Galerie Daru, one of the largest spaces in the museum. Today's tolerance for only the authentic object and nothing else would have made far less sense to the men and women of the nineteenth century.

* * *

Important civic architecture tends to impose itself upon us with almost hypnotic power: it conjures us into feeling that it is so manifestly right, that it neither could nor should be anything other than what we see today. To many present-day observers, the nineteenth-century Louvre, transfigured through the magic of custom and familiarity, has indeed achieved such formal success. It is true that no part of that structure, according to the pure and eternal principles of architecture, stands forth as an exemplary achievement in itself: almost by definition, the Beaux-Arts style favors stunning theatrical reenactments of earlier idioms over the absolute perfection

of form that distinguishes the seventeenth-century Colonnade. Nevertheless, the complex as a whole is so noble a response to the aesthetic problems that had beset the Louvre for centuries, that one is hard put to imagine how it could possibly be much better.

At the time of its completion, however, many Parisians begged to differ, and initially the censure outweighed the praise. The critic Victor Fournel described the Louvre of the Second Empire as a *toilette de parvenue*, the boudoir of a nouveau-riche woman, adding that "not being able to make her beautiful, you [Lefuel] made her rich." Horace de Viel-Castel, a famously waspish curator at the Louvre, had the idea of placing over the entrance a stately Latin inscription: "Lefuel constructed this deformed monster that besmirches taste and defies all understanding."[15]

But the most famous and also the most ambiguous assessment of the new Louvre comes from Charles Baudelaire's 1861 poem *Le Cygne* (The Swan). In it, a thought occurs to the poet as he crosses the newly voided space where once stood the bohemian Impasse du Doyenné:

> *Le vieux Paris n'est plus (la forme d'une ville*
> *Change plus vite, hélas! que le coeur d'un mortel).*

> *[Old Paris is no more (the form of a city changes faster, alas, than the heart of a man)].*[16]

From this perception his mind moves on, past the labors that are still being carried out before him, to the memory, sad but resigned, of what once was there:

> *Je ne vois qu'en esprit tout ce camp de baraques,*
> *Ces tas de chapiteaux ébauchés et de fûts,*
> *Les herbes, les gros blocs verdis par l'eau des flaques,*

Et, brillant aux carreaux, le bric-à-brac confus.
Là s'étalait jadis une ménagerie . . .

[Only in my mind do I see this field of huts, these unfinished
capitals and shafts of columns, the grass, the large stone
blocks stained green by the puddled water and, gleaming in
windowpanes, a confused jumble of oddments. Here once
upon a time there stood a menagerie . . .]

The poet then recalls a swan he encountered in the place du Carrousel that had broken free from its cage: in the confusion of its sudden liberty it suggests to the poet man's dislocation in the modern world. Baudelaire, that bellwether of modernity, was one of the first to record, with full consciousness, a sentiment that would come to define modernity more than any earlier period of human history—the shock that the pedestrian experiences when some element of the urban landscape, something that had seemed permanent and eternal, has been suddenly and categorically expunged from it, while something vast and new now takes its place. Long before the Second Empire, cities had changed and evolved, but never with the speed of pistons and turbines that defined the Paris of Napoleon III. What Baudelaire, perhaps, had not reckoned with was that the reinvented Louvre, standing in the heart of the city, would itself one day become assimilated to *le vieux Paris*. Today it is impossible to think of Paris without the Louvre of the Second Empire. One of the largest structures on the planet, it is also—against all odds—one of the most consolingly human. It has become Paris itself.

- 9 -

THE LOUVRE
IN MODERN TIMES

If a Parisian of 1880 had somehow managed to return to the Louvre in 1980, he would have noticed little if any change, at least externally. In the century between the fall of the Second Empire in 1870 and President François Mitterrand's momentous decision to expand the museum in 1981, even alterations to the interior were limited in scope. On three occasions during this period the Louvre was so buffeted by adversities—during the Prussian siege of Paris in 1870 and the two World Wars—that it was forced to shut its doors and evacuate its collections to distant parts of France. By the end of that long century, pieces of masonry were falling from the darkened façade of the Cour Napoléon, which had become little more than a dingy car park for the employees of the Ministry of Finance. And yet it was also during this period that the Louvre underwent a kind of transubstantiation: in a very real sense it became *the Louvre*. Following the stumbling, hesitant progress of its early years, it emerged as the institution that we know today, establishing its preeminence among the museums of the world.

* * *

France's Second Empire came to an end at the Battle of Sedan in northern France on 2 September 1870. Over twenty years later

Émile Zola devoted an entire novel to that defeat, simply titled *La Débâcle*. The results were so catastrophic that by evening, Napoleon III was a prisoner of the Prussian army. This was the first time that a French ruler had been captured on the field of battle since François I's surrender at Pavia in 1525. Napoleon III would never see France again, dying in exile in England two years later.

The effects of this battle on Paris and especially on the Louvre were no less drastic. Napoleon III's wife, the Empress Eugénie, had been made regent while he was in the field. When she learned, a month before Sedan, of the French defeats at Forbach and Reichshoffen, she hastened to the Tuileries and placed it, together with the rest of the newly completed Louvre, on a war footing. On 31 August, she ordered Émilien van Nieuwerkerke, the superintendent of the imperial museums, and the curator Frédéric de Reiset to begin evacuating paintings from the Louvre. Three hundred works, the cream of the collection, were sent by train to the Arsenal of Brest, the point on French soil farthest from the advancing Prussian army. In his journal on 2 September, Edmond de Goncourt recalls Reiset weeping before Raphael's *La Belle Jardinière*. "In the evening, after dinner," Goncourt wrote, "we went to the train station on the Rue d'Enfer; I saw seventeen crates containing the Antiope [of Correggio], the most beautiful Venetians etc.—those paintings that had seemed attached to the walls of the Louvre for all eternity and now are nothing more than luggage protected from the hazards of travel and displacement by the word *fragile*."[1] Even Veronese's *Wedding Feast at Cana*, the largest painting in the Louvre, was unceremoniously rolled up and carted away. Meanwhile, the sarcophagi of the Egyptian department served as repositories for jewels and papyrus, the *Venus de Milo* was relegated to the basement of a local police precinct, and the reliefs of Jean Goujon and David d'Angers on the façades overlooking the Cour Carrée were slathered in plaster to protect them from incoming fire.

The day after the Battle of Sedan, Napoleon III capitulated at Metz, and twenty-four hours later the Second Empire had been abolished and replaced by the government of the *Défense Nationale*. Nieuwerkerke fled to England, where in due course he managed to sell his personal art collection—including more than eight hundred medieval and Renaissance sculptures and ceramics, as well as fifteen suits of armor—to Sir Richard Wallace, who would make them the nucleus of his famed Wallace Collection. Just as Nieuwerkerke was making good his escape, an angry mob began to gather in the place du Carrousel, in front of the Tuileries Palace. The empress, who was inside, scarcely had time to collect a few heirlooms before hastening half a mile on foot, first south to the recently renovated (and soon to be destroyed) Pavillon de Flore, then east through the Grande Galerie and finally to the Colonnade, where a waiting carriage bore her away to safety and exile.

But the abdication of Napoleon III was only the beginning of the travails of France and especially Paris. In place of the empire, which had capitulated, the provisional government of the *Défense Nationale* was determined to continue fighting the Prussians. Because the most determined resistance came from Paris itself, on 19 September the Prussian invaders laid siege to the city, which was defended by the thirty-year-old Enceinte Thiers, a fortification that surrounded the city. For much of the siege, the armies of the *garde nationale* were encamped in the Tuileries Garden, while several sections of the Tuileries Palace and the Louvre were transformed into makeshift hospitals for the wounded. In the Grande Galerie itself, now void of paintings, industrial machinery was set up to manufacture firearms. Hoping to conclude the siege quickly, Otto von Bismarck, the Prussian chancellor, pestered the generals to fire on the city, but they refused. Instead, as hunger set in with the onset of winter, they preferred to squeeze the citizens. But when the Parisians proved hardier than expected, Kaiser Wilhelm I himself ordered General Helmuth

von Moltke to fire his large-caliber Krupp siege guns into the capital. Considerable damage was done to the outskirts of the city, but the Prussian ordnance couldn't reach three miles into its center and so menace the Louvre.

Three days later, the city capitulated. After an armistice was signed on 26 January, the Prussians went home, winning Alsace Lorraine (by the Treaty of Frankfurt on 10 May) for the soon-to-be-united German state. But now a far graver danger emerged as civil strife broke out between the *Défense Nationale*, based in Versailles, and the new government in Paris, known as the Commune. This assortment of Communists, Socialists and anarchists assumed power on 18 March and promptly set up a revolutionary regime whose immediate measures included the separation of church and state, the prohibition of fines imposed on workers by their employers and, perhaps most discommoding of all to a Parisian, the abolition of night work in bakeries.

The painter Gustave Courbet, a leader in the Commune's make-shift assembly, was chosen as president of the *Fédération des artistes de Paris*, an association that included more than four hundred artists, among them the painters Manet, Millet and Daumier and the sculptor Jules Dalou. In one of his first acts after he assumed power, Courbet passed a bill in the legislature to dismantle the column in the place Vendôme—crowned by a statue of Napoleon I—on the grounds that it was "a monument devoid of any and all artistic value." (Once order was restored, Courbet was fined 330,000 francs for its destruction. Clearly unable to pay, he fled to Switzerland, where he died six years later). According to Edmond de Goncourt, writing in his journal on 18 April, "The staff of the Musée du Louvre are very nervous. . . . They are afraid that Courbet may be on the trail [of the *Venus de Milo*] and they fear—wrongly, I think—that this crazy modernist is capable of anything against that classical masterpiece."[2]

Jules Dalou, who would become one of the finest sculptors of the Third Republic, took up residence in the Louvre with his family as its provisional administrator, and in that capacity he reopened the museum on 18 May. The Communards also occupied the Tuileries Palace, where they offered concerts and tours for fifty centimes a head—since few commoners had ever been admitted to the palace, it was predictably a subject of great interest—with the proceeds going to help the wounded and the orphans of the Franco-Prussian War. But such diversions were short-lived. Several days later the *garde nationale*, commanded by General Patrice de MacMahon, marched from Versailles and took up positions in the capital as they prepared to crush the Communards. Barricades arose throughout the city, especially along the rue de Rivoli on the north side of the Louvre. Dalou enlisted forty-seven of the Louvre's guards to put up barricades around the museum as well, little suspecting that, within the week, he and his family would be fleeing to London. There, for the next decade, he would have to fight the unfounded claims of the new government that he had "threatened with death some forty-seven guards of the Louvre."[3]

The rule of the Commune reached its violent conclusion during the so-called *semaine sanglante*, or Bloody Week, from 21 to 28 May 1871. It began when the forces of the *garde nationale* lobbed projectiles into the city: one of these landed on the roof of the Grande Galerie, without damaging any of the paintings, while another shattered some of the stuccos on the ceiling of the Rotonde de Mars. And yet, even amid such conflagrations, the museum somehow remained open, at least initially. One of the few curators to remain at his post, Barbet de Jouy, shut the museum down only on 23 May, by which time fighting had broken out in the streets of Paris.

That was also the day when one of the Commune's military leaders, Jules Bergeret, resolved to set fire to the Tuileries Palace. He had taken steps to prepare for such an eventuality, stocking its central

pavilion with oil, turpentine and alcohol. Around nine o'clock in the evening, he and his followers formed three groups of ten men and began to strew the floors and walls with bucketfuls of these highly flammable materials, which he then set on fire. At exactly that moment at various points around the city, similar teams were setting fire to other public buildings, among them the Hôtel de Ville in the place de Grèves. But the area around the Louvre sustained the greatest damage from this systematic vandalism. Within a matter of hours, the Ministry of Finance at the corner of the rue de Rivoli and the rue de Castiglione was totally gutted by flames. Soon the Palais-Royal was in flames as well, together with the Bibliothèque du Louvre, directly across the street. Although the Palais-Royal sustained relatively little damage, the Louvre's library was completely destroyed, with incalculable loss of books and especially archival documents touching on the history of the Louvre: to this day, there are gaps in our understanding of the Louvre's early evolution as a result of the violence of that night.

And then the Communards came for the Louvre itself, intending to attack les Grands Guichets, the magnificent southern entrance that had been completed only a few years earlier by Hector Lefuel. At this point the curator Barbet de Jouy, who has been called the savior of the Louvre, sprang into action, directing several dozen of the guards to protect the museum, aided by members of the 26th Battalion of chasseurs commanded by Martian Bernardy de Sigoyer. They thus managed to control the flames until the fire department could arrive. On the south side of the Grande Galerie, the Porte Barbet de Jouy has been named in recognition of this and other services that the curator rendered to the Louvre Museum.

When all the dust had settled the next morning, the Palais des Tuileries was a smoldering ruin, together with the pavilions on either side of it: the Pavillon de Flore at the western end of the Grande Galerie and the Pavillon de Marsan at the western end of the Aile

Rivoli. A day later, on 25 May, the Commune collapsed and many of its leaders were rounded up and stood against a wall near the octagonal basin of the Jardin du Luxembourg. A plaque commemorates the spot were they were executed by firing squad. Bergeret himself escaped into exile, dying thirty-four years later in New York City.

Enough of the Tuileries remained standing, however, that many contemporaries hoped to restore it to its former glory. But when Hector Lefuel examined it a few days after the event, he determined that it could not be saved, and several years later this opinion was confirmed by Charles Garnier, the architect of the Paris Opera. Even so, the ruin of what had been one of the most sumptuous palaces in Europe remained standing in picturesque desolation for another twelve years. The rubble was finally carted away in 1883, thus flinging open the entire western limit of the Louvre. But for this fortuitous consequence of Bergeret's vandalism, the Louvre today would feel closed off from the rest of Paris. The history of architecture may afford no greater irony than that the unification of the

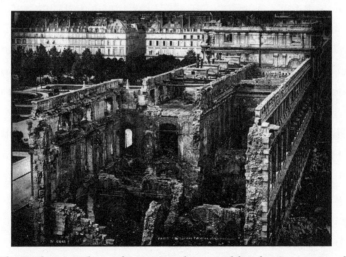

The Tuileries Palace after it was destroyed by the Communards on 23 May, 1871, as seen from the Pavillon de Flore. The last of the wreckage was removed only 12 years later, in 1883.

Louvre and the Tuileries, the ambition of almost every French ruler for three hundred years, lasted scarcely a decade.

But as so often in the history of architecture, there is something nearly indestructible about a building: parts of it almost always remain, enabling us—at least in thought—to reconstruct much that has vanished. Many elements of the Tuileries have survived, scattered throughout Paris and the rest of Europe. One of the arches that spanned the western façade of the palace can now be found near the southern terrace of the Tuileries Garden, while another occupies the Cour Marly in the Louvre itself. Several of the seventeenth-century allegorical figures that adorned the palace's west-facing pediment stand in the vast shopping center underneath the place du Carrousel. Other fragments wound up in the École des Beaux-Arts in the Sixth Arrondissement and in the Square Georges-Cain in the Marais, while still others came to rest at the Château de la Punta in Ajaccio, Corsica, and in Babelsberg Palace near Berlin.

In the first decade of the Third Republic, a great deal of time, effort and money was spent in cleaning up the damage and debris left in the aftermath of the Commune. Today visitors who enter the grounds of the Louvre from the west are apt to be impressed by a general sense of harmony, symmetry and stylistic unity among its various parts. That impression is due to the fact that almost everything that meets the eye—or at least the surface of everything—was conceived in the third quarter of the nineteenth century by one man, Hector Lefuel. But a closer look immediately gives the lie to this initial impression and reveals hidden irregularities. The most glaring example occurs in the northern wing, the Aile Rivoli, about halfway between the Pavillon de Marsan at the western end and the Pavillon de Rohan next to the Nouveau Louvre. This northern pendant to the Grande Galerie, which Percier and Fontaine built for Napoleon I around 1810, is divided into two parts that differ so clamorously in height, width and surface treatment that at the point

of their critical contact a bare, crudely built stone wall juts out. It is almost as though, amid the extravagant classicism of the surrounding Beaux-Arts style, the twelfth-century Louvre of Philippe Auguste has reasserted itself. Lefuel had planned to build here a structure identical to the Pavillon des Sessions in the Grande Galerie. But money proved scarce in the early days of the Third Republic and so that work was never carried out.

* * *

Over the ensuing century, from the founding of the Third Republic to the first stirrings, in 1981, of the Grand Louvre, the museum was gradually transformed into the great institution that we know today: it became *the Louvre*. Indeed, the very notion of the great national art museum—whether the Prado, the Rijksmuseum, the Hermitage or the Metropolitan Museum of Art—was only beginning to harden into the category that we now recognize as a fixture of our modern world. During this period the Louvre assumed its place as the foremost art museum on earth, occupying a position of uncontested primacy. But in physical and institutional terms, the transformations it underwent were gradual and incremental. The greatest changes came in the form of new acquisitions and in the adoption of a more modernist display of the art, in response to the great historical convulsions of the First and Second World Wars.

The main exterior differences between 1880 and 1980 were mostly a question of landscaping. Today, for example, there is a dramatic divide between the Tuileries Garden and the place du Carrousel to the east, and this division was even starker when the Tuileries Palace stood between them. But with the removal of the last vestiges of that palace in the 1880s, Edmond Guillaume, Lefuel's successor as the main architect of the Louvre, had the idea to

reproduce the patterns of the eastern third of the garden in the place du Carrousel, thus visually binding together two spaces that had stood apart for centuries. The effect was a stately extension of André Le Nôtre's grand seventeenth-century garden and a more harmonious space than is found there today.

Continuing east into the Cour Napoléon, a visitor in 1900 would have encountered one of the most striking monuments of the Belle Époque, a tribute to Léon Gambetta, the statesman who distinguished himself during the Prussian invasion and the early days of the Third Republic. For well over half a century, this now forgotten monument greeted every visitor who entered the Louvre, and it must have been intimately associated in the minds of many Parisians with a visit to the museum. As pure stagecraft, its overall effect was surely greater than the indifferent quality of its individual parts. Designed by the architect Louis-Charles Boileau and sculpted by Jean-Paul Aubé, it rose nearly sixty feet, confronting the Arc du Carrousel on equal terms. It was erected in 1888, six years after Gambetta's premature death, and it took the form of an obelisk. Thus, although the Egyptian associations of I. M. Pei's *Pyramide* initially puzzled observers, in fact it was not the first large Egyptian-inspired structure in the Cour Napoléon. The Gambetta monument depicted the statesman in stone, striking the sort of oratorical pose that the age demanded, with a cannon and a crouching soldier at his feet. Lying across the pedestal were bronze female figures, nude, as the age also required, and representing such edifying abstractions as truth and force and, at the summit, democracy straddling a winged lion.

Since Gambetta was famously a defender of democracy and a foe of Germany, his statue did not survive the Nazi occupation, which began in 1940. Soon after the Germans arrived, it was removed and its bronzes were melted down into armaments—the dismal lot of so much bronze statuary in time of war. The rest of the monument was torn down in 1954, at a time when such unapologetically oratorical

Jean-Paul Aubé's Monument to Léon Gambetta (1838–1882), a French statesman during the early years of the Third Republic. Before being dismantled in 1954, the monument stood in the Cour Napoléon.

expressions had fallen out of favor, and the truncated remains of Gambetta's likeness reside today in the Square Édouard-Vaillant in the Twentieth Arrondissement. Two other sculptures that long occupied the Cour Napoléon, Paul Landowski's Rodinesque *Sons of Cain* and Paul Wayland Bartlett's equestrian statue of Lafayette, remained there until 1984, when they too were removed to make way for I. M. Pei's *Pyramide*.

Throughout the period between Lefuel's death in 1880 and the hiring of I. M. Pei to design the Grand Louvre one century later, the museum had an architect on hand, even when little work was to be done. Still, small projects were always in the works, some of considerable importance to the institution. Before the First World War, this position of *architecte du Louvre* was held in succession by Edmond Guillaume, Paul Blondel, Gaston Redon, Charles Girault and Victor Blavette.

Because most of their work concerned the Louvre's interior spaces and because each generation is apt to alter those spaces according to its changing tastes, the work carried out by these five men has left little or no trace. This is true even for the earliest of those architects, Edmond Guillaume, who nevertheless made several major contributions to the interior of the Louvre.

First, he completely reconceived the décor of the Salles des États in keeping with its new function of displaying art alone: unfortunately, the drab minimalism of its present state gives no idea of the gallant opulence it once possessed. Guillaume also completed the Escalier Daru, the enormous stairway that still leads the visitor from the antiquities in the Galerie Daru, on the ground floor, up to the *Winged Victory of Samothrace* and then to the Galerie d'Apollon on the left and the Salon Carré and Grande Galerie on the right. The version we see today, shorn of all ornament, dates to the 1930s and is very different in décor, but not in form or function, from Lefuel's original design and from Guillaume's revision of it. Guillaume's stairway was covered with allegorical figures in mosaics, the only part of the museum—and one of the few monuments in France—to use this archaic medium. His version of the stairway was never popular, not only because of the general mediocrity of the mosaics, but also because that medium was felt to be foreign to French taste and out of place at the Louvre.

Still, the completion of the stairway furnished the museum with a stage fully equal to the display of one of its newest and greatest treasures, the *Winged Victory of Samothrace*. This masterpiece of Hellenistic sculpture, first put on display in 1883, was installed one year later at the summit of the Escalier Daru and has remained there ever since. But the effect it has today, while still imposing, pales in comparison with the impression it made before the opening of the Grand Louvre in 1989. Today one enters the museum by descending into the *Pyramide* and proceeding to one of three pavilions: Denon,

Sully or Richelieu. In the past, however, visitors entered on the ground floor of the Pavillon Denon: when they turned left to enter the galleries, virtually the first thing they saw was the *Winged Victory*, rising in majestic isolation at the summit of the Escalier Daru.

Guillaume's other important contribution had to do with the Salle des Caryatides in the sixteenth-century Aile Lescot. The curators of the Louvre feared that the humidity in the chamber was putting the art in jeopardy. Guillaume accordingly undertook to hollow out the damp and porous earth beneath the floor. This required him to excavate the site in 1882, almost a generation after Adolphe Berty had begun his crucial excavations of the medieval remains in the Cour Carrée. In the course of this later dig, Guillaume discovered the so-called Chapel of Saint Louis from the mid-thirteenth century. But as with Berty's excavations, this chamber was subsequently covered over and forgotten and would not be seen again for many years.

Although he was not nearly as active as Guillaume, Gaston Redon (the brother of the great symbolist painter Odilon Redon, thirteen years his senior), carried out two important projects in his capacity of *architecte du Louvre*. The most exhilarating of these projects has disappeared without a trace: in the western half of the Grande Galerie, Lefuel had created the Pavillon des Sessions, which still exists, bulging out from the rest of the structure, and originally intended for state gatherings during the Second Empire. But with the fall of Napoleon III, it was given to the museum itself for the display of art. Around 1900, Redon reconceived it in splendid fashion as the frame for Rubens's vast *Marie de Médicis* cycle. This was one of the stateliest chambers in the entire Louvre, illuminated by a large opening in the coved and coffered ceiling. Each of Rubens's paintings was framed by an elaborate architectural cartouche crowned with an escutcheon, or heraldic shield. The main entrance was a stately portal consisting of two Ionic columns flanked by Ionic pilasters

leading eastward to the so-called Van Dyck Room. A narrow gallery displaying smaller Dutch and Flemish works stood on either side of the main gallery. Even though all twenty-four paintings by Rubens could not fit in the Pavillon des Sessions (several hung in the adjoining Van Dyck Room), this illustrious cycle had never been seen, and would never be seen again, to such advantage. In the postwar era the gallery was modernized and largely shorn of its magic, and with the removal of the Dutch and Flemish school to the Aile Richelieu after the creation of the Grand Louvre in the 1980s, it was brutalized even further, its grand Ionic entrance having been replaced by a pair of public toilets.

Only one work by Redon survives in the Louvre complex. The stately main entrance of the Musée des Arts Décoratifs, with two tiers of balustraded boxes, seems like a cross between the boxes of Garnier's Opera, half a mile to the north, and Mansart's chapel at Versailles. Technically it is not part of the Louvre Museum (the Musée des Arts Décoratifs is an entirely autonomous entity that occupies the western part of the Louvre's Aile Rivoli), but the museum, throughout its history, has been nothing if not changeful, and the day may well come when this noble gallery is assimilated into the Louvre.

* * *

In the aftermath of the Prussian siege and then the Commune, the museum reopened, but only gradually. Once Republican control was reasserted in late May 1871, three and a half years would pass before the museum became fully operational in November 1874. Around this time, several important changes were made that would streamline the administration of the Louvre and raise its professionalism for generations to come. The collections were divided into five distinct departments: 1. Greek and Roman Antiquities; 2. Egyptian

Antiquities; 3. European Paintings and Drawings; 4. Sculptures and Art Objects of the Middle Ages, the Renaissance and Modern Times; and 5. Marine and Ethnology. This last department was a catch-all for whatever was not covered by the other four. The Musée de la Marine included model ships and other displays having to do with the French navy: its collection had been moved around the museum for generations and none of the curators or directors seemed especially happy to have it in their midst. Nevertheless, it remained part of the Louvre until 1937, when it finally moved to the brand new Palais de Chaillot in the Sixteenth Arrondissement. As for ethnology, this collection essentially comprised all manner of artifacts that were neither classical, Western European, Christian, nor ancient Egyptian.

Another important institutional development occurred in 1882, when Jules Ferry, the minster of education, founded the École du Louvre. Initially this academy occupied the Aile Mollien in the southwest wing of the Nouveau Louvre. With the creation of the Grand Louvre in the late 1980s, the École moved to the Aile de Flore at the western end of the Grande Galerie. Today it offers one of the most rigorous and prestigious courses of art historical instruction in the world, and from among its 1,600 students it provides curators not only to the Louvre, but to a hundred other museums that make up the Réunion des Musées Nationaux. This latter entity was formed in 1895 to finance the acquisition of new works of art, a procedure that had previously been stymied by an excess of red tape. In this ambition the Réunion was aided by the creation, two years later, of the Société des Amis du Louvre, which today also oversees annual memberships to the museum. Together these two entities procured, in a more orderly fashion than previously, the funds necessary to make the purchases that remained, as before, under the jurisdiction of the Louvre's curatorial staff.

To facilitate purchases even further, some of the curators began to discuss a radical idea: charging admission. Until then, the Louvre

had never charged anything, and many in the French government were determined to keep it that way. When the collector Charles Mannheim first broached the idea in 1884, the critic Louis Gonse responded, "The principle of absolutely free entry and of democratic welcome is the very essence of our national museums and their singular honor in the eyes of foreigners."[4] Gonse was thinking of the British, who at the time certainly did charge admission. For some of the curators, however, charging admission had less to do with raising funds than with keeping out undesirables who, it seemed, were coming to the museum during the winter to take advantage of the newly installed heating systems. In the event, the Louvre would have to wait until 1922 before being allowed by law to charge the public to enter.

The Louvre's collections did indeed continue to grow, but they now relied as much on donations and archaeological digs as on purchases. By the end of the nineteenth century, the freewheeling archaeological excursions that had yielded the *Winged Victory of Samothrace* were drying up. The local authorities in Italy, Greece and Egypt, ever more keenly aware of their national identities and the value of what lay buried in the earth, increasingly hesitated to grant French, German and British archaeologists the liberties they had enjoyed a generation earlier. Nevertheless, the collections of the Louvre were enriched by Ernest de Sarzec's excavations in Mesopotamia and by Olivier Rayet's in Miletus, both carried out in the 1870s.

Each object that entered the Louvre in this period called for a curatorial decision on whether or not to acquire the work that was presented for sale or as a gift. In either case there were notable hits and misses. In 1888, for example, some twenty years after the museum had acquired Rembrandt's masterful *Boeuf Écorché* for five thousand francs, the curator Georges Lafenestre purchased Alexandre Decamps's highly detailed *Bulldog and Scottish Terrier*

for more than three times the price. At the same time, Ingres's great *Portrait of Comtesse d'Haussonville* of 1845 was judged to be of no interest to the Louvre. It is now one of the most admired paintings in the Frick Collection in New York. That said, Ingres's masterpiece *La Baigneuse de Valpinçon* (the Valpinçon Bather) did meet the exacting standards of the curators, as did Fra Angelico's *Crucifixion*, Pisanello's *Portrait of a Princess of the House of Este* and Botticelli's *Lemmi* cycle, whose two frescoes are now set into the walls of the Salles Percier and Fontaine, between the *Winged Victory of Samothrace* and the Salon Carré.

In the first fifty years of the Third Republic, from its creation in 1871 to the Treaty of Versailles that ended the First World War, the Louvre was the beneficiary of fully 1,137 charitable donations[5] that varied considerably in size and quality. In 1880, the estate of Adolphe Thiers, the second president of the Third Republic, was offered to the museum with the onerous stipulation—common to gifts of this sort—that all of its 1,470 objects be kept together, despite the fact that most of the objects were not of sufficient quality to be displayed in the museum. Speaking of this *deshonneur du Louvre*, Georges Clemenceau, the future prime minister, inveighed against Thiers, "that awful little bourgeois who—not content to murder Parisians while he lived [in the last days of the Commune]—presumes to grace them eternally after his death with the spectacle of his dinner plates and chamber pots!"[6] In fact the collection also included a preparatory drawing for Verrocchio's *Angels* and a female head, in majolica, by Luca della Robbia, among other Louvre-worthy objects. Sometimes such stipulations made perfect sense, for example with respect to Edmond James de Rothschild's excavations from Miletus. At other times, however, compliance taxed the ingenuity of the museum's curators: in 1911, when the will of Count Isaac de Camondo stipulated that his renowned but uneven collection be displayed together in a dedicated room for at least fifty years, it was

discretely placed on the top floor of the Aile Mollien, where it was almost certain never to be seen.

At the same time, there was continued resistance to modernism, specifically the art of the impressionists. These painters found acceptance in England and especially America long before they appealed to their compatriots—one of the reasons why the Metropolitan Museum's impressionist holdings rival those of any French collection, including the Musée d'Orsay. Thus, when Monet and several friends pooled their resources to purchase and donate Manet's scandalous *Olympia*—representing a naked female form with none of the consoling layers of mythology that contemporary French taste demanded—the critic Georges Lafenestre wrote to the director that the work was not worthy of the Louvre. And although he was ultimately overridden by a vote of eight to three, the work landed in the Luxembourg Gallery (the usual venue for contemporary art) rather than the Louvre itself. Still, Monet's eagerness for the painting to enter the Louvre implicitly confirmed that institution's authority to confer or withhold canonic status for the art in question. Only in 1907 did the painting enter the museum, when no less a personage than Clemenceau, once again, pressured the Louvre to display it in the Salle des États, beside Ingres's *Grande Odalisque*. Oddly enough, when the painter Étienne Moreau-Nélaton, ten years earlier, had offered the museum Manet's even more scandalous *Déjeuner sur l'Herbe*, it was accepted without incident. If both paintings are now across the Seine in the Musée d'Orsay, that is only because, with a few insignificant exceptions, the Louvre no longer displays the impressionists, since this essential subchapter of French art was felt to deserve a museum unto itself.

* * *

The greatest example of the Louvre's power to anoint a work of art is surely the *Mona Lisa*. Although Leonardo da Vinci painted his masterpiece in the first decade of the sixteenth century, in a very real sense the icon that we know today was born in the galleries of the Louvre sometime during the Third Republic. If it is difficult today to think of the Louvre without the *Mona Lisa*, it is just as difficult to imagine the *Mona Lisa* (or *La Joconde*, as it is usually called in French) outside of the context of the Louvre. If the painting had been in the Kunsthistorisches Museum in Vienna or the Prado in Madrid it would still be famous and would still work its magic in drawing crowds to those institutions. But it would not be *the Mona Lisa*. Only Leonardo da Vinci could have created this masterpiece, but only the Louvre could have conferred upon it the transcendent status that it enjoys today as the *nec plus ultra* of Western art and culture. For the Louvre stands at the center of Paris, and Paris, from the middle of the eighteenth century to the middle of the twentieth, was the undisputed center of Western art.

Many first-time visitors to the Louvre come largely if not exclusively to see this one painting. The exhilaration they feel in encountering a celebrity, and the peace they experience in knowing that they can check a particular item off their bucket list, are apt to be among the main satisfactions of a visit to the Louvre. At the same time, although few will admit it, the experience is almost certain to be disappointing: visitors are unlikely to come within sixty feet of what is, after all, a rather small painting, and even if they do get closer, the slightly greenish tint of the bulletproof glass is sufficiently distorting that they are no longer quite seeing the painting and just as surely will find little aesthetic pleasure in their inspection. Such was not always the case. Until the early 1980s, if you saw the painting toward closing time on a weekday, you could linger before it in luxurious isolation and savor every detail. Today that is all but impossible. When the film version of *The Da Vinci Code* appeared

in 2006, the museum literally had to reroute the entire circulation of its southern half to accommodate the crowds struggling to catch a glimpse of this masterpiece.

But the main impediment to appreciating the *Mona Lisa*, oddly, is our constant exposure to it. Most people become familiar with it—perhaps uniquely among old master paintings—long before developing the capacity to appreciate it. And at such time as that capacity is acquired, the painting has been experientially flattened to an icon: like a dollar bill or an American flag, it is so familiar that we no longer see it and are therefore likely to misunderstand it completely. Today the *Mona Lisa* stands as a classic of art, as the four-square embodiment of beauty or truth or something of the sort: in fact, it is one of the strangest paintings ever made, and it was this very strangeness that transfixed the public one hundred years ago, before the masterpiece had been branded through millions of posters and postcards.

Old master portraiture is designed to convey one thing at a time: usually power in men and beauty in women. In this sense, the *Mona Lisa* conforms to the type, since the sitter is obviously a beautiful woman. But before 1900, when it was still possible to view the painting with fresh eyes, no sooner had visitors assimilated the fact of her beauty than they were jolted by the realization that she also seemed touched with sadness. There were surely depictions of sorrow among the works of the old masters, but almost never in portraits, whose whole point was to project, in a general way, some enviable condition in life. But no sooner had one perceived that sadness than a third and far stranger impression followed fast upon it: the sitter looked menacing, even cruel. "Like the vampire," wrote the nineteenth-century British essayist Walter Pater, "she has been dead many times, and learned the secrets of the grave."[7] His French contemporary Jules Michelet wrote that "this canvas attracts me, entices me, invades me and absorbs me. And I go to her in spite

of myself, as the bird to the snake."[8] This feeling is enhanced by the twilit, grayish-green background before which she rises. If one considers the matter, it makes absolutely no sense that this beautiful, well-born young woman—perhaps alone among the sitters of the age—should inhabit the crepuscular, almost subaquatic world that surrounds her.

But if such considerations account for what makes the *Mona Lisa* unique, they still do not explain how or why this one work became the most famous painting in the world, rather than, say, Raphael's equally magnificent portrait of Baldassare Castiglione, hanging some two hundred feet to the southwest in the Grande Galerie, or Ingres's equally magnificent portrait of Louis-François Bertin, hanging some two hundred feet to the northeast in the Salle Daru. In fact, the fame of the *Mona Lisa* has a great deal to do with one of the greatest heists in the history of art, when the painting was mysteriously removed from the walls of the Salle des États on 21 August 1911. For weeks, even months, all the major newspapers of the world were fixated on its disappearance, as they would be on the kidnapping of the Lindbergh baby a generation later. On 22 August, the academic painter Louis Béroud arrived at the museum and went looking for the work, only to find it missing. Initially the guards informed him that it was in the museum's photo studio, but eventually they became alarmed when they discovered that it was not being photographed, and so they alerted the police, who soon found its discarded glass covering elsewhere in the museum. Although they were able to extract fingerprints from the glass, they could find no match among the museum's 257 employees.

The first consequence of the theft was that the Louvre's director, Théophile Homolle, was fired. Then the poet Guillaume Apollinaire was briefly imprisoned because once, in an excess of vanguardist enthusiasm, he had called on contemporaries to burn down the Louvre. This suspicion of guilt was not as idiotic as it might first appear,

since Apollinaire had employed a Belgian, Géry Pieret, who had already stolen several Phoenician masks and statuettes from the Louvre. More importantly, one week after the theft of the *Mona Lisa*, Pieret called the daily *Paris-Journal* to say that he himself had taken the painting and was now demanding the 150,000-franc reward for its return. Since Pieret had also sold some of the purloined masks to Pablo Picasso, the young Spaniard was also interrogated, but was soon let go.

In the event, the thief turned out to be one Vincenzo Peruggia, a glazier by trade whom the Louvre had employed to provide glass coverings for some of the more important paintings in the collection. For two years he kept the masterpiece in a valise under his bed, and it might have remained in his possession much longer had he not tried to sell it to the Florentine antiquary Alfredo Geri. This man feigned interest, luring Peruggia to Florence even as he alerted the police, who promptly intercepted the thief in his hotel room. Peruggia was condemned to one and a half years in prison, but was let go after only seven months. Long afterwards, many Italians continued to view him as a national hero in the mistaken belief that he was bravely seeking to repatriate a work that had been plundered by Napoleon, whereas, in fact, Leonardo da Vinci had sold it directly to François I in 1518. The drama ended when the painting, after being briefly displayed in Florence and then in Rome, returned to Paris on 4 January 1914 in a chartered first-class train.

The theft exponentially enhanced the fame of the painting: before the theft it was surely admired and almost universally known, but after the theft it became, as it has remained, the most famous painting in the world.

* * *

Although the First World War did not pose any existential threat to the Louvre or to Paris, as did the Franco-Prussian War and the Second World War, the risks involved in that conflict were taken very seriously by the Louvre's directors, and the museum was largely, if not entirely shut down for the duration of the war. On 2 August 1914, the day after France declared a general mobilization of all able-bodied men, the government ordered the Louvre's directors to make provisions for protecting all the art in their possession. A few weeks later, however, as German troops advanced toward the border, 770 of the most valuable works, including the *Venus de Milo*, were sent to the church of the Jacobins in Toulouse, one of the largest and most solid churches in medieval Christendom. With the French army's successes in the war, parts of the Louvre's medieval and modern collection remained on view for most of 1916 and roughly half of the following year. But when, in spring 1918, two shells from a Krupp howitzer exploded in the gardens of Louvre, the directors decided to disperse parts of the collection around the capital and its environs, including in the basement of the Panthéon and the Palace of Fontainebleau. Not until a month after the Armistice was signed on 11 November 1918 did convoys of objects begin to return from Toulouse, and a month after that, on 17 January 1919, the museum was finally, if still partially, reopened to the public.

If the First World War did not change Western culture and society quite as fundamentally as its successor would, the implications of that earlier conflict were nevertheless considerable. In the aftermath of the war, modernity first began to permeate Western civilization in a way that was pervasive and unavoidable. This shift was expressed in the lengths of women's skirts no less than in the planning of the cities of the West. And it was equally evident in the galleries of the Louvre. "*Il faut être de son temps,*" Daumier had said several generations before—"We must be up to date"—and the direction of the Louvre was determined to act upon that precept.

One of the first steps taken on reopening the Louvre was to increase the hours of public access to the collections. Although the museum was now open to the public more than one day a week, as had originally been the case, still it was more apt to be closed than otherwise. In remedying this deficiency, the directors also took the momentous step to begin charging an admission fee of one franc, a measure made necessary by the dire financial conditions that confronted the museum after the war. Even then, however, it remained free on Sundays and holidays, as well as on Thursday afternoons, when school was out. At the same time, in response to the spirit of populism that defined the new age, the directors experimented with novel ways to engage a larger public, through paid lectures and walking tours, Louvre-centric cultural programs over the radio, and, for the very first time, a gift shop.

All of these measures were tentative steps toward recognizing what was fast becoming the most salient fact of Western society in the aftermath of the First World War: with the emergence of radio and movies and the eight-hour work day, which vastly increased the leisure to enjoy these new media, a mass culture was being born that was more unified and also more widely disseminated than anything witnessed in earlier human history. By the end of the 1920s, half a million visitors a year were paying their franc to visit the Louvre.

The man most responsible for hauling the Louvre into the modern world was Henri Verne, who was the museum's director from 1926 to 1940 and the author of the so-called Plan Verne, which formalized that modernization. For the first time the museum developed a department for public education. In this it was taking a page from American museums, from Benjamin Gilman at the Museum of Fines Arts in Boston, Charles Hutchinson at the Art Institute in Chicago, and Alfred H. Barr Jr. at the newly created Museum of Modern Art in New York City, all three pioneers of such outreach.

Several features of museum experience that we take for granted today were introduced during this period. The most important, perhaps, was the revolutionary concept of the focused loan exhibition. Before 1900, the duty of a museum was largely thought to begin and end with the upkeep and display of the objects in its possession; commercial galleries might mount small-scale special exhibitions, but museums generally did not. In the years following the Great War, however, such notions fell away. Suddenly objects were traversing continents and even oceans with such regularity that the special exhibition came to equal, and in some cases to surpass, the permanent collection in its power to draw the public into the museum. One of the pioneers of the temporary exhibition was a young curator of the Louvre, René Huyghe, who in 1930 mounted an exhibition of Eugène Delacroix in the Salle des États. Given that most of the Louvre's galleries were already spoken for, however, such exhibitions were usually sent to the Musée de l'Orangerie in the southwest corner of the Tuileries Garden. In the first six years of the 1930s, this venue offered retrospectives of Pissarro, Degas, Monet, Manet, Chassériau, Renoir, Hubert Robert, Daumier, Corot and Cézanne, among others. Each of these shows, of course, gave inveterate visitors to the Louvre a good reason to return, while generating an interest in the museum among the broader public. And the shows tended to be well received: 72,000 visitors paid to see Manet in 1932, and three years later, 97,400 visitors came to admire an exhibition of Flemish masters from Jan Van Eyck to Pieter Bruegel.[9]

For the first time, Verne found space for the impressionists and symbolists. More surprisingly, perhaps, Jules Bastien-Lepage, Alexandre Cabanel and Carolus-Duran, the fading stars of nineteenth-century academic art, were also exhibited, since no stigma attached to them as yet, as it would after the Second World War. At the same time, the museum finally rejected the Salon style of stacking paintings four high, all the way to the ceiling: henceforth, although

two paintings were occasionally displayed one atop the other, usually there was only one, as remains the policy to this day. Verne also established the main entrance to the museum in the Vestibule Denon. Located on the ground floor of the southern half of the Nouveau Louvre, the Vestibule Denon was equipped with a ticket booth and a small shop: and for more than sixty years, generations of Parisians and foreigners in their millions entered the Louvre through this relatively unprepossessing space.

Also at this time, the Escalier Daru assumed the form that we encounter today. These steps are far more than a simple stairway:

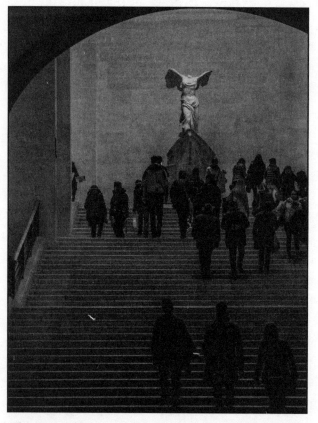

The Winged Victory of Samothrace *atop the Escalier Daru, as redesigned by Albert Ferran in 1934.*

they are stagecraft on the grandest scale. One thinks of Audrey Hepburn in *Funny Face* flying down them in a resplendent red gown, her arms aloft in imitation of the *Winged Victory* at her back. Here, Anna Karina and the two rivals for her affection concluded their sprint through the Louvre in Jean-Luc Godard's *Bande à part*.

In 1934, fifty years after it was first completed, Albert Ferran, the reigning *architecte du Louvre*, preserved the general form of the Escalier Daru even as he recast it in a very different language. All of its original ornaments, and especially the neo-Byzantine mosaics, were stripped away. As we see it today, it has been reconceived in the so-called *moderne* style, contemporary with art deco and similar in some respects. This was the style that created whole stretches of Paris, especially in the Sixteenth Arrondissement. Such was this style's popularity that Ferran used it to good effect in the Louvre's Assyrian Gallery and Palmyra Gallery, as well in as the Cour du Sphinx, just to the right of the Escalier Daru.

* * *

Contemporary visitors to the Louvre were surely impressed, as they are today, by the sight of a single building stretching, along its northern and southern sides, nearly half a mile from end to end. But in fact only about a third of that vast structure was available for the display of art. The rest was allocated to the Ministry of Finance, the museum's curatorial and conservation departments, and the École du Louvre. This was the case despite the enormous growth of the museum during this period. If the museum had 650 paintings and sculptures when it opened in 1793, one and a quarter centuries later that number had grown, by Henri Verne's estimate, to more than 173,000 objects.[10] And through donations and purchases, it was growing larger every day.

With the end of the war, archaeological digs could resume, and those at Arslan Tash in Syria, at Tello in Iraq and at Susa in Iran—where the newly installed Shah Reza Pahlavi welcomed Western archaeologists—greatly enriched the museum. Even the old masters, the spiritual core of the collection, were enhanced when some of the most emblematic early French paintings entered the collection, among them Jean Cousin's *Eva Prima Pandora* in 1922 and the anonymous *Gabrielle d'Estrées and One of Her Sisters* in 1937, all through purchases made possible by the Amis du Louvre. Dürer's early *Self-Portrait with a Thistle* was acquired in 1922 for 300,000 francs, as was Delacroix's famous *Death of Sardanapalus* in 1925 for 610,000 francs. Around the same time the great provincial French master of the Baroque, Georges de La Tour, entered the collections of the Louvre with *The Adoration of the Shepherds* and *Saint Jerome Reading*, acquired respectively in 1926 and 1935.

* * *

By the late 1930s, the Louvre's staff became increasingly aware that a new war might break out at any moment. As early as 21 October 1938, gas masks were distributed to the museum's personnel. Nine months before the Nazis marched into Paris on 14 June 1940, indeed before the Second World War had formally begun with Germany's invasion of Poland, the *Mona Lisa* was on the move again, for the third time in seventy years. On 28 August 1939, the portrait departed the museum to begin an exile that would last six years. It was accompanied at least part of the way by the crown jewels from the Galerie d'Apollon and by Watteau's great *Pèlerinage à l'île de Cythère*. Like some member of the Resistance restlessly staying one step ahead of her pursuers, the *Mona Lisa* was sent first to Chambord, the château on the Loire, then northeast to the Château de

Louvigny in the Moselle, then south to the Loc-Dieu Abbey in the Aveyron, before heading east to the Musée Ingres in Montauban, and finally north again to the Château de Montal in the Lot region.

This time the sense of urgency was even greater than during the two previous evacuations of the Louvre. While Paris emerged from the Second World War largely unscathed, no one could have predicted that outcome at the beginning of the conflict, or that General Dietrich von Choltitz, the last German governor of Paris, would simply refuse to carry out Hitler's order, in the final days of the occupation, to burn the city to the ground. Even before fighting began, everyone could see that the destructive power of modern warfare far surpassed anything seen in the two earlier conflicts. The curators of the Louvre were keenly aware of the aerial bombardments of Madrid during the Spanish Civil War, just three years earlier, and this new menace—which had scarcely existed in 1918—was feared most of all.

And so, much of 1939 was spent in preparation: a triage of paintings was carried out in the Salle des Caryatides and of sculptures in the Galerie Daru and the former stables beside the Cour Visconti. So many precious objects had to be wrapped up that the museum enlisted the aid of the employees of two famous nearby department stores, La Samaritaine and the Magasin du Louvre, both on the rue de Rivoli. Meanwhile, Albert Ferran designed a scaffold of hoists and planks by which the *Winged Victory* was eased down the perilous length of the Escalier Daru, on its way, together with the *Venus de Milo* and Michelangelo's two *Slaves*, to the Château de Valençay in central France. These were only a few of the treasures that, between September and December of 1939, were borne away to safety in thirty-seven truck convoys. For especially large paintings like Géricault's *Raft of the Medusa* and David's *Coronation of Napoleon*, the curators requisitioned from the neighboring Comedie Française a trailer that, in better times, had transferred stage

sets around Paris. Not all of the art left the capital. Some works were stored in the Banque de France, situated in the Hôtel de Toulouse a few blocks from the Louvre, while others remained hidden in the remoter depths of the Louvre itself. But while the museum was closed and the art dispersed, its staff was by no means idle, dutifully restoring the paintings and sculptures in their various places of exile. The removal of the works, however, did not always go off without a hitch. In his autobiographical *Souvenirs de l'exode du Louvre* (Memories of the Exodus from the Louvre), Germain Bazin, an art historian and Louvre curator who would figure prominently in the postwar museum, recalls visiting one of the depots stocked with works waiting to be shipped south. A curator from the department of medieval sculpture, Pierre Pradel, who was charged with overseeing the site, had fled with his family, leaving entirely unguarded Titian's *Portrait of François I*, Holbein's *Portrait of Anne of Cleves* and da Vinci's *La Belle Ferronnière*.[11]

A famous photograph was taken in the autumn of 1939, looking west down the endless corridor of the Grande Galerie toward

The Grande Galerie in September, 1939, some nine months before the Nazis occupied Paris.

the Pavillon des Sessions. This image brings to life the chilling consequences of all those preparations. Even in broad daylight the place seems haunted, the more so because its denuded walls still bear the traces of the paintings that were recently hanging there, while their empty, discarded frames lie flat across the scuffed floors. Seeing this image, one is reminded of Hubert Robert's fanciful painting of 1796, in which he reimagined this very gallery as a ruin and a desolation.

But if there was something charming in the way nature reasserted itself amid the ruins of that earlier work, no such consolation could be found now.

* * *

When the war came, Henri Verne, the Louvre's long-standing and transformative director, was no longer in charge. He had been dismissed on 12 June 1939, when Watteau's *l'Indifférent* was stolen off the walls of the museum. Despite the fact that it was returned two months later, the much-publicized theft revealed, yet again, the inadequacies of the museum's security apparatus. And so it would fall to another man, Jacques Jaujard, as director of the Musées Nationaux and the École du Louvre, to guide the museum through the perils of the Second World War. Originally a journalist, Jaujard became general secretary of the Musées Nationaux in 1925. Because he had been instrumental in protecting the Prado's collections during the aerial assaults of the Spanish Civil War, he seemed uniquely prepared—to the extent to which anyone could be—for the troubles ahead.

But even if the Louvre and many of the other museums in Paris had been emptied of their treasures, their doors would not remain shuttered for long. It was very much the policy of the German occupiers to signal a return to "business as usual." And so the Louvre, such as it was after being closed for a year, reopened on 29 September 1940, one week after the Orangerie reopened and two weeks after the Musée de l'Homme, the Musée Carnavalet and the Musée Cernuschi. The German official in charge of these proceedings, Franz von Wolff-Metternich, was the director of the Wehrmacht's *Kunstschutz* (literally, art protection unit) from 1940 to 1942. He was a trained art historian and curator, and there is plausible evidence that he stood in the way of Nazi aggressions against the Louvre and other

French museums. Twelve years later, in 1952, at the suggestion of Jaujard himself, General de Gaulle acknowledged the contributions of Wolff-Metternich by making him a *chevalier de la Légion d'honneur*. During the war, however, Jaujard resisted calls from the Germans to bring back the collections, using the clever dodge that it was not yet safe to do so, since the British Royal Air force might decide to attack Paris. Only two parts of the museum's collections remained on view: medieval sculptures, on the ground floor of the Pavillon des Sessions, and a few items of ancient art around the Cour Carrée. Most Parisians, in any case, stayed away and the German soldiers and nurses who showed up were themselves few and far between.

In a general way, the Germans were acutely aware of the public relations aspect of their roles. Remembering the bombardment of Reims Cathedral in the early days of the First World War and the lasting damage it caused to Germany's reputation as a "civilized nation," they were careful, at least for now, to avoid any such reproach. At the same time, their collective memory extended far enough back to recall how, nearly one and a half centuries before, the French revolutionary armies had hauled entire collections out of Germany to enhance the Louvre, even though restitution had long since been completed. Jaujard was able to deter the Germans from seizing Boucher's *Diane Sortant du Bain*, but had to cede Gregor Erhart's polychrome statue of *Saint Mary Magdalene*, which Hermann Goering very much wanted for his personal collection. At the same time, to curry favor with Francisco Franco, the Spanish dictator, the Germans removed Murillo's *Immaculate Conception* from the Louvre and sent it to Spain, together with six Visigothic crowns from the Musée de Cluny.

For the most part, however, the Nazis left France's public collections untouched. Their well-known and well-documented plundering was mostly limited to the private property of Jewish collectors who had fled or been sent to concentration camps. Through the diligence of the Einsatzstab Reichsleiter Rosenberg (the Reichsleiter Rosenberg

Taskforce, or ERR—named for Alfred Rosenberg, a prominent Nazi ideologue), as many as twenty thousand works of art were thus processed in the Jeu de Paume, in the northwest corner of the Jardin des Tuileries, although three rooms on the ground floor of the Cour Carrée's southern wing were also occasionally used to this end.

In the war's later phases, the countryside, with its arable land, was generally better provisioned than the great cities, especially Paris. By 1943, many of the green spaces of the capital were turned into vegetable gardens, and so the two landscaped parterres on either side of the Pavillon de Marengo, between the Cour Carrée and the rue de Rivoli, became vast plantations for the cultivation of leeks, while carrots grew in the Jardin de l'Infante and the gardens before the Colonnade.

Toward the end of the war, as the most extreme and desperate elements took control of the German high command, they insisted on bringing east the art that had been dispersed throughout France. This measure was presumably designed to facilitate the art's eventual removal to Germany. Jaujard did all he could to stall the implementation of these measures. At the same time, in expectation of an eventual Allied aerial assault of the countryside, Germain Bazin went to the Château de Sourches and several other depots and constructed twenty-foot-tall wooden letters that were set flat upon the ground and spelled out MUSÉE LOUVRE to alert the Allied bombers to spare the site. Those bombers came soon enough, and in the days leading up to the liberation of Paris, from 19 to 25 August 1944, armed skirmishes broke out in the Jardin des Tuileries. By the time the fighting ended, the Cour Carrée had become a makeshift detention camp for captured German soldiers. Less than two months later, the Salle des Antiques had reopened, but the dispersed treasures of the Louvre did not return to the capital until Germany formally capitulated on 8 May of the following year.

* * *

Entering the Antichambre Henri II on the main floor of the Aile Lescot, one's glance is drawn, even in spite of itself, toward the ceiling, that tour de force of Renaissance woodcarving by Scibec de Carpi. What arrests attention, however, is not this canopy of fretted gold so much as the paintings of birds set into a rectangular frame and two smaller oval frames on either side. These schematic black raptors, contoured in white against a bluish ground, are the work of Georges Braque, whom Georges Salles, the museum's enterprising new director, had commissioned to paint them. They were formally unveiled on 20 April 1953.

The Second World War was a multidimensional conflict that admits of many readings. In cultural terms, however, and at the risk of simplification, we can see it as a battle between conservative traditionalism, allied to the established orders of the Right, and vanguardism, allied to the Left and especially, in France, to the Resistance. And precisely because, in France, the partisans of the Resistance won the political and military part of the conflict, they also won the cultural battle that accompanied it. For the next three decades and more, until the rise of postmodernism and the Grand Louvre of François Mitterrand, this attitude of cultural vanguardism would, in a general way, dominate museums throughout the developed world, inspiring everything from the look of the galleries of the Louvre to the very exhibitions that the museum mounted. The postwar museum, in spirit and to some degree in form, cannot be understood without addressing this pervasive, if often implicit, triumphalism, of which Braque's ceiling is one of the most striking illustrations.

There was, however, an obvious problem with this new tendency, at least as it regarded the Louvre. Throughout its history, certainly since the days of Louis XIV, the Louvre's political and aesthetic mission—first as a palace and then as a museum—was to project and exalt power, while implicitly encouraging obedience to centralized authority. Indeed, the entire aesthetic mission of France,

for three hundred years, was expressed in this passion for mastery and unyielding symmetry. Now, however, that very projection of power had become suspect, even despised, by the newest generation of curators and architects. Braque's birds, with their intentionally crude asymmetries, declared open war on such conventions, and they won the cultural war, at least for the space of several generations. It was a victory that sought to disrupt the prim symmetry of Henri II's ceiling, which could never assimilate such modern intrusions or conciliate them to what was already there.

This new spirit was largely embodied in the transformative person of Georges Salles, who, as director of the Musées Nationaux for most of the fifties, was also in charge of the Louvre. Together with such slightly younger curators as René Huyghe and Germain Bazin, Salles, a specialist in Asian art, had been raised in the context of a positivist approach to art history, with its rigorous, almost scientific inquiry into the past. But writings like Salles's *Le Regard* (The Glance) of 1939, as well as Huyghe's *Formes et forces* from a generation later, advocate a different approach to art in general and to the Louvre's collections in specific, an approach that is radically personal and subjective. "In order," Salles wrote, "for a free exchange to exist between the work of art and our eye, it is necessary for us to have silenced the chatter of our rational faculties in the interests of obscurer faculties. There has emerged a reversal of our normal equilibrium: our clear memory, that of facts and ideas, of images that have been identified and localized, has been shut down."[12] Silencing the chatter of our rational faculties, reversing our normal equilibrium, shutting down facts and ideas: certain poets, besotted by absinthe or hashish, might have talked like that in earlier days, but now it had become the semiofficial policy of the curators of the Louvre and the inspiration behind Salles' commissioning Braque to paint his birds. Implicit in Salles' words and in Braque's birds was a rejection of the oppressive order of the prewar world, of a rigor

and symmetry that were now tarnished by their association with Fascism. Suddenly enchanted by its reborn freedom, Western culture chose to reject most of what it had been before the war.

This new spirit of change would find material expression in the museum's revamped galleries, designed by Jean-Jacques Haffner, who replaced Albert Ferran as the main *architecte du Louvre*. In these spaces, a distinctly modernist idiom began to replace the *moderne* style of the prewar years, even if it was a mediated modernism that aspired, through its pared-down forms, to preserve some sense of an older elegance and refinement. The results were not always admirable. An aesthetic of functionality and almost proletarian simplicity could not coexist successfully with the extravagant opulence—implicitly princely and certainly plutocratic—of the Louvre of Napoleon III. Neither Haffner nor the curators were so far gone as to do any violence to the actual architecture of the Louvre: there was no equivalent here to Le Corbusier's infamous Plan Voisin, in which that archmodernist advocated replacing much of the Marais—which even Haussmann had spared—with two square miles of cruciform towers in a park. But the interior spaces of the museum did not fare as well. The décor of the Salon Carré and the Salle des États was brutally repudiated. Although the ceiling of the Salon Carré was left largely intact, its walls were covered in dull gray fabric where they were not eliminated altogether. At the same time, low-lying partitions divided up the gallery in flowing and unclassical ways. By the end of this process, all of the magic and alchemy of Félix Duban's décor of a century before had been systematically excised, never to be restored.

The Salle des États suffered an even worse fate. Few galleries in the Louvre could rival the opulence of this space as reconceived by Edmond Guillaume in the 1880s. From the phalanx of stucco deities prancing across the ceiling to its Corinthian pilasters and dark wooden wainscotings, with no lateral light from without, this

chamber, the holy of holies of the international cult of art, had been stripped bare of all adornments. Even the Salon Carré had been allowed to keep its ceiling intact. And the masterpieces of Titian and Veronese, though still suffered to remain in their gilded frames, were henceforth to be seen against drably neutral walls.

Space was added to the museum, in 1954, when it was allowed to expand into the Pavillon de Flore all the way at the western end of the Grand Galerie, such that the museum now occupied the entire southern half of the Louvre, as well as the Cour Carrée. But there was still no dedicated space for special exhibitions, beyond the relatively small Cabinet des Dessins, and so they continued to be relegated to the Orangerie. On rare occasions, the Grande Galerie itself was commandeered, resulting in the unwelcome displacement of the permanent collection. In 1952 the curators staged the *Hommage à Léonard de Vinci* to celebrate the quincentennial of the artist's birth. The center of the exhibition, of course, was the *Mona Lisa*, raised on a three-tiered pedestal before a curtain of green velvet. Behind it a white silk curtain curved round the Corinthian columns of one of the Serlian screens that have punctuated the Grande Galerie since the time of Napoleon. The display, with all its silk and velvet flourishes, represented an attempt, only partially successful, to find some middle ground between prewar tradition and postwar modernity.

This fragile pact would be tested even further when, on 10 April 1957, the new British monarch, Elizabeth II, visited Paris and was given *les honneurs du Louvre*, an official tour followed by a state dinner. In this respect, she was following in the footsteps of her ancestor Queen Victoria almost exactly a century before, when that monarch crossed the channel to view the Exposition Universelle of 1855. On that occasion, as protocol appears to have demanded, Victoria moved through the museum in a wheelchair during ordinary hours, but returned after it had closed to visit on her own two feet. Such protocols were no longer in force a century later.

Elizabeth, accompanied by Prince Philip, met the president of the Republic, René Coty, in the Pavillon Denon before passing through the Galerie Daru, up the inevitable Escalier Daru, then down again, through a few of the *salles des antiquités*, to the Salle des Caryatides. There, facing the caryatides themselves, the royal couple and three thousand guests listened to a concert of Lully and Rameau and supped on fare brought from makeshift kitchens in the Pavillon de l'Horloge (the Pavillon Sully). Afterwards, Elizabeth and some of the more exalted guests repaired to the gallery that displays the *Venus de Milo*. For this occasion, however, the museum's carpenters had transformed the space into an oval chamber from whose makeshift walls hung Vermeer's *Lacemaker*, Raphael's *Saint Michael* and Watteau's *Pèlerinage à l'île de Cythère*.

* * *

In 1958, France's short-lived Fourth Republic collapsed, giving rise to the Fifth Republic of Charles de Gaulle. And just as this new president wielded far more power than the figurehead presidents of the previous dispensation, so did André Malraux, his newly minted minister of cultural affairs, exercise far greater authority than any previous (or subsequent) director of the Louvre. Malraux's predecessors had been, almost to a man, eminent scholars who were respected in their profession but little known beyond it. Malraux, however, had been a cultural powerhouse for decades, as a novelist, art critic, filmmaker and Resistance fighter. A born showman as well as a somewhat nervous and spasmodic figure—he was thought to have a mild form of Tourette syndrome—he seemed to consume all the oxygen of any room he entered and he dominated France's cultural landscape from 1959 to 1969. His goal, with regard to the Louvre and to French culture in general, was not only frankly

nationalist, but also an affirmation of the new role that mass culture played in the cultural life of France. He stated his wish "to make accessible the foremost works of humanity, and first of all those of France, to the largest number of Frenchmen, [and also] to ensure the largest audience for our national patrimony."[13]

Like de Gaulle, his new minister held powerful ideas about French culture. Every step Malraux took at the Louvre and at all the other museums over which he exerted his control, to say nothing of such related fields as literature and the performing arts, was intended to advance France's cultural hegemony through the world. But there was a paradox at the heart of the new cultural policy that he so ably articulated and enforced. Twenty years before, nobody in his position—if such a position had existed at the time—would have felt that French culture needed to be defended or promoted. Its primacy in art, literature and much besides was implicit and unchallenged, as

André Malraux (1901–1976), who, as Minister of State for Cultural Affairs under Charles de Gaulle from 1959 to 1969, greatly raised the Louvre's international profile.

was its military and economic prestige. But just as the postwar years vastly expanded mass participation in culture, they also represented a drastic diminution in France's role on the world stage. Despite its continued eminence, it had become, as England had become, one great nation among a number of great nations, but largely shorn of its former political and economic preeminence. This reduced status was due to the rise of the United States, but also of Russia and of China. Even with respect to culture, no perceptive observer could fail to note that the world and France as well were now more apt to look to the United States for cultural guidance and innovation than to any one European nation.

It is perhaps suggestive of the cultural condition of postwar France that two of its most emblematic moments were funerals, the very public ones for Georges Braque in front of the Colonnade of the Louvre in 1963 and for Le Corbusier in the Cour Carrée two years later. On both occasions, the mass media broadcast the image and words of the master of ceremonies, Malraux himself, his voice quavering with feeling as he delivered one of his baroque funeral orations. Such ceremonies had been staged in part to send the message that the Louvre was the center of Paris, that Paris was the center of France, and that France was the center of the world. It was also seen as an act of signal honor to these men to be thus solemnized in or near the Cour Carrée, the heart of the original Louvre. Doubtless Picasso as well would have been so honored had he not died in 1973, four years after Malraux had returned to private life, together with his patron de Gaulle. Still, it could not have escaped the notice of perceptive viewers that something had changed in France's cultural stature, and that France was the worse for it.

Malraux, however, never seemed to be aware of that fact. In furtherance of his nationalistic mission to promote French culture—or at least culture in France—the *Mona Lisa* was destined to play an essential role. On a trip to Washington, DC, in 1962, Malraux

visited the National Gallery together with its director, John Walker, and First Lady Jacqueline Kennedy. On that occasion Mrs. Kennedy expressed the wish that *La gioconde* should be exhibited in the United States. Such a request would be unthinkable today and it was almost unthinkable half a century ago. Still, it was duly considered and, after an examination of the poplar wood panel on which the work was painted, the curator Germain Bazin, the restorer Jean-Gabriel Goulinat and the head of the Louvre's conservation laboratory, Magdalene Hours, concluded that it was in sufficiently good condition to make the trip. Sent by air in a climate-controlled casing, the painting arrived in Washington, where it was displayed at the National Gallery from 8 January to 3 February of 1963, before traveling to New York City, where, from 7 February to 4 March, it was on view at the Metropolitan Museum. Malraux came with it and used the occasion to deliver yet another of his orations, in which, standing beside President Kennedy, he invoked America's role in the Normandy invasion eighteen years before. "Here then," he said, "is the most famous painting in the world. . . . Some have spoken of the risks that this painting took in leaving the Louvre. Those risks are real, but exaggerated. But the risks taken by the boys who landed one day in Arromanches [on the Normandy coast] were far greater. To the humblest among them who might hear me, I feel bound to say . . . that the masterpiece to which you pay homage this evening, Mr. President, is a painting that he has saved."[14]

The exhibition was a tremendous success, at a time when the American museum-going public was far smaller than it is today. Fully 623,000 visitors came to see it in Washington, DC, and well over a million in New York City. A decade later the painting traveled to Tokyo for nearly two months in the spring of 1974, where more than one and a half million visitors clamored to see it. On the flight back, the Louvre agreed, almost as an afterthought, to display it in the Pushkin Museum in Moscow for four weeks. Nearly half

a century has passed since then, during which the painting has not left the museum, and it is not easy to see under what conditions it might ever do so again.

By all accounts Malraux enjoyed his perch at the Louvre. Like Louis XIV and the two Napoleons, he would stop by on a daily basis to examine the works that he had commissioned, even if they were relatively minor, and to confer with his architects, Jean Trouvelot and Olivier Lahalle. Perhaps his greatest contribution to the Louvre centered on the Cour Carrée, whose exteriors he ordered to be thoroughly scrubbed for the first time in centuries. From this decision emerged the so-called Malraux's Law, which stipulated, among other things, that the façades of Paris's public buildings be cleaned every thirty years. Also under his watch, all four sides of the second floor of the Cour Carrée were allocated to the display of the Louvre's collection of French old masters. Other than that, Malraux's most lasting mark on the physical Louvre was the controversial (some might say pointless) decision in 1964 to excavate the moat in front of the Colonnade. This had been designed and then suppressed by Louis Le Vau three centuries before. As it happens, these excavations did indeed yield certain archaeological discoveries, among them a number of old wells and parts of the Petit-Bourbon palace, which had stood just east of the original Louvre and was demolished when Louis XIV completed the enlargement of the Cour Carrée in the 1660s. But beyond that, this pet project of Malraux yielded few benefits, and to this day the moat is little more than a storage facility for construction equipment.

A more welcome intervention occurred at the other end of the Louvre. The destruction of the Tuileries Palace in 1871 led, around 1900, to Edmond Guillaume's radical redesign of the adjoining place du Carrousel, which was then colonized by an abundance of sculptures in the bombastic pompier style that the age admired. By 1960, however, this style had fallen into utter, if occasionally underserved,

disrepute. Malraux, who fully shared in the dominant taste of his time, removed the offending statues and replaced them with the female nudes of Aristide Maillol, who pioneered a neoclassical *moderne* style that achieved an expressive compromise between tradition and modernity. With the creation of the Grand Louvre in the late 1980s, even though this part of the museum's grounds was fundamentally reconceived, those sculptures remained.

Malraux's time at the Louvre and at the head of the Musées Nationaux ended in June of 1969, shortly after the resignation of de Gaulle, as an indirect and delayed consequence of the student uprisings of May 1968. During that upheaval, the directors of the museum, reminded of the Communards a century before, shut its doors for an entire month. And when Malraux himself died in 1976, his passing was solemnized by the display in the Cour Carrée of a bronze cat from the nearby Egyptian collections, encased in Plexiglas and accompanied by a guard (Malraux liked cats).

In truth the postwar years were a somewhat dreary time for Parisian urbanism in general and for the Louvre in specific. In a half-hearted attempt to remain up to date, the musty old furnishings of the galleries were removed, to be replaced by the mod insipidities of Pierre Paulin, many of which, unfortunately, remain to this day and look no better for half a century of wear. "The aesthetic had changed," according to Genevieve Bresc-Bautier. "One returned to a discreet modernism: lightly colored walls of pale brown and muffled pink, floors of sandstone and parquet."[15] Opinions differ regarding these changes, but to some observers it seems quite evident that they contributed to a general banalization of the museum.

Much the same could have been observed on a far larger scale at a site across the street from the recently excavated Colonnade, beside the Church of Saint-Germain l'Auxerrois. Few visitors to the Louvre ever see it, and even the Parisians who pass it each day on the rue de l'Amiral de Coligny are apt to overlook it. It is the unassuming

entrance to an underground parking lot, built at the instigation of Malraux himself, that can accommodate four hundred vehicles. This infrastructural enhancement would seem entirely unimportant except that it was originally intended as part of a far larger transformation of the Louvre. Like so many mid-century cities—like London and especially like New York under Robert Moses—Paris had to come to terms with the car culture that dominated urbanist thinking in the postwar period. And although the French capital has generally been spared the worst of these effects—its main highway, the Periphérique, was relegated to the circumference of the city in 1958—still, car culture has largely ruined four of its greatest focal points, the places de l'Étoile, de la Concorde, de la Nation and de la Bastille, from which pedestrians are effectively banned. And there was talk of altering the Louvre as well to serve the dominant car culture. One proposal advocated building a parking lot for eight hundred cars under the Tuileries and the place du Carrousel. Another called for a garage under the gardens north of the Cour Carrée (where, a generation earlier, the makeshift leek plantation had stood). This garage was to be part of a vast underground city—similar, no doubt, to what was built a decade later, to such dismal effect, under les Halles half a mile away. There was also talk of a submerged road under the rue de Rivoli, stretching from the Colonnade to the place de la Concorde, similar to what was built on the southern side of the Louvre, with the Voie Georges Pompidou and Voie Léopold Senghor. As for the underground city, something along those lines did indeed come to pass with the creation of the Carrousel du Louvre, one generation later, but with far greater sensitivity and charm, surely, than would have been possible in the 1960s.

- 10 -

THE CREATION OF THE CONTEMPORARY LOUVRE

The Louvre as we see it today is the result of more than twenty building campaigns over five centuries, and some of those campaigns were clearly more successful than others. But on the three occasions when it mattered most, a design emerged, as though providentially, that yielded exactly the right result. The first of these projects was Claude Perrault's Colonnade of the 1660s, the second was Visconti and Lefuel's Nouveau Louvre of the 1850s, and the third was the Grand Louvre of the 1980s, designed by the Sino-American architect I. M. Pei. The success of this last project, however, was hardly certain: for ten long years, from the first excavations of the Cour Napoléon in 1984 to the completion, in 1993, of the shopping center known as the Carrousel du Louvre, half a mile of the center of Paris looked like a war zone, with critics assailing it on all sides, assuring the world of its certain failure.

Throughout that period, the Louvre remained open and fully operational, and with good reason: by this point in the cultural and economic life of France, it would have been unthinkable for the museum to shut its doors. Various reasons have been advanced for why the Grand Louvre was undertaken in the first place, ranging from the extravagant ambitions of François Mitterrand, president of the French Republic, to the growing pains of the museum itself and the pressing need, in a recession, to find jobs for the construction sector. But overriding all of these considerations stands a creature of

transcendent importance to the modern age, although it is usually overlooked and rarely accorded any respect: the tourist. Throughout the world, but especially the developed world, this casually attired, often confused interloper is seen as something between a nuisance and a parasite, scorned by the very natives whose livelihood the tourist ensures. And yet the tourist is one of history's greatest vectors for the transfer of wealth from one nation to another. In Paris alone, as of 2012, nearly 20 percent of salaried workers, or 263,212 of them, were employed in a trade or profession related to tourism, thus contributing, as of 2014, some 17 billion dollars to the economy. Only London and New York surpassed the French capital in this regard; but whereas most tourists in New York come from elsewhere in the United States, most tourists in Paris (and London) come from abroad, thus enhancing not only the local economy, but the national economy as well.[1]

In earlier ages, except for a few places like Venice and Rome, tourism was an inconsiderable part of the local or national economy. But all of that was changing by the 1980s: thanks to paid vacations and ever-cheaper transportation, more people were traveling than ever. Before then, you could simply show up and walk into Notre-Dame in Paris, Saint Peter's in Rome or the Basilica San Marco in Venice. Now each of these monuments had a forty-five minute line that, in recent years, has grown even longer. But in the 1980s few destinations were as popular as Paris and few sites in Paris were as popular as the Louvre: attendance figures were growing each year and doubling every ten years.

And as such figures doubled, and as the collections grew, the Louvre found it ever harder to accommodate these zealous millions. Unlike most of the great museums of the world—the Prado, the Metropolitan Museum, the National Gallery in London—the Louvre was not originally built as a museum, and most of its vast nineteenth-century additions were similarly intended for other uses

than the display of art. To this day, almost every part of the structure is laid out one room after another, according to an archaic pattern that had fallen out of favor by 1850. Almost alone among the great museums of the world, the Louvre betrays in its very floor plan a building typology that it has adapted with only partial success to a new and very different function from the one originally intended. At the same time, the exteriors of the Louvre, from the Pavillon de Flore to the Colonnade, had grown filthy with age and decades of car exhaust. The very stone had begun to decay, as well as the mortar that held it in place, to say nothing of the bronze and iron supports and accents of the façade. By the election of François Mitterrand as president on 21 May 1981, such shortcomings could no longer be overlooked. For the sake of the tourist, for the sake of the French economy, something had to be done.

* * *

The expansion of the Louvre under Mitterrand was part of a larger phenomenon that coincided with an emerging awareness of tourism's role in the wealth of the nation. In the period from the 1970s to around 2006, four consecutive French presidents contributed greatly to museum construction in the capital. The first of these projects, the Centre Pompidou in the Fourth Arrondissement, was devoted to modern art and opened in 1977, three years after Georges Pompidou, who had initiated the work, died in office. His successor, Valéry Giscard d'Estaing, transformed the Gare d'Orsay, a massive train station on the Left Bank, into a museum of nineteenth-century art that opened in 1986. Mitterrand's successor, Jacques Chirac, founded the Musée du Quai Branly more than a mile west of the Musée d'Orsay: devoted to the arts of non-European peoples, it opened in 2006. Although Mitterrand did not create an entirely new

museum, he permanently left his stamp on the Louvre, the most essentially French museum of all. Like Chirac, Mitterrand served two full terms—from 1981 to 1995—and so would be in office from the inception of the Grand Louvre in 1983, through its official opening in 1989, to the completion of such collateral projects as the Carrousel du Louvre in 1993.

Mitterrand took to the project with rare zeal. Of the many reasons motivating the president, perhaps the most potent was that simple love of building things, of leaving an indelible mark on Paris, that had animated so many of the rulers of France over the centuries. In addition to the Grand Louvre, Mitterrand was responsible for such massive projects as the Parc de la Villette (1987), the Grande Arche de la Défense (1989), the Opéra Bastille (1990), the new Bibliothèque nationale de France (1996) and the stunning metro line, Ligne 14 (1998), that connected it to the Church of the Madeleine. No French leader since Napoleon III, more than a century before, had spent as much time and treasure on building massive projects in the capital. These projects were so ambitious in scale as to seem pharaonic, an association that the Louvre's new pyramid only strengthened. In the press Mitterrand was called Mitteramses and Tontonkhamon (*tonton* being an affectionate term for uncle that was often applied to him) and not only because his generally impassive expression suggested, to unsympathetic observers, the initial stages of mummification.

The idea to reimagine the Louvre does not appear, however, to have originated with Mitterrand, and initially he exhibited some resistance to it. In July of 1981, scarcely two months into the first of his two seven-year terms, his new minister of culture, Jack Lang, wrote a report broaching the idea of the Grand Louvre: its most radical proposal consisted of assimilating into the museum the entire northern half of the Louvre complex, which had been occupied by the Ministry of Finance for more than a century. In fact, this idea

had first been mentioned by Henri Verne as far back as 1929, and again by Georges Serres in 1950. In his report, Lang declared that "by reclaiming its earliest unity, the Louvre would become the biggest museum in the world. From the Arc de Triomphe to the place des Vosges, a vast promenade could be designed. . . . Only an act of sovereignty can give weight to the ambitious project of the Grand Louvre."[2] In this declaration, Lang seemed to echo an earlier minister, Colbert, who had counseled the young Louis XIV: "Your Majesty knows well that . . . nothing reflects better upon the greatness and spirit of princes than buildings."[3] Initially Mitterrand hesitated, scribbling in the margins of the report: "*Bonne idée mais difficile (par définition comme toutes les bonnes idées). F.M.*" ("A good idea, but difficult, by definition like all good ideas. F. M.") Two months later, however, in his first press conference as president, on 24 September 1981, he seems to have warmed to the idea, declaring his intention to bring the Louvre to its destined completion.

For the president, the creation of the Grand Louvre (so called because it would enlarge the museum by including the north wing) came with an important time constraint: just as Napoleon III had tried, but failed, to complete the Nouveau Louvre in time for the Exposition Universelle of 1855, so Mitterrand wanted his project to be finished in time for the Exposition Universelle of 1989. That year saw not only the bicentennial of the start of the French Revolution, but also the one hundredth anniversary of the Exposition Universelle of 1889, for which the Eiffel Tower had been built. Unlike Napoleon III, Mitterrand would largely achieve his goal. In September of 1982, he chose Émile Biasini to oversee the process by which, in Mitterrand's own words, "the Louvre would become the greatest museum in the world, due not only to the breadth of its structures and its collections, but also to the very quality of its conception and to the originality of its museology."[4] Biasini, who had been Malraux's right-hand man in the 1960s, was widely known as *le bulldozer* for

his assertive personality and for his ability, seemingly against all odds, to see difficult projects through to completion. All of his skills, however, would now be tested to the utmost degree.

<center>＊ ＊ ＊</center>

The project for the Grand Louvre consisted of three parts that sometimes overlapped. The first part entailed the creation of a great central reception area, crowned with I. M. Pei's *Pyramide*, that would allow access to the museum's three main wings: the southern wing, the Aile Denon; the eastern wing, the Aile Sully; and the northern wing, the Aile Richelieu. This last would be completely transformed and assimilated into the museum for the first time. The second part of the project was the thorough overhaul of the Louvre's façades, especially those on the Cour Napoléon, which had fallen into serious disrepair after a century of neglect: visitors rarely understand or appreciate the degree to which the exteriors they see today are a fastidious reconstruction, rather than simply a repair, of the original building. This work would be overseen by Georges Duval, the official *architecte du Louvre*. The third and final part of the project consisted in extensive archaeological work on the medieval Louvre in the Cour Carrée by Michel Fleury and Venceslas Kruta, on the place du Carrousel by Yves de Kirsch and on the Cour Napoléon by Jean Trombetta. Although the creation of the Carrousel du Louvre, the vast underground shopping center, with its cavernous garages and conference rooms, was always an essential part of the plan, it was viewed as conceptually distinct from the Grand Louvre project.

Once the decision had been made to embark on this great labor, of course, an architect had to be chosen. Among those considered were men who had already distinguished themselves in the design

The Sino-American architect Ieoh Ming Pei (1917–2019),
principal architect of the Grande Louvre, before his Pyramide
at its official inauguration on 29 March 1989.

of museums: the American Richard Meier, the Sino-American I. M. Pei, the British architects Norman Foster and James Stirling and the Frenchman Jean Nouvel, whose dazzling Institut du Monde Arabe was already under construction in the Fifth Arrondissement. Although each of these architects had developed a unique and identifiable language of forms, none of them worked in the classical style of postmodernism that was dominant in the early 1980s and that might have seemed like a plausible choice in the Beaux-Arts context of the Louvre. And yet, that style never appears to have been seriously considered. Instead Mitterrand and his advisers sought a formal language that was emphatically modernist, but also compatible with the language of what already existed: as gifted as Richard Meier was, the industrial aesthetic he favored would have made little sense in the context of the Cour Napoléon.

Ultimately the commission went to Pei, who is usually referred to in France as Ieoh Ming Pei. When approached in 1983 with the

idea of reinventing the Louvre, the sixty-four-year-old architect made it clear that he did not wish to participate in any competition for the project, although he did consent to study the issue and offer his ideas. After two months he submitted his proposal, the essence of which was a radical altering of the very shape of the museum's footprint, and thus of the visitor's experience of the institution. By the mid-1970s, the Louvre Museum—as distinct from the Louvre complex—extended in a lazy L shape from the Pavillon de Flore, the westernmost point of the Louvre complex, all the way to the Colonnade in the east, with the entire northern half off-limits to the museum. Pei was determined to centralize the museum: the area around the Pavillon de Flore would be given to the École du Louvre, while the entire northern section (excluding the part occupied by the Musée des Arts Décoratifs) would be given to the museum. At the time, getting from the Pavillon de Flore to the Assyrian antiquities in the Cour Carrée was a trek of half a mile, or roughly a ten-minute walk. By turning the L into an abbreviated U centralized around the Cour Napoléon, Pei's plan cut that time in half.

On 27 July 1983, Pei was awarded the commission. His adjutants were to be two Frenchmen, Georges Duval and Michel Macary. The process of his selection is not entirely clear, but Mitterrand likely had the final say in such deliberations: on a recent trip to Washington, DC, he had admired the National Gallery's East Building, which had opened according to Pei's designs in 1978. Pei had also designed the west wing of the Museum of Fine Arts in Boston, which opened three years later, in 1981.

* * *

I. M. Pei was born in Guangzhou, in Southern China, on 26 April 1917. The son of a banker, he was raised in Hong Kong and

Shanghai but immigrated to the United States in 1935, when he was eighteen years old, to study architecture at MIT and Harvard. The style that defined much of his career was brutalism, a postwar variant of the so-called International Style, and traces of this movement can be found throughout his work at the Louvre. The movement's name, popularized by Le Corbusier toward the end of his career, refers to its marked preference for unfaced and unadorned concrete (béton brut, in French), as well as the assertive forms and volumes that it favored. But Pei was always something of an exception in the context of this style: although many of its adherents implemented an aggressive idiom verging at times on abrasiveness, Pei developed a personal variant that reflected the polish and politeness of the man himself. The result was a use of bare concrete that transformed that material into a thing of great refinement. Despite his speaking little or no French, Pei intuitively understood and responded to the ceremonious grace of France's official culture.

In some respects, Pei's work at the National Gallery in Washington, DC, anticipates the Hall Napoléon, the reception area beneath the *Pyramide*. Both projects consist of a vast emptiness at ground level, surrounded on three sides by a raised gallery formed from cream-colored stone. The crucial difference between the two projects is one of symmetry. The East Wing of the National Gallery consists of energetically shifting and irregular planes, while the Hall Napoléon preserves that serene sense of order that has defined French architecture for nearly five hundred years.

But the Hall Napoléon is below grade and entirely invisible from the surface of Paris. The most immediately arresting element of the entire design is surely the *Pyramide*, a seventy-foot-tall glass structure that serves a mainly ornamental function. Both formally and thematically, this highly controversial addition may represent the single greatest stroke of genius in the architecture of the past half century: so much was riding on its success and so much could have

gone wrong but did not. In the abstract, it might have seemed absurd to plant an enormous glass pyramid of modernist design in the center of the Beaux-Arts Palace of the Louvre. But the visitor who enters the Cour Napoléon without prejudicial memories of how it was before will experience no jarring sense of incongruity. The contours and axes of the new structure line up perfectly with the décor of Napoleon III's Louvre. Few tourists will fail to notice and admire how the point of the pyramid locks into perfect alignment with the attic pediment of the Pavillon de l'Horloge to the east, or with those of the Pavillons Richelieu and Denon to the north and south. At the same time, the *Pyramide* emphatically reaffirms the symmetry of the Louvre, as well as that grand axiality—arrangement along an axis—that defines the westward expansion of Paris from the Cour Napoléon all the way to the Grande Arche de la Défense, which was under construction at the same time as the *Pyramide*. Formally as well, its shape was an inspired choice: although the *Pyramide* has the requisite bulk for the site, by its very shape and nature it narrows to a point and evaporates into thin air. Anything of a more uniform volume would surely have felt onerous and out of place.

To this formal success must be added the thematic aptness of the *Pyramide*. If one is not versed in French culture, it will surely seem odd that a building type associated with ancient Egypt should rise up in the center of contemporary Paris. But part of the modern Frenchman's national identity is bound up with the Napoleonic age, and that age was indissolubly linked to Egypt. Every Frenchman knows of the Battle of the Pyramids, which Bonaparte successfully fought during his famed Egyptian campaign on 21 July 1798, and of the sublime eloquence with which, on the eve of the battle, he aroused the valor of his men: "Consider that, from the height of these pyramids, forty centuries are watching you!"

In honor of that battle Bonaparte ordered the construction of the place des Pyramides and the rue des Pyramides, which still

stand at the northwestern limit of the Louvre. One of the museum's curators, Vivant Denon, through his book *Travels in Upper and Lower Egypt during the Campaigns of General Bonaparte*, sparked that *Égyptomanie* that took Europe by storm in the first quarter of the nineteenth century. And it was another curator, Jean-François Champollion, whose deciphering of hieroglyphics fostered the science of Egyptology that so deeply influences what we see in the galleries of the Louvre. Pei's *Pyramide*, then, embodies that essentially French openness to other cultures, as well as the odd and unparalleled ability of France in general and of the Louvre in specific to assimilate those foreign elements and somehow make them essentially French. The one object that most symbolizes Paris and the Louvre, after all, is the *Mona Lisa*, painted by a Tuscan artist over five centuries ago.

Despite its startling presence in the midst of Lefuel's neobaroque Cour Napoléon, the *Pyramide*, with its four sides, lines up in strict axiality with the rest of the Louvre and thus, both above ground and in the reception area below, it subtly but resolutely reinforces the essentially French symmetry of the structures that surround it. In fact there are fully five pyramids in the Grand Louvre, and each of them plays its part in reinforcing that axiality. In addition to the largest of them in the center, there stand to the north, east and south three smaller pyramids, also of glass, at a forty-five degree angle to the main one, admitting light into the Hall Napoléon. Several hundred feet to the west, in the roundabout that separates the Cour Napoléon from the Cour du Carrousel, an inverted pyramid, invisible to the pedestrian, descends thirty feet into the earth and serves as a light well for the main axis of the shopping center under the Carrousel. And the pavers of the Cour Napoléon that surround the *Pyramide* are diamond-shaped and exactly reproduce the footprint of the three smaller pyramids around the main one. Their shape is further echoed in the glass panes—held in place by a network of

cables created for sailboats in the America's Cup—that make up the central pyramid as well as its three smaller counterparts. Finally, the three-sided footprint of the sequence of fountains surrounding the *Pyramide* recalls the shape of the main structure.

Although no postmodern architect was ever seriously considered for the Grand Louvre, that movement was at its height when the project was being built. Throughout the world, architects, painters, composers and novelists were rebelling against modernism's constraints, specifically its general preference for formal purity over the projection of a theme or message. Pei was never a postmodernist as such, and his *Pyramide*, like every other part of his work at the Louvre, uses an unimpeachably modernist vocabulary of form and function. But the presence of such a pregnant symbol here—as well as the absence of anything like it in Pei's earlier additions to the National Gallery and the Museum of Fine Arts—suggests a new responsiveness to the current cultural moment.

When Pei presented a first draft of his design to the Higher Commission on Historical Monuments on 23 January 1984, six months after he had been selected for the project, it was considered, to no one's surprise, controversial. The commission pronounced it "incongruous," and the very next day a screeching headline on the front page of *France-Soir*, one of the nation's main dailies, declared, *"Le Nouveau Louvre déja fait scandale"* ("The New Louvre Is Already Causing a Scandal").[5] But final and plenary authority lay with the president who, on 13 February, declared his full support for the project.

The commission had in fact already acknowledged the wisdom of turning the Cour Napoléon and the space beneath it into the main entrance of the Grand Louvre. But anxious about such an unusual structure intruding upon so hallowed a context, they asked Pei to create a life-sized simulation, which he did. Numerous photographs survive of this seventy-foot-tall phantom pyramid,

made out of a few metal rods that were etched against the skyline and rose over the rubble of the partially excavated Cour Napoléon. The public was invited to see it on the weekends of 27 and 28 April and 4 and 5 May 1985. Even in this wraithlike version, there was something commanding about the *Pyramide*, and the mockup succeeded in neutralizing much, though not all, of the opposition. Biasini predicted that "in ten years, [the *Pyramide*] will be part of the Parisian landscape and will mark the realization, at the end of the twentieth century, of a great architectural plan patiently constructed over five hundred years."[6] His words have been amply borne out.

* * *

The *Pyramide*, of course, is really little more than a glorified glass shed, a marker directing tourists to the museum's main entrance. The real architectural event of the Grand Louvre, and the main contribution that Pei made to it, is the reception area that spans out beneath the *Pyramide* over a surface roughly twice the size of its footprint. In fact, the architect Jean Trouvelot had suggested just such a use below grade—without the *Pyramide*—nearly twenty years before, in 1966. This new area under the Cour Napoléon serves as preamble to the art that the visitor has come to see. One descends about forty-five feet into the earth to discover a sun-flooded space, clad mostly in traditional travertine, that contains the ticket booths, the sundry Louvre-run bookstores and gift shops, as well as an information center, a restaurant, a cafeteria and restrooms.

One of the issues that Pei had to address was how the public would descend from street level into the reception area. Originally he considered a ramp, but settled on the present solution, which he called the most perfect among imperfect solutions: a porch—which

he called a belvedere—overhangs the vast Hall Napoléon, into which one descends either by escalators, a spiral stairway or an elevator that seems to rise out of nowhere as a towering cylinder and is reserved for people with wheelchairs or strollers. This belvedere was designed in a language somewhat different from that of Pei's other work at the Louvre. Its dense concrete presence reminds us that Pei came of age in the heyday of brutalism, with its aggressive volumes and equally aggressive use of unfaced concrete. This brutalist heritage is detectable, as well, in the belvedere's coffered underside, which invokes Louis Kahn's Yale University Art Gallery, one of the landmarks of that style. It can also be seen in the cruciform pylons at three of the *Pyramide*'s corners, which support the roof of the Hall Napoléon.

Once visitors purchase their tickets, they can then move in any of four directions. If they move west, they will pass directly through a gauntlet of shops and modest eateries on the same subterranean level, past a security checkpoint and into the shopping center known as the Carrousel du Louvre. Otherwise they can walk north, south or east, to the Ailes Richelieu, Denon and Sully, respectively. In each case, they must ascend and enter the arena of art itself. Here several divergent landscapes await them. The most traditional is that of the Aile Denon, by far the most frequented because it is home to the works of Leonardo and Michelangelo. Of the three sections of the Grand Louvre, this is the oldest and has sustained the least change. Indeed, throughout the creation of the Grand Louvre, this part of the museum always remained open.

Very different, however, is the Aile Sully. On entering it, one passes through two galleries dedicated to temporary exhibitions, with other, larger galleries on the floor below. Until the opening of those spaces, temporary exhibitions were always something of a challenge for the museum. Even today the Louvre mounts far fewer special exhibitions than its great American counterparts

in Washington, DC, Boston, Philadelphia and New York, to say nothing of the main museums in London. And while the exhibition spaces in those other institutions are seamlessly interwoven with the permanent collection, in the Louvre they stand apart, cantonized in admittedly ample rooms, but so far removed from the center of most visitors' attention that they are frequented mostly by Parisians.

From there the visitor proceeds beyond the lustrous and rusticated cream-colored counterscarp of the Louvre's westward moat, designed by Louis Le Vau in the 1660s and unexpectedly rediscovered in the course of the excavations of the 1980s. What follows thereafter is one of the most spectacular areas of the Grand Louvre, the remains of the palace of Charles V, from around 1370, as well as the Chapel of Saint Louis. Thanks to the valiant efforts of the archaeologists Michel Fleury and Venceslas Kruta, the medieval Louvre, which had once seemed as distant as Camelot, has been not so much recovered as resurrected. What has been preserved, to a uniform height of twenty feet, is most of the medieval structure's northern and eastern walls, its great keep or donjon, and the so-called Chapel of Saint Louis. It is a twilit world unlike any other part of the Louvre or any other part of Paris. It was also the first part of the Grand Louvre to open to the public in 1989. The Aile Sully lies above it and contains much of the Louvre's Egyptian collections and almost all of the French paintings now on view.

The greatest change to the museum, however, occurred in the northern half, the Aile Richelieu. This was also the last part of the Grand Louvre to be inaugurated (in 1993, four years after the official reopening of the Aile Denon and exactly two hundred after the Louvre opened as a museum in 1793). The reason for the delay was purely political. In 1987, Pierre Bérégovoy, the minister of finance and an ally of Mitterrand, agreed to move the ministry to the new quarters that were under construction along the Quai de Bercy in

the Twelfth Arrondissement. But in the next parliamentary elections, before that move had taken place, Bérégovoy lost his position and was replaced by Eduard Balladur, an adversary of Mitterrand who had no intention of moving. Only when Mitterrand's party regained control in the next election two years later was the ministry sent packing and work could resume.

In the two older wings, which were already part of the museum, there was relatively little work for Pei or his colleagues. But because most of the northern half of the Louvre did not exist before the 1850s and because it had never been intended for the display of art, the interior spaces of the Aile Richelieu had to be completely gutted, except for the grandiose Appartement du Ministre and the two magnificent stairways that Hector Lefuel had designed more than a century before. Otherwise all floors, ceilings and interior walls, from the summit down to the basement, were reduced to rubble, forty-five thousand cubic meters of it, and removed. Little remained beyond the masonry envelope.

Because the interior has been so fundamentally altered, this part of the museum is the most modern and up to date. During the century when it housed the Ministry of Finance, its three courtyards were used either by the ministry workers or, more ignobly, as a parking lot for the staff. From west to east, the courtyards Marly, Puget and Khorsabad are all now dedicated to the display of sculpture. These luminous spaces were formerly outdoors—before Pei installed glass roofs—and so it seems appropriate that the sculptures on display are mostly outdoor sculptures. The Cour Marly is so called because all of the works on view came from Louis XIV's Château Marly and were dispersed when it was razed in the nineteenth century. The statues in the Cour Puget (named for Pierre Puget, one of the finest French sculptors of the seventeenth century) are largely of a piece with those of the Cour Marly, except that they come from a number of other sites. Surrounding these two courtyards is

the Louvre's splendid collection of French sculptures from the Middle Ages to the beginning of the nineteenth century. Only the Cour Khorsabad is an outlier, displaying Assyrian sculptures from the palace of Sargon II in the ancient Northern Iraqi city of Khorsabad.

As reimagined by Pei's assistant, Michel Macary, the Cour Marly and the Cour Puget are spatially among the most interesting and complex in the entire Louvre. One of the reasons for this complexity was the need to build around the so-called Passage Richelieu, an astonishing space that Lefuel designed in the 1850s to lead from the rue de Rivoli into the Cour Napoléon. For over 130 years it was closed to all but the employees of the Ministry of Finance, and only after 1993 did it finally offer visitors a much-needed second entrance to the museum. But because it stood between the Cour Marly and the Cour Puget, it could be preserved only by building a passageway beneath it to connect the two courtyards.

If the Louvre possesses an astounding dowry of grand stairways, its elevators are at best cramped and functional, and have been purposely scattered around the museum to escape the notice of most visitors. All visitors can ride the elevators, but only if they can find them: they are really intended for staff and handicapped visitors. Other than those unwelcoming elevators, the one exception to climbing stairs is the escalators that Pei designed for the Pavillon Richelieu. It might seem hard to generate much excitement about an escalator, but those of the Aile Richelieu are among the grandest one will ever see. They extend across six full bays of the Aile Colbert and their two flights rise nearly eighty feet. The inclusion of this jolt of modernism in the context of the Louvre (there are other escalators into and out of the Hall Napoléon, but not in the galleries themselves) was controversial, but it was made necessary by the fact that there was no other way to move crowds to the upper levels of the Aile Richelieu without even greater disruption. It is typical of Pei's gifts that he immediately understood how to transform this functional necessity

into a bold cultural statement: as visitors ascend the escalators, the Cour Napoléon and the *Pyramide* spread out before them to the south, while to the north the marble statuary of the multileveled Cour Puget gleams through two massive occuli twenty feet across. This aggressive perforation of the walls recalls similar passages in Le Corbusier's brutalist *Congress of Chandrigar*, but rarely has textured concrete looked quite so rich as here.

＊　＊　＊

The reopening of the Passage Richelieu was part of a far larger plan to reintegrate the Louvre (together with the Tuileries Garden) into the city of Paris. The creation of the Nouveau Louvre under Napoleon III, together with the removal of the streets that occupied the area for centuries, had resulted in a vast enclosure, almost as cut off from the rest of Paris as the fortress of Philippe Auguste had been six centuries before. One hundred years after the destruction of the Tuileries Palace, the means of reaching the museum had hardly improved. From the Pavillon de Marsan at the western end along the rue de Rivoli, all the way to the Colonnade half a mile to the east, the main entry into the Louvre was through the Guichet de Rohan, where the pedestrian had to compete with oncoming traffic. Now, in addition to the Passage Richelieu, visitors can enter by the shopping center of the Carrousel du Louvre. In a similar spirit, the avenue du Général-Lemonnier, between the Tuileries Garden and the place du Carrousel, with its ceaseless flow of cars and buses, was submerged in 1987. This decision enabled Pei to create the esplanade that now rises over that busy road. Finally, in 1998, a new bridge (the passerelle Solférino, renamed the passerelle Léopold-Sédar-Senghor) was thrown across the Seine, from the Tuileries Garden to the Musée d'Orsay. Taken together, these infrastructural enhancements

(together with a new metro station—Palais-Royal-Musée du Louvre) fundamentally altered and improved how Parisians and tourists interacted with the entire Louvre complex. In the process, nearly a mile of central Paris was suddenly reclaimed in the name of its citizens and its tourists.

An essential part of this project to reintegrate the Louvre into the life of Paris was the shopping center known as the Carrousel du Louvre. The notion of joining a temple of culture to what was in effect a mall seemed a radical idea in 1981, and almost forty years on, it remains so, at least in the sense that it has not been repeated on a comparable scale anywhere else in the world.

But in fact, since its foundation as a museum in 1793, the Louvre has never been exclusively a temple of culture: it always coexisted with other entities. Napoleon III had hoped to create an entire administrative city in the Louvre, containing all the ministries and both legislatures, in addition to an imperial palace, a theater and an opera house. But such precedents for the new shopping center did little to mollify many in the French chattering class, who reflexively drew unfavorable analogies to America. Some described it as an "annex of Disneyland" while others reminded the public, "*On n'est pas à Dallas!*" ("We're not in Dallas!").[7]

But over time the Carrousel du Louvre has become an integral part of most peoples' visit to the museum, especially now that visitors are more or less compelled to leave by the Carrousel. More materially, this mall is only the latest chapter in the millennial history of the land occupied by the Louvre complex. To most visitors, the mall will seem like a vast maze. The part that the public usually sees accounts for only half of its true extent: a massive convention center, usually closed to the broader public, neighbors it to the west, as does its vast underground garage and bus depot. Together these expansive spaces account for roughly 40 percent of the territory occupied by the entire Louvre complex.

To reach the Carrousel du Louvre from the Hall Napoléon, visitors pass through a charming passageway where booths protrude at an angle from walls perforated by rounded oculi. This commercial corridor was conceived in 1993 by Michel Macary, the able designer of the Cour Marly and Cour Puget in the Aile Richelieu. From that passageway, visitors emerge into a spacious white area illuminated by the inverted glass pyramid that descends from the roundabout, almost touching a far smaller stone pyramid, scarcely three feet high, that seems to rise to meet it. This area, which was designed by Pei himself, leads to a retail area arrayed in three broad avenues.

Continuing due west, visitors arrive at one of the great revelations of the Grand Louvre, the remains of the wall of Charles V, as revised under Louis XII around 1512. Obviously no one comes to the Louvre, or even to the shopping center, to see this escarpment, but it is one of the most significant parts of the Grand Louvre, and even the most inert visitor will not fail to be impressed by its sheer mural massiveness. Unlike the excavations of the Cour Carrée, where archaeologists knew in advance what they would find, the two massive walls that face one another as scarp and counterscarp—the two sides of a moat—were a revelation. Historians had long known that these walls had once stood here, but it was assumed that Louis XIII had razed them without a trace around 1640. But that was not the case, and these walls now take their place among the finest medieval remains in the French capital. However large the shopping center may be, to its immediate south is a sequence of massive rooms that, in their totality, constitute a space almost as expansive. To their north is a great subterranean parking area accessed from the avenue du Général-Lemonnier that lies, unsuspected by most visitors and even by most Parisians, under the esplanade east of the Jardin des Tuileries. Here is the precise point where the Palais des Tuileries stood for three hundred years. This avenue was opened in 1877 and submerged in 1985. The parking area is a vast subterranean

zone of gray upon gray that seems to exist in perpetual twilight. Like most garages its design is defined by a banal functionality. But in its way it is a stunning achievement, if not a thing of beauty. It can even be read as a sly parody of the glittering, sunlit splendor of the upper regions that are all that most people will ever see of the Grand Louvre.

During the excavations carried out in preparation for building this garage, archaeologists unearthed clay subsoil that had last seen daylight three thousand years before the founding of Rome. Among the things discovered was the complete skeleton of an adult man, one of the rare skeletons to come to light in Paris from the beginnings of the Bronze Age, four thousand years ago. Several axeheads made of flint were also discovered, dating back more than ten thousand years, perhaps to the Upper Paleolithic. At the same time, excavators unearthed kilns from the fourteenth and fifteenth-century tileries that gave their name to the Tuileries Palace that Catherine de Médicis ordered to be built on this soil in the 1560s.

The Carrousel du Louvre, with its bus depot and its conference halls, is so skillfully concealed from the pedestrian standing on the surface of Paris that it seems almost unimaginable from that perspective. In part, this result was achieved through landscaping, which the creators of the Grand Louvre took very seriously. The work proceded along three fronts: the eastern end of Jardin des Tuileries, the place du Carrousel and the design of the space in between, covering the newly submerged avenue du Général-Lemonnier. If the Jardin des Tuileries is added, nearly sixty acres of landscaping were largely or completely reconceived during the renovation of the Louvre.

The Tuileries Garden was entrusted to three landscape architects: Pascal Cribier, Louis Benech and François Roubaud, who were tasked with restoring le Notre's design from the 1660s to its former glory, by replacing trees that were dying and by relandscaping the

parterres that flanked the great eastern basin. At the same time, these gardens represented one of the most important open-air sculptural museums in the world. That had been the case for centuries, but now—following the advice of the architect Jean Nouvel—it became a gallery for some of the most advanced mid-century and contemporary work by such masters as Alberto Giacometti, Max Ernst, Tony Cragg and Alain Kirili. Such deference to precedent disappeared in the landscaping of the place du Carrousel, where a massive green lawn, with a gravel promenade down the center, is marked by six hedges on either side that converge upon the Arc du Carrousel. In between these two landscaped areas stands an austerely minimalist walkway, designed by Pei himself, that was built over the avenue du Général-Lemonnier.

These modifications of the landscaping of the Louvre tend to be taken for granted by pedestrians, but they are an essential part of the amenity of the entire project. Visitors who know the Louvre only as it has been since 1993 cannot imagine how much it has changed for the better. Before that time it was surely a great and noble museum, but hardly a pleasure to inhabit and certainly not a source of fun. After its ten-year transformation, however, what had been a chilly, drafty, ill-lit but infinitely august institution was transformed into a precinct of light and life. Through a triumph of architecture and urban planning, it has become a happy place.

EPILOGUE

Over thirty years have passed since the opening of the Grand Louvre. In a sense, the story of the museum, as a structure and an institution, has now been told. In another sense, of course, the Louvre is still evolving and, presumably, will continue to do so for centuries to come.

The contemporary Louvre—which has been guided by such able directors as Michel Laclotte, Pierre Rosenberg and Jean-Luc Martinez—comprises eight curatorial departments, including, as of 2012, the arts of Islam. In what is surely the largest architectural intervention to date in the Grand Louvre, (notwithstanding the renovation of the Musée Charles X in 1997 and of the Galerie d'Apollon in 2004), this newest department occupies the entire surface of the Cour Visconti in the Aile Denon. It lies beneath a winnowing golden roof designed, by the architects Rudy Riciotti, Mario Bellini and Renaud Piérard, to suggest a Bedouin tent.

Perhaps the most striking change to come over the Louvre in the past thirty years has been a threefold increase in attendance: under three million in 1988, that number swelled to nearly nine million in 2011 and has remained above eight million in each year since. As a consequence of that success, the Louvre is already in need of more space: the thirty-six thousand works now on view in its galleries represent less than one-tenth of the entire collection. There has been talk of turning the bloated mansard roofs of the pavilions, which for the past four centuries have served a purely ornamental function, into exhibition space. It seems more likely, however, that very soon the curators will start to gaze hungrily at the two parts of the Louvre complex that remain beyond their jurisdiction: the Pavillon de Flore

at the southern limit of the Grande Galerie, which now houses the École du Louvre, and the Musée des Arts Décoratifs (including le Musée de la Mode et du Textile) in the Pavillon de Marsan. Only when those two spaces have been claimed by the museum will every part of the Louvre complex, for the first time in its history, serve the museum alone.

If the museum is growing in terms of attendance, it is also growing through the acquisition of ever more objects. But over the past thirty years, its experience in this regard has mirrored that of many other museums around the world, at least those devoted to the arts of antiquity and premodern Europe. Now that most of the great old master paintings, once in private hands, have come to safe harbor in the museums of Europe and the United States, new acquisitions tend on the whole to be smaller and more modest than in the past. It is true that, in recent years, the Louvre has acquired Ribera's *Saint John the Evangelist*, Cranach's *Three Graces* and Jean Malouel's late fourteenth-century *Christ de Pitié*, and these, without question, are substantial acquisitions. But as a measure of how prohibitively expensive such major works of art have become, relative to the museum's budget, in 2004 Ingres's portrait of the *Duc d'Orléans* was purchased for twelve million euros, while Houdon's sculpture of the *Standing Vestal* cost just under ten million. These, as well, were major works of art. Most recent acquisitions, however, have been far more modest. Typical of these are the nine panels of rustic diversions painted by the eighteenth-century master Jean-Baptiste Oudry: acquired in 2002, they are surely pleasant, but they fall far short of the sort of work that the museum could regularly afford a century ago.

Although the Louvre generally has little to do with contemporary painting and sculpture, nevertheless, like many other museums devoted to older art, it has been enticed in recent years by the energy and interest that attach to newer forms of visual culture, and so it

has tactically included examples at various points in its galleries. The model for such interventions was Georges Salles's commission, in 1953, of Braque's amorphous *Birds* on the ceiling of the Salle Henri II. For half a century, that rather unsuccessful experiment had no sequel, but in the early years of the new millennium, the idea was revisited on three occasions. The first of these resulted in a commission awarded to Anselm Kiefer, the German neoexpressionist, in which he depicts a prostrate body, apparently a self-portrait, formed from a viscous mix of paint and soil, as so often with this artist. Thirty feet high and fifteen feet wide, the painting occupies the stairway that Percier and Fontaine designed in 1808 in the northern corner of the Colonnade. On either side is a sculpture depicting sunflowers and more soil.

One year later, the French conceptual artist François Morellet intervened in a far more discrete fashion in the Escalier Lefuel in the Aile Richelieu by redesigning the iron frames of the windows. The work, however, is so subtle and self-effacing that few visitors to this underserved section of the museum are likely to be aware of his subversion in the first place.

Finally, in 2010, the biggest intervention of all occurred when Cy Twombly, the renowned American abstract painter, covered all 3,800 square feet of the ceiling of the Salle des Bronzes, just north of Braque's birds, with a deep-blue field scored with circles and the names, spelled out in Greek letters, of the ancient sculptors Polyclitus, Praxiteles, Lysippus, Myron, Phidias, Scopas and Cephisodotus. Since none of these sculptors is displayed in the room in question, the artist's point, here as well, is apt to elude visitors. But Twombly seems, in a general way, to respect the formal mood of the chamber and his painting has done little to disturb it.

The most publicized development at the Louvre in the past decade has been the opening of two *succursales*, or franchises—the Louvre-Lens in the Pas-de-Calais region of Northern France (2012),

and the Louvre Abu Dhabi in the United Arab Emirates (2017). These new museums, designed respectively by the Japanese firm of SANAA and by Jean Nouvel, include objects from the Louvre's collection that are on temporary loan. In the case of Abu Dhabi, the connection to the Louvre is for only a thirty-year period, while the museum of Lens, although affiliated with the Parisian institution, is funded entirely by the local government of Pas-de-Calais. Both of these museums are essentially autonomous and separate from the Louvre and they have emerged through two very different impulses. Louvre-Lens was a response to a widespread feeling, in parts of France far removed from Paris, that the capital received an outsized share of the national budget for culture. Louvre Abu Dhabi, by contrast, is the latest manifestation of the national government's desire to propagate and export French culture, exactly as André Malraux tried to do half a century ago when he allowed the *Mona Lisa* to tour the United States.

* * *

The future of the Louvre surely is not in doubt: everything we have learned over the past century suggests that the almost idolatrous regard for the authentic art object is likely to persist and grow ever stronger. And since that appetite can be satisfied by nothing less than standing in direct physical proximity to the real thing, it is certain that the crowds will continue to pour into the Salle des États to bear witness to the *Mona Lisa* and the treasures of the Italian Renaissance. But it is an open question what exactly these works of art will mean to subsequent generations. Doubtless the objects will continue to be admired by many visitors for their obvious beauty and skill, while other visitors will feel drawn to them through a sense of their fame and monetary value. But ever fewer visitors, one

suspects, will go to them, as earlier generations did, as to a temple of culture whose Greco-Roman antiquities and old master paintings defined the Western canon.

Since its creation in 1793, the Louvre Museum has always been oriented toward the past, but its relation to that past has proved highly changeful. During the French Revolution, the paintings and sculptures in the Louvre were mostly older works, but were seen, crucially, as having a vital bearing on the life and art of the latest generation of humanity. A quarter of a century later, with the rise of historicism, it was the pastness of the objects in the Louvre, the pastness of the past itself, that exerted a powerful spell on the newest generation, even as the direct influence of older art on newer art began to fade. This sentiment in turn yielded, in the second half of the nineteenth century, to an almost scientific view of the past, which presumed to value the object for its form and meaning, rather than for its effect on living art or for what it explained about the genesis of contemporary European society. That point of view endured for nearly a century and a half and it largely continues to define the intentions of the curators of the Louvre and the interests of many visitors to the museum. But although it would be wrong to say that society as a whole has rejected such interests, clearly a major shift has occurred in the collective mentality of the West: as a society, we have turned away from the past as such and toward the contemporary as such. This shift as well may be a temporary, passing fad; but for now, the energy of the art market—which reflects and shapes important currents in society itself—has largely been redirected from Greek and Roman antiquities, old master paintings and impressionism to what is being created now. In consequence, the Louvre and comparable institutions will still be of great value to our culture, but perhaps in slightly different ways, and perhaps to a slightly diminished degree, compared to earlier generations.

Nonetheless, standing apart from such fluctuations of fashion, the Louvre itself rises up, both in its physical dimensions and as a glorious abstraction. Like all things created by human beings, from an Upper Paleolithic arrowhead or a Sumerian cylinder seal to a palace nearly half a mile from end to end, there is something at once presumptuous and miraculous in its emergence out of nothing, out of the brute materiality of nature. The territory on which the Louvre now stands beside the waters of the Seine was once grass and clay and stone outcroppings. Perhaps in ten thousand or ten million years, it will revert to something like that earlier condition. But the Louvre, both in its physical immensity and in its role as the largest repository of humanity's finest artifacts, takes on a certain exemplary status beyond all the other institutions of the world that were created to serve the same function. It represents, as Henry James said of the Galerie d'Apollon, "not only beauty and art and supreme design, but history and fame and power, the world, in fine, raised to the richest and noblest expression."

Hotel Brighton, Paris
2 October, 2018

GLOSSARY

Avant-corps: part of a building that protrudes from the main body of the façade, usually along its entire height.

Balustrade: a sequence of small vertical shafts along a stairway or the summit of a building.

Bay: the unit of a façade between two columns.

Caryatid: a column or pillar sculpted in the form of a draped female figure.

Cornice: a decorative horizontal molding that protrudes from the top of a building's exterior.

Corp-de-logis: the principal part of a building, as opposed to its wings. In medieval castle architecture, the portion that contains the living or inhabitable spaces, as opposed to the curtain wall and fortifications.

Curtain-wall: in medieval fortifications, the outer wall of a castle extending between two turrets or bastions.

Donjon: the fortified tower of a castle.

Dormer: an upright window built into a sloping roof.

Entablature: in classical architecture, the summit of a building that rises above the columns.

Frieze: in architecture, the broad central portion of an entablature, often adorned with sculptural decoration.

Frontispiece: see avant-corps.

Giant order: refers to a column or pilaster that rises through two or more stories of a façade.

Hipped roof: a roof whose sides all slope downwards to the walls of the structure.

Lancet: in gothic architecture, a tall, narrow window, usually with a pointed arch.

Lintel: a flat, as opposed to curved, horizontal structure that spans an opening between a pair of vertical supports.

Loggia: a covered exterior gallery, usually elevated and open to the elements.

Metope: a small, horizontal sculpted element that adorns a frieze.

Oculus: a circular opening or window in a wall or ceiling.

Parterre: in formal gardens, a group of plantings, usually arranged symmetrically in a square shape.

Pediment: in classical architecture, the triangular central portion of a façade's roof, whose interior space, the tympanum, often has sculptural ornament.

Pilaster: an architectural ornament in the form of a flattened classical column.

Rusticated: referring to rustication, a variety of masonry techniques in classical architecture that produce a textured, as opposed to a flat and uniform, surface, usually in the lower portion of a building.

Soubassement: the base or bedrock walls of a medieval structure.

String course: an often-projecting horizontal band that runs across a façade.

Toit en poivrière: the conical roofing of a small tower, suggestive of a pepperpot.

NOTES

1. *The Origins of the Louvre*

1. Geneviève Bresc-Bautier and Guillaume Fonkenell, eds., *L'Histoire du Louvre* (Paris, 2016), vol. 1, p. 76.

2. Adolphe Berty, *Topographie Historique du Vieux Paris* (Paris, 1866), p. 120–121.

3. Ibid., p. 118.

4. Ibid., p. 119.

5. Octave Delepierre, ed., *Philippide de Guillaume-Le-Breton* (Paris, 1841), p. 130.

6. Bresc-Bautier and Fonkenell, eds., *L'Histoire du Louvre*, vol. 1, p. 63–64.

7. Berty, *Topographie Historique du Vieux Paris*, p. 5.

8. Christine de Pizan, *Le Livre des Fais et Bonnes Meurs du Sage Roy Charles V*, quoted in Bresc-Bautier and Fonkenell, eds., *L'Histoire du Louvre*, vol. 1, p. 68.

9. Berty, *Topographie Historique du Vieux Paris*, p. 101–102.

10. Soizic Donin, *La Bibliothèque de Charles V*, passim, BNF classes.

11. Pizan, quoted in Bresc-Bautier and Fonkenell, eds., p. 76.

12. Henri Sauval, *Histoire et Recherches des Antiquités de la Ville de Paris* (Paris, 1724), vol. 2, p. 13.

13. Pizan, quoted in Bresc-Bautier and Fonkenell, eds., p. 85.

14. Christine de Pizan, quoted in Monique, Chatenet, and Mary Whiteley, "Le Louvre de Charles V," *Revue de l'art* (1992), no. 97, p. 70.

15. *Les Comptes du Bâtiment du Roi*, quoted in Chatenet and Whiteley, "Le Louvre de Charles V," p. 69.

16. Philippe Lorentz and Dany Sandron, *Atlas de Paris au Moyen Âge* (Paris, 2008), p. 77.

17. Sauval, *Histoire et Recherches des Antiquités de la Ville de Paris*, p. 209.

2. *The Louvre in the Renaissance*

1. Jacques Androuet du Cerceau, *Le Premier Volume des plus excellents Bastiments de France* (Paris, 1576), p. 5.

2. Geneviève Bresc-Bautier and Guillaume Fonkenell, eds., *L'Histoire du Louvre* (Paris, 2016), vol. 1, p. 123.

3. Geneviève Bresc-Bautier, *The Louvre, a Tale of a Palace*, (Paris, 2008), p. 22.

4. Bresc-Bautier and Fonkenell, eds., *L'Histoire du Louvre*, vol. 1, p. 127.

5. Ibid., p. 97.

6. Ibid.

7. Johann Peter Eckermann, *Gespräche mit Goethe*, 23 March 1829 (Leipzig, 1836).

8. Anthony Blunt, *Art and Architecture in France, 1500–1700* (Harmondsworth, 1953), p. 16.

9. Du Cerceau, *Le Premier Volume des plus excellents Bastiments de France*, p. 2.

10. Théodore Agrippa d'Aubigné, *Les Tragiques* (Paris, 1857), p. 240.

3. *The Louvre of the Early Bourbons*

1. Hilary Ballon, *The Paris of Henri IV: Architecture and Urbanism* (Cambridge, 1991), p. 10.

2. Alistair Horne, *The Seven Ages of Paris* (London, 2002), p. 84.

3. Geneviève Bresc-Bautier and Guillaume Fonkenell, eds., *L'Histoire du Louvre* (Paris, 2016), vol. 1, p. 237.

4. Georges Poisson, *La grande histoire du Louvre* (Paris, 2013), p. 80.

5. Ibid., p. 76.

6. Ibid., p. 84.

7. Jean Héroard, *Journal de Jean Héroard sur l'enfance et la jeunesse de Louis XIII (1601–1628)* (Paris, 1868), vol. 2, p. 4.

8. Poisson, *La grande histoire du Louvre*, p. 79.

9. Anthony Blunt, *Nicholas Poussin* (London, 1995), p. 157.

10. C. Jouany, ed., *Correspondance de Nicolas Poussin* (Paris, 1968), vol. 5, p. 41.

11. Blunt, *Nicholas Poussin*, p.159.

12. Jouany, *Correspondance de Nicolas Poussin*, p. 86.

13. Ibid., p. 134.

14. Ibid., p. 142.

4. *The Louvre and the Sun King*

1. John B. Wolff, *Louis XIV* (New York, 1974), p. 6.

2. Charles Freyss, ed., *Mémoires de Louis XIV pour l'instruction du Dauphin* (Paris, 1860), vol. 2, p. 567.

3. Anthony Blunt, *Art and Architecture in France, 1500–1700*, p. 342.

4. Henry James, *A Small Boy and Others* (New York, 1914), p. 346.

5. Geneviève Bresc-Bautier and Guillaume Fonkenell, eds., *L'Histoire du Louvre*, vol. 1, p. 435.

6. Antoine Schnapper, *Curieux du Grand Siècle* (Paris, 2005), p. 285.

7. Bresc-Bautier and Fonkenell, eds., vol. 1, p. 374.

8. Ibid., p. 395.

9. Paul Fréart de Chantelou and Ludovic Lalanne, eds., *Journal du voyage du Cavalier Bernin en France* (Paris, 1885), p. 206-207.

10. Ibid. p. 15.

11. Bresc-Bautier and Fonkenell, eds., vol. 1, p. 396.

12. Andrew Marvell, *The Complete Poems* (Harmondsworth, 1972), p. 191.

13. Quoted in Stefano Ferrari, "Gottfried W. Leibnitz e Claude Perrault," in *Leibnitz' Auseinandersetzungen mit Vorgängern und Zeitgenossen* (Stuttgart, 1990), p. 341.

14. Charles Perrault, *Les Hommes illustres qui ont paru en France pendant ce siècle* (Paris, 1697), vol. 1, p. 67.

15. Ibid.

16. Ibid.

5. The Louvre Abandoned

1. Voltaire, quoted in M-H. Fucore, *ses Idées sur les Embellissements de Paris, Voltaire.*

2. Étienne La Font de Saint-Yenne, *L'Ombre du grand Colbert, le Louvre et la Ville de Paris, dialogue* (Hague, 1749), p. v.

3. Ibid., p. iv.

4. Geneviève Bresc-Bautier and Guillaume Fonkenell, eds., *L'Histoire du Louvre*, vol. 1, p. 511.

5. Ibid., p. 479.

6. Ibid., p. 483.

7. Hannah Williams, "Artists' Studios in Paris: Digitally Mapping the 18th-Century Art World," *Journal18, no. 5 Coordinates* (Spring 2018), http://www.journal18.org/issue5/artists-studios-in-paris-digitally-mapping-the-18th-century-art-world/.

8. Hannah Williams, *The Other Palace: Versailles and the Louvre* (Sydney, 2017), https://www.youtube.com/watch?v=vLNKpe0aXCE.

9. Ibid.

10. David Maskill, "The Neighbor from Hell: André Rouquet's Eviction from the Louvre," *Journal18*, no. 2 *Louvre Local* (Fall 2016), http://www.journal18.org/822.

11. Andre Felibien, Preface to *Conférences de l'Académie royale de peinture* (Amsterdam, 1726) p.15.

12. Bresc-Bautier and Fonkenell, eds., vol. 1, p. 450.

13. Quoted in Thomas Crow, *Painting and the Public* (New Haven, 1985) p. 4.

14. Ibid., p. 19.

15. Bresc-Bautier and Fonkenell, eds., vol. 1, p. 534.

16. Quoted in Crow, *Painting and the Public*, p. 20.

17. *Explication des Peintures, Sculptures, et Gravures de Messieurs de l'Academie* (Paris, 1761), p. 20.

18. Bresc-Bautier and Fonkenell, eds., vol. 1, p. 529.

19. Ibid., p. 532.

20. Ibid., p. 471.

21. Étienne La Font de Saint-Yenne, *L'Ombre du grand Colbert, le Louvre et la Ville de Paris, dialogue*, Ibid.

22. Bresc-Bautier and Fonkenell, eds., vol. 1, p. 557.

6. *The Louvre and Napoleon*

1. Geneviève Bresc-Bautier and Guillaume Fonkenell, eds., *L'Histoire du Louvre* (Paris, 2016), vol. 1, p. 758.
2. Ibid., p. 592.
3. Ibid., p. 587.
4. Ibid., p. 594.
5. Anatole France, "Le Baron Denon," in *La Vie Littéraire* (Paris, 1912), p. 169.
6. Bresc-Bautier and Fonkenell, eds., vol. 1, p. 604.
7. Ibid., p. 605.
8. Ibid.
9. Ibid., p. 606.
10. Ibid., p. 629.
11. Ibid., p. 610.
12. Ibid., p. 708
13. Ibid., p. 711.
14. Ibid., p. 712.
15. Notice des tableaux des écoles primitives de l'Italie, de l'Allemagne, et de plusieurs autres tableaux de différentes écoles, exposés dans le grand Salon du Musée royal, ouvert le 25 juillet 1814 (Paris, 1814), p. i–ii.
16. Michel Carmona, *Le Louvre et les Tuileries: Huit siècles d'histoire* (Paris, 2004), p. 234.

7. *The Louvre under the Restoration*

1. Michel Carmona, *Le Louvre et les Tuileries: Huit siècles d'histoire* (Paris, 2004), p. 287.
2. Geneviève Bresc-Bautier and Guillaume Fonkenell, eds., *L'Histoire du Louvre*, vol. 1, p. 739.
3. Stendhal, *Promenades dans Rome*, vol. 3, 27 November 1827.
4. Bresc-Bautier and Fonkenell, eds., vol. 1, p. 742.
5. David Hume, *An Enquiry concerning the Human Understanding*, p 83.

6. Bresc-Bautier and Fonkenell, eds., vol. 2, p. 49–50.

7. Ibid., p. 49.

8. Ibid.

8. *The Nouveau Louvre of Napoleon III*

1. Geneviève Bresc-Bautier and Guillaume Fonkenell, eds., *L'Histoire du Louvre*, vol. 2, p. 159.

2. Théodore de Banville, *Paris et le Nouveau Louvre*.

3. Alfred Delvau, *Les Dessous de Paris* (Paris, 1860), p. 258.

4. Arsène Houssaye, *Oeuvres Poétiques* (Paris, 1857), p. 106.

5. Arsène Houssaye, *Souvenirs de Jeunesse, 1830–1850*, (Paris, 1895), p. 26.

6. Gérard de Nerval, *La Bohème Galante, Oeuvres Complètes*, vol. 5 (Paris, 1868), p. 268.

7. Susan R. Stein, *The Architecture of Richard Morris Hunt* (Chicago, 1986), p. 60.

8. Bresc-Bautier, Geneviève and Fonkenell, Guillaume, eds., *L'Histoire du Louvre*, vol. 2, p. 228.

9. Ibid., p. 130.

10. Anne Dion-Tannenbaum, *Les appartements Napoleon III du musée du Louvre* (Paris, 1988), p. 38.

11. Bresc-Bautier and Fonkenell, eds., vol. 2, p. 192.

12. Ibid., p. 107.

13. Ibid., p. 244.

14. Ibid., p. 245.

15. Ibid., p. 228.

16. Charles Baudelaire, "Le Cygne," from *Les Fleurs du Mal*, p. 89.

9. *The Louvre in Modern Times*

1. *Journal des Goncourt, Deuxième Série, Premier Volume* (Paris, 1890), p. 18.

2. Ibid., p. 267.

3. Geneviève Bresc-Bautier and Guillaume Fonkenell, eds., *L'Histoire du Louvre*, vol. 2, p. 296.

4. Ibid., p. 324.

5. Ibid., p. 358.

6. Ibid., p. 359.

7. Walter Pater, "Leonardo da Vinci," in *The Renaissance: Studies in Art and Literature* (London, 1917), p. 124.

8. Jules Michelet, *Histoire de France au XVIe siècle* (Paris, 1855) p. xci.

9. Bresc-Bautier and Fonkenell, eds., vol. 2, p. 391.

10. Ibid., p. 399.

11. Germain Bazin, *Souvenirs de l'exode du Louvre* (Paris, 1991), p. 15.

12. Georges Salles, *Le Regard* (Paris, 1939).

13. Bresc-Bautier and Fonkenell, eds., vol. 2, p. 491.

14. Ibid., p. 510.

15. Georges Poisson, *La grande histoire du Louvre*, p. 418.

10. *The Creation of the Contemporary Louvre*

1. Data from "Paris Convention and Visitor's Bureau—Tourism in Key Figures 2013" and "Mastercard 2014 Global Destination Cities Index," cited in Wikipedia article.

2. Jack Lang, *Les Batailles du Grand Louvre* (Paris, 2010), p. 246.

3. Antoine Schnapper, *Curieux du Grand Siècle* (Paris, 2005), p. 285.

4. Geneviève Bresc-Bautier and Guillaume Fonkenell, eds., *L'Histoire du Louvre*, vol. 2, p. 544.

5. Emile Biasini et al., *The Grand Louvre, A Museum Transfigured 1981–1993* (Paris, 1989), p. 27.

6. Bresc-Bautier and Fonkenell, eds., vol. 2, p. 556.

7. Georges Poisson, *La grande histoire du Louvre*, p. 425–426.

BIBLIOGRAPHY

1. Agrippa d'Aubigné, Théodore. *Les Tragiques*. Paris, 1857.

2. Androuet du Cerceau, Jacques. *Le Premier Volume des plus excellents Bastiments de France*. Paris, 1576.

3. Aulanier, Christiane. *Histoire du Palais et du Musée du Louvre*. 9 vols. Paris, 1971.

4. Avril, François, et al. *Paris 1400: Les arts sous Charles VI*. Paris, 2004.

5. Ballon, Hilary. *The Paris of Henri IV: Architecture and Urbanism*. Cambridge, 1991.

6. Baudelaire, Charles. "Le Cygne." In *Les Fleurs du Mal*. Paris, 1868.

7. Bazin, Germain. *Souvenirs de l'exode du Louvre: 1940–1945*. Paris, 1992.

8. Berger, Robert W. *Public Access to Art in Paris: A Documentary History from the Middle Ages to 1800*. University Park, PA, 1999.

9. ———. *A Royal Passion: Louis XIV as Patron of Architecture*. Cambridge, MA, 1994.

10. Berty, Adolphe. *Topographie Historique du Vieux Paris*, vol. 1. Paris, 1866.

11. Blunt, Anthony. *Philibert de l'Orme*. London, 1958.

12. ———. *Nicolas Poussin*. London, 1995.

13. ———. *Art and Architecture in France 1500–1700*. Harmondsworth, 1953.

14. Bordier, Cyril. *Louis Le Vau: Architecte*. Paris, 1998.

15. Bresc-Bautier, Geneviève. *The Louvre, a Tale of a Palace*. Paris, 2008.

16. Bresc-Bautier, Geneviève, and Guillaume Fonkenell, eds. *L'Histoire du Louvre*. Paris, 2016.

17. Burchard, Wolf. *The Sovereign Artist: Charles Le Brun and the Image of Louis XIV*. London, 2016.

18. ———. "Savonnerie Reviewed, Charles Le Brun and the 'Grand Tapis de Pied d'Ouvrage à la Turque' Woven for the 'Grande Galerie' at the Louvre." *Furniture History* vol. 48 (2012).

19. Carmona, Michel. *Le Louvre et les Tuileries: Huit siècles d'histoire.* Paris, 2004.

20. Chanel, Gerri. *Saving* Mona Lisa: *The Battle to Protect the Louvre and Its Treasures during World War II.* New York, 2014.

21. Chantelou, Paul Fréart de. (Lalanne, Ludovic, ed.) *Journal du voyage du Cavalier Bernin en France.* Paris, 1885.

22. Chatenet, Monique, and Mary Whiteley. "Le Louvre de Charles V." *Revue de l'art* vol. 97 (1992).

23. Cordellier, Dominique. *Toussaint Dubreuil.* Paris, 2010.

24. Corey, Laura D., et al. *The Art of the Louvre's Tuileries Garden.* New Haven, 2013.

25. Cox-Rearick, Janet, *The Collection of Francis I: Royal Treasures,* New York, 1995.

26. Crow, Thomas. *Painting and the Public.* New Haven, 1985.

27. Daniel, Malcolm R., and Barry Bergdohl. *The Photographs of Édouard Baldus.* New York, 1994.

28. Delepierre, Octave, ed. *Philippide de Guillaume-Le-Breton.* Paris, 1841.

29. Delvau, Alfred. *Les Dessous de Paris.* Paris, 1860.

30. Dion-Tenenbaum, Anne. *Les appartements Napoléon III du Musée du Louvre.* Paris, 1993.

31. Donin, Soizic. *La Bibliothèque de Charles V.* BNF classes.

32. Eckermann, Johann Peter. *Gespräche mit Goethe.* Leipzig, 1836.

33. *Explication des Peintures, Sculptures et Gravures de Messieurs de l'Académie.* Paris, 1761.

34. Ferrari, Stefano. "Gottfried W. Leibnitz e Claude Perrault." In *Leibnitz' Auseinandersetzungen mit Vorgängern und Zeitgenossen* (I. Marchlewitz and A. Heinekamp, eds.). Stuttgart, 1990.

35. Fonkenell, Guillaume, ed. *Le Louvre pendant la guerre: Regards photographiques, 1938–1947.* Paris, 2009.

36. ———. *Le Palais des Tuileries.* Paris, 2010.

37. France, Anatole. "Le Baron Denon." In *La Vie Litteraire*. Paris, 1912.

38. Freyss, Charles, ed. *Mémoires de Louis XIV pour l'instruction du Dauphin*. Paris, 1860.

39. Fucore, M.H. *Voltaire, ses idées sur les embellissements de Paris*. Paris, 1909.

40. Gady, Alexandre. *Le Louvre et les Tuileries: La fabrique d'un chef-d'oeuvre*. Paris, 2015.

41. ———. *Jacques Lemercier: Architecte et ingénieur du Roi*. Paris, 2005.

42. Goncourt, Edmond. *Journal des Goncourt, Deuxième Série, Premier Volume*. Paris, 1890.

43. Herrmann, Wolfgang. *The Theory of Claude Perrault*. London, 1973.

44. Héroard, Jean. *Journal de Jean Héroard sur l'enfance et la jeunesse de Louis XIII (1601–1628)*. Paris, 1868.

45. Horne, Alistair. *The Seven Ages of Paris*. London, 2002.

46. Houssaye, Arsène. *Oeuvres Poétiques*. Paris, 1857.

47. ———. *Souvenirs de Jeunesse, 1830–1850*. Paris, 1895.

48. Hume, David. *An Enquiry Concerning Human Understanding*. Oxford, 1894.

49. James, Henry. *A Small Boy and Others*. New York, 1914.

50. Jouany, C., ed. *Correspondance de Nicolas Poussin*, vol. 5. Paris, 1968.

51. La Font de Saint-Yenne, Étienne. *L'Ombre du grand Colbert, le Louvre et la Ville de Paris, dialogue*. Hague, 1749.

52. Lang, Jack. *Les batailles du Grand Louvre*. Paris, 2010.

53. Laugier, Ludovic. *Les antiques du Louvre: Une histoire du goût d'Henri IV à Napoléon Ier*. Paris, 2004.

54. Lemerle, Frédérique and Yves Pauwels. *Philibert De l'Orme: Un architecte dans l'histoire: arts, sciences, techniques*. In Actes du LVIIe colloque international d'etudes humanistes, CESR. Turnhout, 2015.

55. Lesné, Claude, and Françoise Waro. *Jean-Baptiste Santerre: 1651–1717*. Paris, 2011.

56. Lorentz, Philippe, and Dany Sandron. *Atlas de Paris au moyen âge: Espace urbain, habitat, société, religion, lieux de pouvoir*. Paris, 2006.

57. Malraux, André. *Écrits sur l'art/André Malraux*. Paris, 2004.

58. Marvell, Andrew. *The Complete Poems*. Harmondsworth, 1972.

59. Maskill, David. "The Neighbor from Hell: André Rouquet's Eviction from the Louvre." *Louvre Local, Journal 18*, no 2.

60. McClellan, Andrew. *Inventing the Louvre: Art, Politics, and the Origins of the Modern Museum in Eighteenth-Century Paris*. New York, 1994.

61. Millen, Ronald, and Robert Wolf. *Heroic Deeds and Mystic Figures: A New Reading of Rubens' Life of Maria de' Medici*. Princeton, 1989.

62. Mitford, Nancy. *The Sun King*. New York, 2012.

63. Moon, Iris. *The Architecture of Percier and Fontaine and the Struggle for Sovereignty in Revolutionary France*. New York, 2016.

64. Nerval, Gérard de. *La Bohème Galante, Oeuvres Complètes*, vol. 5. Paris, 1868.

65. Pater, Walter. "Leonardo da Vinci." In *The Renaissance: Studies in Art and Literature*. London, 1917.

66. Pei, I. M., Emile Biasini, and Jean Lacouture. *L'invention du Grand Louvre*. Paris, 2001.

67. Perrault, Charles. *Les Hommes illustres qui ont paru en France pendant ce siècle*, vol. 1. Paris, 1697.

68. Petzet, Michael. *Claude Perrault und die Architektur des Sonnenkönigs*. Munich, 2000.

69. Picon, Antoine. *Claude Perrault, 1613–1688: Ou, la curiosité d'un classique*. Paris, 1988.

70. Poisson, Georges. *La grande histoire du Louvre*. Paris, 2013.

71. Prinz, Wolfram, and Ronald G. Kecks. *Das französische Schloss der Renaissance: Form und Bedeutung der Architektur, ihre geschichtlichen und gesellschaftlichen Grundlagen*. Berlin, 1985.

72. Roussel-Leriche, Françoise, and Marie Petkowska Le Roux. *Le témoin méconnu: Pierre-Antoine Demachy, 1723–1807*. Paris, 2013.

73. Salles, Georges. *Le Regard*. Paris, 1939.

74. Sauval, Henri. *Histoire et Recherches des Antiquités de la Ville de Paris*, vol. 2. Paris, 1724.

75. Scailliérez, Cécile. *François Ier et ses artistes dans les collections du Louvre*. Paris, 1992.

76. ———. *Léonard de Vinci: La Joconde*. Paris, 2003.

77. Schnapper, Antoine. *Collections et collectionneurs dans la France du XVIIe siècle*. Paris, 1994.

78. ———. *Le métier de peintre au Grand Siècle*. Paris, 2004.

79. ———. *Curieux du Grand Siècle*. Paris, 2005.

80. Serlio, Sebastiano. *L'architettura: I libri I-VII e extraordinario nelle prime edizioni*. Milan, 2001.

81. Siksou, Jonathan. *Rayé de la carte*. Paris, 2017.

82. Stein, Susan. R. *The Architecture of Richard Morris Hunt*. Chicago, 1986.

83. Stendhal. *Promenades dans Rome*, vol. 3. Paris, 1829.

84. Williams, Hannah. "Artists' Studios in Paris: Digitally Mapping the 18th-Century Art World," *Journal 18*, Issue 5 Coordinates (Spring 2018).

85. Wolff, John B. *Louis XIV*. New York, 1974.

IMAGE CREDITS

INDEX

Note: Page numbers in *italics* refer to illustrations or their captions.

Académie d'Architecture, 155
Académie de Peinture et de Sculpture, 155, 156–163, 187
Académie des Beaux-Arts, 147, 155–156
Académie des Inscriptions et des Belles-Lettres, 155
Académie des Sciences, 155
Académie française, 91, 147, 151, 155
Accademia di Bologna, 156
Accademia di San Luca, 156
Adoration of the Shepherds, The (La Tour), 316
Agrippa d'Aubigné, 60
Aile Denon, 1, 189–190, 346
Aile Lemercier, 257
Aile Lescot, xx, 46–54, 56, 95, 155, 254, 257
Aile Richelieu, 85, 347–348, 349
Aile Rivoli, 248, 296–297
Aile Sud, 55
Aile Sully, 11, 12, 22, 23, 346–347
Alaux, Jean, 235
Albigensian heretics, 3
All of Italy Submits to the Laws of Its Liberator (frieze), 213
Allegory of the Vices (Correggio), 116
Allegory of War (Goujon), 52
Angels (Verrocchio), 305
Angers, David d,' 290
Angevin kings, 3
Anguier, Michel, 124
Anne de Bretagne, 285
Anne of Austria, 103–104, 123–124, 156

Annunciation (Reni), 130
ansculottes, 180–181
Antichambre Henri II, 322–323
Aphrodite of Melos, 226
Apis Bull, 283
Apollinaire, Guillaume, 309–310
Apollo Belvedere, 32, 193, 197, 198, 199, 200, 217, 226
Apollo Slaying the Serpent Python (Delacroix), 113
Apollo Vanquishing the Serpent Python (Delacroix), 264
Apotheosis of Homer (Ingres), 231, 233–234, *234*
Appartement du Ministre, 262, 263, 348
Appartements de Napoléon III, 266
appartements d'été (summer apartments), *73*, 122, 123–124, 148, 197, 206
Arc de Triomphe, xix, 41, 211–212
Arc du Carrousel, xv, 2, 111, 211–212, *212*, 219, 245, *260*, 354
archaeological work/excavations on site, xv, 2, 7, 12, 18, 23, 120, 181, 338
Aretino, Pietro, 32
aristocrats, houses of, 25–26
Aristotle, 17
art nouveau movement, 273
art restoration, 202
artists' dwellings, 79–80, 151–154, 210
Arundel, Earl of, 116
Ashmolean, 166, 222
Assyriology, 282–283
Atlantes, 265
Aubé, Jean-Paul, 298, 299
Austerlitz, Battle of, 212–213

Bacchanales (Poussin), 91
Bacchus (da Vinci), 33
Bacchus of Versailles, 80
Baigneuse de Valpinçon, La (Ingres), 305
Baldus, Édouard, 259, *260*, 277
Balladur, Eduard, 348
Bandinelli, Baccio, 80
Banville, Théodore de, 238
Barbier, Jacques-Luc, 197
Barère, Betrand, 180
Barr, Alfred H., Jr., 312
Bartlett, Paul Wayland, 299
Bassano, Jacopo, 115
basse-cour, 24
Bastien-Lepage, Jules, 313
Bastille, 11, 19, 22, 175–176, 178
Bathers, The (Fragonard), 282
Bathsheba at Her Bath (Rembrandt), 282
Baudelaire, Charles, 286–287
Baullery, Nicholas, 84
Bazin, Germain, 318, 321, 323, 329
Beauharnais, Eugène de, 227
Beaux-Arts style, 242–243, 263, 273, 285–286
Becket, Thomas à, 7
Bellay, Guillaume du, 32
Belle Ferronnière, La (da Vinci), 33, 186, 318
Belle Jardinière (Raphael), 35, 167, 186, 290
Bellini, Mario, 355
Benech, Louis, 353
Bentivoglio, Archbishop, 43
Bérégovoy, Pierre, 347–348
Bergeret, Jules, 293–295
Bernini, Gian Lorenzo, *110*, 127–133, 244
Béroud, Louis, 309
Berthélemy, Jean-Simon, 206
Bertin, Louis-François, 309
Berty, Adolphe, 1, 6, 13, 301
Biasini, Émile, 337–338, 345
Bibliothèque du Louvre, 258, 267, 294
Bibliothèque nationale, 17–18, 91

Biennale di Venezia, xviii
Birds (Braque), 322, 323, 357
Birth of the Virgin (Murillo), 279
Bismarck, Otto von, 291
Blavette, Victor, 299
Blondel, Jacques-François, 164
Blondel, Merry-Joseph, 219
Blondel, Paul, 299
Blücher, Gebhard von, 217
Blunt, Anthony, 49, 98, 100, 108
Boeuf Écorché (Rembrandt), 278, 304
Boffrand, Germain, 164
Bohémienne, La (Hals), 282
Boileau, Louis-Charles, xvi, 298
Bonaparte on the Pont d'Arcole (Gros), 177
Bonington, Richard Parkes, 29
Borghese, Camillo, 218
Borromini, Francesco, 127–128
Bosio, François Joseph, 213
Botta, Paul-Émile, 230
Botticelli, 305
Boucher, François, xviii, 158–159, 182, 320
Boullée, Étienne-Louis, 165
Bourbon, Henri de, 59
Bourbon Restoration, 216
Bouvines, Battle of, 3, 9
Bramante, Donato, 49
Braque, Georges, 322–323, 328, 357
Bréant, Pierre, 14
Brébion, Maximilien, 180, 210
Bresc-Bautier, Geneviève, 40, 331
Breteuil, Baron de, 194
Brissac, duc de, 194
British Museum, 166, 168, 218, 222, 224–225, 228, 278
Brosse, Salomon, 87
Bruegel the Elder, Pieter, 201, 313
Brumaire, 173–174
brutalism, 341, 346, 350
Budé, Guillaume, 31
building materials, 261
Bulldog and Scottish Terrier (Decamps), 304–305
bulwarks, 19

Bunel, Jacob, 74
Burgundy, Duke of, 3

Cabanel, Alexandre, 313
Cabaret de la Mort, 248
Cachet, Victor, 257
Caffieri, Jean-Jacques, 152
Callet, Antoine, 114
Camondo, Isaac de, 305–306
Campana, Giampietro, 279
Campana Collection, 279–280
Canova, Antonio, 217
Capet, Louis, 181
Capetian dynasty, 3
Capitoline Brutus, 198, 199
Capitoline Museums, 166, 168, 192, 199
car culture, 256, 331
Caravaggio, 116–117
Carbonari, 239–240
Carcassonne, 8
Carême, xvii
Carmontelle, Louis Carrogis, 161–162
Carolus-Duran, 313
Carpaccio, 198
Carpi, Scibec de, 322
Carrousel du Louvre, 20–21, 23, 332–333, 336, 338, 346, 350–353
caryatids, 52–53
Castiglione, Baldassare, 35, 309
Cateau-Cambrésis, Peace of, 57, 58
Catherine de Médicis
 apartments of, 55
 expansion of Louvre under, 61–62
 marriage of, 41, 48
 Musée des Souverains and, 285
 Peace of Cateau-Cambrésis and, 57
 Petite Galerie and, 73, 74
 as regent, 58
 Saint Bartholomew's Day Massacre and, 60
 Tuileries Palace and, 65
Catherine de Vivonne, Marquise de Rambouillet, 97
Catherine II of Russia, 169
Catholic League, 68

Catholic League (Ligue Catholique), 60–61
Cavaignac, Louis-Eugène, 239
Centre Pompidou, 335
Certosa of Pavia, 48–49
Chalgrin, Jean, 212
Champaigne, Philippe de, 90, 92, 118
Champoiseau, Charles, 283–284
Champollion, Jean-François, 228–229, 229, 232, 343
Champs-Éylsées, xix, 41
Chantelou, Paul Fréart de, 98, 101, 130, 131
Chantereau, Jérôme-François, 154
Chapel of Anet, 63
Chapel of Saint Louis, 301, 347
Chapelle de Saint-Napoléon, 213
Chardigny, Barthélémy-François, 210
Chardin, Jean-Baptiste-Siméon, xviii, 152, 153, 158, 159, 163
Charles Emmanuel II of Savoie, 81
Charles I of England, 116
Charles I of Spain, 41–42
Charles IV, 25
Charles IX, 58, 61
Charles the Fat, 7
Charles V
 changes made by, 21, 22–23
 curtain-wall of, 77
 library of, 17–18
 at Louvre, 25
 Musée des Souverains and, 284
 palace of, 1, 9, 12
 reign of, 16–17
 statue of, 14–15, 15, 118, 223
 wall of, 19, 23, 67, 96, 352
Charles VI, 13, 18, 24, 26–27
Charles VIII, 30, 31
Charles X, 149, 229, 231
Château de Vincennes, 11, 18, 19, 21–22
Château of Clos Lucé, 33
Chateaubriand, 231
Chavet, Victor, 255
Chilperic, 6
Chirac, Jacques, 335

Choiseul-Gouffier, Comte de, 224–225
Chouans, 174
Christ de Pitié (Malouel), 356
Church of Saint-Germain l'Auxerrois, 7, 59, 331
Church of Saint-Gervais, 7
Church of Saint-Nicolas, 14
Church of Saint-Thomas, 14
Cimetière des Innocents, 4, 24
civil war, 58–61
Clarence, Duke of, 25
Clauzel, Bertrand, 198
Clemenceau, Georges, 305, 306
Clément, Jacques, 68
Clement VII, Pope, 58
Clérisseau, Charles-Louis, 153
Clouet, Jean, 30
Clubfoot, The (Ribera), 282
Codex Vallardi (Pisanello), 278–279
Cogniet, Léon, 229
Colbert, Jean-Baptiste, 119, 120–121, 136–138, 159, 167, 337
Colbert Introducing Perrault to Louis XIV, 235
Coligny, Admiral de, 59
Collection Campana, 209
Collège de France, 31
Colonnade du Louvre
 Bernini and, 132
 building of, 26, 39, 333
 clearing of, 144–145
 description of, 125, 133–138
 deterioration of, 142–144
 façade of, xx
 lack of roof for, 106
 Le Vau and, 121, 122–123
 Percier and Fontaine's contributions to, 209–210
 Perrault and, 130
 stairways of, 209–210
Colonna-Walewski, Alexandre, 268
Comité d'Instruction, 196
Communards, 65, 267, 292–295
Concert Champêtre (Titian), 116
Concini, Concino, 88–89
Condé, Prince of, 193–194

Congress of Chandrigar (Le Corbusier), 350
Conspiracy of Amboise, 59
construction workers, 259–261
Convent of the Petitis Augustins, 194
Coronation of Napoleon (David), 317
Coronation of the Virgin (Fra Angelico), 218
corps-de-logis, 9
Correggio, 116
Cortona, Pietro da, 127–128
Cotte, Robert de, 148
Coty, René, 326
Cour Carrée
 archaeological work on, 338
 expansion of, 95
 Fragonard and, xviii
 houses within, 150
 as main space, xv
 Malraux and, 330
 Palace of the Louvre and, xix
 Philippe Auguste's fortress and, 10
 revisions of, 145
 roof for, 207–208
 Silvestre's engraving of, 122
 soubassement under, 1
Cour des Cuisines, 56
Cour du Sphinx, 122, 246
Cour Khorsabad, 213, 230, 246, 282, 349
Cour Lefuel, 246, 258
Cour Marly, 14, 246, 348–349
Cour Napoléon
 archaeological work on, 338
 clearing for, 248
 excavation of, xv, 2
 Grand Louvre and, 350
 les hommes illustres and, 274–276
 Hôpital des Quinze-Vingts and, 14
 Lefuel and, 253
 photograph of, 275
 Pyramide and, 298–299
 Visconti's plan and, 246
Cour Puget, 246, 348–350
Cour Visconti, 246
Courbet, Gustave, 292

Cousin, Jean, 316
Coustou, 152
Coypel, Charles-Antoine, 152, 182
Cranach, 356
Cribier, Pascal, 353
crown jewels, 74, 111, 124, 316
Crucifixion (Fra Angelico), 305
curtain-wall of Charles V, 77
Cygne, Le (The Swan; Baudelaire),
 286–287

da Vinci, Leonardo. *See also Mona
 Lisa* (da Vinci)
 Bacchus, 33
 La Belle Ferronnière, 33, 186, 318
 Drapery Study for a Seated Figure,
 33
 François I and, 33
 Grande Galerie and, xx
 Ingres painting of, 29, *40*
 Leda and the Swan, 34
 Saint John the Baptist, 33, 116
 on sculptors, 156
 special exhibition of, 325
 *The Virgin and Child with Saint
 Anne*, 33, 91
 Virgin of the Rocks, 33
Daddi, Giotto and Bernardo, 280
*Dagobert Embarking before His
 House in the Louvre*, 235
Dallington, Robert, 70
Dalou, Jules, 293
Dammartin, Drouet de, 22
d'Angiviller, Charles-Claude Flahaut
 de La Billarderie, Comte, 168–171,
 182, 274, 275
Dante and Virgil (Delacroix), 231
Daumier, 311
David (Michelangelo), 34
David, Jacques-Louis, 152, 176–177,
 182, 183, 187, 221, *221*, 317
Day of the Dupes, 84
d'Azincourt, Augustin Blondel, 169
de Gaulle, Charles, 320, 326, 331
de Goya, Francisco, 201
Death of General Desais (Regnault),
 177

Death of Marat (David), 177
Death of President Duranti
 (Delaroche), 219–220
Death of Sardanapalus (Delacroix),
 316
Death of the Virgin (Caravaggio),
 116–117
Débâcle, La (Zola), 290
Debucourt, Philibert-Louis, 151
Decamps, Alexandre, 304–305
Déclaration des droits de l'homme
 (The Declaration of the Rights of
 Man), 197
Défense Nationale, 291, 292
Déjeuner sur l'Herbe (Manet), 306
Delacroix, Eugène, 113, 114, 231,
 264, 313, 316
Delaroche, Paul, 219–220
Delorme, Philibert, 51, 62–64, *63*, 252
Delvau, Alfred, 248
Demachy, Pierre-Antoine, 151,
 152–153, 162
Denon, Dominique Vivant, Baron,
 189–191, *191–192*, 200–203,
 216–218, 220, 228, 230, 343
Deposition (Regnault), 176
Descent from the Cross, The (Rubens),
 197
Desmoulins, Camille, 177
Diana at the Hunt, 80
Diana of Fontainebleau, 272
Diane de Poitier, 58
Diane Sortant du Bain (Boucher), 320
Diderot, Denis, 160, 163
Directory, 173
d'Orbay, François, 136, 156
Dou, Gerrit, 198
Dourdan, 11
Draftsman of Antiquities, The
 (Robert), 193
Drapery Study for a Seated Figure (da
 Vinci), 33
Dream of a Knight (Pereda), 201
du Cereau, Jacques I Androuet, 37,
 54–55, 62
du Cereau, Jacques II Androuet, 78,
 208

Duban, Félix, 73, 111–112, *113*, 243–244, 263–264, 274, 324

Dubois, Étienne, 74

Dubreuil, Toussaint, 68

Duc d'Orléans (Ingres), 356

Duccio, xix

Dumont, Edme, 152

Durameau, Louis Jean-Jacques, 114, 153

Durand, Edmé, 224

Dürer, 92, 316

Duval, Georges, 338, 340

Dying Slave, The (Michelangelo), 34, 92, 317

east façade, 125–130, 133–138

Echo and Narcissus (Poussin), 118

Eckermann, Johann Peter, 46

École du Louvre, 78–79, 303, 315, 356

Economics (Aristotle), 17

"*Education sentimentale, L'* (Flaubert), 241

Edward III, 25

Edward of Woodstock, 16

Egyptian collection, 228–229, 232, 343

Egyptian Galleries, xviii

Einsatzstab Reichsleiter Rosenberg (Reichsleiter Rosenberg Taskforce), 320–321

Elgin Marbles, 218, 224–225

Elisabeth de Valois, 57

Elizabeth II, 325–326

Emmanuel-Philibert, Duke of Savoy, 57

enceinte, 4

Errard, Charles, 124, 156

Escalier Daru, xx, 1, 210, 272, 283, 300–301, 314–315, *314*

Escalier de la Bibliothèque, 272–273

Escalier du Ministre, 272

Escalier Henri II, 53–54

Escalier Lefuel, 272–273

Escalier Mollien, 272–273

Escoffier, xvii

Estaing, Valéry Giscard d,' 335

Estrées, Gabrielle d,' 70–71

Eugénie, Empress, 290, 291

Eva Prima Pandora (Cousin), 316

Exposition des produits de l'industrie française (The Exhibition of the Products of French Industry), 189

Exposition Universelle, 259, 325, 337

Falconet, Étienne Maurice, 152

Family of Darius at the Feet of Alexander (Le Brun), 186

famine, 178

February Revolution (1848), 243

Fédération des artistes de Paris, 292

Félibien, André, 101, 157, 158

Ferran, Albert, 272, *314*, 315, 317

Ferrand, Count of Flanders, 9–10

Ferry, Jules, 303

Fersen, Comte de, 179

Férussac, Baron de, 230

Feuillants, 177–178

Fiorentino, Rosso, 49

First Arrondissement, 7, 207

First World War, 311–312

Flandrin, Hippolyte, *240*

Flaubert, 241

Fleury, Michel, 338, 347

Fontaine, Pierre, 21, 206–213, *212*, 215–216, 219, 232–233, 243, 271

Forbin, Comte Auguste de, 220, 224, 235

Fould, Achille, 268

Fouquières, Jacques, 100

Four Seasons, The (Poussin), 118

Fournel, Victor, 286

Fra Angelico, 218, 305

Fragonard, Alexandre-Évariste, 29

Fragonard, Jean-Honoré, xviii, 152, 163, 187, 235, 282

France, Anatole, 190

France in the Midst of French Legislators and Legal Scholars (Blondel), 219

France Surrounded by Divers Allegories (Müller), 270

Franco, Francisco, 320

François I

acquisitions of, 80
as art collector, 32–35
building projects of, 36–37
Catherine de Médicis and, 58
Cour des Cuisines and, 56
court of, 43–44
description of, 29–30
at Louvre, 27
Mona Lisa and, xxi
painting of, *40*
in Paris, 37–40
Petit-Bourbon and, 26
reign of, 30–31
François I Receives the Paintings and Sculptures Brought from Italy by Primaticcio (Fragonard), 235
François II, 57, 58
Frankfurt, Treaty of, 292
Fréminet, Martin, 74–75
Fronde uprisings, 105–106

Gabrielle d'Estrées et une de ses soeurs (Gabrielle d'Estrées and One of Her Sisters), 70–71, 316
Galerie Campana, 232–233, 235
Galerie d'Apollon, 74, 111–114, *113*, 123–124, 235–236, 263–264
Galerie des Batailles, 211
Galerie du Bord de l'Eau, 76
galerie neuve, 208
Galigaï, Leonora Dori, 88–89
Gambetta, Léon, 298–299, *299*
Garbriel, Ange-Jacques, 165
gardens, 24. *See also* Jardin de l'Infante; Jardin des Tuilleries
Garnier, Charles, 242, *295*
Gautier, Théophile, 249, 250
Gentileschi, Orazio, 117
Géricault, 230–231, 317
Gerusalemme liberata (Tasso), 158
Gilles (Watteau), 282
Gilman, Benjamin, 312
Giotto, xix, 191, 218
Girardon, François, 113, 133
Girault, Charles, 299
Girondin faction, 184, 186–187

Glory Distributing Crowns to the Arts (Müller), 272
Godefroid, Ferdinand-Joseph, 154
Goering, Hermann, 320
Goethe, 46
Goncourt, Edmond de, 290, 292
Gonse, Louis, 304
Goujon, Jean, 51–54, 55, *95*, 208, 290
Goulinat, Jean-Gabriel, 329
Grand Châtelet, le, 7
Grand Louvre
architect for, 339–340
building of, 333–334, 336
excavations and, 7
excavations for, 353
landscaping for, 353–354
plans for, 336–338
work on, 2
Grande Galerie, la
building of, 75–81
joining of Tuileries with, 11, 64–65
length of, xx
lighting for, 170–171
Percier and Fontaine's contributions to, 209, 211
Poussin and, xviii
Poussin's work on, 98, 99–101
Second World War and, 318, *318*
Grande Odalisque (Ingres), 231, 306
Grande Sainte Famille de François Ier, La (Raphael), 35, 186, 187
Grande Vis, la, 22–23
grands boulevards, les, 120
Grands Guichets, 20, 256, 294
Greater Bacchanales (Poussin), 98
Greek and Roman antiquities, 224–228. *See also individual works*
Grégoire, Abbé, 197–198
Greuze, Jean-Baptiste, 152, 163
Gros, Baron, 177, 233
Grosse Tour, 9, 22–23, 39, 120
guards, 220–221, *221*
guide books, 221
Guillaume, Edmond, 272, 297–298, 299–301, 324, 330
Guise family, 57–58, 59

Haffner, Jean-Jacques, 324

Hall Napoléon, 341, 343, 345–346

Halles, les, 4, 24

Hals, 282

Hamilton, William, 224

hanging of pictures, change to method of, 276–277, 313–314

Hardouin-Mansart, Jules, 242

Hauser, Aloïs, 284

Haussmann, Baron, 129, 206, 239, 252, 256

Heim, François Joseph, 233

Helene Fourment and Her Children (Rubens), 169

Henri II

 acquisitions of, 80

 death of, 57

 impact of on Louvre, 39, 54–55

 marriage of, 41, 58

 Peace of Cateau-Cambrésis and, 57

 reign of, 47–48

Henri III, 43, 61, 67–68

Henri IV (Henri de Bourbon)

 assassination of, 81–82

 conservation and, 80–81

 expansion of Louvre under, 61

 expansion of Paris and, 3–4

 Grande Galerie and, 75–76, 78–80

 Marie de Médicis and, 71

 marriage of, 59

 Petite Galerie and, 74

 popularity of, 69–70, 81

 portrait of, 69

 reign of, 67–68

 sieges of, 67, 68–69

 urban developments under, 72–73

 work on Louvre and, 71–72

Henry II of England, 3

Henry VI of England, 27

Hercules Commodus, 32

Hercules Farnese, 197

Hermaphrodite Mazarin, 118

Hermitage, 279

Héroard, Jean, 83, 97

Holbein, 116, 173, 318

hommes illustres, les, 274–276, 275

Homolle, Théophile, 309

Hôpital des Quinze-Vingts (Hospital of the Three Hundred), 13–14, 96–97

Horne, Alistair, 70

Horses of San Marco, 218

Hortense de Beauharnais, 239

hospital pauperum clericorum de Lupara, 8

Hostel des Lions, l,' 24

Hôtel d'Alençon, 26

Hôtel de Nantes, 251–252

Hôtel de Nesle, 194

Hôtel de Rambouillet, 97

Hôtel des Tournelles, 37–38, 57, 62

Hôtel du Petit-Bourbon, 26, 39, 120, 122

Hôtel Saint-Pol, 18, 21

Houdon, 356

Hours, Magdalene, 329

Houssaye, Arsène, 249–250

Hoyau, Germain, 20

Hugo, Victor, 2, 242

Humboldt, Wilhelm von, 216

Hume, David, 222–223

Hunchback of Notre Dame, The (Hugo), 2

Hundred Days, 216

Hundred Years War, 16, 26–27

Hunt, Richard Morris, 254–255

Hutchinson, Charles, 312

Huyghe, René, 313, 323

Île de la Cité, 2, 12

Imaginary View of the Grande Galerie in Ruins (Robert), 192–193, *194*

Immaculate Conception (Murillo), 320

Impasse du Doyenné, 249–251

impressionists, 306

Indifférent, l' (Watteau), 319

Ingres, Jean-Auguste-Dominique, 29, 40, 231, 233–234, *234*, 305, 306, 309, 356

interior design, 262–268

Interior View of the Grande Galerie (Robert), 185

International Style, 341
ironwork, 171, 262
Irving, Washington, 240
Israelites Gathering the Manna
(Chantelou), 98
Italy, François I's invasion of, 30–31

Jabach, Everhard, 116, 119
Jacobin faction, 187
James, Henry, 111–112, 360
Jardin de l'Infante, 148
Jardin des Tuilleries, 62, 165, 297–
298, 353–354
Jaujard, Jacques, 319–320, 321
Jean, Duc de Berry, 15–16
Jean II, 15–16
Jeanne de Bourbon, 14–15, *15*, 118,
223
Jeanron, Philippe-Auguste, 264,
277–278
jeu de paume, 24
Joan of Arc, 20
John of Salisbury, 17
Joseph Bonaparte, 201
Jouvenet, Jean, 169
Jouy, Barbet de, 293, 294
Joyeuse (sword), 195
July Monarchy, 220, 227, 230,
232–233, 235, 239, 241
June uprising (1848), 252

Kamptulicon, 262
Kennedy, Jacqueline, 329
Kennedy, John F., 329
Kermesse (Rubens), 167
Khorsabad, 230, 282, 349
Kiefer, Anselm, 357
Kirsch, Yves de, 338
Klagmann, Jean-Baptiste-Jules, 272
Kruta, Venceslas, 338, 347

La Caze, Louis, 281–282
La Font de Saint-Yenne, Étienne, 142,
160, 167
La Hyre, Laurent de, 118
La Sueur, Eustache, 169

La Tour, Georges de, 316
La Tour, Maurice Quentin de, 152, 153
labels, 200
Lacemaker (Vermeer), 278, 326
Lackland, John, 3
Laclotte, Michel, 355
Lafayette, Marquis de, 177–178
Lafenestre, Georges, 304–305, 306
Lagrenée, Louis-Jean-François, 114
Lahalle, Olivier, 330
Lamartine, Alphonse de, 239
Landowski, Paul, 299
Lang, Jack, 336–337
Laocoön, 198, 199, 217, 218, 226
lavatories, 25
Lavoisier, Antoine-Laurent, 176
le Breton, Guillaume, 6, 9–10, 14
Le Brun, Charles
Académie Royale de Peinture et de
Sculpture and, 156
Colonnade and, 136–137
departure from Louvre, 263–264
*Family of Darius at the Feet of
Alexander*, 186
Galerie d'Apollon and, 111,
113–114, *113*
Meal in the House of Simon,
217–218
murals of, xx
petit conseil and, 127
Le Corbusier, 328, 341, 350
Le Gray, Gustave, 259
Le Nôtre, André, 298
Le Vau, Louis
Aile Sud and, *55*
Beaux-Arts style and, 242
Bernini and, 132
Colonnade and, 136–137
completion of work of, 207
Cour Carrée and, 145
impact of on Louvre, 121–124
Institut de France and, 155
moat and, 330, 347
petit conseil and, 127
Petite Galerie and, 74, 205
Vigarani and, 126

Leczinska, Marie, 149
Leda and the Swan (da Vinci), 34
Lefévre, Robert, *191*
Left Bank
 fortification of, 4
 historical context of, 2–3, 4
Lefuel, Hector
 Aile Rivoli and, 296–297
 Appartement du Ministre and, 263
 burning of Tuileries and, 295
 Cour Napoléon and, 274
 Fournel on, 286
 impact of on Louvre, 208
 interior design and, 267–268
 Nouveau Louvre and, 243–244,
 252–257, 333
 stairways designed by, 271–273,
 348
 western façade and, 125, 243
Legrand, Jacques Guillaume, 165, 180
Lehman, Karl, 284
Leibnitz, Gottfried Wilhelm, 136 .
Leipzig, Battle of, 215
Lemercier, Jacques, 10, 21, *50*, 93–96,
 100–102, 121, 151, 207, 271
Lemmi cycle (Botticelli), 305
L'Enfant, Pierre, 139
Leo X, Pope, xxi
Lescot, Pierre, Seigneur de Clagny,
 45–47, 50–51, *50*, 53, 63, 122,
 144–145, 207, 271
Lesser Bacchanales (Poussin), 98
Liberty Leading the People
 (Delacroix), 231
library of Charles V, 17–18
*Lictors Bring to Brutus the Bodies of
 His Sons, The* (David), 176
Lievens, Jan, 169
Life of Saint Bruno (Le Sueur), 169
Ligue Catholique (Catholic League),
 60–61, 68
Limbourg brothers, 22
limestone, 261
Lippi, Filippino, 280
*Livre des fais et bonnes meurs du sage
 roy Charles V* (Pizan), 17

*Livre du gouvernement des rois et des
 princes* (Peyraut), 17
loan exhibitions, 313, 329–330
Longhi, Pietro, 116
Loos, Adolf, 267
Louis I of Anjou, 15, 16
Louis IX (Saint Louis), 12, 14
Louis Philippe d'Orléans, 241
Louis VII, 4
Louis XII, 21, 30–31, 33
Louis XIII
 Anne of Austria and, 103–104
 ascension to throne by, 83
 bulwarks and, 19
 Concini and, 88
 death of, 101
 expansion of Louvre under, 10,
 61, 90
 mother and, 84
 Poussin and, 99
 razing of fortification and, 64
 reign of, 89
Louis XIV
 architecture of, 107–109, 119–120
 as art collector, 114–116,
 117–119
 bulwarks and, 19
 carrousel and, 109–111
 Charles V and Jeanne de Bourbon
 statues and, 15
 childhood of, 104–106
 Colonnade and, 135
 equestrian statue of, *110*
 monarchy and, 29
 move to Versailles, 138–139, 141
 Petit-Bourbon and, 26
 reign of, 106–107
 sculptures of, 132–133
 succession of, 145–146
 work on Louvre by, 120–121,
 131–132
Louis XV, 146–147, 164–165, 168
Louis XVI, 149, 165, 168, 173,
 178–181
Louis XVIII, 149, 216, 218, 219, 220,
 226

Louvre
 abandoned, 141–171
 as academy, xviii
 admission charge for, 304, 312
 architectural influence of, 11
 centrality of, xvii
 as complex, xix
 creation of contemporary, 333–354
 description of early structure of,
 8–11
 division of collections of, 302–303
 donations to, 305
 early acquisitions for, 168–171
 early Bourbons and, 67–102
 early photographs of, *251, 252,*
 259, 260
 evacuations of, 290, 311, 316–318
 expansion of collection of,
 222–228, 278–284, 316
 François I's modernizing of, 38–40
 future of, 358–360
 growth of, 355–356
 influence of, 189
 landscaping changes to, 297–299
 under Louis XIV, 103–139
 in modern times, 289–332
 name of, 5–6
 Napoleon and, 173–213
 Napoleon III and, 237–287
 objects of, xx–xxi
 origins of, 1–27
 parts of, xix–xx
 "placeness" of, xv–xvi
 in Renaissance, 29–66
 Restoration and, 215–236
 seizures of art and, 193–202
Louvre, le, as name for area, xv–xvi
Louvre Abu Dhabi, 358
Louvre-Lens, 357–358
Love Fleeing Servitude (Vien), 176
Luxeumbourg exhibition, 167–168

Macary, Michel, 340, 349, 352
MacMahon, Patrice de, 293
Maderno, Carlo, 93
Madonna with a Rabbit (Titian), 167

Maillotins (Hammer-Wielders), 26–27
Mairobert, Pidansat de, 161
Malherbe, François de, 72, 97
Mallarmé, xvii
Malouel, Jean, 356
Malraux, André, 326–332, *327,* 358
Malraux's Law, 330
*Man Formed by Prometheus, or the
 Origin of Sculpture* (Berthélemy), 206
Man with a Glove (Titian), 116
Mancini, Philippe, duc de Nevers, 150
Manet, 306, 313
Mannheim, Charles, 304
Mansart, François, 121, 127
Mansart, Jules-Hardouin, 121
Mantegna, 198
Maratta, Carlo, 154
Marcel, Étienne, 16, 18, 19
Marché Saint-Honoré, 177–178
Maréchal, Charles Raphael, 268
Maréchal des Lesdiguières, 43
Margot, la reine, 285
Marguerite de France, 57
Marguerite de Valois, 59–60, 70–71
Maria Theresa of Spain, 109–110
Mariana Victoria, 148–149
Marie Antoinette, 150, 162, 178–179,
 181, 285
Marie de Médicis, 71, 81, 83–84,
 87–88, 89
Marie de Médicis cycle (Rubens),
 84–87, 301–302
Marie of Anjou, 30
Mariette, Auguste, 282–283
Mariette, Pierre-Jean, 170
Marigny, Abel-François Poisson,
 marquis de, 143–144, 145, 153
Marnier, Charles, 233
Marsy, Gaspard and Balthazar, 113,
 124
Martinez, Jean-Luc, 355
Martyrdom of Saint Erasmus
 (Poussin), 198
Marvell, Andrew, 135
Marville, Charles, 259
Maskill, David, 154

Massacres at Scio, The (Delacroix), 231

Massif Central, 3

Mauzaisse, Jean-Baptiste, 206

Mazarin, Cardinal, 105–106, 118, 120, 124

Mazière, Simon, 148

Meal in the House of Simon (Le Brun), 217–218

Medici Venus, 226

Médor (dog), 231

Meeting of Marie de' Medici and Henry IV at Lyons, The (Rubens), 87

Melzi, Francesco, 33

Memoires pour l'instruction d'un dauphin (Louis XIV), 108

Mercier, Sebastien, 162

Mercury the Flutist (Bandinelli), 80

Mesopotamia, 229–230

Métezeau, Louis, 78, 80

Metropolitan Museum, 306, 329

Meun, Jean de, 17

Meynier, Charles, 210

Michelangelo, 32, 33–34, *34*, 92, 317

Michelet, Jules, 308–309

Ministry of Finance, 258, 266, 315

Ministry of State, 258, 265–269, 272. *See also* Appartement du Ministre

Miracle of Saint Diego, The (Murillo), 279

Mitterrand, François, 2, 289, 322, 333, 335–337, 339, 340, 347–348

modernism, 324

Moench, Charles and Auguste, 234

Molière, 97

Molinos, Jacques, 180

Moltke, Helmuth von, 291–292

Mona Lisa (da Vinci). *See also* da Vinci, Leonardo
abroad, 328–330
description of, 307–310
evacuation of, 316–317
François I and, xxi, 33
Josephine and, 173
popularity of, 1, 43, 343, 358

special exhibition and, 325
at Versailles, 186

Monet, 306

Monge, Gaspard, 200

Montagnards, 184, 187

Montholé, Jean-Baptiste de, 169

Moreau-Nélaton, Étienne, 306

Morellet, François, 357

Morse, Samuel F. B., 265, 276

Müller, Charles-Louis, 270, 272

Murger, Henri, 249

Murgey, Theophile, 272

Murillo, Esteban, 170, 279, 320

Musée Assyrien, 230

Musée au bord de la Seine, 232–233

Musée Charles X, 209, 232–233, 235

Musée de la Marine, 303

Musée des Arts Décoratifs, 302, 356

Musée des Souverains (the Museum of Sovereigns), 284–285

Musée d'Orsay, 306, 335

Musée du Louvre
early success of, 187–188
establishment of, 183–184
foundation of, 163
opening of, 166–167, 184–188

Musée du Quei Branly, 335

Musée Royal, 215

Muséum National des Arts, 187

Napoleon and his Architect Fontaine on the Staircase of the Louvre, 235–236

Napoleon Bonaparte
abdication of, 215–216
art seizures and, 198–202
assassination attempt on, 174–175
Battle of the Pyramids and, 342
Musée des Souverains and, 285
Percier and Fontaine and, 21
in power, 173
removal of marks of, 219
Tuileries Palace and, 65
Wedding Feast at Cana (Veronese) and, xxi
work on Louvre by, 166, 204–206

Napoleon III
 abdication of, 291
 banquet for workers given by, 237,
 255, 259
 early life of, 239–241
 interior spaces and, 262
 Musée des Souverains and,
 284–285
 Paris and, 4
 portrait of, *240*
 as president, 241–242
 Solferino and, 269–270
 taken prisoner, 290
 Tuileries Palace and, 65
 Visconti and, 192
 work on Louvre by, xvi, 11, 14,
 205, 211, 237–239, 255–256
National Gallery (London), 278
National Gallery (Washington, DC),
 329, 340, 341
neoclassicism, 243
Nerval, Gérard de, 249, 250–251
Nicomachean Ethics (Aristotle), 17
Nieuwerkerke, Émilien de, 267,
 277–278, 290–291
Normandy, annexation of, 5
Normans, siege of, 7
northern façade, 208–209
Notre-Dame de Paris, 4, 22
Notre-Dame de Paris (Hugo), 2
Nouveau Louvre, 11, 243–244,
 246–247, 257–258, 333
Nouvel, Jean, 354, 358
Noverre, Jean-Georges, xvii
Nuit ou Diane, La (Night or Diana; Le
 Brun), 114
Nymphs of Parthenope . . . , The
 (Marnier), 233

Oath of the Jeu de Paume (David),
 177
Olympia (Manet), 306
ombre du grand Colbert, L' (La Font
 de Saint-Yenne), 142
Ornament und Verbrechen (Ornament
 and Crime; Loos), 267

Oudry, Jean-Baptiste, 356

paintings. *See also individual works*
 classification of, 277
 hanging of, 276–277, 313–314
Pajou, Augustin, 152, 187
Palace of Fontainebleau, renovation
 of, 49
Palais Cardinal, 94, 95
Palais de la Cité, 12, 21, 25
Palais-Royal, 105, 294. *See also*
 Tuileries Palace
Palazzo Caprini, 49
Palissy, Bernard, 224
papyri, 229
Parabère, la, 146
Paris
 fortifications of, 18–21
 François I's settling in, 37–40
 map of, *20*
 Nazi occupation of, 298–299
 Philippe Auguste and, 3–4
 population growth in, 4
 Prussian siege of, 291–292
 Treaty of, 215
 tripartite division of, 2–3
 wall around, 4–5
Paris and Helen (David), 176
Paris Commune (1871), xix, 241, 257,
 272, 293–295
parterre émaillé de fleurs, 277
Parthenon Marbles, 224–225
Passage Richelieu, 349, 350
Patel, Pierre, 169
Pater, Walter, 308
Paul IV, Pope, 80
Paulin, Pierre, 331
Pavia, Battle of, 31, 38
Pavillon Colbert, 13, 247
Pavillon Daru, 13, 247
Pavillon de Beauvais, 248
Pavillon de Flore, 65, 150, 243, 245,
 256–257, 270, 294, 325, 355–356
Pavillon de la Bibliothèque, 254
Pavillon de l'Horloge, 10, 94, 253
Pavillon de Marengo, 25, 145

Pavillon de Marsan, 243, 245, 257, 294–295, 356
Pavillon de Rohan, 20
Pavillon Denon, 13, 247
Pavillon des Arts, 122
Pavillon des Sessions, 211, 255, 258, 270, 301–302
Pavillon du Roi, 55–56, 123
Pavillon du Turgot, 14
Pavillon Marengo, 13
Pavillon Mollien, 247
Pavillon Richelieu, 13, 247, 349
Pavillon Sully, 94
Pavillon Turgot, 247, 266
Pei, Ieoh Ming, 2, 7, 298–299, 333, 338–341, 344–346, 349–350, 352, 354
Pèlerinage à l'île de Cythère (Watteau), 157–158, 182, 316, 326
Peninsular War, 201
pepperpot dome, 9
Percier, Charles, 21, 206–213, 212, 220, 232, 271
Père Fuzelier, Le, 221, 221
Pereda, Antonio de, 201
Périphérique, le, xvii
Perrault, Charles, 130–131, 136–138, 209, 212, 333
Perrault, Claude, 127, 136–138, 145, 242
Perrier, François, 169
Peruggia, Vincenzo, 310
Peter the Great, 147
Petit Pont, 22
Petite Galerie, 71–74, 73, 111–112, 122–123, 263
Petite Vis, 23
Peyraut, Guillaume, 17
Philip II of Spain, 57
Philip V of Spain, 147–148
Philippe Auguste, King, xv–xvi, 1, 3–5, 7, 8, 10, 14
Philippe Auguste Ordering the Construction of the Great Tower [of the Louvre], 235
Philippe d'Orléans, 84, 104, 146, 193–194

Philippe II of Burgundy, 16
Philippide (Guillaume le Breton), 10
photography, 259
piano nobile, 71–72
Picasso, Pablo, 310, 328
Picot, François Edouard, 233
Piérard, Renaud, 355
Pieret, Géry, 310
Pierre, Jean-Baptiste Marie, 168–169
Pierrefonds, 8
Pietà (Michelangelo), 32
Pietà of Saint-Germain-des-Prés, 22
Pigalle, Jean-Baptiste, 152
Pilgrims at Emmaus (Rembrandt), 169
Pilgrims at Emmaus (Veronese), 186
Pisanello, 278–279, 305
Pizan, Christine de, 13, 17, 18, 21, 25
Place, Victor, 230, 282
place de la Concorde, 13, 165
place des Vosges, 72–73
place du Carrousel, xv, 164, 206, 246, 248, 249, 298, 330–331, 338
place Vendôme, 292
Plan Turgot, 142–143, 143
Plans Destailleur, 76–77
plaster casts, 218
plundered art, return of, 216–218
Poitiers, Battle of, 16
Policraticus (John of Salisbury), 17
Politics (Aristotle), 17
polychrome marble, 261
Pompidou, Georges, 335
Pont Neuf, 72
Porte Barbet de Jouy, 294
Porte Saint-Denis, 19
Porte Saint-Martin, 19
Portrait of a Princess of the House of Este (Pisanello), 305
Portrait of Anne of Cleves (Holbein), 318
Portrait of Comtesse d'Haussonville (Ingres), 305
Portrait of François I (Titian), 318
Portrait of Giovanna of Aragon (Raphael), 35

Portrait of Hendrickje Stoffels
(Rembrandt), 169–170
Portrait of the Infanta (Velazquez),
170
portraits, first know extant example
of, 16
postmodernism, 344
pottery collection, 227–228
Pourbus the Younger, Frans, *69*
Poussin, Nicolas, xviii, 91, 98–102,
116, 118, 198
Poussin Arriving from Rome . . .
(Alaux), 235
Pradel, Pierre, 318
Prangey, Girault de, *251*, 252
Preaching of Saint Steven, The
(Carpaccio), 198
Préault, Auguste, 276
précieuses ridicules, Les (The Affected
Ladies; Molière), 97
*Presentation of Her Portrait to Henry
IV, The* (Rubens), 87
President Mole on the Barricades
(Thomas), 219–220
Primaticcio, 32, 49
primatives, 202–204
prostitutes, 25
Proust, Marcel, xvii
Pushkin Museum (Moscow), 329–330
Pyramide (Pei), xix, 2, 7, 298–301,
338, *339*, 341–345
Pyramids, Battle of the, 342

Quartier du Louvre
clearing of, 247–251
during eighteenth century, 149–150
as town, 12–13
Quatremère de Quincy, Antoine, 200

Racine, xvi
Raft of the Medusa (Gericault),
230–231, 317
Raie, La (Chardin), 158, *159*
Rainaldi, Carlo, 127–128
Raising of the Cross, The (Rubens),
197

Raphael, xxi, 35, 167, 186, 187, 198,
290, 309, 326
Ravaillac, François, 81–82
Rayet, Olivier, 304
Raymond, Jean-Arnaud, 205
Rebellious Slave, The (Michelangelo),
34, *34*, 92, 317
Redon, Gaston, 85, 299, 301–302
Regard, Le (Salles), 323
Regnault, Jean-Baptiste, 176, 177
Reign of Terror, 181, 184
Reiset, Frédéric de, 290
Rembrandt, 169–170, 186, 278, 282,
304
Renaldo and Armida (Boucher),
158–159
Renard, Jean-Augustin, 180
Reni, Guido, 117, 130, 186
restitution of art, 216–218
Restout, Jean, 153–154
Retable du Parlement de Paris, 22
Réunino des Musées Nationaux, 303
Révoil, Pierre, 224
revolutionary confiscations, 193–196
Ribbentrop, Friedrich von, 217
Ribera, 203, 282, 356
Richard the Lionheart, 3
Richelieu, Cardinal, 84, 90–94, *92*,
98–99, 101, 104–105, 155
Richelieu Bacchus, 92
Ricotti, Rudy, 355
Right Bank
commercial area on, 4
fortification of, 4
wall around, 18
Rivière, marquis de, 226
Rivoli, rue de, 24, 207, 254
Rivoli Wing, 257
Robbia, Girolamo della, 42
Robbia, Luca della, 305
Robert, Hubert, 152, 174, 176, 185,
187, 192–193, *194*, 318
Robespierre, Maximilien de, 177, 181
Roland, Vicomte de, 186–187
Roland de La Platière, Jean-Marie, 183
Roman de la rose (Meun), 17

Romanelli, Giovanni Francesco, xx, 124
Romano, Giulio, 35
Romantic movement, 231
rood screen at the Church of Saint-Germain l'Auxerrois, 45, 51
Rosenberg, Pierre, 355
Rosetta Stone, 228–229
Rothschild, Edmond James de, 305
Rotonde de Mars, 122, 123, 205–206, 210
Roubaud, François, 353
Rouquet, Jean André, 153
Rousseau, Robert, 14
Rubens, Peter Paul, 84–87, 116, 167, 197, 301–302
Rude, François, 276

Saint Bartholomew's Day Massacre, 59–60, 129
Saint Bartholomew's Day Massacre, The, 235
Saint Francis Receiving the Stigmata (Giotto), 191, 218
Saint Jerome Reading (La Tour), 316
Saint John the Baptist (da Vinci), 33, 116
Saint John the Evangelist (Ribera), 356
Saint Margaret (Raphael), 35
Saint Michael Routing the Demon (Raphael), xxi, 35, 326
Saint-Aubin, Gabriel de, 185
Saint-Denis, 223–224
Sainte-Chapelle, 22
Saint-Gelais, Mellin de, 14
Saint-Morys, Charles de, 194
Saint-Thomas du Louvre, 8
Salaì, Andrea, 33
Salle des Antiques, 80
Salle des Caryatides
 chapel in, 12
 effigy of Henri IV in, 82
 Elizabeth II in, 326
 Goujon and, 52–53
 Guillaume's excavation and, 301
 hangings in, 61

Henri II and, 48
Lemercier's work on, 94–95
photograph of, 50
statues in, 118
Salle des États, xxi, 114–115, 255, 258, 269–270, 300, 324–325
Salle des Machines, 109–110
Salle des Sept-Chieminées, 263, 265
Salle du Manège, 258
Salle Mollien, 237
Salles, Georges, 322–323, 357
Salon, concept of, xviii–xix
Salon, annual, 159–163, 175–177, 185
Salon Carré, xviii–xix, 1, 122, 160, 210–211, 263, 265, 324–325
Salt, Henry, 229
San Romano, Battle of, 280
SANAA, 358
Sanctuary of the Great Gods, 283
Santerre, Jean, 146
Sarazin, Jacques, 95, 156
Sarzec, Ernest de, 304
Sauvageot, Alexandre-Charles, 280–281
Sauval, Henri, 5–6, 24, 26
Scènes de la vie de bohème (Murger), 249
sculptural adornments, 273–274
Seated Scribe, 283
Second School of Fontainebleau, 74–75
Second World War, 316–321
Sedan, Battle of, 289–291
Self-Portrait with a Friend (Raphael), 35
Self-Portrait with a Thistle (Dürer), 316
semaine sanglante (Bloody Week), 293
Serapeum of Memphis, 282
Seringes-et-Nesles, 11
Serlio, Sebaastiano, 44–45
Serres, Georges, 337
Sigoyer, Martian Bernardy de, 294
Silvestre, Israel, 63, 110, 122
Simart, Pierre Charles, 265
Small Boy and Others, A (James), 112
Société des Amis du Louvre, 303

Soir ou Morphée, Le (Evening or Morpheus; Le Brun), 114
Solferino, Battle of, 269–270
Sons of Cain (Landowski), 299
Sorbonne, 4
soubassement, 1, 11
Soufflot, Jacques-Germain, 55, 144–145, 207
Soult, Jean-de-Dieu, 279
South Kensington Museum (now Victoria and Albert Museum), 279
Souvenirs de l'exode du Louvre (Bazin), 318
special exhibitions, 325, 346–347
Sphinx of the Dooms, 283
stairways, 271–272
Standing Vestal (Houdon), 356
statuomanie, 273
Steen, Jan, 282
Stendhal, 217
stones, 24
Sublet de Noyers, François, 95–96, 99, 101
Suger's Eagle, 196
Suisses, les, 150
Sully, Maximilien de Béthune, duc de, 73
summer apartments (*appartements d'été*), 73, 122, 123–124, 148, 197, 206

Talleyrand, 230
tapissier, 162–163
Taraval, Hugues, 114, 153
Tasso, Torquato, 158
Temple, Raymond du, 21–22
Termidorean Reaction, 187
The French Army, Embarking at Boulogne, Threatens England (frieze), 213
The Kingdoms of Bavaria and Wurtemburg Are Created (frieze), 213
Thiers, Adolphe, 305
Thiers, Enceinte, 291
Third Crusade, 3

Thomas, Antoine, 219–220
Thoré-Bürger, Théophile, 277
Three Graces (Cranach), 356
Tintoretto, 117
Titian, 30, 32, 92, 115, 116, 167, 318, 325
Tochon, Joseph François, 227
Tocqué, Louis, 153–154
toit en poivrière, 9
Tolentino, Treaty of, 217
Topographie historique du vieux Paris (Berty), 6
Tour de Bois, 20
Tour de la Fauconnerie, 17
Tour de Nesle, 5
Tour du Coin, 5
tourism, 334–335
Tournehem, Lenormant de, 167
Trajan's Column, reproduction of, 285
Transfiguration, The (Raphael), 198, 217
Travels of Sir John Mandeville, The, 17
très riches heures de Jean, duc du Berry, Les (Limbourg brothers), 22
triomphe de Neptune et d'Amphitrite, Le (Le Brun), 114
Triumph of French Painting, The (Meynier), 210
Trois Glorieuses, Les (The Three Glorious Days), 231
Trombetta, Jean, 338
Trouvelot, Jean, 330, 345
Truschet, Olivier, 20
Tuileries Palace. *See also* Palais-Royal
 building of, 62–65
 burning of, xix, 267, 293–295, 295
 Communards' occupation of, 293
 creation of, 11
 Delorme and, 51
 engraving of, 249
 fortification of, 96, 206
 illustration of, 63
 impact of, xix–xx
 joining with Louvre, 76, 237, 244–247, 255

Marie Antoinette and, 150
photograph of, *260*
riots and, 241
surviving elements of, 296
Tura, Cosmè, 280
Twombly, Cy, 357

Uccello, Paolo, 280
Uffizi, 166
universalism, 222–223
University of Paris, 8
urbanism, 241

Valentin de Boulogne, 117–118
Van Eyck, Jan, 15, 313
van Ostade, Isaak and Adriaen, 282
Vase d'Aliénor, 195–196
Vauchelet, Théophile, *247*
Velazquez, Diego, 156, 170, 282
Venus de Milo, 225, 226, 290, 311, 317, 326
Vermeer, 278, 326
Verne, Henri, 312, 314, 319, 337
Veronese, Paolo, xxi, 92, 198, 217, 269, 280, 290, 325
Verrocchio, 305
Versailles, 138–139
Vestibule Denon, 314
Viel-Castel, Horace de, 286
Vien, Joseph-Marie, 176
Vigarani, Carlo, 109–110, 126
Vignola, Giacomo Barozzi da, 44–45
Violet-le-duc, Eugène, 263
Virgin and Child with Saint Anne, The (da Vinci), 33, 91
Virgin of Victory (Mantegna), 198
Visconti, Ennio Quirino, 189, 192, 200, 224
Visconti, Louis, 192, 206, 243–244, 246, 247, 252–253, 261–262, 274, 333
Visitation of the Virgin (Lievens), 169
Voltaire, 142, 164, *275*
Vouet, Simon, 99, 118
Voyage dans la basse et la haute Égypte (Denon), 190

Wailly, Charles de, 187, 211
Walewska, Marie-Anne, 268–269
Walker, John, 329
Wallace, Richard, 291
Wallace Collection, 291
War of the Third Alliance, 213
Wars of Religion, 58–61, 68, 72
Waterloo, Battle of, 216, 239
Watteau, Antoine, 157–158, 182, 282, 316, 319, 326
Wedding Feast at Cana (Veronese), xxi, 198, 217, 269, 290
Wedding Feast (Bruegel), 201
Whitney Biennial, xviii
Wicar, Jean-Baptiste, 196
Wilhelm I, Kaiser, 291–292
Winged Victory of Samothrace, xix, 1, 210, 272, 283–284, 300–301, *314*, 317
Winter (Bruegel), 201
Wisdom and Force Present to the Imperial Couple . . . (Maréchal), 268
Wolff-Metternich, Franz von, 319–320
Woman with a Mirror (Titian), 116
World War I, 311–312
World War II, 316–321
World's Fair, 189

Zix, Benjamin, 175
Zola, Émile, 290
Zurbarán, Francisco de, 201, 203, 279